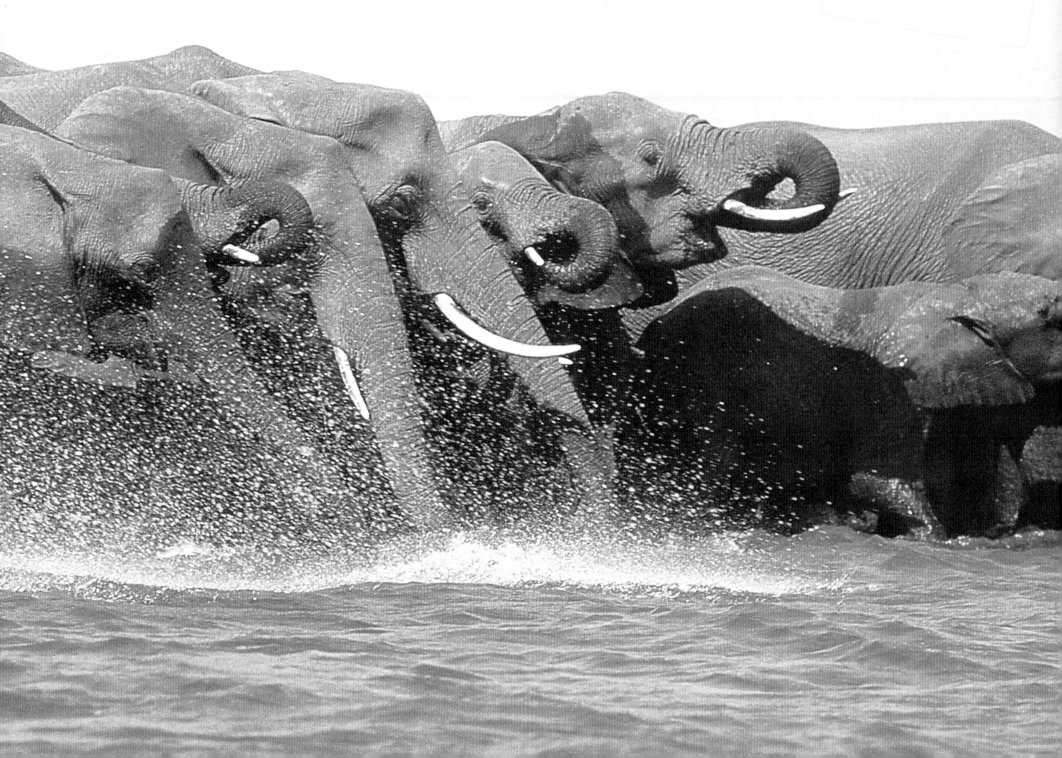

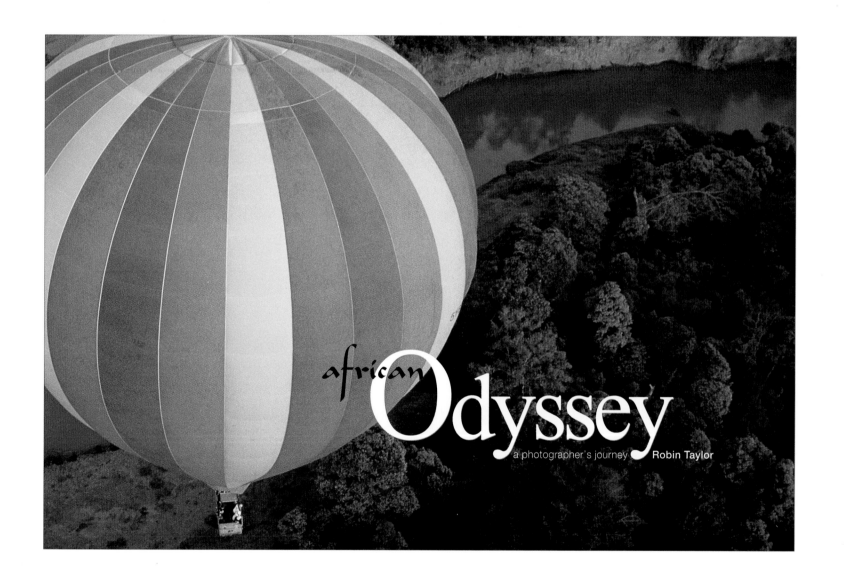

african Odyssey
a photographer's journey　Robin Taylor

Dedication

*This book is dedicated to my partner and soul mate
Sue. Your input and support has been invaluable
and incalculable. Without you it would not have been
possible - editor, administrator, typist, stylist, P.A.,
critic, co-producer of the TV series and an integral
part of the crew. Indispensable in every way.*

First Published 2006
Fountain Press Ltd
Old Sawmills Road, Faringdon,
Oxfordshire SN7 7DS, UK

Copyright © published edition:
Fountain Press
Copyright © photographs: Robin Taylor
Copyright © text: Robin Taylor

Publisher: Christopher Coleman
Editor: Robin Taylor
Designer: Rob House/Arden House Design

Reproduction by Unifoto (Pty) Ltd,
Cape Town, South Africa
Printed and bound by Star Standard Industries
(Pte) Ltd, Singapore

ISBN 0-86343-369-3

FOUNTAIN PRESS

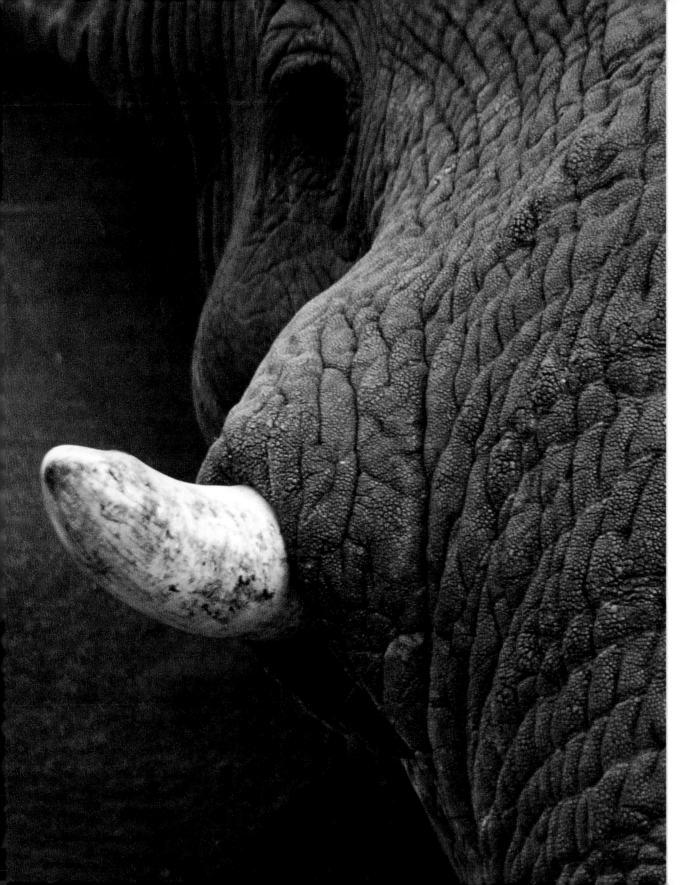

Contents

Contents	3
Introduction	6
South Africa Sabi Sabi - *Selati*	16
South Africa Sabi Sand - *Simbambili*	32
Tanzania Dar es Salaam & The Selous - *Boma Ulanga*	46
Botswana Central Kalahari - *Deception Valley*	62
Zambia Upper Zambezi & Victoria Falls - *Tongabezi*	74
Zambia Lower Zambezi Valley - *Sausage Tree*	88
Uganda Semliki - *Semliki*	102
Kenya Masai Mara - *Governors'*	114
Namibia Caprivi Strip - *Impalila & Susuwe*	132
South Africa Madikwe - *Jaci's*	148
Botswana Okavango Delta - *Ker & Downey Camps*	160
South Africa Sabi Sand - *Mala Mala*	186
South Africa Sabi Sand - *Notten's*	198
Lodges	210
Acknowledgements	211

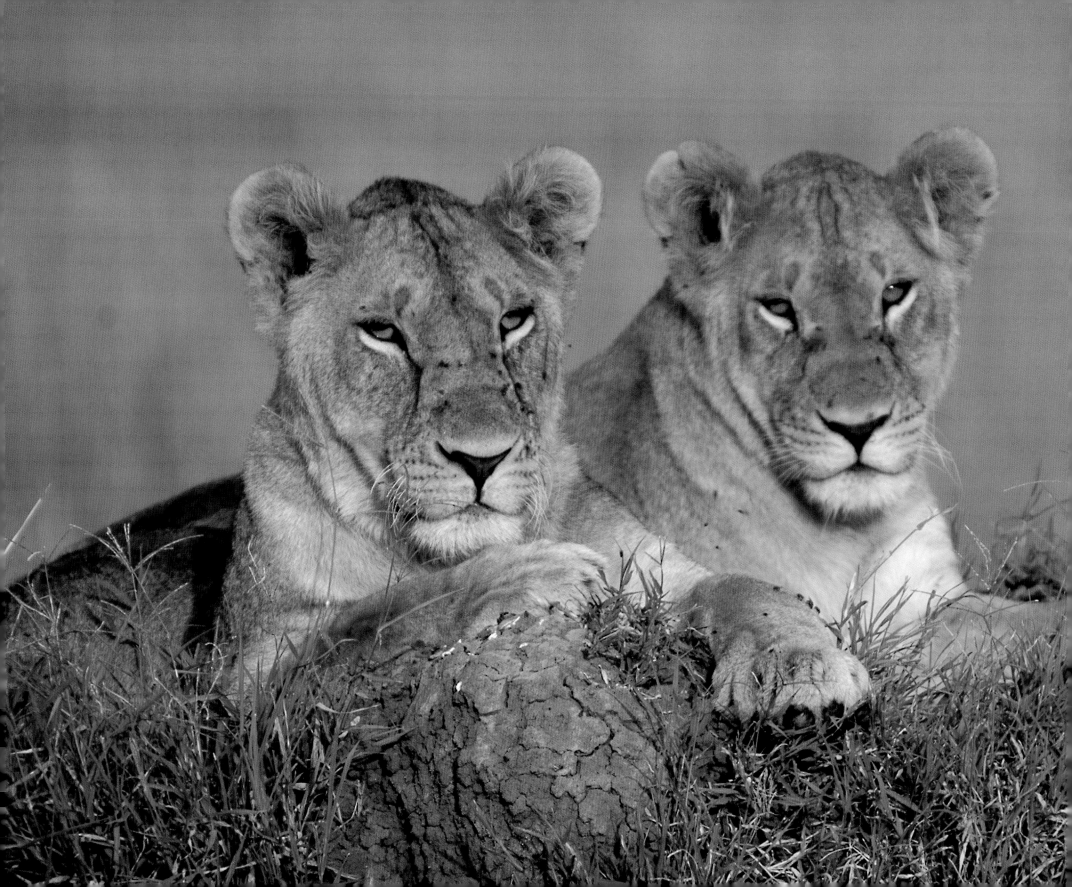

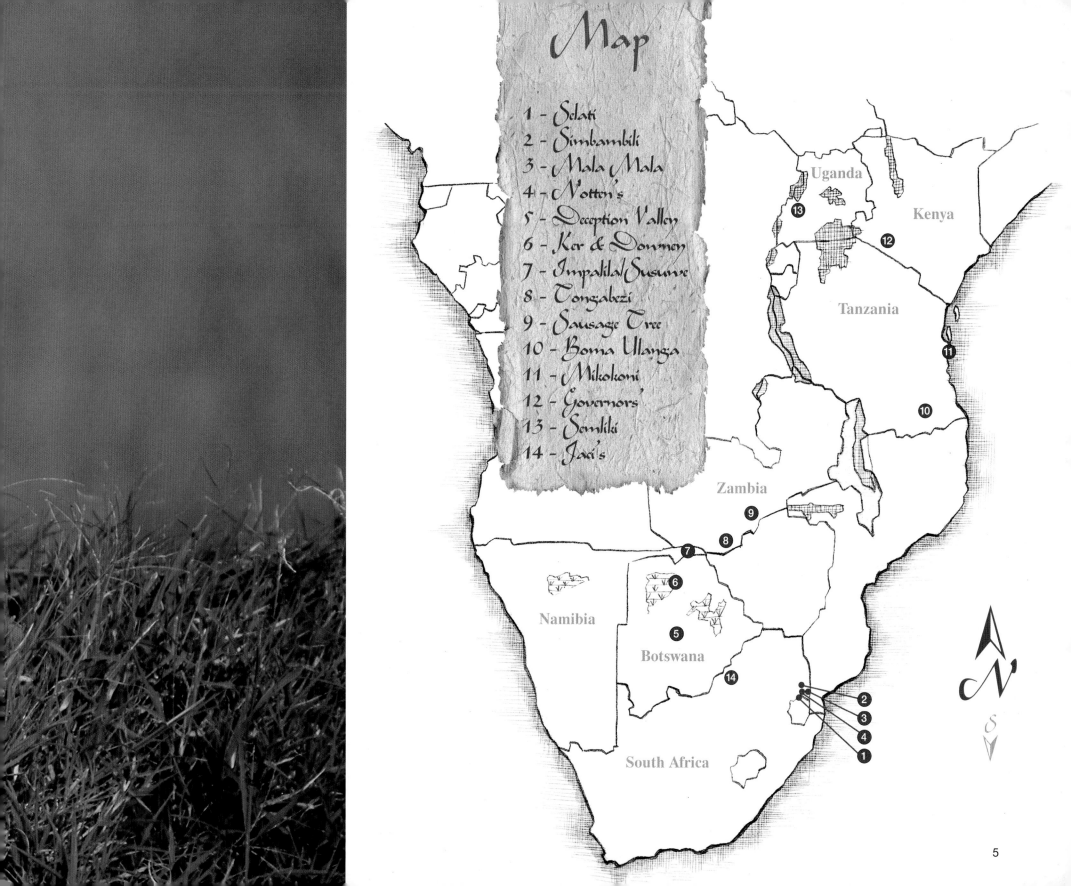

Map

1 – Selati
2 – Simbambili
3 – Mala Mala
4 – Notten's
5 – Deception Valley
6 – Ker & Downey
7 – Impalila/Susuwe
8 – Tongabezi
9 – Sausage Tree
10 – Boma Ulanga
11 – Mikokoni
12 – Governors'
13 – Semliki
14 – Jaci's

Uganda

Kenya

Tanzania

Zambia

Namibia

Botswana

South Africa

Introduction

I'm very lucky: I live and work in this often frustrating, always exciting continent. Africa is a paradise for any photographer but at the same time a mighty challenge.

A paradise because of its incomparable diverse scenery serving as a backdrop to the high profile stars of the African veld – elephants, lions, leopards, buffalos,

cheetahs, rhinos, hyenas, wild dogs and in supporting roles, the quintessential Africans - giraffes, zebras, hippos and many antelope species; the primates, reptiles and myriad birds.

Someone once described Africa as a vast zoo with wild animals as far as the eye can see. Regretfully they no longer migrate across the continent but are confined –

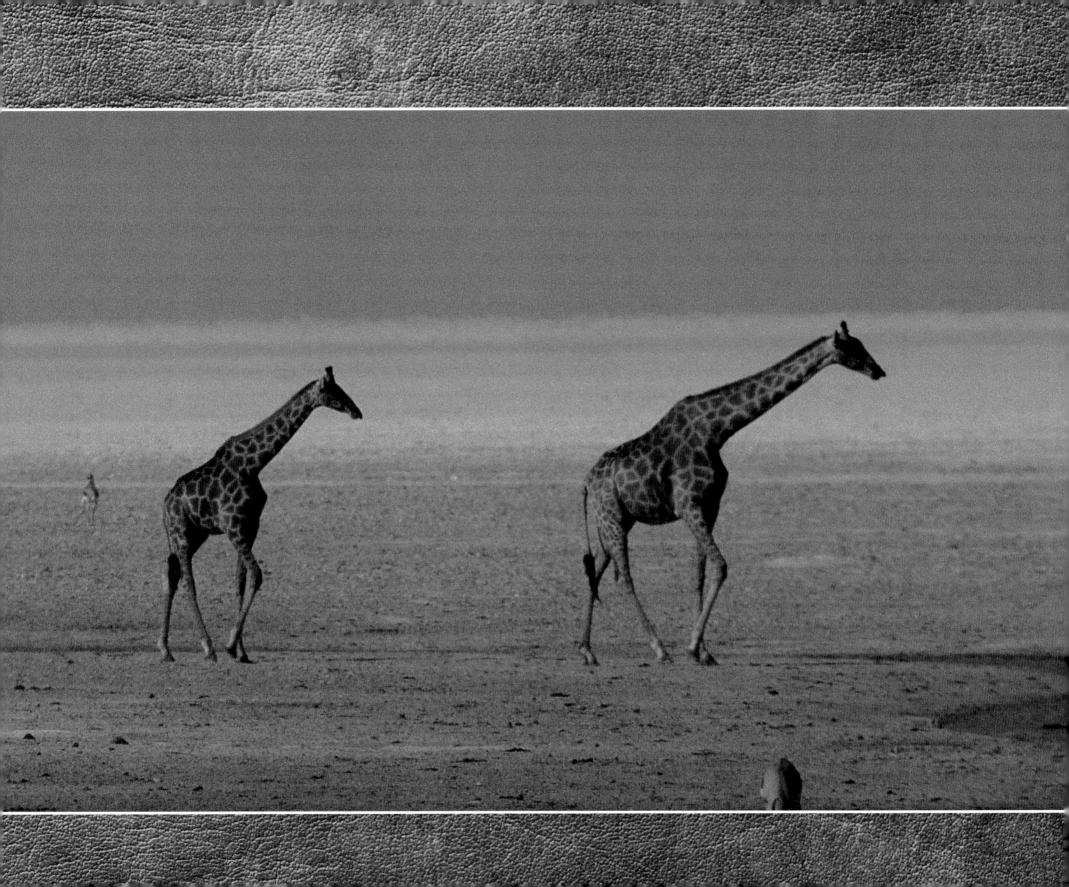

if that's the right word – to game reserves and national parks. Selous, Etosha, Kruger, Serengeti, Masai Mara, Moremi, Chobe, Luangwa, some are bigger than small countries; the Kgalagadi Trans-Frontier Park is more than thirty-eight thousand square kilometres, the Selous and the Central Kalahari more than fifty thousand - bigger than Wales, Belgium, Switzerland or Holland, and wildlife ranges freely within these huge sanctuaries.

The challenge is getting to these magnificent areas. By their very nature reserves tend to be remote, often only accessible by bush plane, 4-wheel drive, or boat and some totally inaccessible during their rainy seasons.

Africa has witnessed turbulent times but is slowly dragging itself from its dark past. From time immemorial people have left scars and ugly footprints on the continent. Africa has been mauled by civil wars and power struggles that racked it in the post-colonial era, despots and dictators who siphoned off zillions into foreign bank accounts, the mismanagement and poverty that followed and the exploitative colonialists themselves who hunted the continent's priceless big game to near extinction.

Many, however, have more positive perceptions and see the bright side of the African coin, the mystery and legend of its past and the riches of its future. The new buzzwords are democracy, sustainable development and conservation. But it is surely the evocative past that draws people to this enigmatic continent – the explorations of Burton, Speke, Livingstone and Stanley, the jazz-age images of White Mischief, Naivasha and the Happy Valley set, and the vivid writings of Rider Haggard, John Buchan, Karen Blixen, Hemingway and Ruark recalling adventures and travels of the 1920's, 30's and beyond.

They created wonderfully descriptive images of Africa. Travelling in the heat and dust of a spectacularly scenic continent, setting up luxury camps in the wilderness, days away from the nearest settlement, with beer bubbles bursting ice-cold in the back of a dusty dry throat. That first heart stopping sighting of

elephant, lion or leopard and then stalking them on foot. Feasting on superbly prepared meals under velvet African skies, and swapping the day's tall stories around the campfire with the bitter tang of tonic in the evening's gin. Hissing hurricane lamps and the mournful symphony of hyenas whooping from the dark. Sights and sounds redolent of a less hurried era that stirred my imagination and fueled a passion to make my own personal exploration of Africa.

The African wilderness is like nothing else on earth, nothing parallels it. It is not one habitat but many, from desert to equatorial forest and everything in

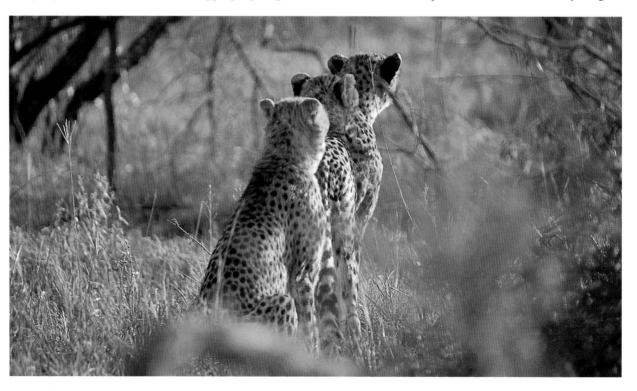

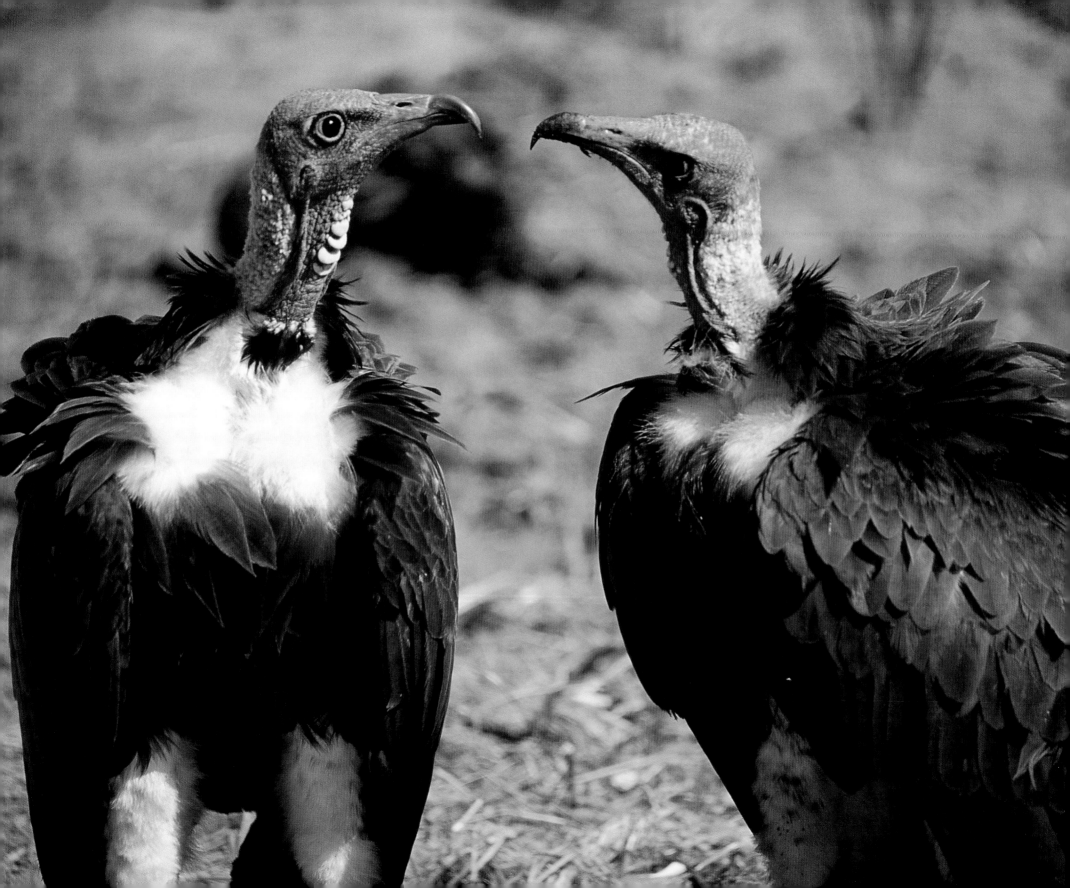

My fascination started when I returned to live in Africa after a ten-year sojourn abroad, mainly under the grey lowering skies of London, broken by periods in smoggy Los Angeles. The connection was photography – I'd been an avid snapper, recorder of events since my early 20's when I back-packed around Europe, lugging my 35mm view-finder camera to the far reaches of that very civilized but crowded continent. I recall taking lots of pictures of castles, cathedrals and mountains, with the occasional pretty girl thrown in, as I hitched through the slush of a French October and the dour reaches of Germany's industrial Ruhr before hitting the sunnier climes of Spain and Italy.

My self-imposed exile in the narrow confines of Europe had made me more appreciative of Africa's broad horizons – real Big Sky Country – and I was determined to make the most of it.

From Johannesburg where I live, it's quite easy to get into the wilderness – the Kruger is a mere five-hour drive. On a bad traffic day in a London winter I can remember spending that getting to work and back

For me this was a voyage of discovery, a whole new world was opening-up before my eyes. I felt like David Livingstone as I foraged into, for me, unknown territory, taking pictures of unfamiliar animals, people and places.

My umbilical cord to the music business proved fragile and eventually snapped. I was free to pursue my passion and progressed from would-be music mogul

between supporting Africa's greatest attraction, its stunning wildlife. Populated by few people but many animals, big game holds sway over these vast tracts, dominating wilderness life. Small wonder that Africa has fascinated so many for so long. Pliny the Elder, Roman author of the encyclopedic 'Natural History', said "There's always something new out of Africa." As true today as it was then, nearly 2000 years ago.

I came to the wilderness late – after what seemed almost a lifetime in the hurly burly world of big business in big cities and what I had thought was the adrenalin rush and glamour of the music industry and international commuting. I was to discover I didn't know what an adrenalin rush really was.

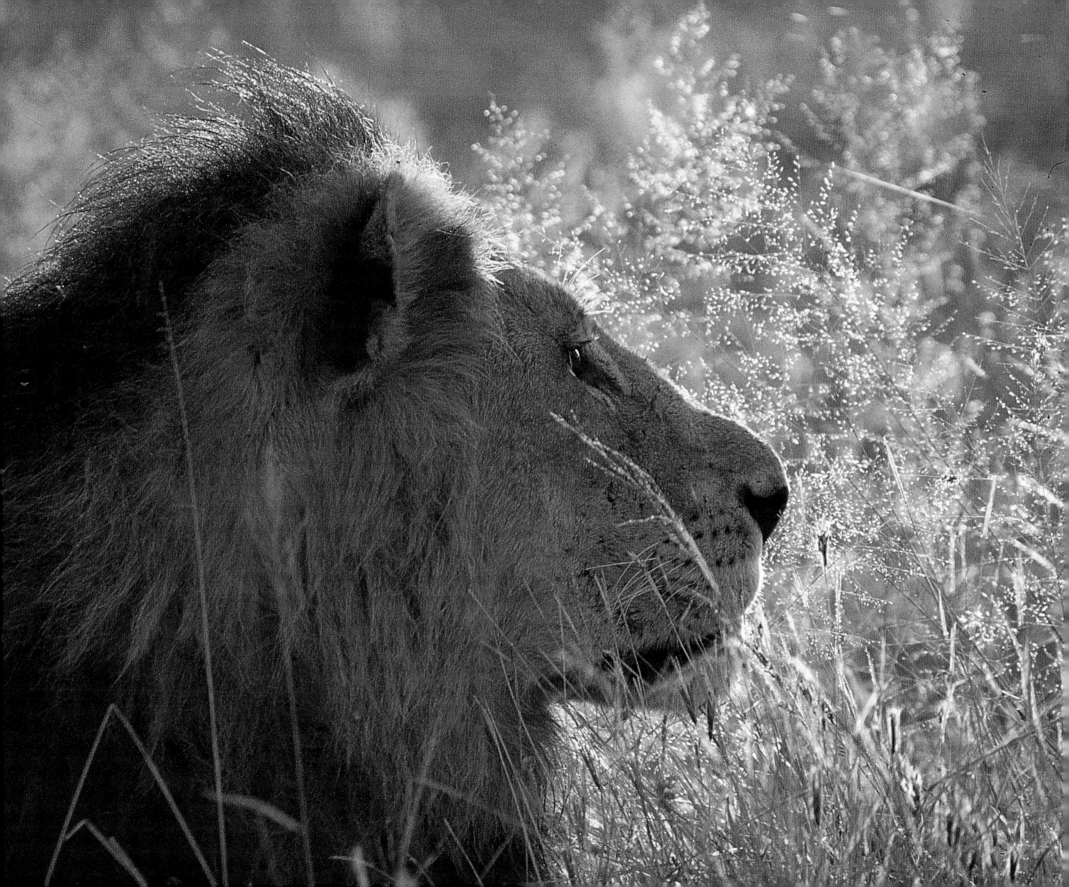

and amateur photographer, to travel writer and photo-journalist, location manager for TV and film productions, to TV producer, scriptwriter and wildlife photographer. My rationale was, and is, the African wilderness. I was hooked.

Wearing my photo-journalist hat I'd made many forays into the bush on photographic shoots for particular game lodges, taking stills for film and TV productions, writing and shooting pictures for some magazine or other. But I'd never been away for more than a few days, never on a real safari. The Hemingways and Ruarks may have been writing fiction, but their safari descriptions were clearly borne out of personal experience – an experience I was determined to emulate. However, for me, there was a personal challenge – how to justify months away on a safari through Southern and East Africa, having what, for most, would be an extended vacation.

I'd been working on an idea for a TV series, 'African Odyssey – A Photographer's Journey'. I put a crew together to shoot some footage and made a 3-minute promotional film. UK distributor, TVF International, showed interest so we followed up with a 26-minute pilot.

My partner Sue and I were in the UK for a meeting with TVF managing director Lilla Hurst. On the way to lunch she announced, almost in passing, that Discovery Europe had made an offer for the series. This had come out of the blue and I was totally knocked-out. Passers-by in grey, wet, slushy Islington must have thought I was crazy as I gave Lilla a huge hug. The deal was done and I had my passport for my own African Safari.

Travelling in Africa can be, well, erratic. You can't just jump in a car or plane and go. Planning is essential – African journeys are seldom without the odd surprise or incident. Our safari was going to take us from South Africa via Botswana, Namibia, Zambia, Tanzania and Kenya to Uganda and back, so the next question was how to get to these places.

My problem was solved at Indaba, the big African travel show, when I met Chris Briers, owner of Naturelink, air-charter company extraordinaire, specialising in travel to remote and out-of-the-way places. With literally thousands of hours experience of flying in Africa, Chris and his pilot team were already familiar with many of the areas we were planning to

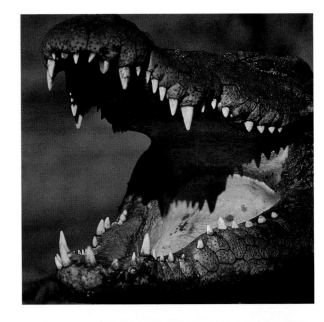

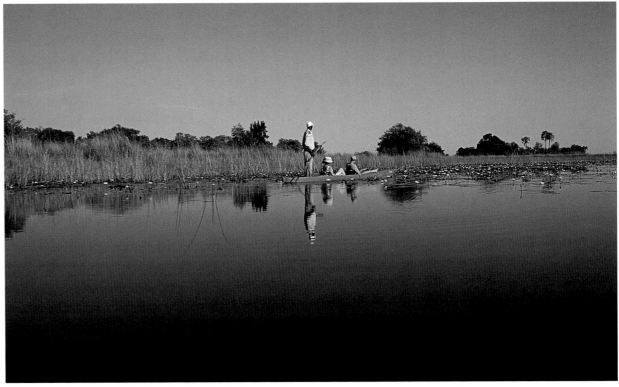

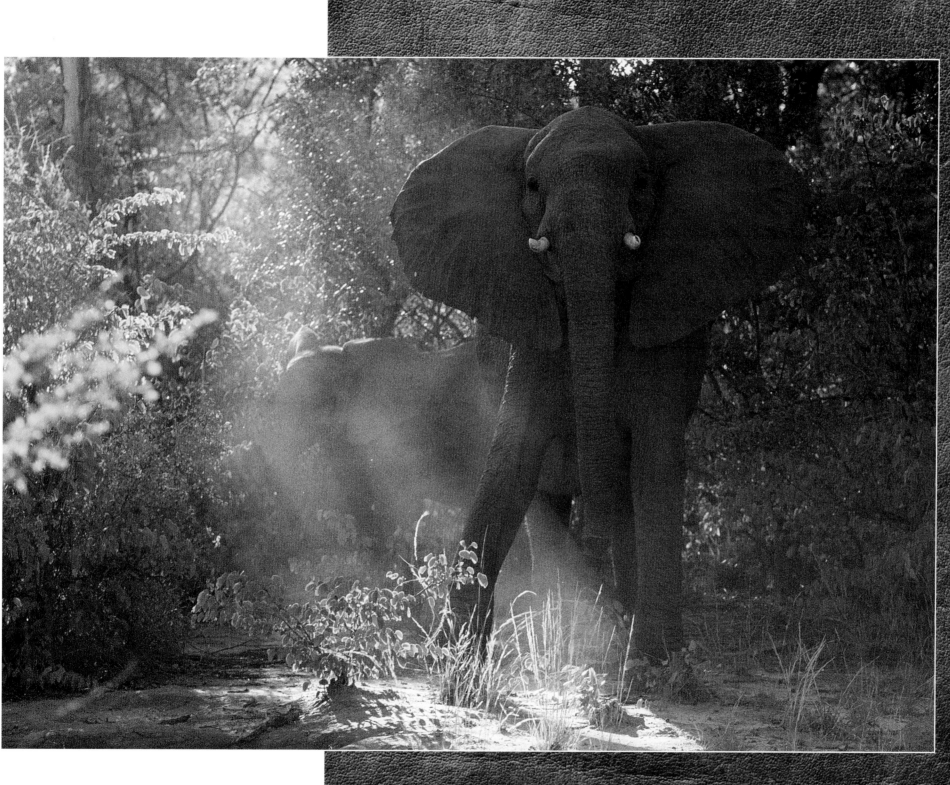

visit and he proved to be a great help in organising the safari. Believe me, if you're flying into the Central Kalahari or the Lower Zambezi Valley it helps to have someone who knows the landing strips, local conditions and potential bureaucratic pitfalls.

The planning could have taken weeks, maybe even months; communication with safari camps is not always easy and certainly not quick. Fortunately my previous

African excursions had given me lots of valuable contacts and I'd laid some groundwork and set things in motion prior to our Discovery deal being finalised. I'd had discussions with safari operators and camp owners whenever the opportunity arose and already had a route and schedule in my head. Nevertheless, it still took lots of e-mails, faxes, phone calls and time to really get it together, but eventually everything slotted into place and we were on our way!

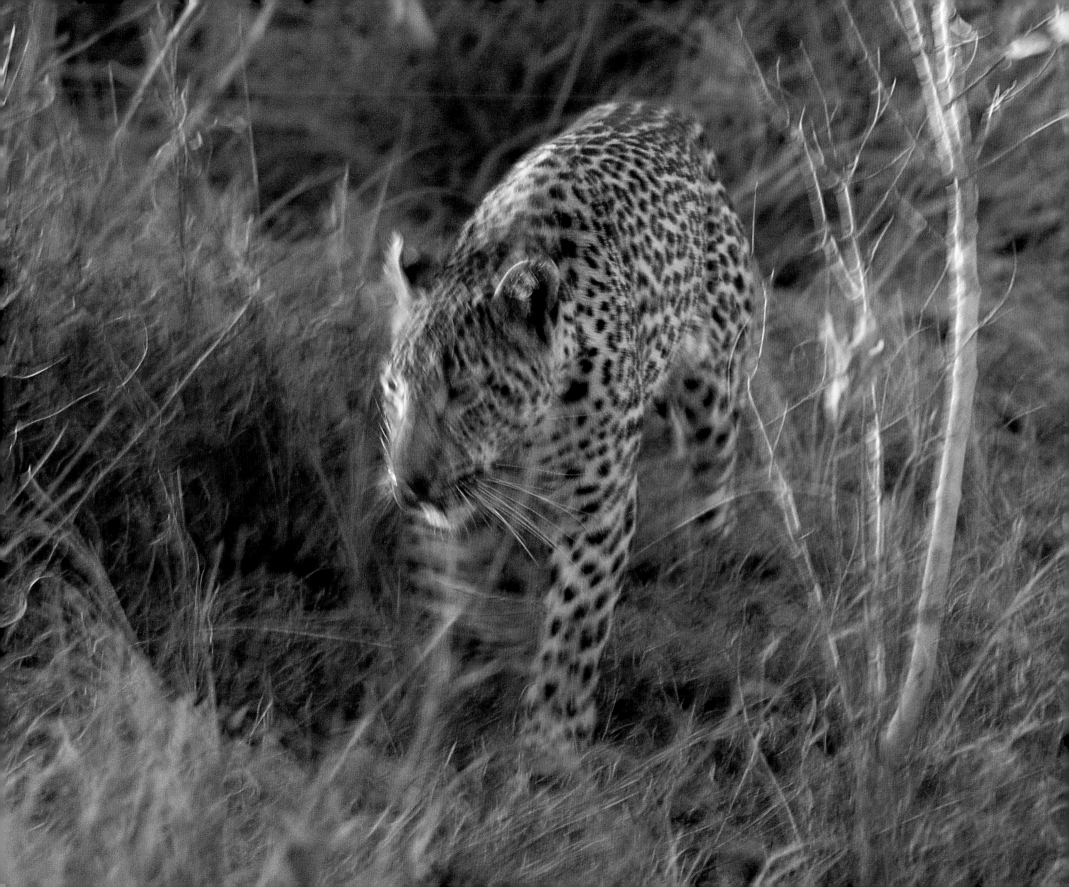

Sabi Sabi

Salva

Snaking some three hundred and fifty kilometres down South Africa's border with Mozambique and virtually due east of Gauteng is one of the world's great wilderness areas, the two million hectare Kruger National Park. Snuggling along its unfenced western boundary lie the private reserves of Sabi Sand, Timbavati, Klaseri, et al, sharing the Kruger's vegetation, habitat and prolific, spectacularly diverse wildlife. Our destination – Sabi Sabi in the Sabi Sand.

We've congregated at 7.00am at Naturelink's Wonderboom hanger just north of Pretoria. A cup of coffee to fight off the early morning chill, load our gear and we're airborne by 8.00 – a far cry from commercial flights with two hour check-ins, multitudes

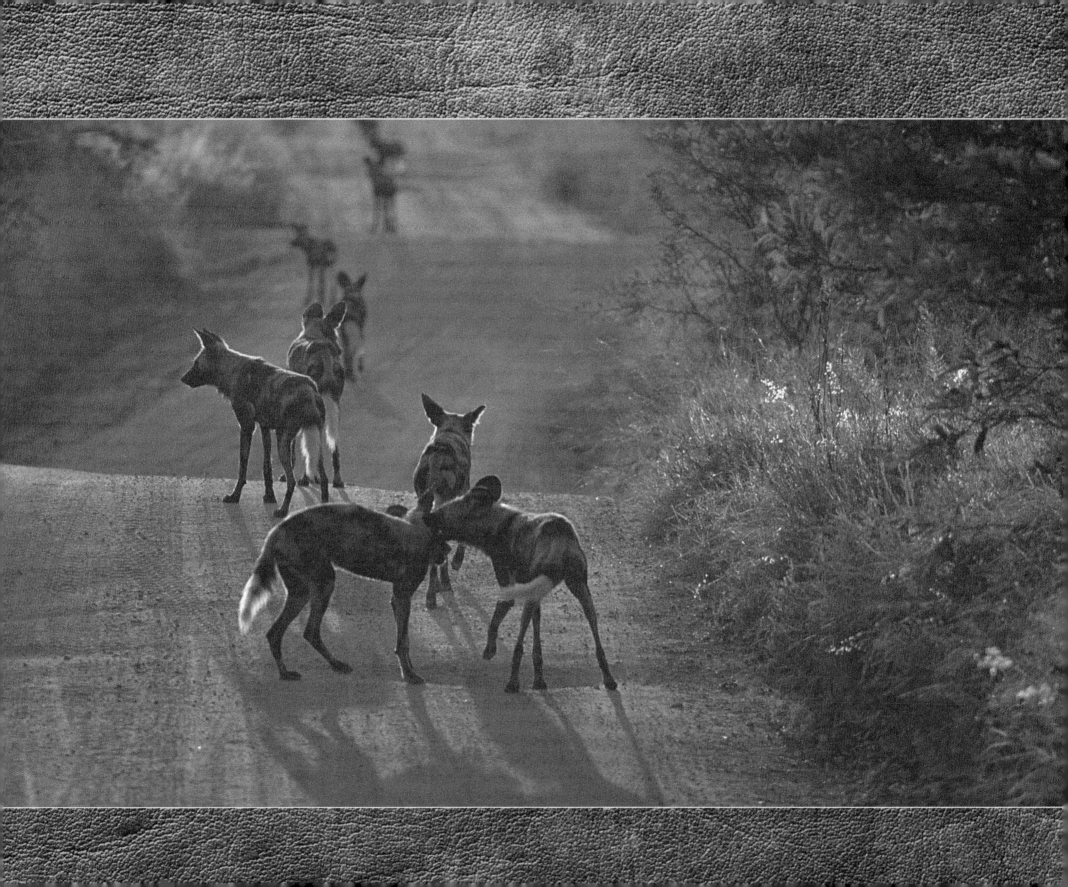

of security checks – and then waiting at the other end for luggage that may never appear.

One of the things I like about flying in small planes is that I can actually watch the world go by. I feel in touch with the world, not isolated above the clouds at thirty-five or forty thousand feet.

The first part of the journey is pretty boring; the Highveld plateau is featureless unless you're into the grain elevators and power stations that seem to litter the landscape. Alarmingly the ground drops away abruptly, the feeling is almost vertiginous. From being only a thousand feet above ground we're suddenly at four thousand, we've just crossed the edge of the escarpment, the jagged Drakensberg running like a dragon spine down South Africa's eastern side, dividing the lush lowveld from the rather barren highveld.

As the mountains recede behind us the landscape changes dramatically, vast forests mark the foothills, burgeoning rivers meander towards the Indian Ocean and dense bush, pierced by the occasional rocky kopje, spreads away to the east as far as the eye can see.

Coming into land we bank low over the Kruger getting our first sight of big game – giraffe, disturbed by the noise, loping away from the landing-strip into the trees. Pilot Chris flies low checking the strip for animals before landing in a cloud of dust. Waiting in the Sabi Sabi Land Rover is old friend and Sabi Sabi operations director, Michel Girardin, known locally as Mashangaan, meaning "of the Shangaan" - the local tribe. The Land Rover is to be our transport for the next few days and Michel and tracker July Ngobeni

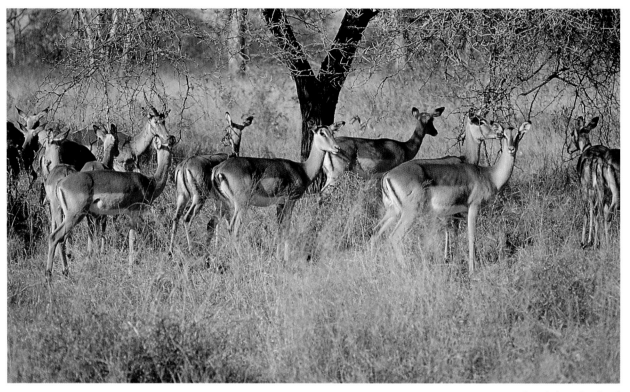

Impala breeding herd

will guide us through this wilderness. We couldn't have a better guide, Michel is an old bush hand with an encyclopedic knowledge of the area and its inhabitants. He was nicknamed by the local community because of his facility with the Shangaan language and familiarity with local customs and history. Michel has been hugely supportive in my quest to become a wildlife photographer/writer and filmmaker. His experience and contacts opened many a door helping me get a foothold in the industry.

It takes only a few minutes to unload the plane, stack everything into the open vehicle and head for Sabi's Selati Lodge about forty five minutes away. Well, it

would be if there were no distractions on the way, something that is almost impossible in this game rich area. We startle a small breeding herd of impalas and they scatter in all directions before stopping to gaze at us with big bambi eyes.

We round a bend and a rough hewn Selati sign on an old ox-cart tells us we've arrived.

Walking down the path I feel as though I've stepped back in time, out of a Finch-Hatton safari. Selati is atmospheric; it evokes the Africa of everyone's

imagination, the heady romantic safaris of the 1920's and 30's when everything moved at a slower pace. Selati re-creates an era when a safari was a journey of weeks, not a couple of days crammed into a whirlwind tour of Africa. But if your time is limited, even two or three days in a wilderness like this, in a camp like this, is better than nothing and an experience to be savoured. But two days? I doubt Papa Hemingway would have even got out of the bar in that time! Fortunately we don't have the average traveller's time constraints.

The camp is unfenced and overlooks a waterhole. Over lunch Michel tells us that elephant, rhino, impala, kudu, waterbuck and wildebeest are regular visitors.

Sabi Sabi is not a vast plain like the Serengeti or Masai Mara, it is dense bush interspersed with open areas and riverine forest. Here you have to work to find the game, hence the reason for tracker July. But the rewards are great. On safari here you know you'll see a lot, but as to what you'll see, expect the unexpected.

The dreaded wake-up call comes at 5 am. It's still dark and there's just time for a shower and a quick cup of tea before we head out into the bush.

It's cold and we're huddled up on the vehicle. A rhino looms in the darkness and stops in the middle of the track, ears twitching, peering short-sightedly. He's not about to move so Michel engages 4-wheel drive and we track up the bank off road to get around him. Looking back he's still standing there – no doubt wondering where we've gone!

Four tons of white rhino at the Selati waterhole (Above)
A flash of black and white - a zebra foal hugs its
mother's side (Right)

Night is slowly retreating and the early birds are starting to call. A francolin screeches a warning, there, in the gloom ahead of us a pair of wild dogs. A cry of distress on our left and they take-off. We follow, but by the time we're through the thick stuff the pack has dismembered a duiker and is skirmishing over a few bloody scraps.

The duiker won't satisfy them for long, a mere hors d'oeuvre. They move off again, still on the hunt and we follow through the bush back onto the road. The sun bursts above the trees as they mill around, enjoying its warmth before vanishing into the thickets on their never-ending quest for food.

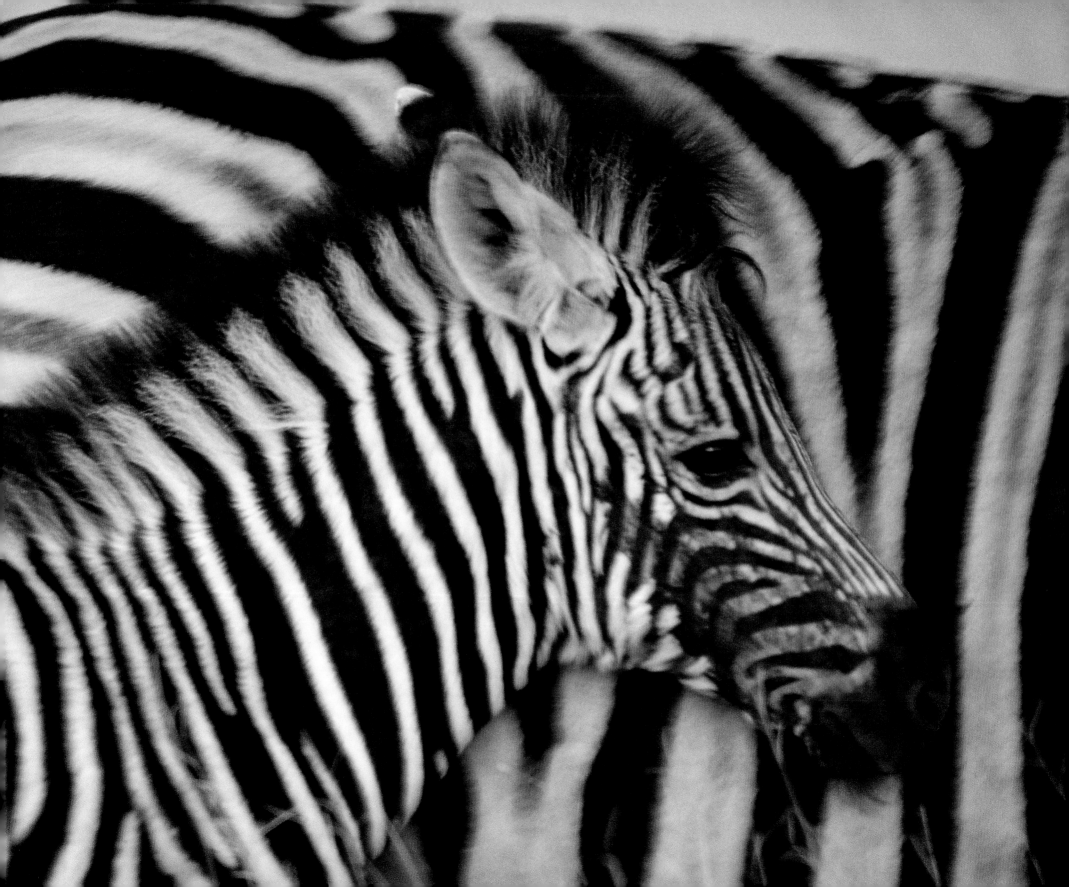

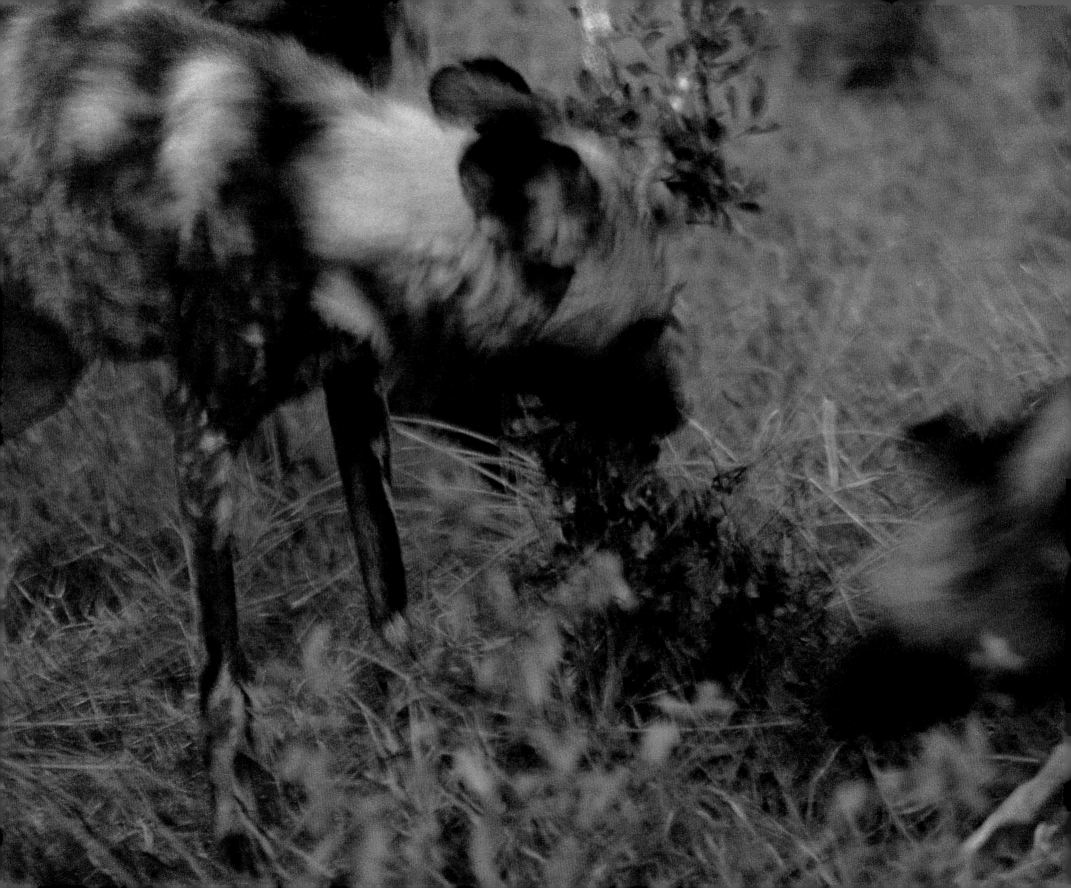

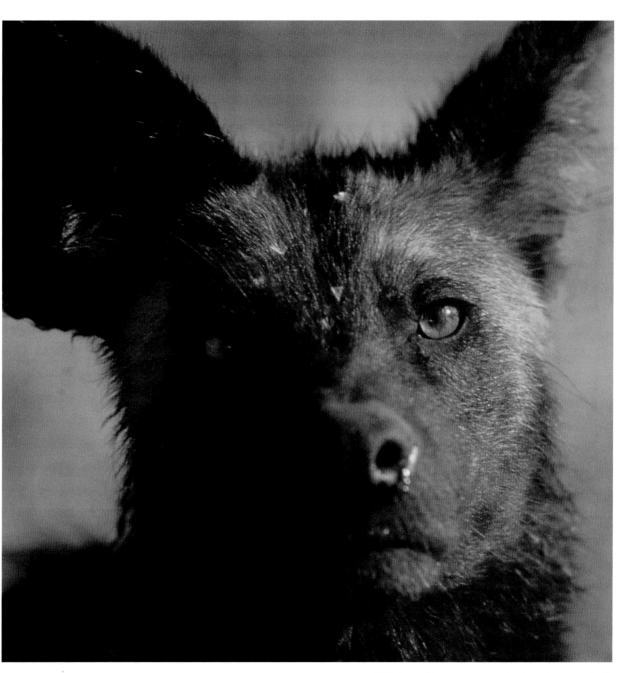

Wild dogs skirmishing over a few bloody scraps (Left)

Glinting like liquid gold in the early morning sun, the huge dew-laden webs of golden orb spiders stretch from bush to tree to grass anchored by the enormous strength of the silk – stronger than steel – a dreaded trap for insects and even small birds. The striking yellow and black female, up to 30mm long, dwarfs her tiny mate who frequently ends-up as her meal. Small mercury spiders, squatting in her web, keep their distance as she prowls from prey to prey.

Static breaks the stillness as the radio crackles to life; a tracker has picked up ingwe - leopard - tracks. Radio traffic is suddenly heavy as everyone gets the message. A second vehicle is dispatched to join the search. Michel decides not to get involved and we carry on.

A fork-tailed drongo catches our attention and brings us to a halt. They follow animals that stir up the grass, disturbing insects. In this case the drongo's been following a dwarf mongoose, wonderful creatures, full of movement. This one's as bright as a button constantly posing for us as he scampers from branch to ground back to branch.

"Lion tracks!" The words always create a sense of excitement, a tingle of anticipation. Michel and July pick up the spoor and we follow. Nobody asks do we want to – of course we do; who doesn't want to see the King of Beasts? This time, Michel tells us, it's two females with small cubs. The tracks turn off the road. July follows the signs – flattened grass here, a broken twig there. The bush isn't too thick and July

spots a female doing what lions do best – sleeping in the shade.

An eye opens and she gives us a baleful glare. There's movement in the grass and a cub appears followed by another and another.

They move to their mother and she lifts her head as they rub against her – a typical lion greeting. They're very tactile creatures, constantly making contact. The cubs are inquisitive and sit watching us, then a couple settle down and suckle. A young male gazes skywards. I look up – vultures – the cub is vulture-watching.

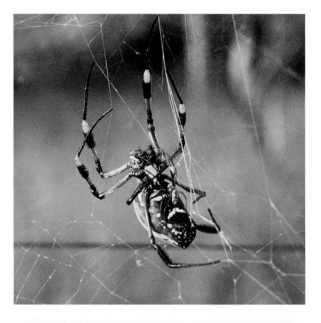

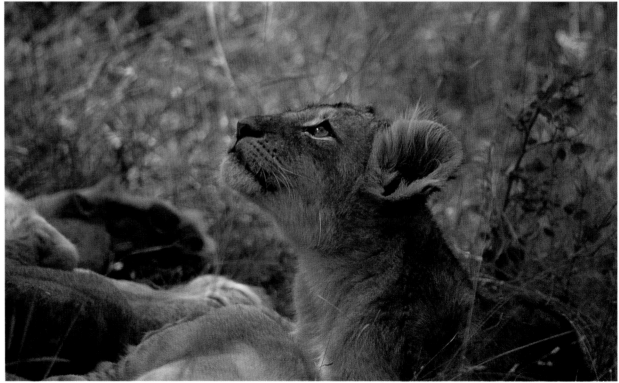

Lion cubs vulture watching (Right)

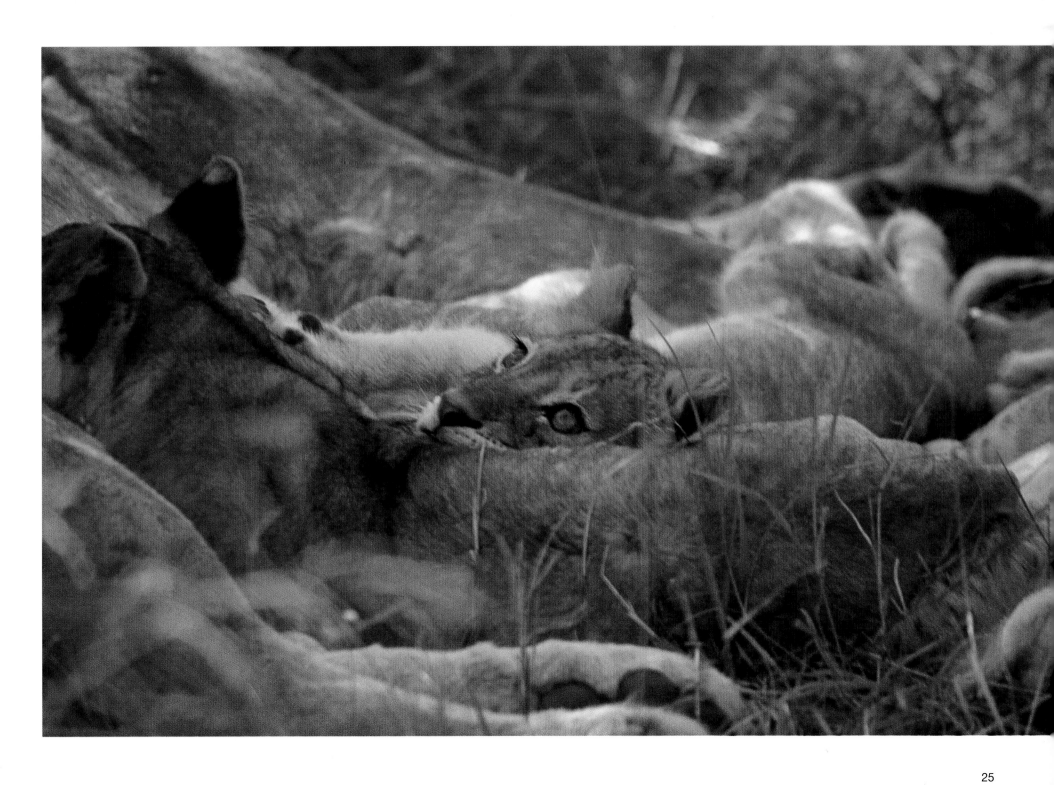

Michel explains that lions do this – they know that if there is a gathering of vultures, it could be the sign of a kill. Lions are not just hunters; they are also great scavengers – easy meat so to speak. Lions learn these survival lessons young - or is it just instinct?

There's a flash of black and white as we emerge from the tree line. We've startled a small zebra herd and they burst away scattering in every direction. A mare dashes across the road in front of us, her leggy foal hugging her side; their unique stripes almost blending as they scoot away before regrouping and coming to a standstill, turning to stare at us, tails twitching, swishing away the flies.

We continue on our way and again it's a bird that catches our attention. A wildebeest is making its stolid way across some open ground. Suddenly it comes to a

puzzled halt threatened by a very vociferous blacksmith plover. Michel stops and we watch this seemingly uneven encounter – imagine 200 grams of plover confronting a 250-kilogram wildebeest. Plovers nest on the ground and they're very protective and aggressive. Unbelievably the wildebeest stops, turns aside, and plods off in a different direction. The plover gives a final screech and goes back to its scratch-in-the-ground nest. Through my binoculars I spot two eggs – perfectly camouflaged.

Sundowners in the bush are a hallowed African tradition – a chance to stretch the legs and quench the thirst. I guzzle an ice-cold beer as the sun goes down to a cacophony of frogs, crickets and other emerging night sounds.

Dark comes quickly, the temperature is dropping and we wrap up against the night chill. Night sightings tend to be brief. A bug-eyed bush baby leaps to a higher branch, away from the light, disappearing into the dark. A nightjar lies bedazzled in the road fluttering up at the last minute before landing again twenty metres away.

No-one's been able to find the ingwe and we head back to camp, ravenous from the fresh night-air, ready for a substantial bush dinner and more than ready for the heat of the boma fire.

The sun is coming up, its warmth seeping through to my chilled bones and I stretch to get the kinks out. A Landy is not the most comfortable of vehicles. A lion roars in the distance and I wonder if we'll see more of these great predators. I wonder too if anyone will find that elusive leopard.

July mutters something in Shangaan to Michel and we stop. He's spotted fresh, very fresh lion spoor – a big male. The distant lion roars again and almost immediately there's a spine tingling answer close by. We don't need the spoor; we round a bend and right next to the track is a magnificent big-maned adult male. Michel pulls off the road and stops, the lion fixes us with an implacable stare, then ignores us. Another bellow from the distance and the world around us seems to explode, reverberating with the most awesome sound as our lion responds. I've only ever heard lions roaring in the distance, never, ever, this close. It is truly awe-inspiring. Whatever he's communicated this time seems to have ended the conversation. It's also taken a lot out of him as he rolls over seemingly exhausted. But not for long.

Mocambique nightjar (Above)

Bush baby (Right)

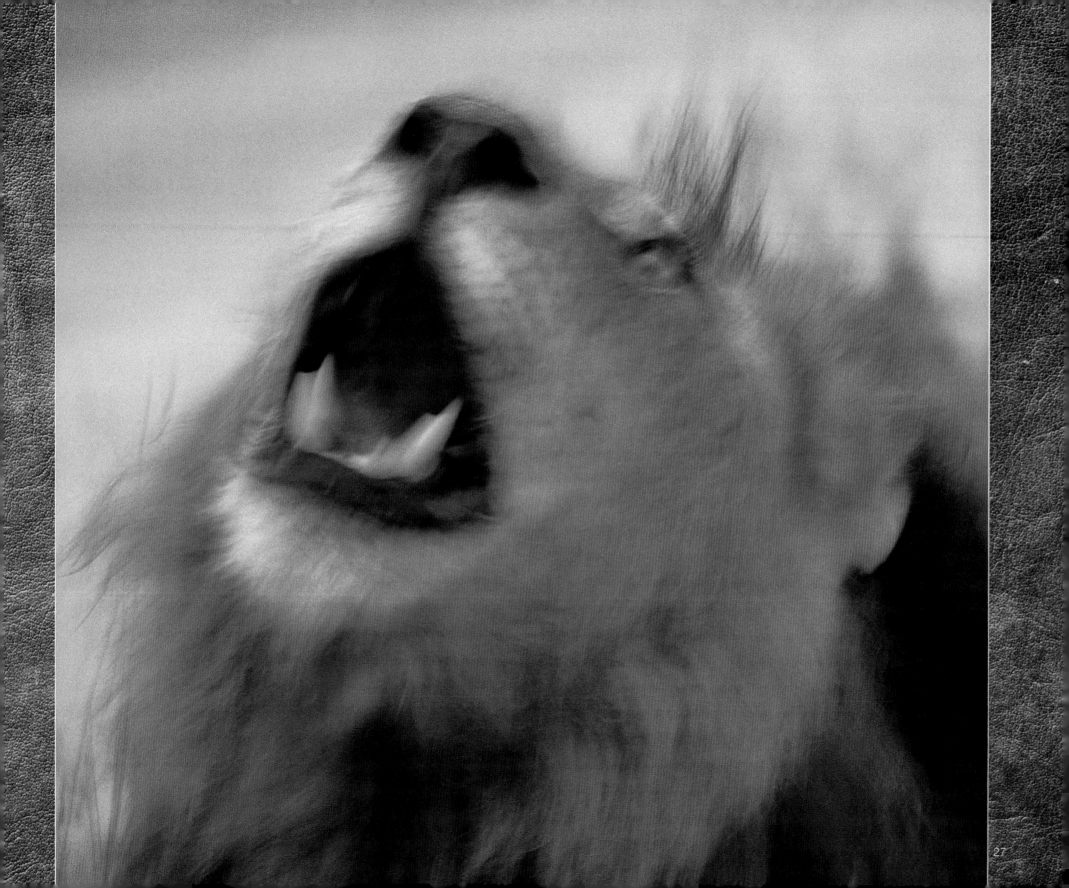

He gets up and stalks away, barely acknowledging our presence. I notice he has a slight limp, which seems to wear off as he lopes away – probably the night chill gets into his bones. He stops and lets out another roar, the response this time is closer. He's probably on his way to meet up with the rest of his pride, but instead he settles down in the long grass enjoying the early morning sun.

Michel checks the radio – "Any sign of that ingwe?" "Nothing." Tracks show the leopard has gone into dense bush but there's no spoor coming out. When the bush is this thick it could be lying just feet away and you'd never see it. But the trackers are now on foot and they may have better luck!

It's hot and we stop at a waterhole for lunch – Michel and July unpack the cool box. A lone elephant joins us, strangely the first we've seen in a couple of days. Elephants can be very possessive about water – he checks us out to make sure we're not drinking any of his water and then carries on taking in some of the 250 litres he'll consume today before immersing himself in the water.

The day slides by and we're on our way to film a sunset – I have a thing about sunsets. The radio blurts to life, lions have made a kill not more than twenty minutes away. As we arrive the last rays of the sun are spotlighting the kill. It's the lioness and cubs gnawing on the remains of a waterbuck. No sign of the male or the rest of the pride, yet they were surely here, there's not much left on the carcass. The male would have eaten first and he's either gone for water or he's lying engorged under a nearby bush. Waterbuck are not high on the list of a lion's menu. They have a thick layer of fat that imparts a musky odour and taste to the meat. Nevertheless lions are opportunistic hunters and will take whatever crosses their path.

The light is fading fast and we're a long way from camp. Watching the lions feed is not a pretty sight but it seems to have stirred everyone's appetite. Dinner is served in the boma and talk around the fire is of the day's sightings – lion, elephant, buffalo, rhino - and the leopard nobody has seen – plenty of tracks but no animal. Leopards are by far the most widespread of the African carnivores, yet they're always the hardest to find. Mainly nocturnal, their shy and elusive habits make them the ultimate photographic quarry.

Regretfully we're losing the services of our guide, Michel's holiday with us is over. His other duties call

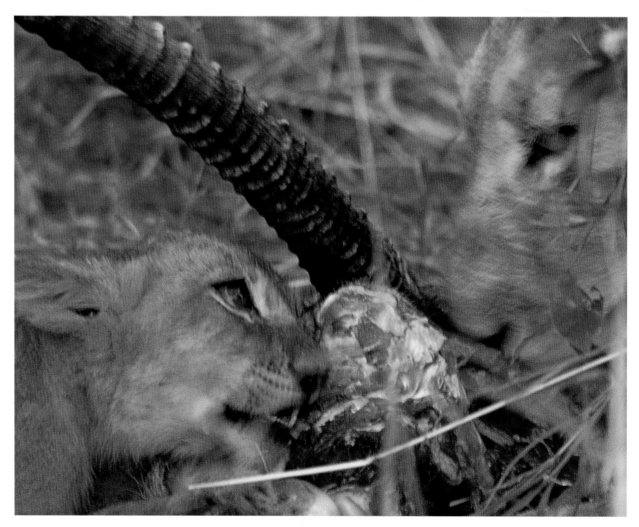

but I'm told we have a more than a capable substitute. For a change it's not the crack of dawn and Patrick Shorten, Sabi Sabi's head honcho, is enjoying driving us – something he doesn't get to do too often these days. From yesterday's hospitality manager and would-be ranger to today's leader of the pack, Patrick has a long association with the reserve and it was he who first employed Michel in 1985. They share a love of wild life, the bush and Sabi Sabi.

From the late 1970's, under Hilton Loon's curatorship,

Sabi Sabi has been in the vanguard of conservation and community development. From the beginning he realised that to be successful the reserve had to offer benefits to the local community, the major one being employment. Today the benefits encompass education and housing, a library and full time schoolteachers employed by the lodge. The community supplies the reserve with services, materials, crafts and artworks. In the mid 1980's, Patrick supported by Michel introduced Sabi Sabi's renowned ranger training programme. The Sabi Sabi course set the benchmark

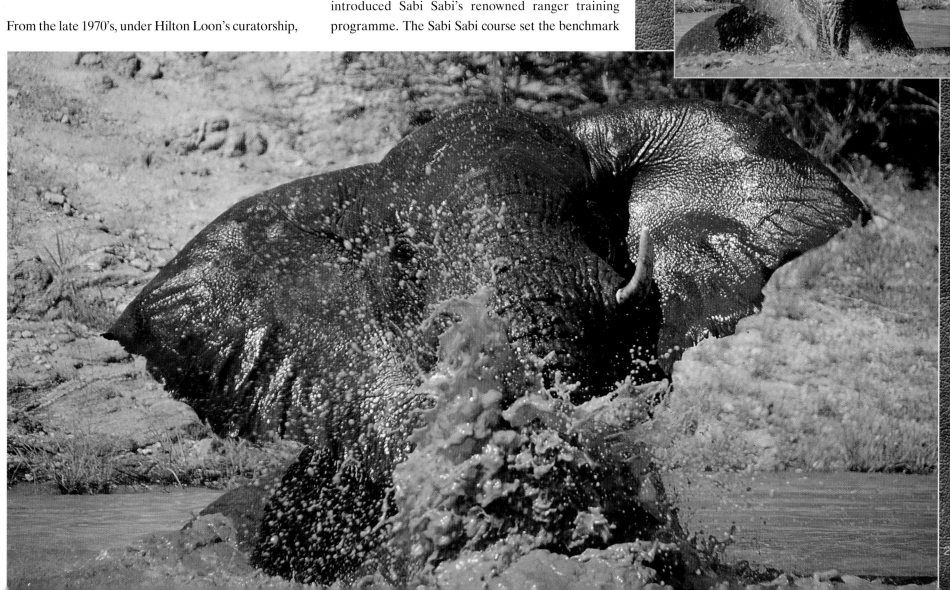

for ranger training and was the first step towards professionalising Guiding. I've bumped into rangers from this school from South Africa to Kenya and all points in between, reflecting the quality of the training.

After twelve years Patrick left Sabi Sabi but was lured back in 2000 to head up the company. "The easiest decision I've ever made," he says. "It was like coming home." But he was certainly dumped in the deep end, re-joining a month after the area's worst floods in living memory had destroyed River Lodge; Bush Lodge was in the middle of a complete renovation and the innovative Earth Lodge was in embryo. Interesting times indeed.

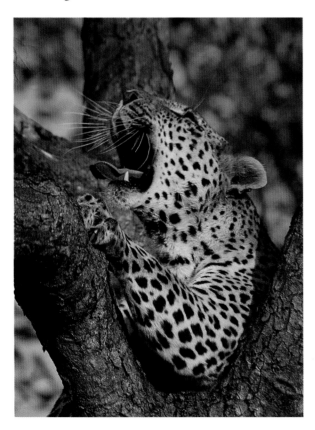

Today, everything's on track, Earth Lodge has created a sensation and Patrick is enjoying being out in the bush with us. The radio's quiet this morning, some elephants further south on Lisbon and lion tracks to the east but still no sign of the ingwe. A kudu, radiant in the early morning light and a coucal's crimson eye glints from long grass.

We're nearing the Sabi Sabi cut-line just enjoying being out here. An impala warning snort breaks the silence and brings us to a halt. The bark's repeated and we turn off the track towards the sound. There, about fifty metres off to our left, a small group, ears perked, looking not at us but just ahead. Patrick looks in the same direction and points.

Lying in the fork of a marula tree
- a magnificent male leopard,
highlighted in the morning sun.

We drive closer, the leopard yawns and changes position, the impalas relax, this ingwe's going nowhere in a hurry – he looks as though he's settling down for the day. He loves the camera and we move around to get him from different angles. I've been anticipating these images since our arrival a week ago and couldn't expect a better finale to this leg of our safari. Regretfully it's time to move on and we leave our beautiful cat dozing in his marula.

Great sightings in a short period and I say to Patrick he should go back to being a ranger. "I wish," he says.

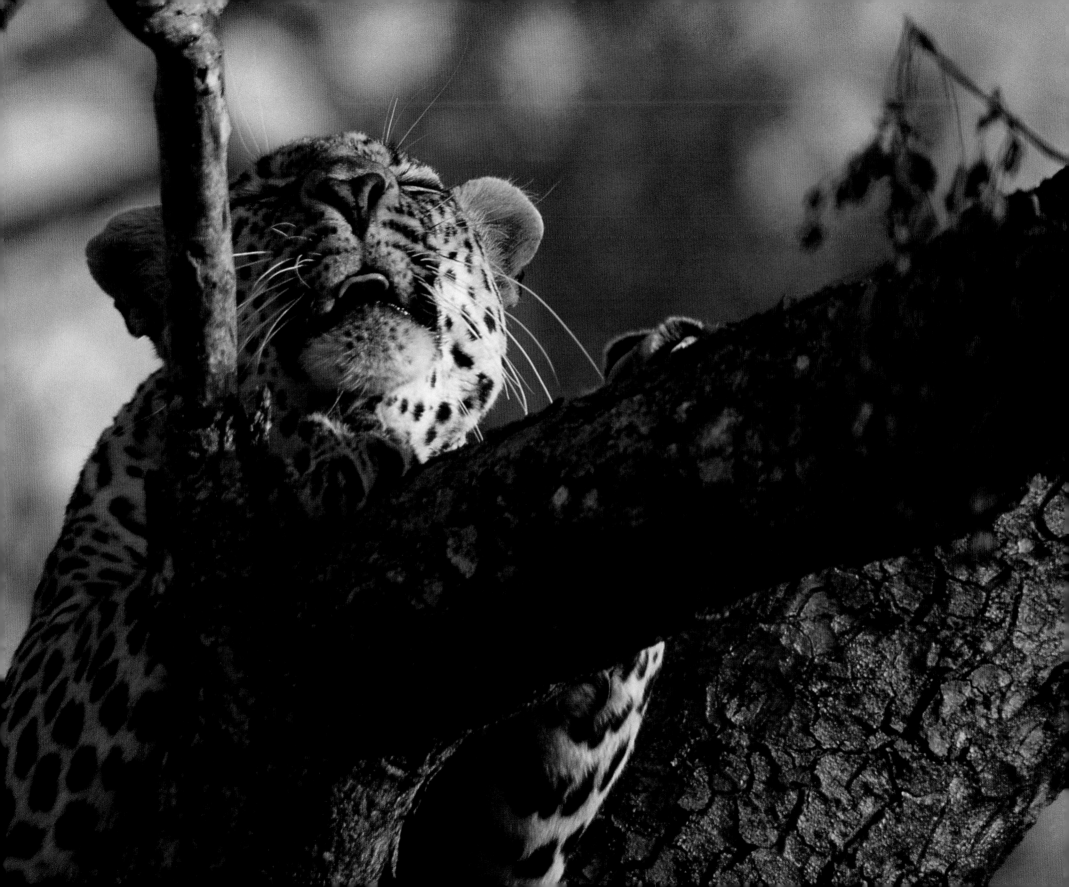

Sabi Sand

Simbambili

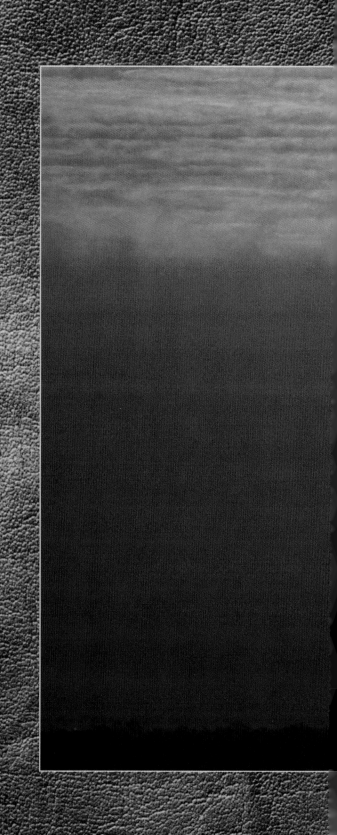

Patrick has just dropped us off after rendezvousing with Mike Cowden, manager at Simbambili our next port of call. "Just a couple of hours up the road," says Mike as we bump over the rough track.

We're full of leopard talk – it took us a week to find that ingwe after all. Mike smiles and tells us that he has been following two leopard cubs since they were 'little fluff balls'. "They're nearly a year old now and almost ready to leave the nest – or more likely be kicked out by mum," he tells us. Leopards are territorial, cubs especially will not stray too far, and Mike reckons he'll be able to find them for us. I look at him sceptically – I've had experience of not finding leopards before.

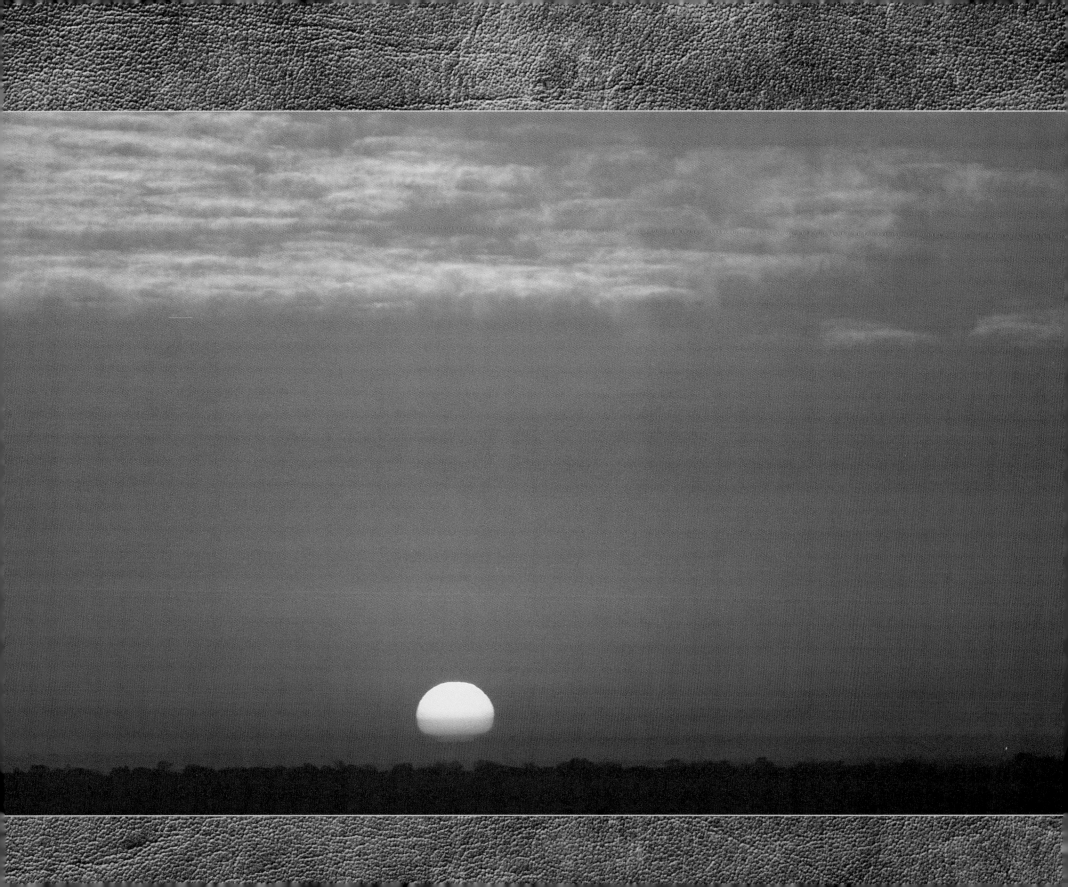

The camp has a great feel, small and intimate, it's on the banks of the Manyeleti, at this time of year a dry riverbed, but when heavy rains fall on the nearby Drakensberg, a raging torrent, sweeping all before it.

An early morning rain shower threatens to dampen our spirits – animals, like humans, tend to shelter and hide in the rain, but the clouds are already lifting and our mood lightens as the sun breaks through. The rain jackets come off and I shake the wet out of my hair. Tracker Patrick grunts and we stop. He mutters "Skankaan" – cheetah. There, on a patch of new growth, rolling over, luxuriating in the still wet grass. Unperturbed by our presence, it shakes itself dry, crosses the road in front of us, bounds up a termite mound and stands tall, surveying the surrounding area – a young male on the hunt. He leaps down and starts quartering the ground – sniffing this bush, smelling that clump of grass before moving off. The bush is comparatively light so we're able to follow quite easily.

Cheetahs stalk until they're close to their prey then use their speed to catch and throttle it – here it's usually impala.

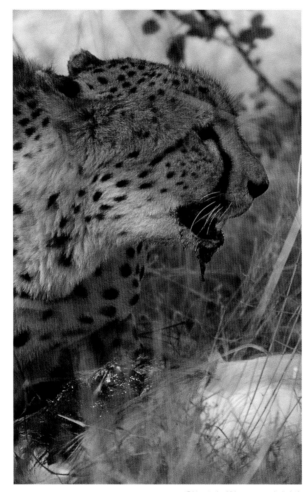

Cheetah (Above and right)

He comes to a halt crouching close to the ground. I follow his gaze – impalas about 50 metres away, grazing peacefully, oblivious of the lurking danger. The cheetah is immobile, then lifts a paw, moving almost imperceptibly. Without warning he explodes into action. His speed is blinding and in seconds there's a loud squeal from a cloud of dust as the impala scatter. We haven't even moved and it's all over. Mere seconds have elapsed and there's one less impala. The

cheetah has a killing hold on its throat. There's no blood – yet. They kill by throttling their prey and we watch as the light slowly dims in those beautiful impala eyes. The cheetah is panting heavily from the exertion of the chase. He'll take some time to recover and won't eat until he has. But he can't wait too long – the vultures will soon be circling, attracting the attention of hyenas and lions. The skankaan drags its prey under a nearby bush and starts feeding, constantly

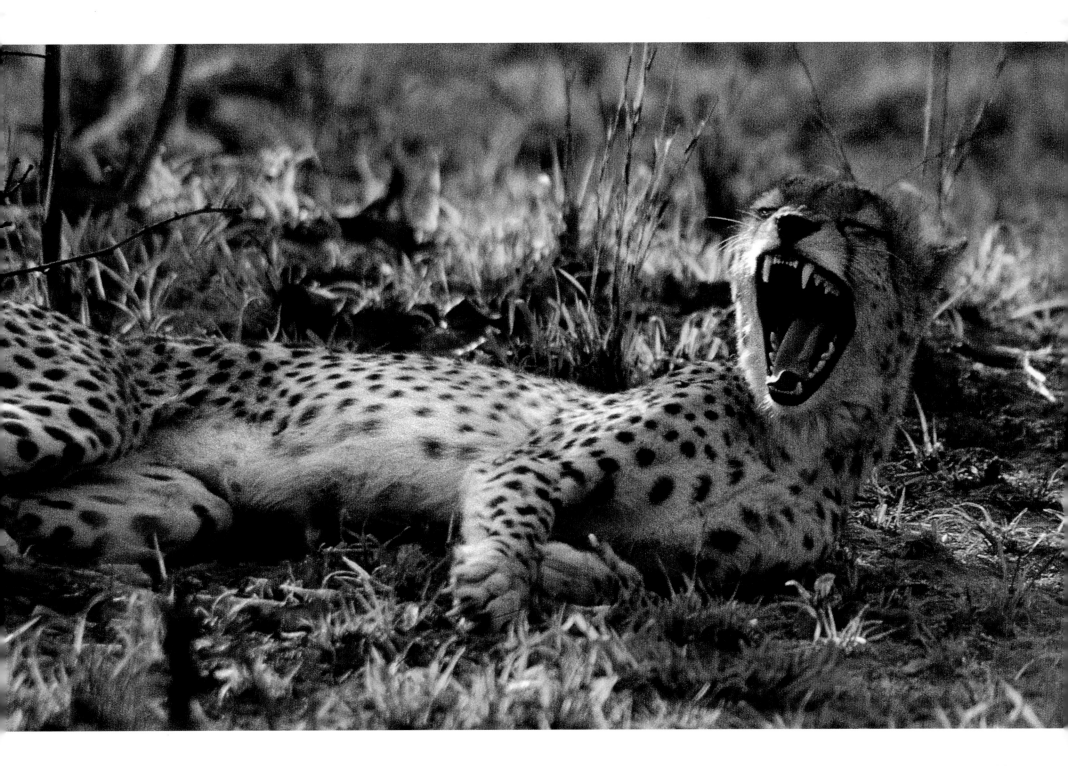

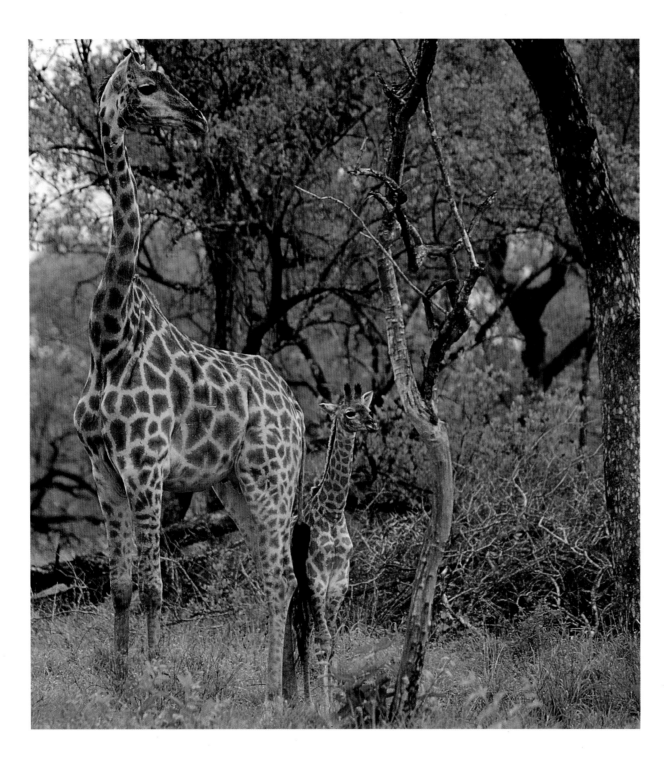

alert, watching for any intruders. He will eat until sated and then maybe not hunt again for four or five days. The remains will be left for the scavengers – jackals, hyenas and vultures – cheetahs rarely return to their kill.

A female giraffe and her calf stare languidly as we drive through the bush – the calf not even a year old is already two metres tall, but still stays close to mum. We stop to watch as they gaze inquisitively back.

Reptile encounters are not things I go in search of, but Mike has spotted something. He screeches to a halt, leaps out of the Land Rover and grabs a young water monitor by the tail. I crouch down to get a picture. This harmless lizard, Africa's largest - full grown it could reach two metres - thinks my lens is a hole, a potential nest, and tries to get inside. It's thrashing around, hissing until Mike lets it go and it snakes-off into the grass. Another reptile, a tree agama, almost invisible until it moves, scurrying up a tree trunk. It looks just like a piece of the bark.

Dusk is approaching and Mike is scouring their usual haunts for those little fluff balls. We're in a donga or gully, the light is fading fast when Patrick picks up the glint of an eye under a bush. We move into the thickets and there they are – two sub-adult cubs, brother and sister, no longer little fluff balls but almost fully-grown. We decide to forego our hallowed sundowner tradition and stay with them. Like kittens they play hide and seek in the spotlight. Mother is nowhere to be seen, probably out hunting. The cubs are still young enough to wait for her to bring home the bacon – or whatever else she might find. Mike tells us the donga is their hideout, the place where mother has stashed them

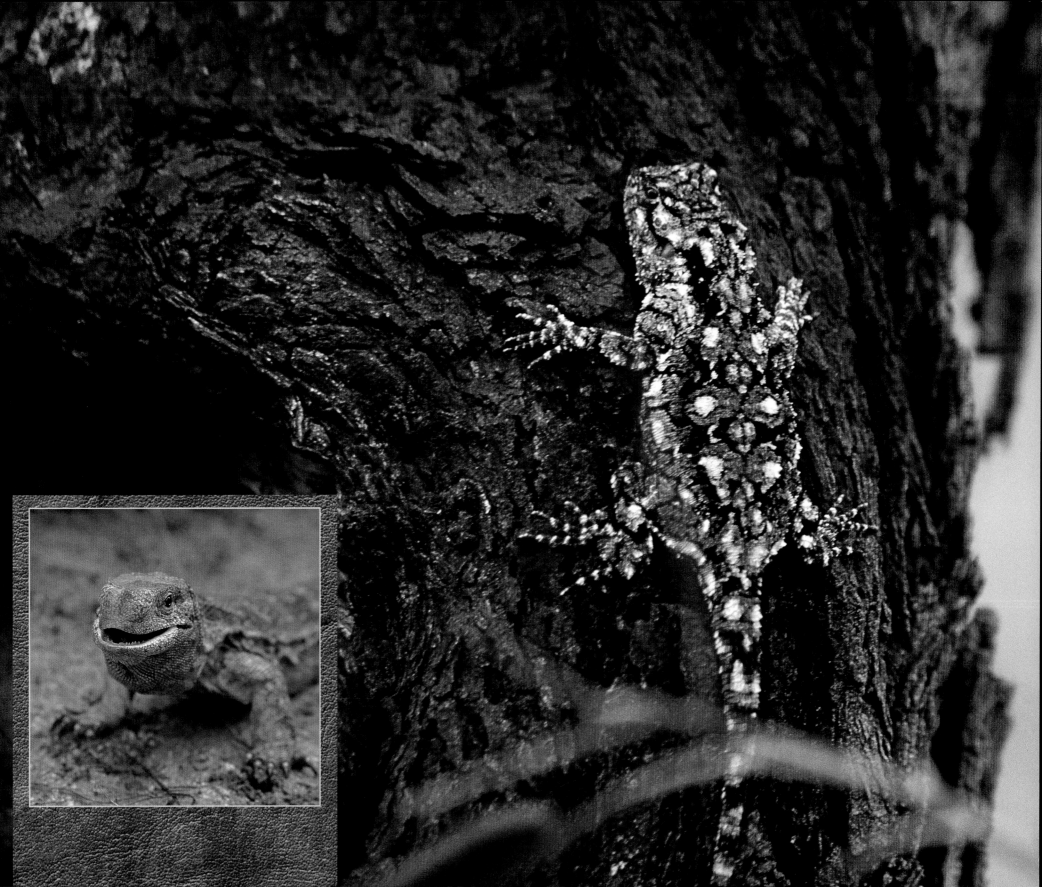

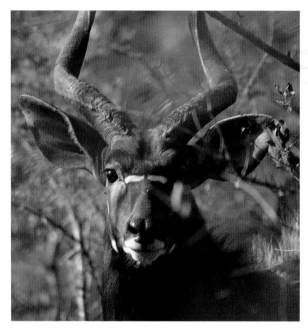

Our passing recorded by many eyes - kudu, nyala

while she's away as they're not yet able to protect themselves. It's starting to spit with rain, the cubs are moving deeper into the donga and we lose them in the thick undergrowth. The drizzle is turning into rain and we decide to head for camp.

Early morning, it's a little damp again and we're tracking a big bull elephant, trying to get close. He keeps moving off and Mike thinks we'll have more luck on foot. As we leave the vehicle Mike says, "Stay behind me and, whatever happens, don't run." Standard wisdom with an elephant charge is to stand your ground, make yourself appear as big as possible and shout at the beast! Shout at a charging elephant? We move cautiously from tree to tree, staying behind cover. Mike has a rifle, I have a camera – and confidence in Mike. We round a thicket and there he is – huge. He backs off, shaking his head as he lumbers away.

We follow and without warning he turns on us and charges, head up, ears flapping, trumpeting loudly. Contrary to all advice we turn tail and sprint for the Land Rover. We've pushed him too far. He stops, with a final triumphant blast. He's just shown who's boss and we collapse aboard the Landy in a heap of nervous laughter. Yes, it was a mock charge but who's going to hang around to find out? He's still moving slowly in our direction, making sure we leave.

Today must be elephant day. We haven't been going for more than fifteen minutes when a small breeding herd bursts out of the bush and crosses the road ahead of us; matriarch and daughters with two very young calves less than a year old. We follow them to a mud hole and it's fascinating to watch the youngsters struggling to

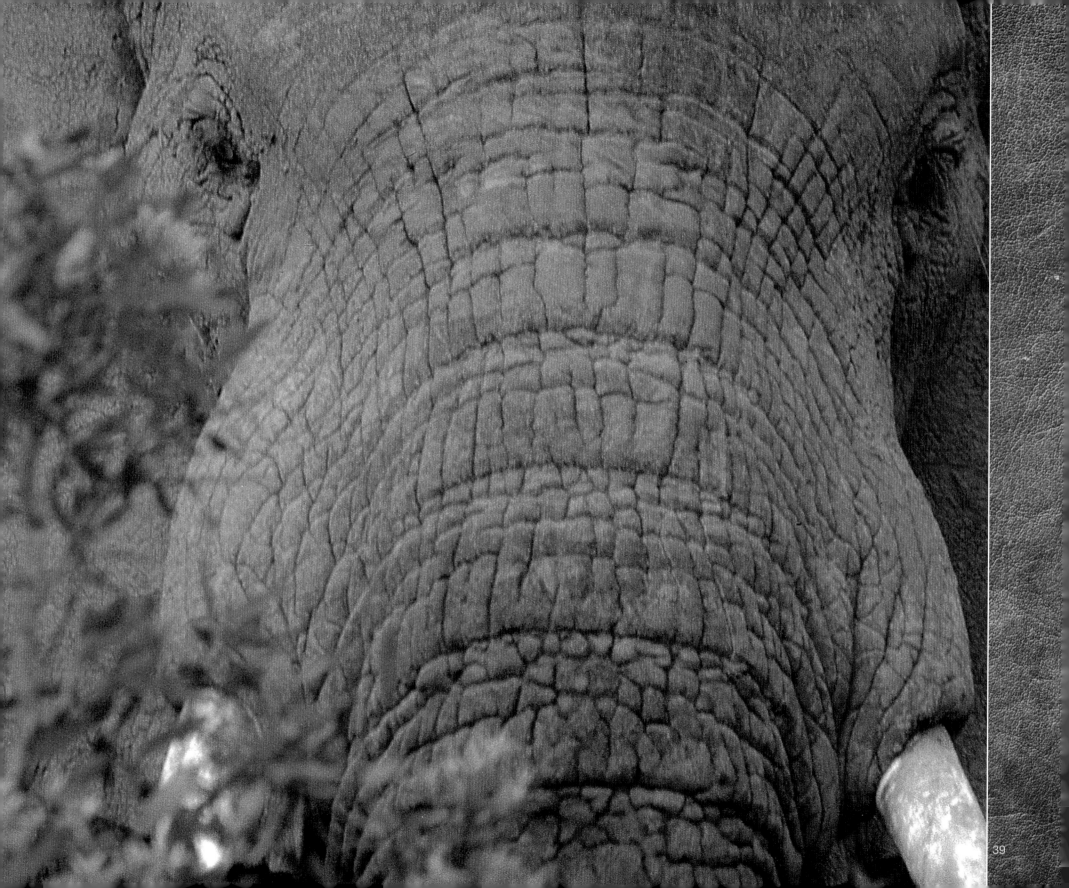

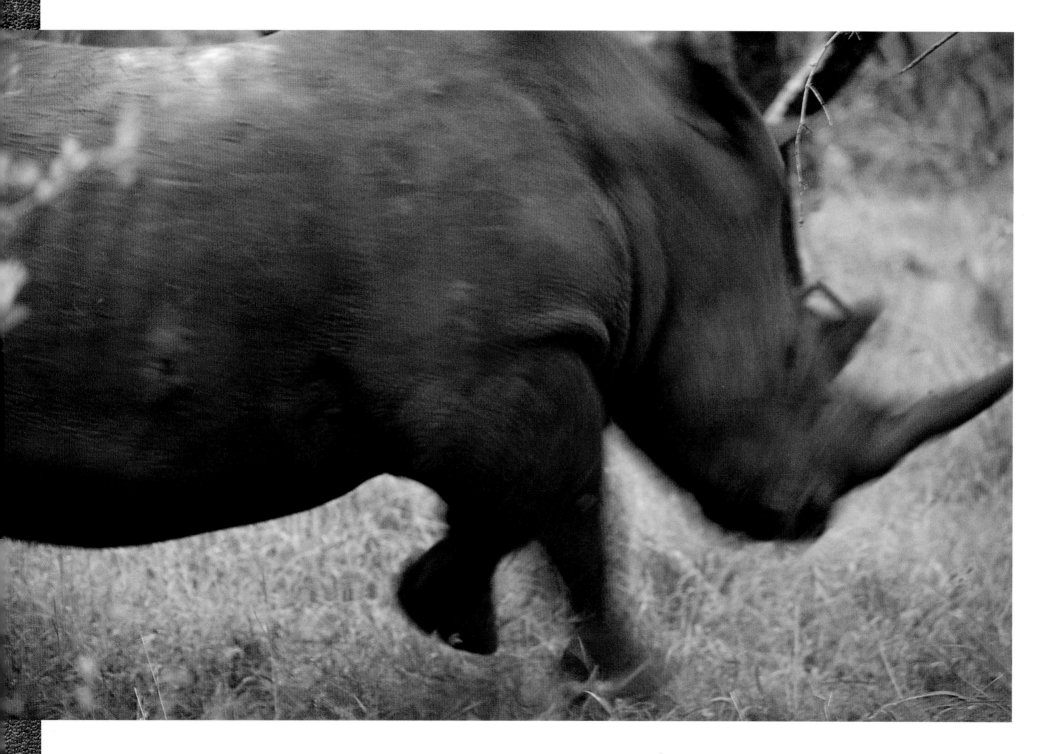

control their trunks. It'll be a year before they can manipulate them properly.

Patrick's hand goes up and we stop. He studies the ground in front of us – "Nkombe," he grunts – rhino. Mike follows the tracks into the bush – rhino are very unpredictable, either plodding along happily grazing or short-sightedly aggressive. Anything weighing two tons can be dangerous so we proceed with caution. The Land Rover pushes through the bush and we come nose to nose with a very big, scarred rhino. He's looking decidedly grumpy; we've startled him and interrupted his feeding. His ears are twitching, moving around picking up the slightest sound. We sit waiting to see what he does, when he moves suddenly, charging half-heartedly, skidding to a halt just a metre away from the front of our vehicle! It's a standoff and we watch him watch us. Someone coughs quietly and the rhino jumps, spinning away snorting and tossing his head before lumbering away into the bush. Mike and I get off the Landy to see if we can track him closer – Mike is a glutton for punishment. But no luck. We haven't gone more than about ten metres before he turns and vanishes into the shlateen - really thick stuff, virtually impenetrable for us.

From a cloudy start the day has cleared and it's become very hot. Mike is casting about looking for signs of the leopard cubs. We're close to where we left them last night but there's no trace of them. Mike casts the net wider but no joy. Those little fluff balls are proving hard to find.

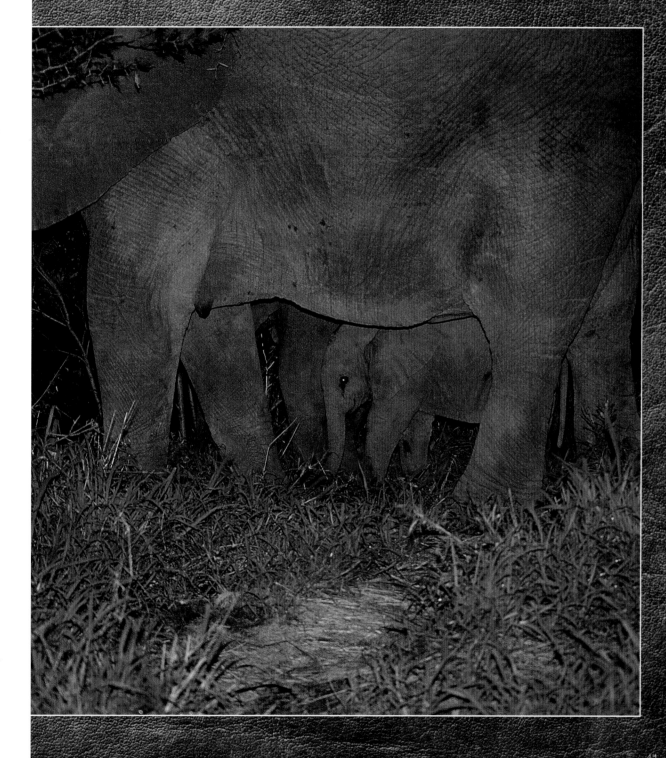

Like grey ghosts - a baby elephant stays close to mum

We continue and Patrick's hand goes up again. He mumbles "Ngonyam nkonzo" – lion tracks. Mike asks Patrick "Mfazi or madoda?" - female or male. Patrick holds-up two fingers and says "Madoda." We follow the tracks and Patrick's sharp eyes pick up a zebra carcass under some trees – just to the left in the long grass, a big male, panting in the heat. There's a movement behind him – his brother lifts his head and stares at us. Their bellies are as tight as drums and I doubt if they'll move before sunset.

We move on, our passing recorded by many eyes – impala, kudu, zebra, waterbuck, bushbuck, nyala watch suspiciously as we go by. The radio crackles intermittently as sightings are called in. The bush is alive but the leopard cubs appear to have vanished. Sound familiar?

Dung beetles are fascinating creatures, all five hundred species! Mike explains that they use dung as both food and nursery. Some breed in a dung heap while others construct a dung ball, lay the eggs inside, then roll it away and bury it where it stays until the eggs hatch. These beetles are using elephant dung as the host.

Dusk is gathering and we're looking forward to sundowners. Driving through some riverine, an elephant appears like a grey ghost in front of us – another behind. Suddenly we're surrounded as they mill around us browsing peacefully, the tardy calves herded along by their elders, the very young staying close to mum. We sit tight until they melt into the bush disappearing as silently as they appeared

Whitefaced owl (Above)
Inquisitive hyena pup (Above right)
Spotted eagle owl (Right)

and we're able to move off to enjoy our delayed drinks by moonlight. This really is jumbo country.

A spotted eagle owl blinks in our spotlight, then a whitefaced owl, but otherwise it's quiet tonight. The rain is making things uncomfortable and we decide to call it a night and head back to camp for dinner stopping only for an inquisitive genet caught in the spotlight.

Early morning and Mike produces yet another rabbit from his hat or in this case hyena pups from their den. Mpisi pups are very inquisitive and playful, but the play is rough, lots of nipping and biting. We move on discussing the missing leopards, Mike is determined to

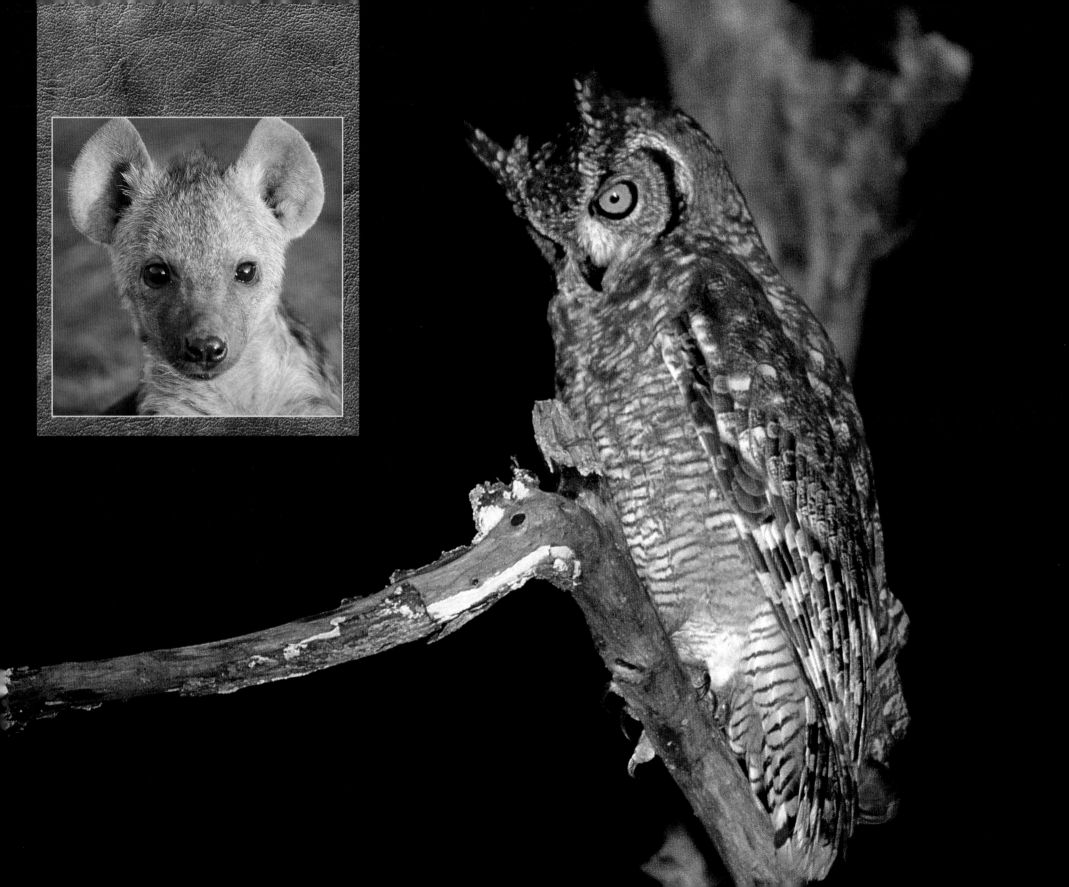

find them again, but it's another two days before we get a sniff of those elusive creatures.

It's another damp start and even the morning bird chorus is muted – the usually noisy francolins only now squawking their sunrise calls. I'm still scrunched into

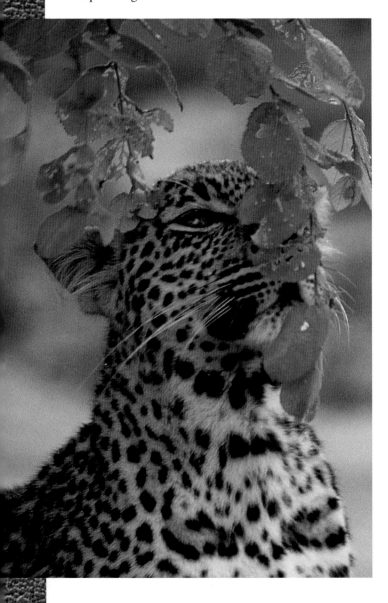

my jacket when Mike picks up leopard spoor and we find the young male hunched under a bush.

He crosses right in front of us, meandering along the track sniffing at some leaves, then a tree trunk and the ground.

Mike thinks he's looking for mother, following her scent markings. He eventually lopes off the track, melting into the bush. Of his sister there is no sign.

The Naturelink Caravan flew in last night to pick us up, we're leaving for Tanzania on Saturday, which gives us only two days back in Joburg to organise everything - collect tickets and visas, sort out our equipment and generally get ourselves together. We head back to camp for breakfast, load the Landy and set off for the airstrip. A mountain tortoise ambles across the road, speeding-up at our approach, almost scurrying into the grass.

Chris is already preparing the plane and it takes but a few minutes to load up and clamber aboard. The turbo roars and as we lift-off, I look back for a last glimpse of one of the world's great game sanctuaries, before we bank left and head west over the cloud covered mountains.

Leopard sniffing scent markings (Left)

44

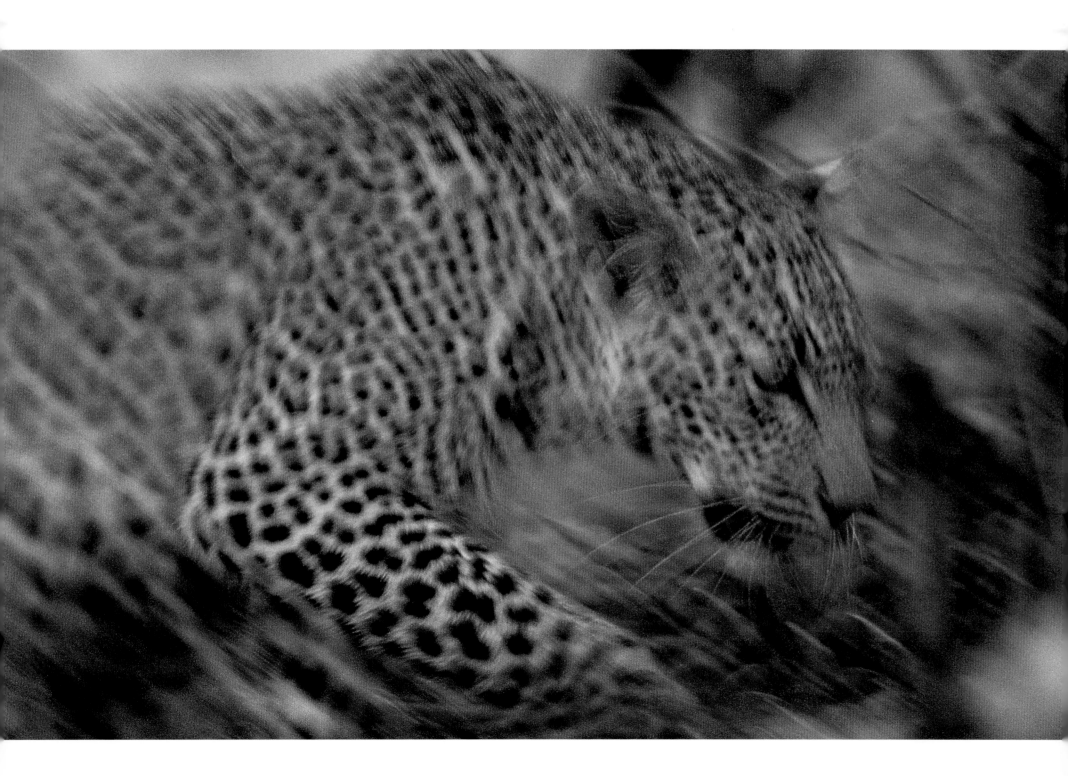

Dar es Salaam & the Selous

Kooma Ulanga

As I've said before, travelling in Africa is not always predictable.

The plan for Tanzania is to fly to Arusha then by Land Cruiser to the Serengeti via Lake Manyara and the Ngorongoro Crater. From there back to Arusha, fly to Dar es Salaam and train down to Ifakara, our jumping off point for the Selous. Sounds fabulous. I've been working on this leg for nearly a year.

Friday, and we're leaving for Arusha tomorrow – or are we? I've just walked into my office to find a fax from Mohamed Yassin our operator and host in Dar

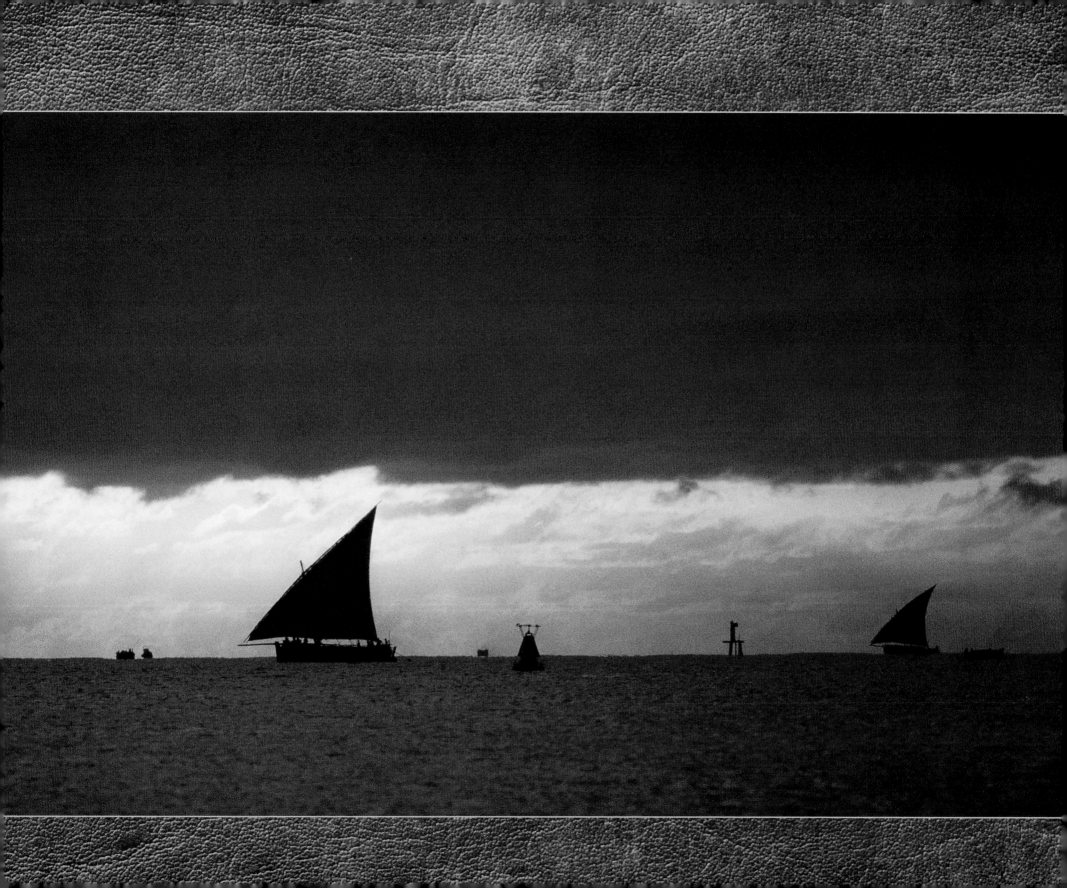

saying that our permit to film in the Serengeti had expired and has not been re-validated. We'd already delayed our trip once because of the unseasonable rain in the Selous and Mohamed wants to know if we want to postpone again. A flurry of faxes later and I decide that we'll reverse the journey and start in the Selous, hoping that in the meantime the necessary permit will be organized – Mohamed sounds hopeful!

Our flight eventually touches down in Dar at 8.30pm, Mohamed is there to meet us and a blaze of his Swahili wafts us painlessly through customs and immigration.

I'm hoping to leave for the Selous tomorrow but over dinner Mohamed tells me that our train only leaves on Tuesday, so we'll be kicking our heels in Dar for a couple of days.

It's only 8.00am but Dar is steaming, already 30°C with high humidity.

Mohamed arrives just as we're finishing our alfresco breakfast. He's going to give us the Dar tour.

It's a fascinating place, an amalgam of Tanganyika's German colonial heritage and its Afro/Arab history. It seems that everyone has something to sell, you can buy almost anything on the side of the road – tyres, furniture, t-shirts, curios, cassettes, any kind of food, fresh or cooked, even medicines - traditional or

The Magagoni Fish Market (Right) and the ferry bus roars off the Ifakara ferry (Far right)

western. The roads are clogged with bicycles, all loaded with fruit, vegetables and other local produce.

Mwengi, the wood carvers' village is apparently world famous, the craftsmen still working with traditional tools carving by hand. Tedious but then every piece is unique. I'm not too taken with the work, but we shoot a piece anyway.

What grabs my fancy is the Tinga Tinga Art Centre, a group of artists carrying on the tradition of artist Tinga Tinga who died in 1972. His pupils and in turn theirs carry on his concepts, painting in this most distinctive and original style. Colourful and vibrant, the paintings depict Tanzanian scenes.

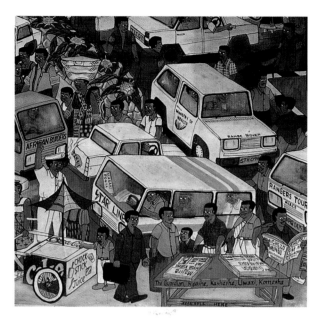

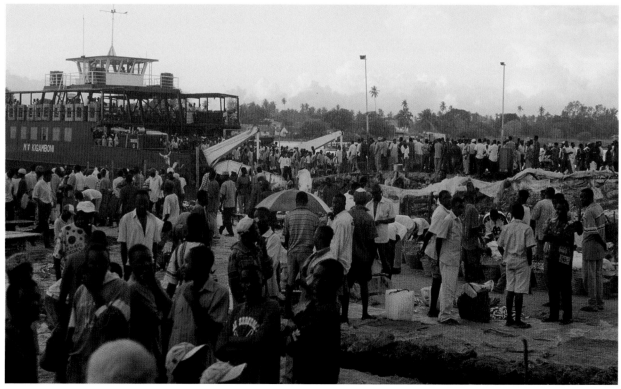

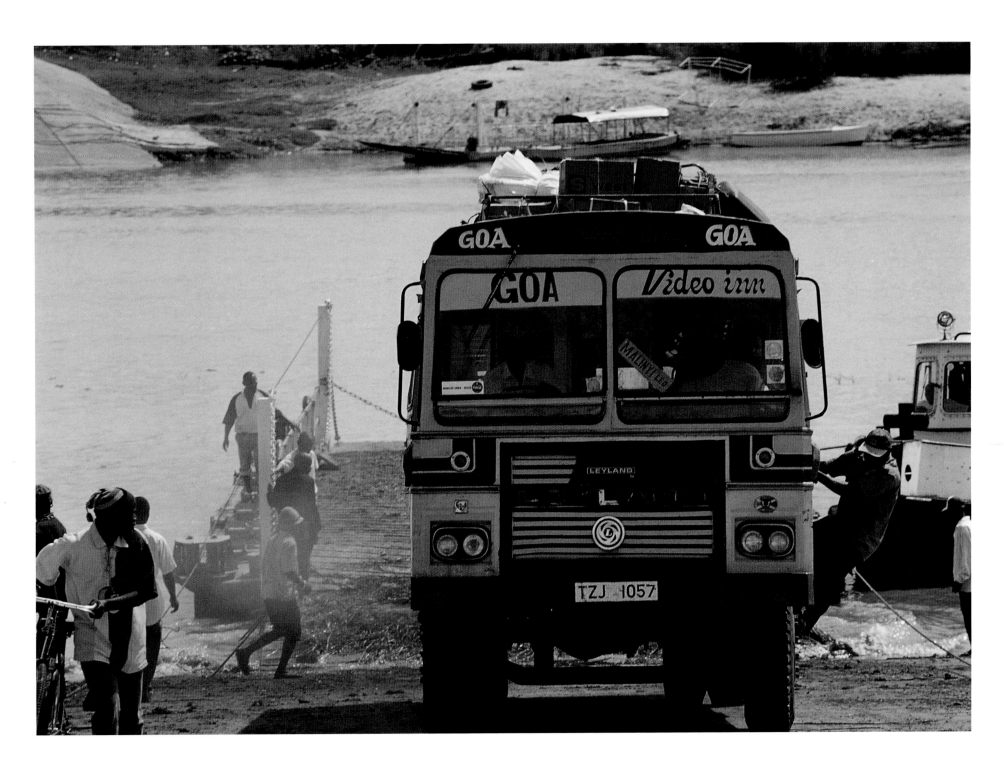

Until we leave for the Selous, we're staying at Mohamed's beach resort at Mikokoni. To get there we take the harbour ferry, it saves a forty kilometres drive around the estuary. It's an amazing scene, there are multitudes waiting and jammed on the boat, it runs from 4.00am until 2.00am the following day, seven days a week. It's only a five-minute trip but it takes about twenty minutes to load and about another twenty to disembark its cargo of vehicles, people and the ubiquitous bicycles. As we get off on the other side there's another horde waiting to board for the return trip.

The bustle of the city recedes as we near the beach. Mikokoni appears, a casuarina fringed beach, with not another person in sight, just a couple of sails on the horizon. We're only fifteen kilometres from Dar but it could be a million miles. Mohamed's wife has prepared a feast for us and we enjoy it sitting round a huge fire on the beach. This is close to paradise.

Five o' clock - we're on our way to Magagoni Fish Market aiming to get there by sunrise when the boats come in. The ferry is already busy with a queue of vehicles, bicycles and people and we have to wait for the next trip. As we cross there's a clear view to the east and I can see the dhows coming in, outlined by the sun rising behind thunderous clouds.

The market is coming to life, the boats already disgorging their cargos. We're surrounded by multitudes of people and mountains of fresh fish.

There are auctions going on all around us, the hubbub is incredible, each seller trying to outdo the other. More boats come in and tons of fish are unloaded by hand, scooped up from the boats in baskets, and swilled off in the sea. The smell of grilling seafood pervades the market – food sellers attracting the hungry crowd. By 9.00am the crowds are starting to disperse so we head back to Mikokoni for a late breakfast – appetites stirred by the succulent cooking smells.

I'm looking forward to the trip down to Ifakara. I haven't been on an African train for years and this one cuts through the Selous. Regretfully we'll be traversing this in the dark – the original idea was to have taken a daytime train. Somehow the best laid plans... !

Quirky things happen in Africa. The Land Cruiser is not big enough and Mohamed has hired a taxi to take our excess gear and paraphernalia including the camp generator to Tazara Station. It is surely the most decrepit vehicle I've seen. We set off in convoy and somewhere along the way we lose the taxi. We arrive – no taxi. In the meantime we employ two porters and suddenly we're surrounded by six, squabbling about who's going to unload our gear and get the tip. We're getting anxious, our departure time is approaching and there's no sign of our taxi. Our porters are almost coming to blows and it takes the station manager to sort it out. In the melee, our taxi chugs up the ramp, we breathe a sigh of relief and scramble for the train that pulls-out precisely on time - 5.34pm. It transpired the taxi had run out of petrol within two hundred metres of the pick up – only in Africa!

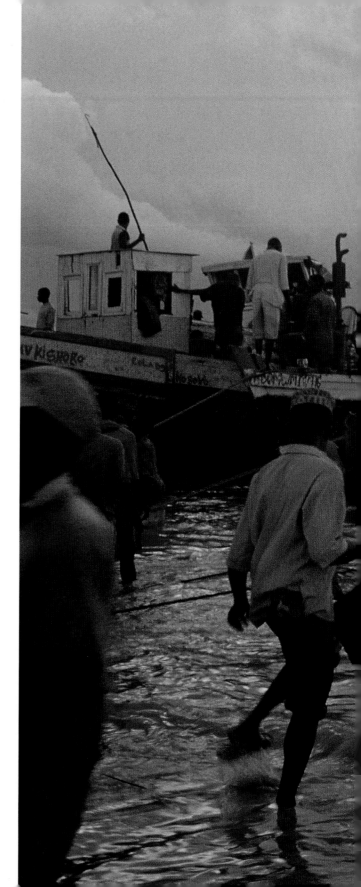

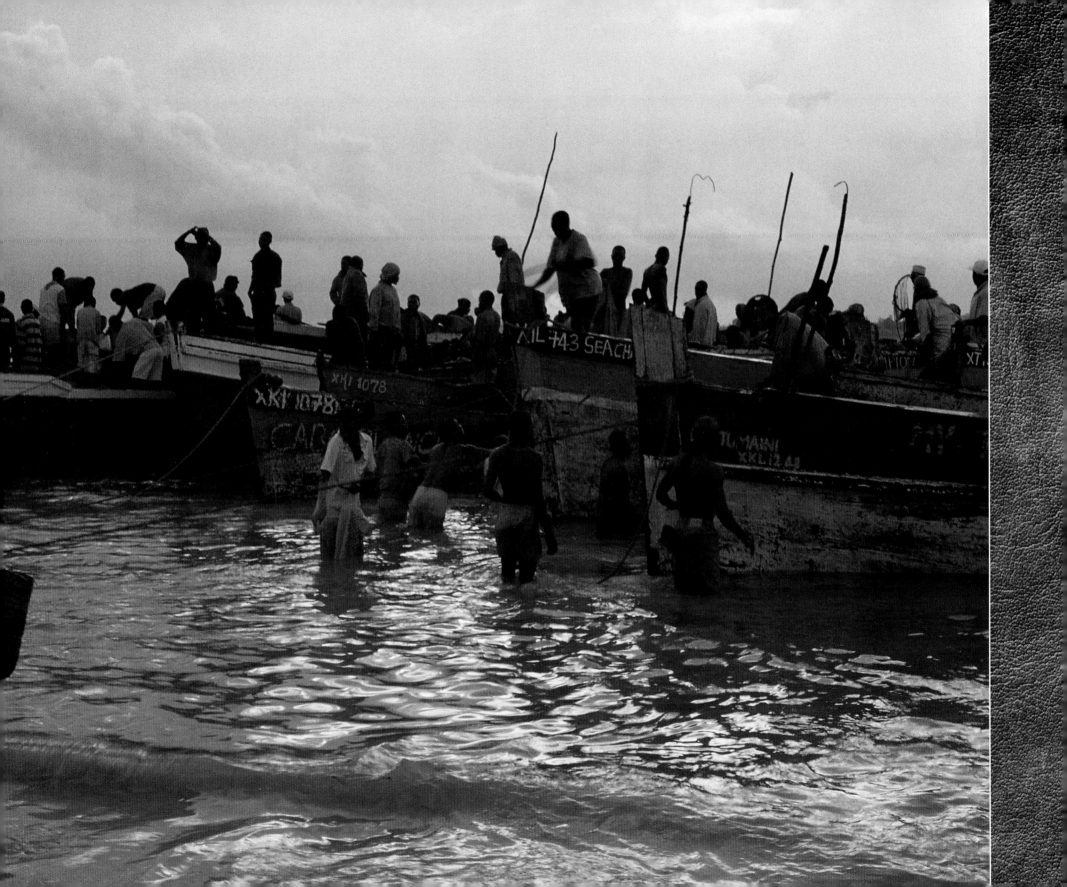

The train has no baggage car so everything is in the compartment with us. Stuffed under seats, loaded on bunks. It's crowded – very crowded. We also have a huge hamper of food prepared by Mrs. Yassin. When we investigate however we find there are no plates or cutlery. Soundman Glenn – our 'Sherpa' - devises forks and spoons from mineral water bottles and plates from the foil covering the food.

The train plods along and after a few Kilimanjaros - the local brew - and some food, Ifakara appears – it's 1.00am. Driver Haile Selassie, yes it is his real name, is waiting for us and we load up. This time there's no taxi to carry excess so Sue, cameraman Charles and I wait on the platform. Charles passes the time trying to teach Zulu to one of the locals! There's a great commotion coming from the station – passengers waiting for the northbound train.

It arrives at 2.00am and the station empties – we're on our own, the silence is eerie.

Eventually the Land Cruiser comes back for us and we bounce and slide along some very rough and muddy roads into town and the Mahemba Guest House. The place looks uninviting. Our room is at best Spartan, but seems clean enough. Sue decides to take a shower – being a contortionist might help; the showerhead is right over the loo, which has a very large frog in it. I get rid of the frog and we manage a shower. The mosquito nets are full of holes, but fortunately the bedroom has a powerful floor fan. I switch it on full blast – no mozzie will be able to settle on us in the gale it creates.

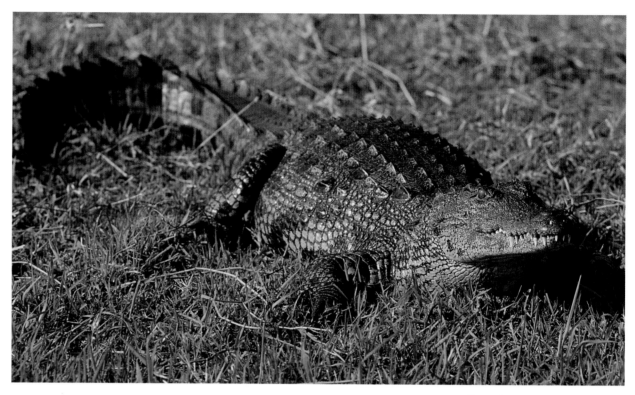

Crocs slither into the water (Above)

Passenger on the Ifakara train (Right)

From here our journey is by boat on the Kilombero, a three-hour journey into the Selous. Raymond is going by road with some of the equipment, there's just one rough track into the reserve and it will take at least a couple of hours longer than the boat.

Mohamed's son, Ali, is at the ferry meet us – he's our Selous guide. Boma Ulanga is a seasonal fly-camp, they can only operate in the dry season, which is supposed to be now but Ali says the rains haven't stopped and the flood plain in the reserve is still almost impassable.

The Kilombero is like a highway and this close to Ifakara there's a lot of traffic – dugout canoes filled to the gunnels with people and provisions being poled along.

We pass primitive fishing villages on the riverbanks. In the background the Undzungwa Mountains are a spectacular backdrop. An isolated rain squall passes in the distance. The current is deceptively quick; probably 5 or 6 knots in midstream and the local fishermen stay close to the banks where they can punt successfully against it.

As we chug downstream the villages are becoming fewer and further and further apart until they come to an end and I realise I haven't seen one in the last half hour. We're getting close and the vegetation is changing – open savanna to flood plain with three-metre grass

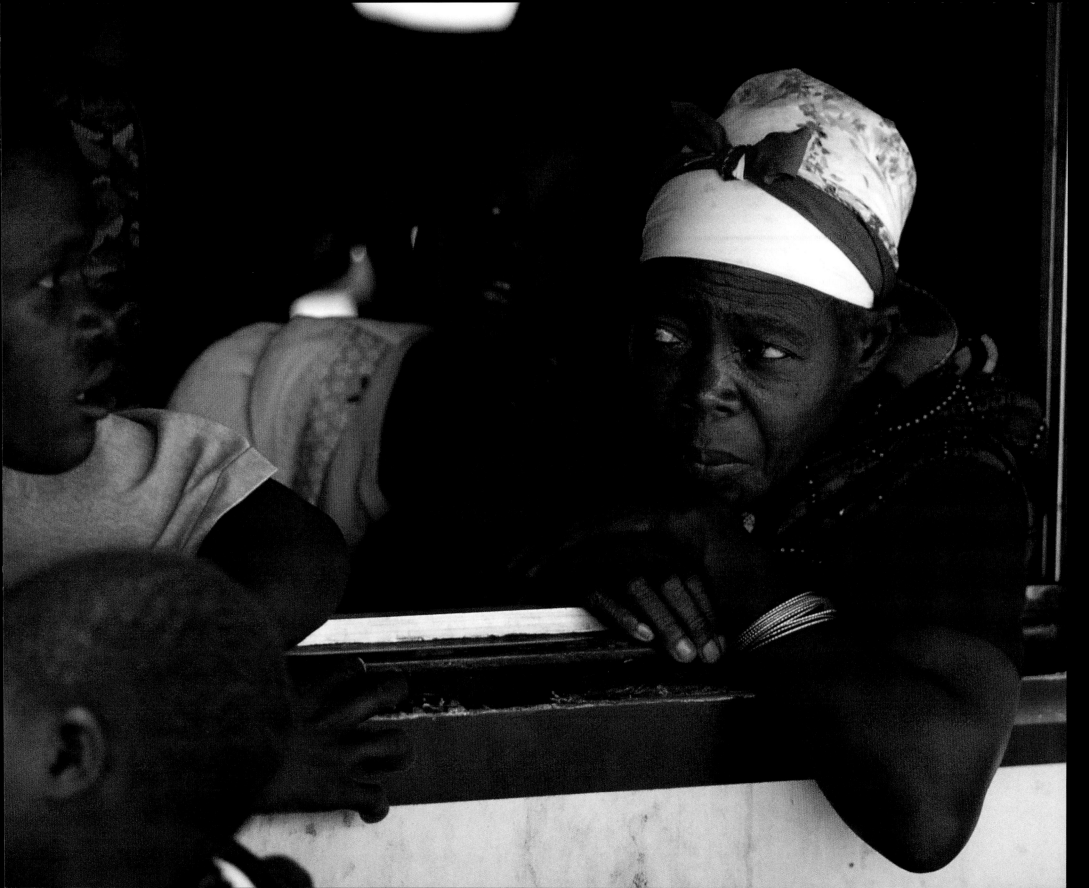

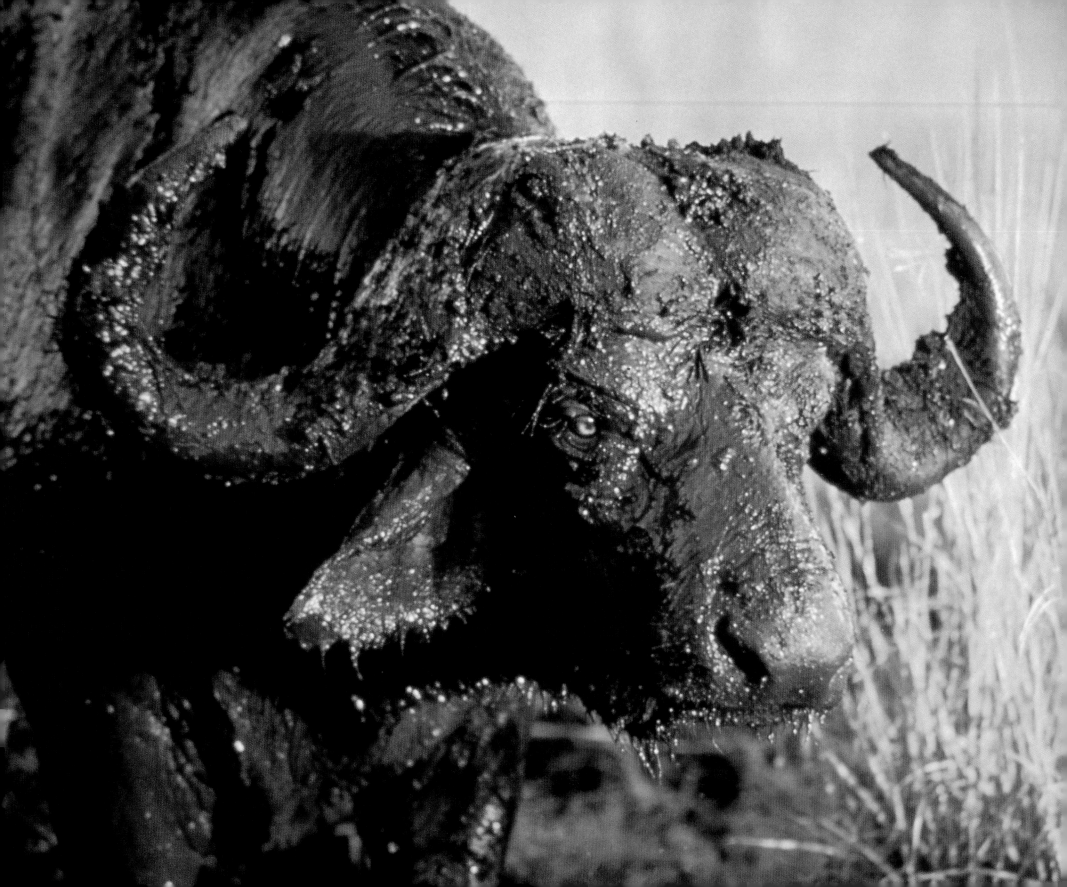

and reeds interspersed with stands of woodland. Wildlife is starting to appear – a lone waterbuck ram gazes at us from the water's edge. The plaintive cry of a fish eagle breaks the silence and herons, egrets and storks fish on the river's banks.

Our game scout says something to Ali. 'Buffalo' he translates. We pull into the bank and climb up. Buffalo all around us, must be a hundred or more. I can also see why Ali says the flood plain is impassable; there are innumerable channels and swamps created by the floods. There are a couple of big dagga boys nearby, old males expelled from the herds, but we can't get near to the main group, as they splash away through the water and disappear into the reeds, quite at home in the quagmire around us.

The Selous has no fences or marked boundaries – nothing to mark the beginning or end of this vast wilderness. Another twenty minutes and Ali steers us into a small beach – Boma Ulanga, our destination and the only camp in the ten thousand square kilometres western sector of the Selous – ours to explore over the next few days. The camp is rustic but comfortable; the safari tents large and well furnished.

Walking around camp, it's clear that most of our activity is going to be on the river, the grass and reeds surrounding us are nearly impenetrable – and dangerous. You wouldn't even see a buffalo or hippo until you walked into it, never mind the crocs! Even an elephant would be hard to spot.

We're waiting for Raymond who's due in about an hour. In the event it's nearly two hours and a few

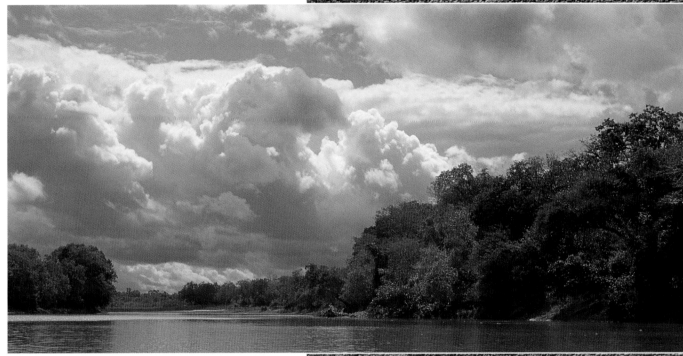

Muddy buffalo (Opposite)
Clouds building on the Kilombero (Above)
Crew filming at Boma Ulanga (Right)

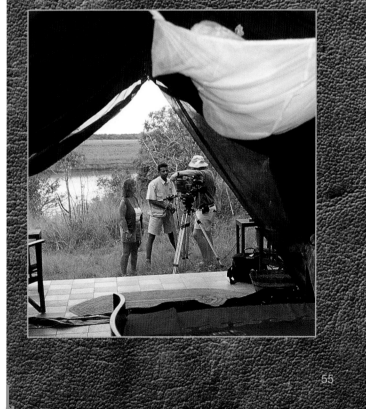

beers before the Land Cruiser makes an appearance – covered in tsetse flies. I don't quite understand why, but the camp itself has no tsetses, walk twenty metres from the perimeter and boy, it's like an invasion; a nasty bite indeed. The normally even-tempered Raymond is pretty irritable because of the tsetses. They'd had to drive with all the windows closed and with the temperature hovering around 40°C and high humidity, the last hour must have been murderous, but a cold beer makes it all go away.

An early breakfast and we're out on the river. Ray is attempting a game drive in the Land Cruiser – I'm not

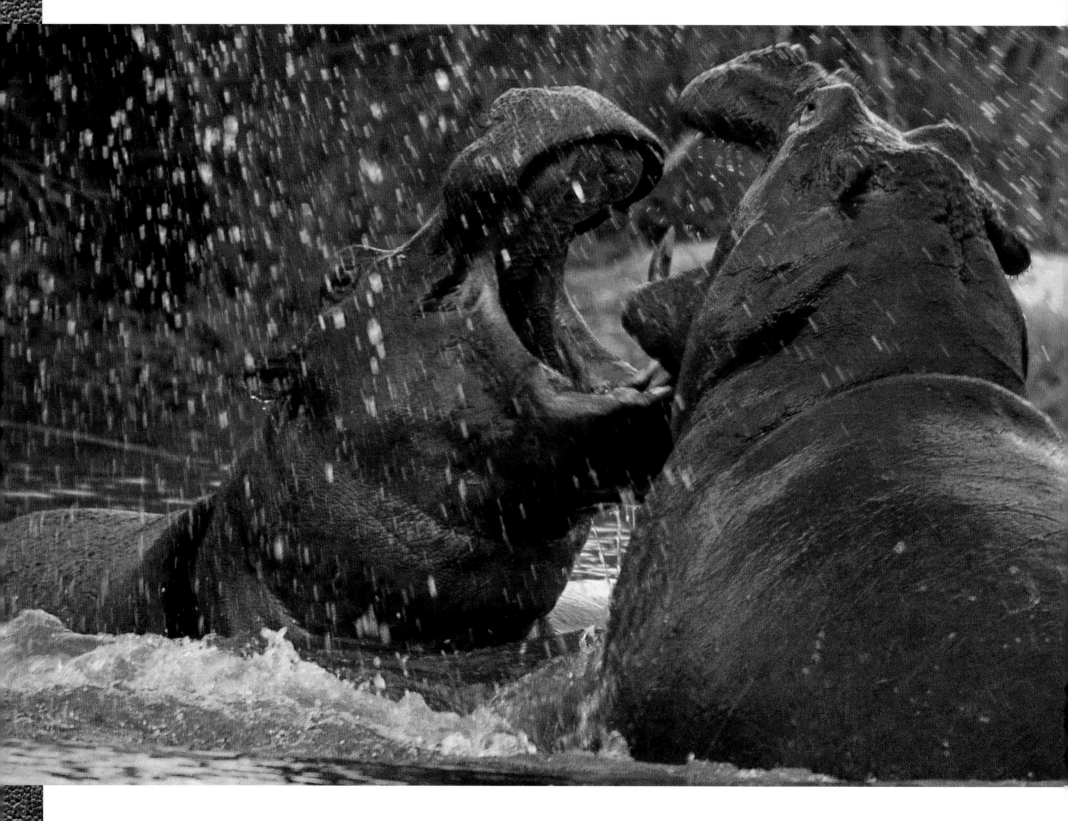

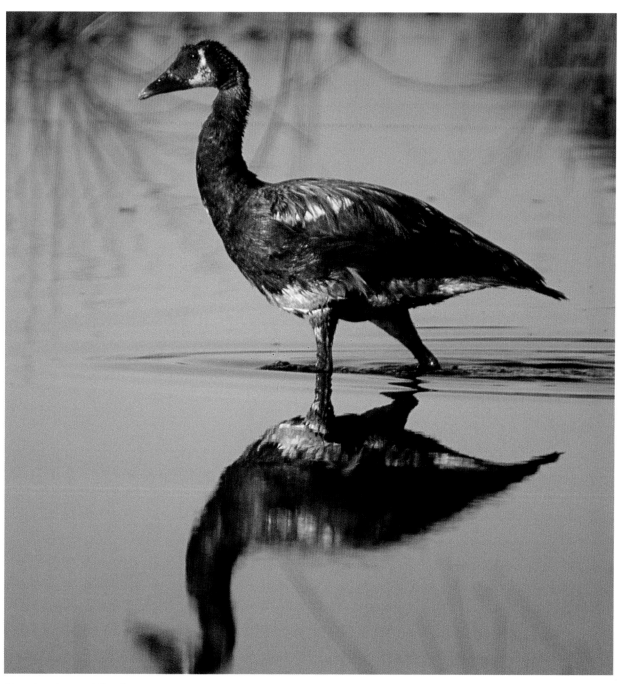

Spurwinged goose (Above)

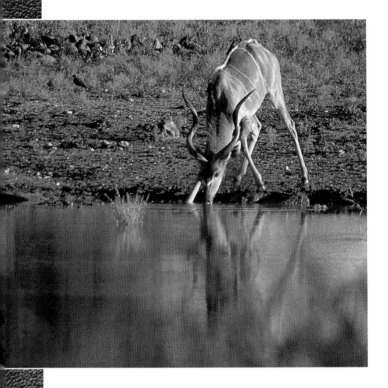

There's a small rise ahead of us, it's only about twenty metres high but in the surrounding plain it looks like a mountain. This is the ranger camp - five rangers and one boat to patrol ten thousand square kilometres!

Just below the rangers' post, a kudu drinks from a quiet pool and as we turn into a smaller channel, another lifts his head from the water's edge, watching as we drift by.

A lone hippo runs along the bank before seeking sanctuary in the river. We take a narrow channel to camp, a lone buffalo just out of its mud bath, glares angrily as we chug past.

Raymond had aborted his drive, as the vegetation was just too high and too thick to see anything. However, when he got back to camp a small herd of elephants appeared out of the reeds on the bank and crossed the river just downstream. We investigate and there are distinct signs of activity, it's clearly a regular jumbo crossing, both banks deeply muddied from the heavy traffic.

Evening closes with a spectacular sunset as camp cook Alan produces a stunning meal against a chorus of croaky frogs, chirping crickets and a lone hyena howling in the distance.

During the night I wake briefly to a distant lion roar. I think it's unlikely we'll see any cats given the dense vegetation, but you never know. I drift back off to

sleep and wake naturally at five. We have a pow-wow over breakfast and decide to set up one camera on the bank near the elephant crossing and the other ready on the boat.

There, a small breeding herd of elephants, right in front of us! Ali steers within metres and we watch them clamber up the bank – the calves struggling in the mud, latching onto the adults' tails with their trunks to be hauled up. The matriarch turns tossing her head at us as the herd moves away. We find a place where we can climb the bank and get off the boat to follow them. They're already well over fifty metres away and the swamp makes it impossible to get closer.

Late afternoon and Ali is taking me to a heron nesting site close to camp. As we get off the boat, we find ourselves surrounded by elephants. They're quite relaxed and carry on browsing, except for one young chap who decides to check us out. Typical adolescent behaviour as he moves aggressively towards us, then stops and backs off a bit before trying again. It's just a bit of show, he's satisfying his ego, knows we're no threat and eventually backs off, rejoining the herd. It's getting dark and dangerous to stay where we are so we get back on the boat – as we push off, one of the adult females pushes through the bushes right above us. Ali guns the motor and we make our escape; all just enough to get the adrenalin going.

It's our last night at Boma Ulanga and after dinner Alan produces a farewell cake. How you bake a cake here – no oven, no gas, no electricity - I have no idea, but then Alan has surprised us every day.

sure if he'll see anything with the vegetation higher than the vehicle. The river is clearly where all the life is. Ali cuts the engine and we drift downstream. Hippos pop up next to us, some leaping out of the water and jousting. Crocs slither into the water as we pass. Bird life is phenomenal - in vast numbers, making the most of the Kilombero's bounty, but apart from the hippos, no sign of mammals. Myriad channels open up and we explore some of the larger ones. Ali says it looks as though there's going to be no dry season this year; the big rains are due to start again soon. With so much water around there's clearly no way we're going to be able to do much on foot. In the ten or twelve kilometres we've come downstream there are not more than two or three places we could have climbed onto the bank.

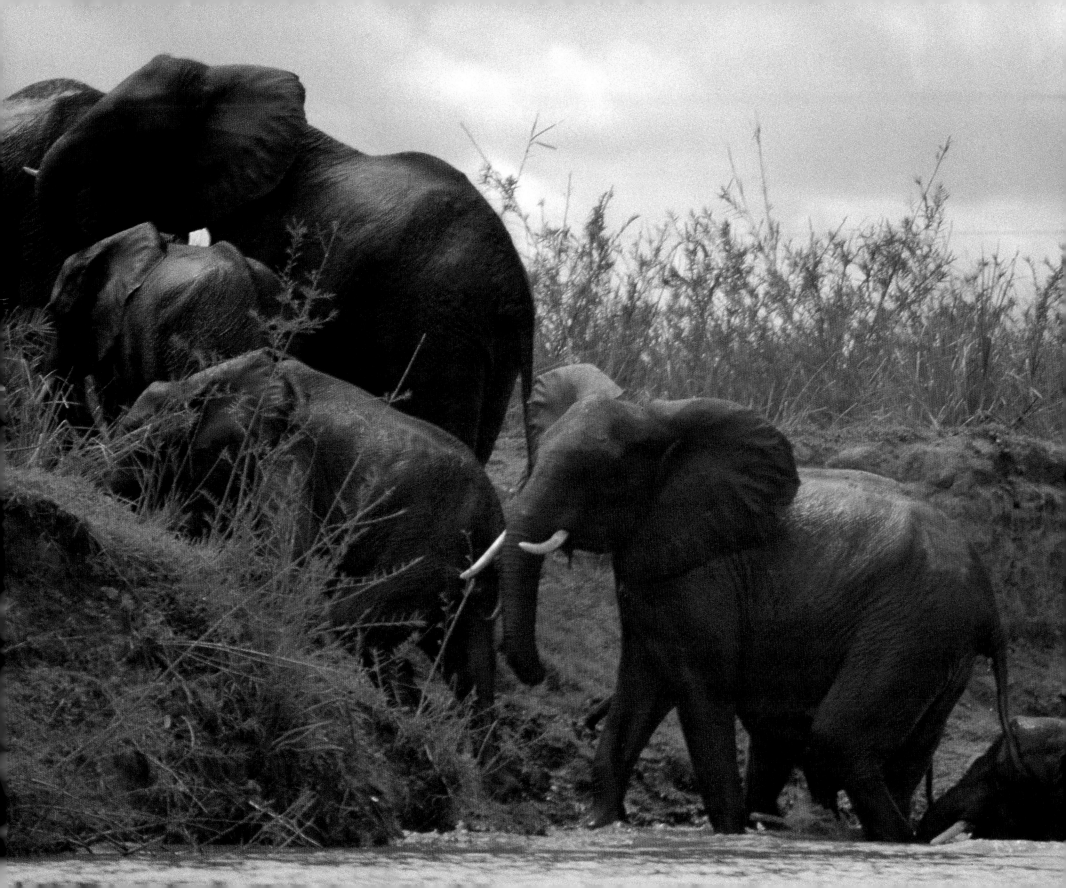

I'm up early; it's a long trip back to Dar. The rough track is tough even for the 4-wheel drives. Four jolting hours later and we're at the Ifakara ferry. There's a large herd of cattle ahead of us, so we have to wait, but it's entertaining watching the Masai manhandle the bulls onto the ferry and tie them to the guardrails before loading the rest of the herd with much shouting and beating of bamboo.

A bus roars off the ferry in a cloud of diesel fumes and I wonder where it's headed.

I take a pic and the driver shakes a fist as he passes. Eventually it's our turn to board and we step onto a very slippery, mucky and smelly ferry. The road to Dar is long and uncomfortable with six of us and our gear crammed into and on top of the 'Cruiser. Our journey is broken only by fuel stops, a break for a picnic lunch and once by the dreaded hissing of a deflating tyre. It's 1.30am before we hit the beach at Mikokoni and gratefully fall into bed.

Mohamed arrives bright and early with the news that our Serengeti permit is still not through – worse news is that the official responsible is 'unavailable'. It's

Openbilled stork with catch (Above)

Not a bad option - dinner on Mikokoni beach (Right)

clear we're not going to get to the Serengeti on this trip. I consider our options and discuss alternatives with Mohammed - "Can we get to Zanzibar?" "Not enough time to make arrangements." "How about Bagamoyo, the old slave centre?" Same problem. There's nothing for it, we'll have to cut our trip short, but the next flight to Joburg is three days away, so we have no option but to chill out on the beach for a couple of days and plan the next leg of our Safari. Not a bad option!

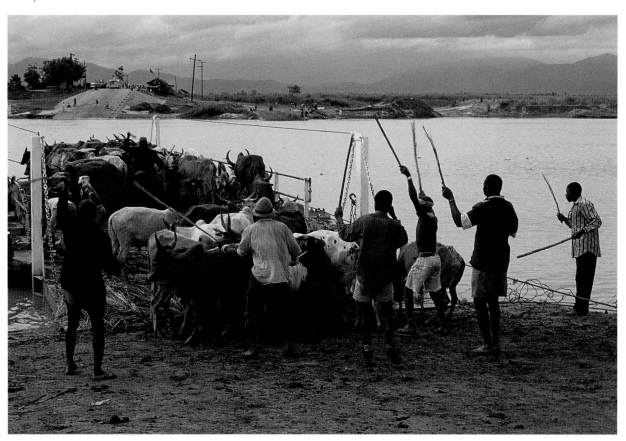

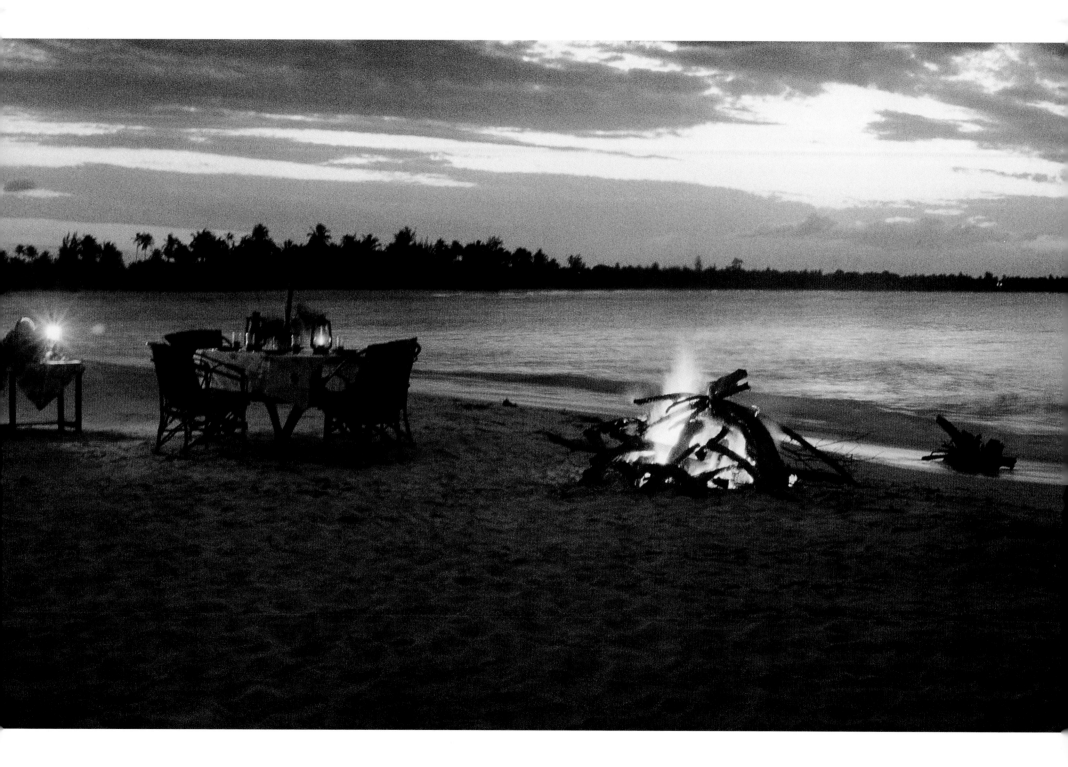

Central Kalahari

Deception Valley lodge

The Caravan drones steadily northwest from Joburg eating up the miles. The arid heart of Botswana beckons. The Central Kalahari is one of the driest places in Africa in stark contrast to the sodden floodplain of the Selous. Drought here is a perpetual feature; annual rainfall is less than a hundred millimetres, some years – nothing. There is no permanent surface water and yet this sixty thousand square kilometre wilderness is a haven for a large number of game animals uniquely adapted to the extreme conditions.

We touch down at Gaborone to clear immigration, it's just another hour to Deception Valley on the northern edge of this vast remote reserve. From the air the landscape is featureless, barren, desolate and very

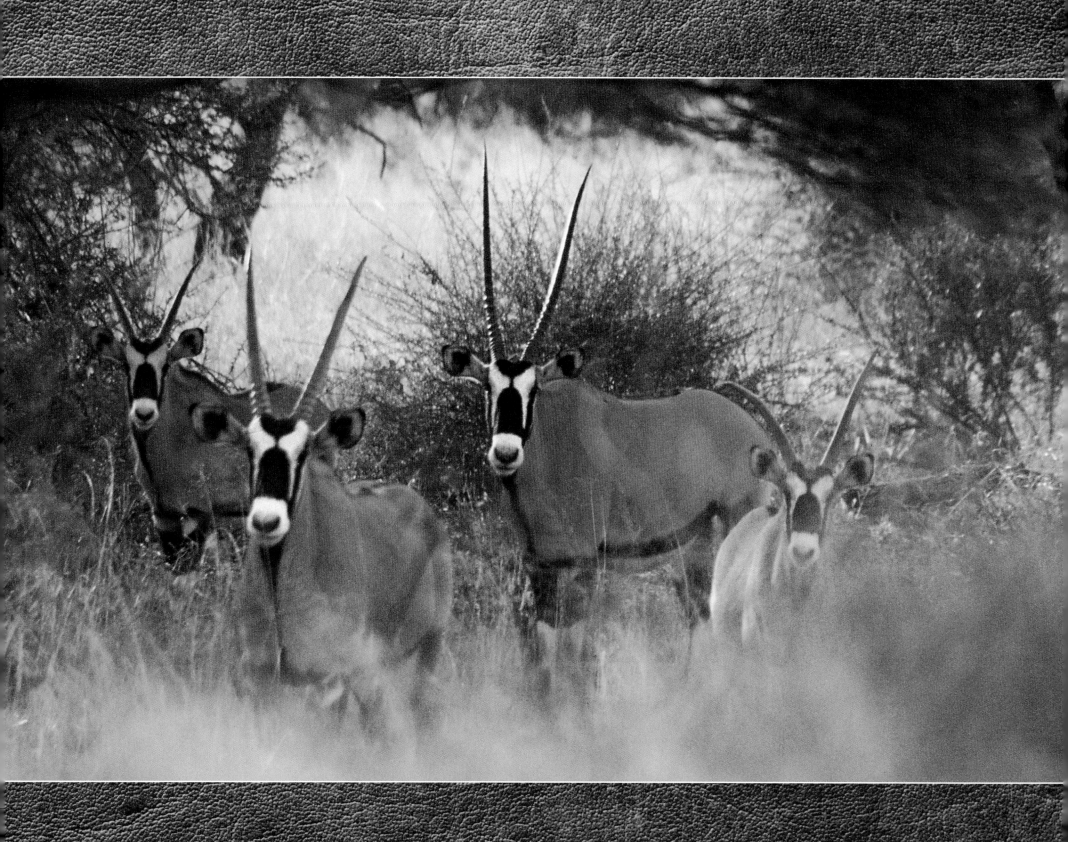

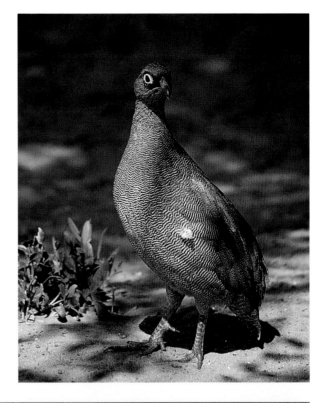

flat. The horizon vanishes into a distant haze. The airstrip appears, a great gash in the surrounding scrub. It's very hot and windy and we bounce into a dusty landing. At ground level there's more vegetation than I'd imagined – lots of dried thickets even drier grasses and the odd stunted tree.

The camp vehicle arrives and it takes a few minutes to load our gear. Our guide, Johan, turns out to be an interesting character, an ex-professional rugby player with a passion for wildlife and nature. He's given up the bright lights and glamour of pro-sport for the solitude and peace of the wilderness. All this I glean on the half hour drive to Deception Valley Lodge. I ask Johan about the name and he explains that when the first white settlers came through the valley they thought it was fertile, a good place to settle and farm. The appearance proved deceptive, there was no water and they were forced to trek onwards.

The lodge appears like an oasis out of the scrub. Here there are real trees and a waterhole. But it's not natural; the water is pumped from deep in the ground. Johan says that the trees attract myriad birds and the waterhole is a magnet for game. As if to prove his point, some rather nervous kudu appear followed by a lone big-tusked warthog that launches itself into the muddy edge of the pool.

With no cloud-cover and clear skies, the day's heat radiates away and the Kalahari winter nights are bitter.

Yesterday when we landed the temperature was hovering around 30^0C, this morning it's still dark and I'm enjoying a steaming outdoor shower looking up at the stars with the mercury at minus 5^0C. We meet on the lodge deck for coffee. Everybody is well wrapped up as we board the Land Rovers.

Our tracker Ruse comes from a nation of trackers, the Khoisan or Bushmen.

The Central Kalahari Reserve was originally set-aside as a sanctuary for these fast vanishing people. Sadly they are being forced out of even this arid wilderness, a sad commentary on modern society. Ruse is one

Pied babler seeking relief from the heat (Right)

A wary redbilled francolin (Top)

Warthog mud bath (Opposite)

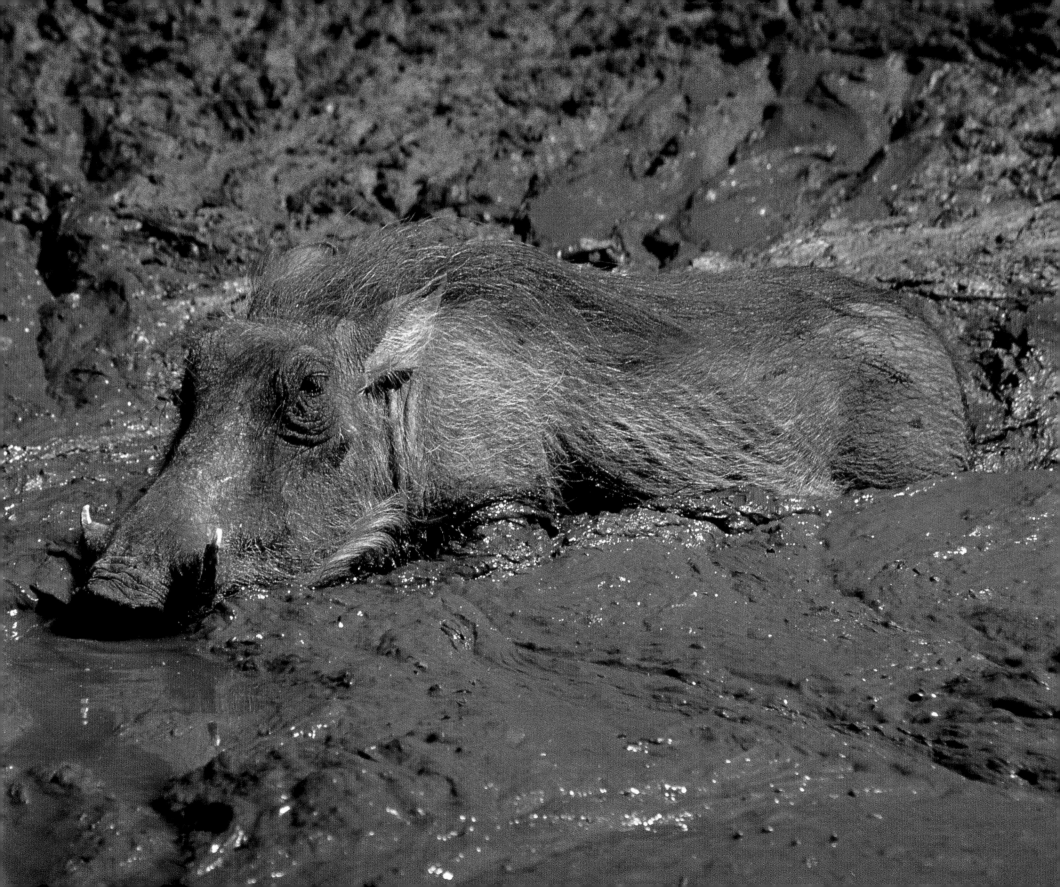

who has adapted to modern life, working full-time as a tracker for the Lodge. Interestingly he still keeps a tribal hut as a refuge and when not working, changes into traditional garb. He continues to practise the ancient San arts, making jewellery and adornments, hunting with bow, arrow and spear. This morning I'm sure he's pleased to have the warmer trappings of civilisation – an old army overcoat, balaclava, boots and gloves. Typical of his race, he's small, no more than 5 feet tall and lean as a whippet. His face is wizened, lined from the harsh Kalahari sun.

The sun comes up and everyone peels off a layer. The birds are starting to wake with francolins leading the early morning chorus.

A flock of guinea fowl gobbles away ahead of us. A kudu bull crashes through the surprisingly thick bush, followed by another. A scrub hare sits in the road enjoying the warmth of the sandy track.

A sign from Ruse brings us to a halt and he and Johan examine some marks in the dust. I join them and Johan points out cheetah tracks and signs of a skirmish. Ruse shows us ostrich tracks and says it looks like the cheetah killed an ostrich and dragged it into the bush. Ruse follows the marks and spoor – I can see nothing – and about fifty metres in we find the remains – a few bone splinters, the feet, crop and lots of feathers. Ruse says the cheetah killed yesterday, fed and left the carcass for hyenas and jackals. I ask him if ostriches are normal prey for cheetah, he says that in the Kalahari they have adapted and became adept at

Ruse in the trappings of civilisation (Above)
Normal ground squirrel business (Right)
Redeyed bulbulls (Far right)

hunting the big birds. A formidable and hard to catch foe I would have thought.

Like many small creatures, ground squirrels are fascinating. Johan has discovered a colony but as we approach they all dive into their burrows. But they're very inquisitive and as we sit quietly, a head pops up to see what's going on. Eventually their curiosity gets the better of them and they emerge from their holes. Realising we are not a threat, they scurry around chasing each other and eating bulbs, grass, roots and the odd insect – just normal ground squirrel business.

Back in camp we take time out to watch the many birds flocking around the water. They seem to take turns swooping down from a thorn tree to drink and

splash around - a striking hornbill, babbler, barbets, shrikes and francolin – a colourful procession. The sun is going down, the temperature dropping.

We've decided to go out after dinner to explore the Central Kalahari nightlife. My experience of night safaris is mixed, apart from the big cats, nocturnal animals tend to be rather shy and sightings are usually very brief. Again we're wrapped up against the cold and as added insulation Johan has brought along a bottle of Old Brown Sherry for 'inner warmth'. There are seven of us, so it doesn't last long but it does help

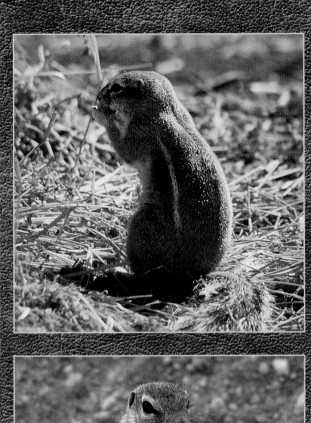

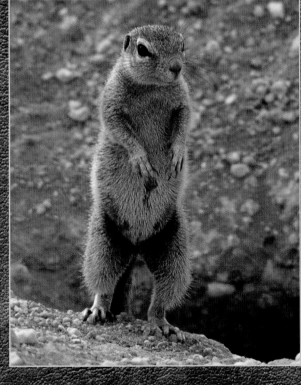

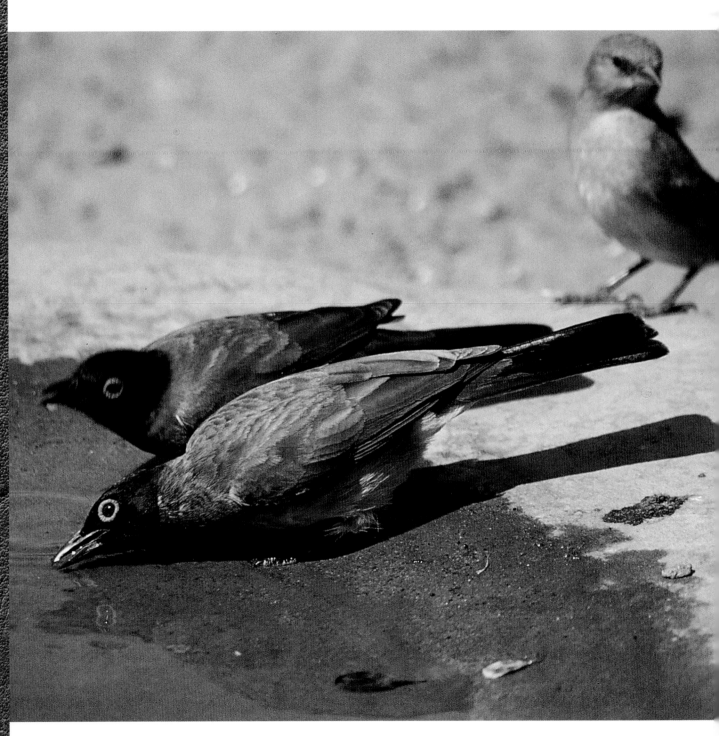

– it also adds to the hilarity. Around us the night silence is almost overpowering.

An African wildcat – a rare sighting - skulks away from the spotlight. A genet scurries into the bush then turns and watches us pass. A spotted eagle owl stares from his perch before flying silently away. Ruse turns the spotlight to the ground and says something to Johan. Leopard tracks, but they're old; he probably passed along here two or three days ago. The cold is beginning to bite, it's after midnight so we head back to camp.

How have the San people managed to survive in this inhospitable wilderness? I was about to find out. I had asked Ruse exactly that question and he offered to show me. Along with his young assistant, Thamae, we start walking in the area of Ruse's hut stopping almost immediately at a young sapling. This, he explains, provides wood for the Bushman bow and digging stick used for a multitude of tasks. The wood seems too slight for such uses but it's extremely whippy and strong. When Bushmen hunt, they track and stalk their prey until they're close, relying on the poison on the arrows to kill their prey.

We move on and Ruse stops next to another bush. "This gives us water," he says. "How?" I ask Using his digging stick he excavates a large root, cuts off a piece and holding it to his mouth squeezes; a stream of liquid gushes into his mouth. "What's it like?" I ask. "Taste," he says. He cuts me a piece and I squeeze – cold water- slightly brackish but perfectly drinkable! An inexhaustible source of fresh water when it would appear there is none. The means of survival are endless. An insect on this tree provides the poison for the

Digging for the water root (Right)

San jewellery (Far right)

hunting arrows and spears, that one supplies edible berries, the ostrich supplies eggs both for food and fresh water storage. The San bury the eggs as they travel and have no difficulty finding them again in this featureless land. Ruse leads us to his hut, we squat on the ground, he produces an ostrich egg shell and demonstrates yet another use – making jewellery, bracelets and necklaces. The deceptively simple and fascinating process utilises two stones, his digging stick and small spear. Essentially he takes a piece of shell, knocks off the rough edges until it's more or less round, drills a hole with the point of his spear, threads it onto a string with other pieces, then smoothes away the edges on a stone until they are the same size and voilà you have of a necklace!

As we walk Ruse explains the Bushman philosophy. They have respect for the environment, never depleting the land of resources or over-hunting. They only own what they can carry. Each clan is self-sufficient, they look after each other and there is no competition or rivalry between clans. In simple terms it's perhaps best summed up by the words 'sustainable conservation'. These gentle people are from another age, the last of the hunter-gatherers and they're being hounded into extinction. And we call ourselves the civilised ones!

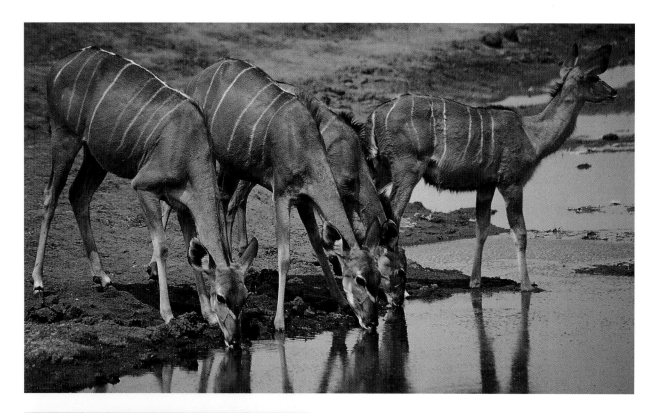

A small flock of ostriches sprint across the road just their heads and necks visible above the bush. They stop to watch our progress before trotting away satisfied we're not some strange predator.

A group of oryx, that beautiful antelope with the long scimitar-like horns, pause in their browsing, gazing at us as we pass. Johan stops and we dismount to see if we can walk in on them. We advance ten metres and they retreat keeping their distance. Using cover we try stalking them, but they're too canny, moving away as we move forward. We give up and return to the vehicle. As we drive away they drift back to their original feeding place.

The waterhole is occupied with a breeding herd of kudu and we approach cautiously not wanting to spook them.

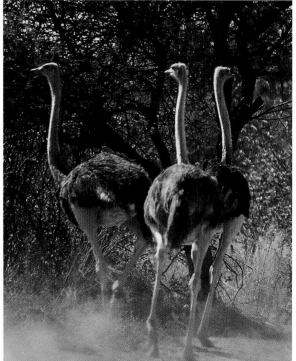

It's a magic time of day, the sky is turning red, the grass reflects golden and we continue our walk in silence. My reverie is broken as an African wild cat springs out of the grass almost from under my feet. I reach for my camera but too late, it's gone, melting away in the long grass. Ruse laughs at my slow reaction. Our shadows lengthen and precede us reaching towards the horizon - and our vehicle and cameras.

The sun is up as we set out – there seems to be no point in leaving before sunrise, the animals certainly don't stir too early in the cold of early morning. Johan is heading for a waterhole to check for any action.

Again Johan and I dismount and we creep towards them. They're very alert, constantly lifting their heads to watch us. We get within fifty metres before they scatter into the bush. There's a hide overlooking the water and we decide to post cameraman Karl here to see what else comes to drink. We help him set-up his camera and leave him with a radio.

Johan and Ruse are tracking cheetah but we're not having much joy, just old spoor, and when we radio Karl neither is he, apart from some

Kudu at waterhole (Top) Ostriches (Left)
Southern yellowbilled hornbills always
look angry (Right)

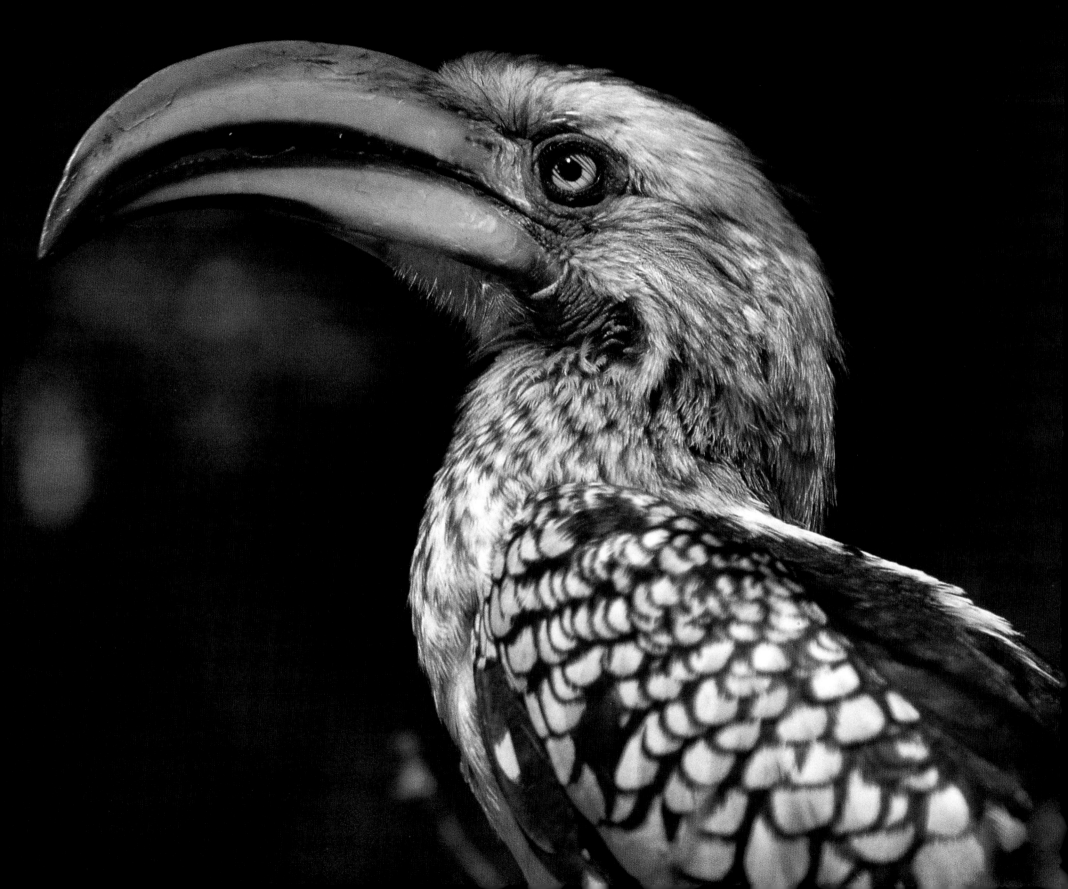

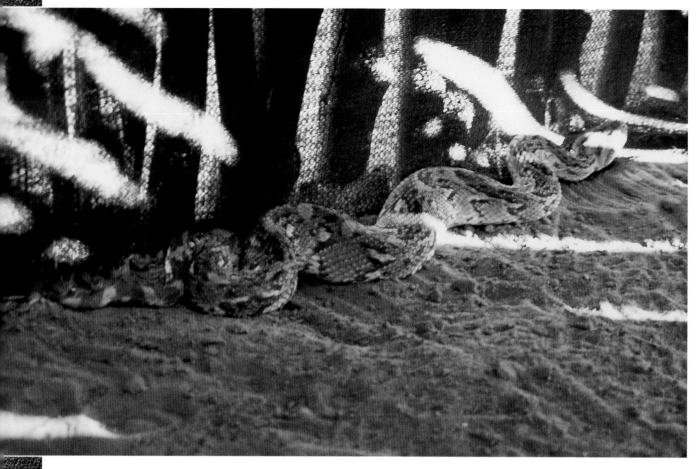

The snake moves (Above)

Johan and Ruse investigate. Big problem. The reptile is still wrapped around the tripod. The last thing you should do is aggravate a puff adder, one of the most dangerous snakes - they move sluggishly but strike very fast - three times a second! But we have to retrieve our gear and the snake shows no sign of moving. Johan cuts a long stick and pokes it. It hisses and curls tighter round the tripod. Ruse attacks through a hole in the wall and the snake moves. Eventually between them they get it out and we jump in and grab the equipment. The reptile lies in the open hissing at us. Fortunately puff adders are slow movers and not aggressive – unless you get in their way.

We take a few shots and leave it in peace. It slithers away into the bush blending immediately into the background.

Johan decides to take a turn past another waterhole before heading for camp. The edges are very muddy and Ruse picks up fresh leopard spoor and marks where the cat lay drinking. We look around but see nothing then Ruse points and I get just a flash of spotted gold disappearing into the setting sun.

Tomorrow we're leaving the solitude and silence of this wonderful wilderness, heading north. First stop Maun to clear Botswana immigration then on to Zambia and the Upper Zambezi.

nothing has come down to drink. Our cheetah hunt is going nowhere, we radio Karl again – no response. Johan tries again – silence. He frowns, "The batteries are fresh, there shouldn't be a problem," he says. We radio the lodge to see if they can raise him. The ground here is flat, reception should be good. We have no problems contacting the lodge but neither of us can get any response from Karl. We decide to investigate. We're about an hour away. We keep trying but still no response. As we approach the hide

Karl appears out of the bush – sans camera. He's looking a little pale and blurts out his story.

He was focusing on some birds when he heard a rustling sound at the entrance – coming through the doorway was a two-metre puff adder. With only one entrance, Karl was trapped. He backed away and the snake went straight for his camera wrapping itself around the tripod. Karl dived for the exit leaving camera, tripod, radio and water behind.

Upper Zambezi & Victoria Falls
Tongabezi

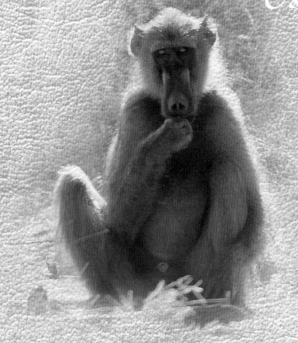

In the days before jet travel I flew from London down Africa en route to my home in Johannesburg. We stopped to re-fuel at cities and towns with colonial names – one of them was Livingstone in what was then Northern Rhodesia. It was late afternoon and I remember sitting in the airport's bougainvillea covered gardens enjoying an ice-cold beer. We could hear Victoria Falls roaring close by and our take-off took us low over them giving me my first sight of Mosi O Tunya – the smoke that thunders.

Well Northern Rhodesia is now Zambia but Livingstone is still Livingstone and I'm flying into that quaint airport on my way to Tongabezi on the Upper Zambezi. Truly déjà vu. I'm amazed to see that although there are spanking new airport buildings

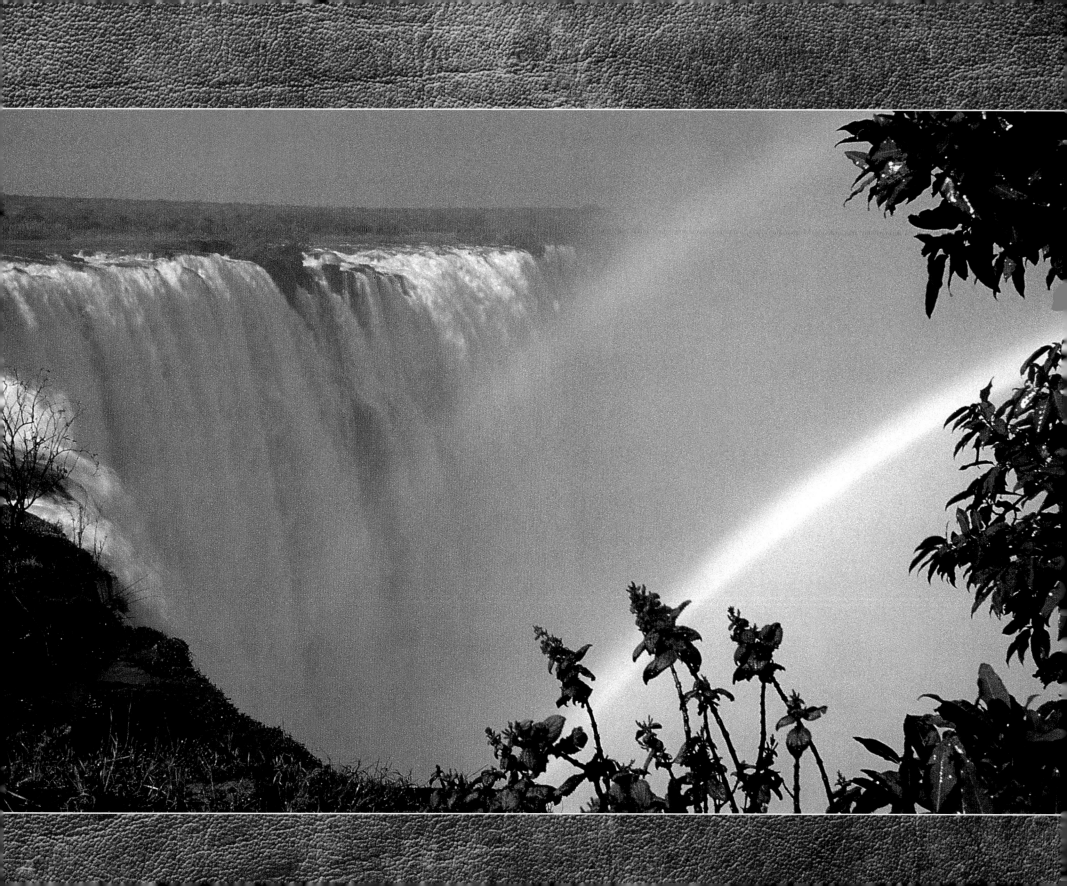

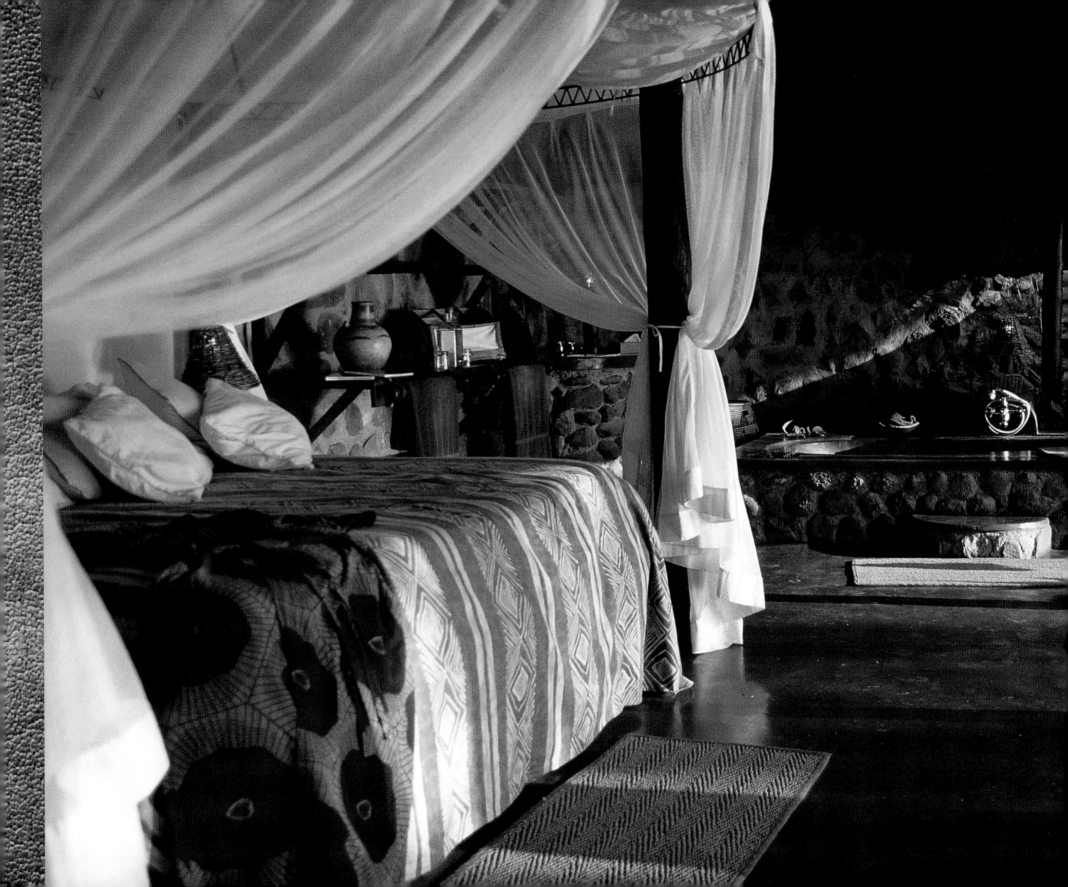

some of the original still stands. It's hard to believe that sleepy Livingstone was once a stop on international air routes.

Ben Parker's Tongabezi is our base for exploring the Zambezi and its islands, the Falls and Mosi O Tunya National Park. The lodge is set on a giant bend of the river facing southwest across to Zimbabwe. The Zambezi is a big river more than a kilometre wide at this point. The Tongabezi position is prime and the style of building eclectic and original. The new suites, spread along the riverbank, are superb, spacious and comfortable but it's the three original 'houses' that are really special. The stone, thatch and wood honeymoon house has a totally open front with its own private garden, set twenty metres above the Zambezi with a 'honeymoon' view, even from the loo!

There's a massive cloud build up this evening and the sunset is spectacular.

Zambia's rhinos were poached to extinction but a couple of years ago a pair were re-introduced here in

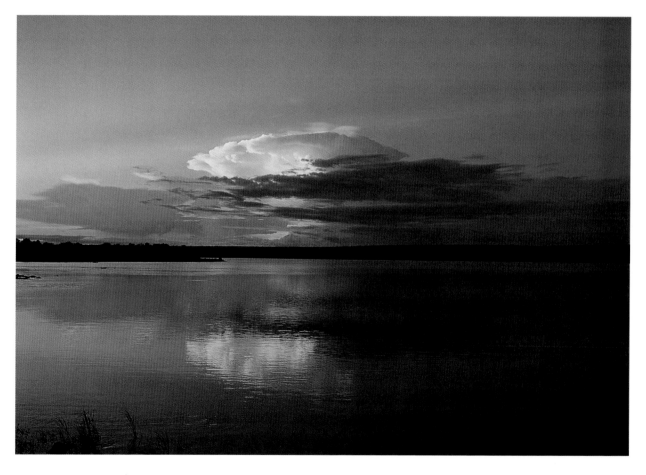

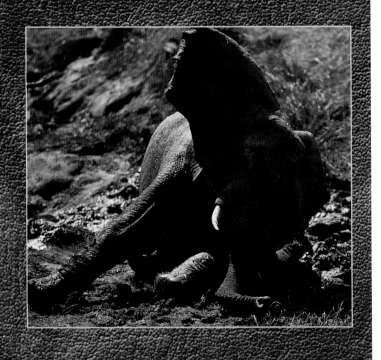

the Mosi O Tunya National Park. Their horns were cut off to discourage poaching and they have their own armed guards who are with them twenty four hours a day! The rhino have produced young, their horns are re-growing and they're thriving in this protected environment.

The Park stretches for several kilometres along the Zambezi and with no predators around it's a perfect stamping ground for buffalo, zebra, giraffe and impala. It's also a favourite feeding ground for elephants that cross the river from Zimbabwe.

Elephants in mud - a magical combination

Baboon mother and baby (Opposite)

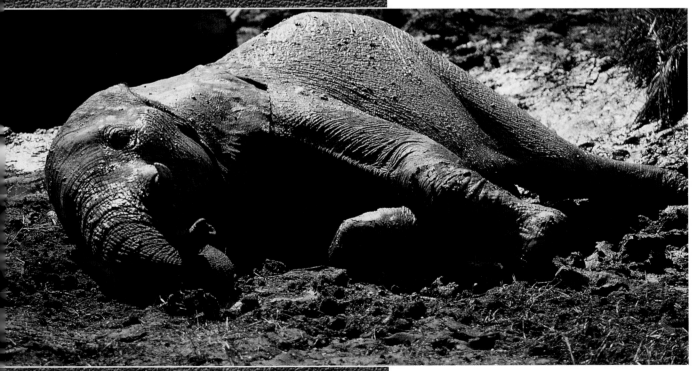

Cruising along River Road we're brought to a halt by two young bull elephants that have just emerged from the water. We back-off but they're only interested in getting to a mud hole on the other side of the road and after a little trunk waving and head shaking, cross then slop into the mud. Elephants love mud and it's quite a show as they slip, slide and roll around thoroughly enjoying themselves, at the same time divesting themselves of parasites. They binge in the mud before making us back away so they can cross over to the river disturbing a large croc as they wash the mud off and swim across to Zimbabwe.

Like the ungulates, baboons also thrive in the reserve and clearly don't feel threatened by us, but this baby hugs mother for comfort.

Their dexterity in opening up the extremely tough ivory fruit to get to the nut is amazing. Our guide George picks up a fallen fruit to show me how tough, I can't make any impression on the skin at all.

Tongabezi is all about the river and the Falls and we're going to experience Mosi O Tunya in two distinct ways – from the river and from the air. The Falls are over 1600 metres wide, 110 metres deep and during the rainy season more than 600 million litres of water spill into the gorge every minute. On a clear day when the Zambezi is running high the cloud created by the spray can be seen 80 kilometres away.

In March 1920 South African aviators Lieutenant Colonel Pierre van Ryneveld and Squadron Leader

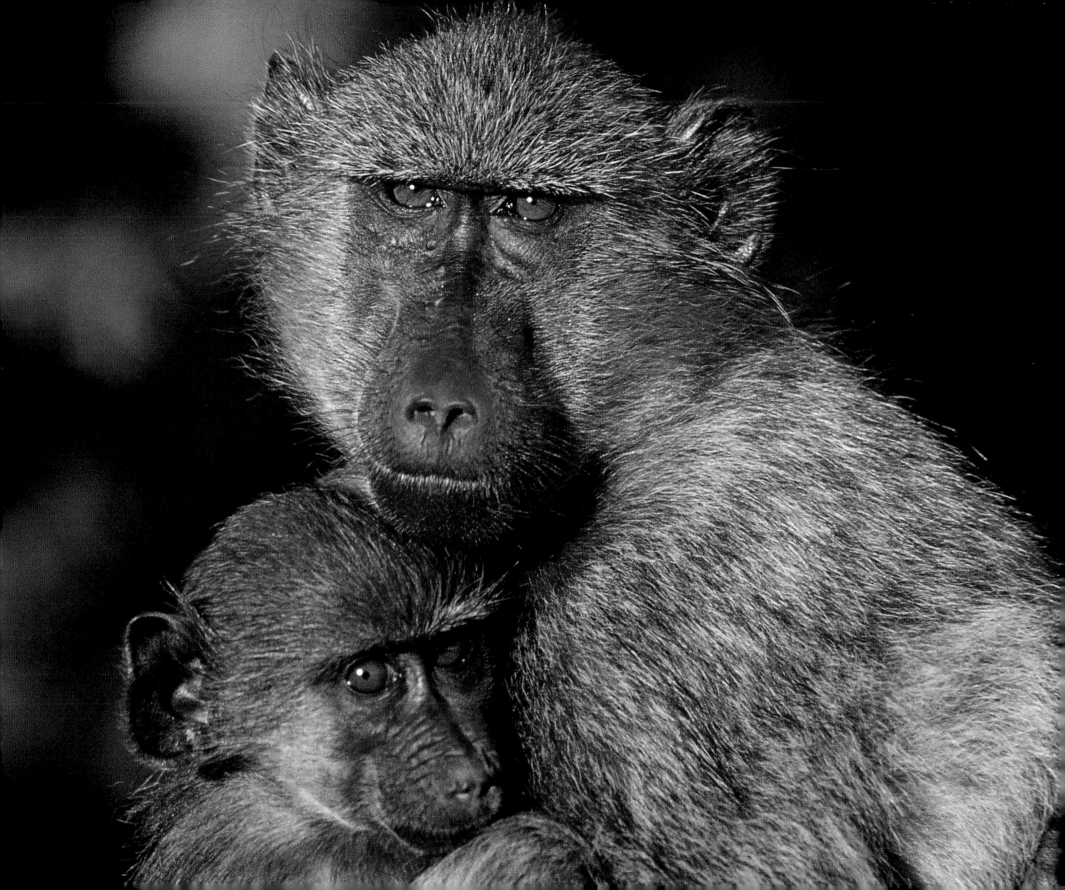

Quentin Brand landed at Livingstone on the first ever flight from London to Cape Town. Their epic journey lasted forty-five days, involved twenty-two stopovers and three aircraft. It was on that flight more than eighty years ago that Quentin Brand took the first aerial photograph of the spectacular Victoria Falls. I'm about to emulate Brand's feat, not from a 1918 vintage Vickers Vimy but from a more modern icon, Ben's microlight. The microlight scoots down the runway and soars into the early morning light, skimming along the river before gaining height over the Falls.

Ben banks sharply right and the frail craft seems to stand on its wing as I look straight down into the mass of water cascading over the edge.

The sharp turn gets tighter and my cameras weigh a ton as G force takes over. The sight is overwhelming and I manage to shoot off a few frames as we come full circle. Ben straightens up then cuts the engine and we glide silently over the river losing height until he jabs the ignition and the engine powers us higher. Now I know why it's called 'The Flight of Angels'. It's a fantastic experience, flying in the open with the wind in your hair – what a way to see one of Africa's great spectacles – exhilarating.

When explorer David Livingstone first saw the Falls it was from a tiny island called Kaleruka now known as Livingstone Island and with Ben as helmsman we're

Looking straight down into the abyss (Top)

Zebra stallion guarding his harem (Far right)

on our way. The river is really pumping and getting to the island is quite hairy. What it must have been like for Livingstone in a dugout canoe is hard to imagine. Even now in a motorboat, one wrong move and we could follow the fate of many hippos and crocs and be swept over the edge. The island is right on the lip of the gorge and we approach from up river steering into calm water at the back of the island before landing. Walking through to the edge of the Falls the spray is drenching; this part of the island is a veritable rain forest created by the constant mist. The view of the Falls is astounding. If you're brave enough you can stand on the edge and look straight down into the abyss. I'm sure this must be where Livingstone sat when he wrote his memorable and apt line 'scenes so lovely must have been gazed upon by angels in their flight'.

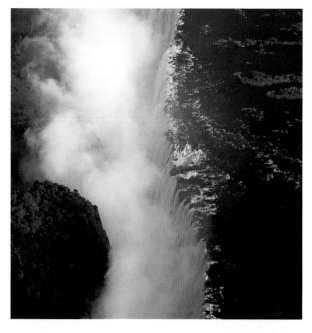

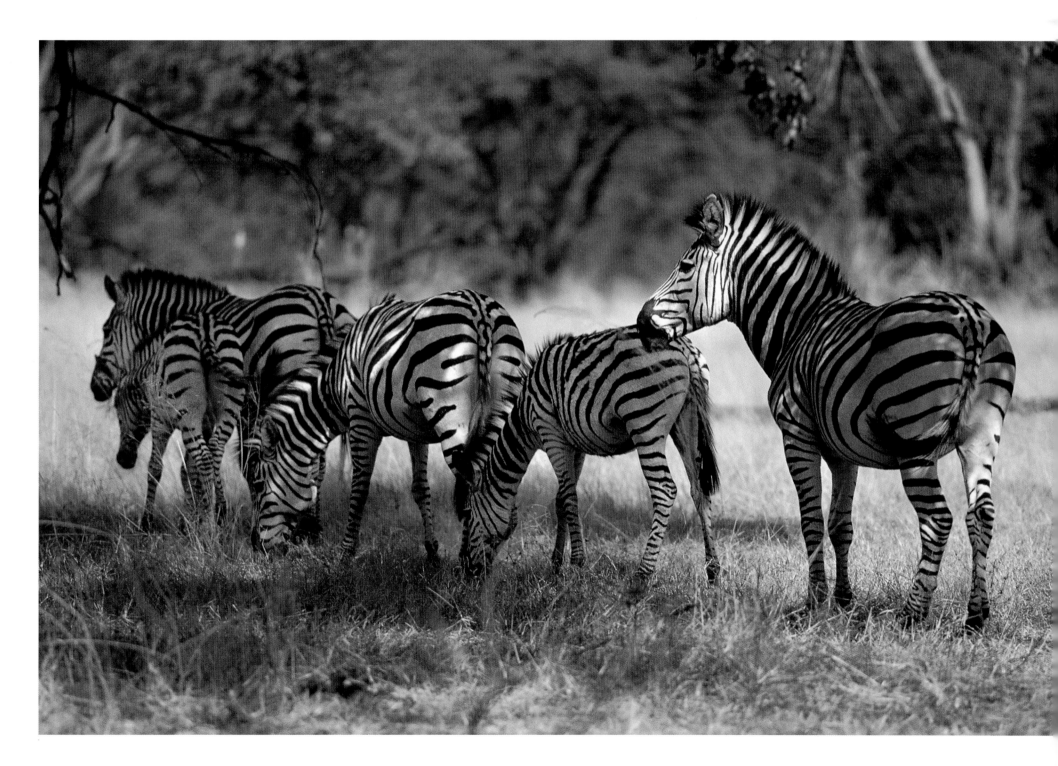

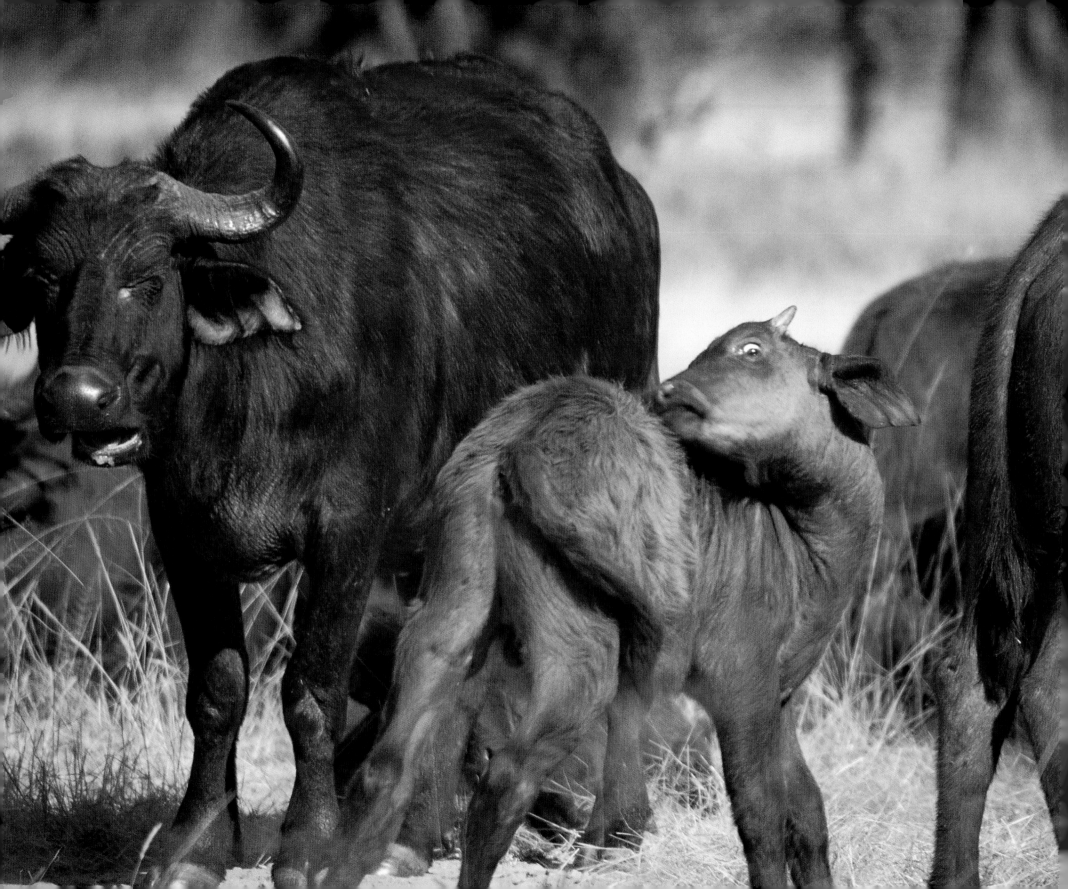

Ben intrigues me. He's flown me over the Falls in his microlight in rather a daredevil way, he's piloted us here to Livingstone Island through wild and potentially dangerous waters and I've watched him take a canoe out on the Zambezi in the late afternoon, paddle off like a streak of lighting returning an hour later not even breathing heavily. I rather think his quiet unassuming manner belies his true character.

The champagne lunch on the Island seems to be a good time to dig a little deeper to see if I can find out more about the real Ben Parker. He's very reticent but eventually I get him talking.

Schooled at Eton Ben was reading zoology at Reading University when his best friend Anthony Beck invited him to South Africa for the vacation. After two weeks of the Cape social whirl, Ben, in his own words, "baled out" and hitchhiked to the wildlife areas of what was then called the Eastern Transvaal and afterwards down to the Eastern Cape. He landed up on a ranch near Queenstown and stayed for a few days. Hitch-hiking back to Joburg to catch his flight home, he stood on the side of the road for two hours without a lift. Already ambivalent about returning to the UK, Ben decided to stay in Africa. Ben spent the next four

Buffalo calf with an itch (Left)

Giraffe's prehensile tongue selecting succulent

leaves between accacia thorns (Rght)

months travelling through Africa landing up in Kinshasa, central Africa. As he says, "Ignorance is bliss, I slept under the stars in really wild places like the Moremi and Chobe Reserves in Botswana. It's a wonder I didn't get eaten!"

Back in England he couldn't settle down, he hankered for the wide-open spaces. He learnt to fly microlights and devised a plot to get back to Africa. He approached the mircrolight company with an idea for selling the craft in Africa, ideal for farmers, crop spraying, wildlife control and generally a great way to get around in areas with poor infrastructure. The idea never took-off but Ben enjoyed himself spending a year flying around Zambia.

Ben and his girlfriend at the time were travelling from Botswana through Zambia when their car broke down outside Livingstone. They were stuck for ten days waiting for parts, staying at Quiet Waters, a farm along the Upper Zambezi and the owner mentioned that she wanted to sell the property.

In 1988 Ben met Will Ruck-Keene through microlight friends and discovering a mutual interest in wildlife, dreamt of starting a mobile safari company. They made an offer for Quiet Waters but the deal fell through. Ben discovered that the next-door property was for sale – it took him three months to track down the owner!

Will and Ben designed and built what is now Tongabezi. In 1993 they gained title to Sindebezi, a small island in the Zambezi, and started overnight canoeing trips. They then acquired the lease for Livingstone Island.

In 1995 Ben was camping at Chakwenga in the Lower Zambezi Valley and fell in love with the area. He tendered for two seasonal camps and built Sausage Tree and Potato Bush Camps, both designed by Will.

The following year tragedy struck, Ben was in Russia on a fishing holiday when his wife Vanessa phoned with the news that Will had been killed en-route to Sausage Tree when his car overturned.

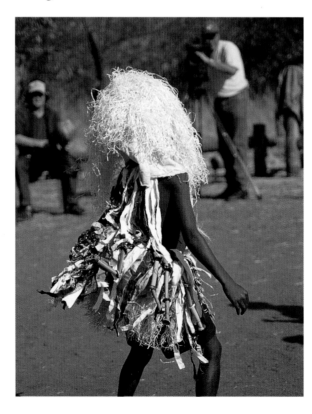

Dancing - an important part of the African heritage

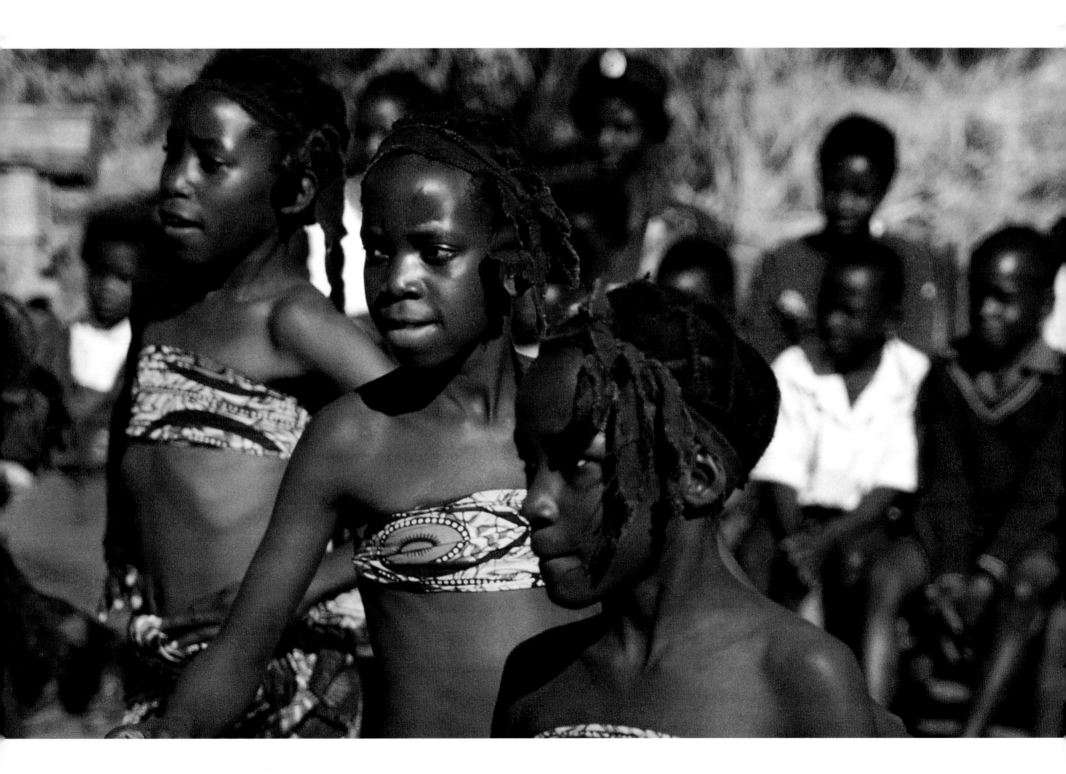

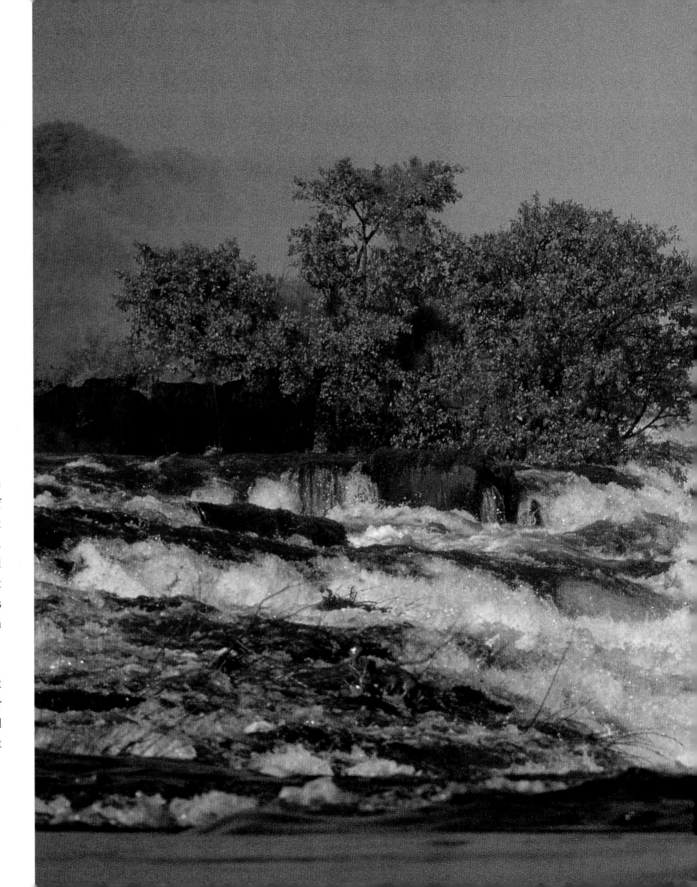

In 1998 Ben sold the Lower Zambezi properties to concentrate on Tongabezi and his family. He built a house next to Tonga and Vanessa started a school for local children.

Livingstone Island must surely be the most spectacular lunch spot, sitting right on the edge of the Falls with water thundering past, the mist creating its own rainbow, enjoying fabulous food and champagne, what could be better?
And Ben's story – fascinating, worthy of old Africa.

Vanessa invites us to look around the school before we leave. Head teacher Violet gives us a guided tour of this simple but impressive facility, then announces that the children are putting on a farewell show for us. In addition to the normal curriculum, the school emphasises traditional culture. Dancing is a vital part of the African heritage and these kids show how it's done. The dances have been passed down through generations and each tells a story.

Tongabezi is truly luxurious – an oasis in this vast wilderness, just 25 kilometres out of Livingstone. For any photographer the Falls are unmissable, a visual feast. But now it's time to head for one of Africa's least known wildlife areas and a wilderness in every sense.

Lower Zambezi Valley

Sausage Tree Camp

Airborne out of Livingstone Chris banks left giving me a last glimpse of the Falls, spray reaching into the sky. We're on our way to Sausage Tree Camp in the Lower Zambezi National Park, a little known nine thousand square kilometre wilderness. We're routing northeast over Kariba, down the Zambezi into Jeki airstrip in the middle of the reserve, about an hour's drive from camp.

Skimming a hundred feet above the river our engine breaks the silence startling elephants and buffalo on the bank, hippos submerging rapidly as we approach.

The camp flashes by on the left bank and we turn inland towards the escarpment. Jeki appears as a dusty track in the surrounding scrub and after checking for animals Chris flies straight in disturbing a lone

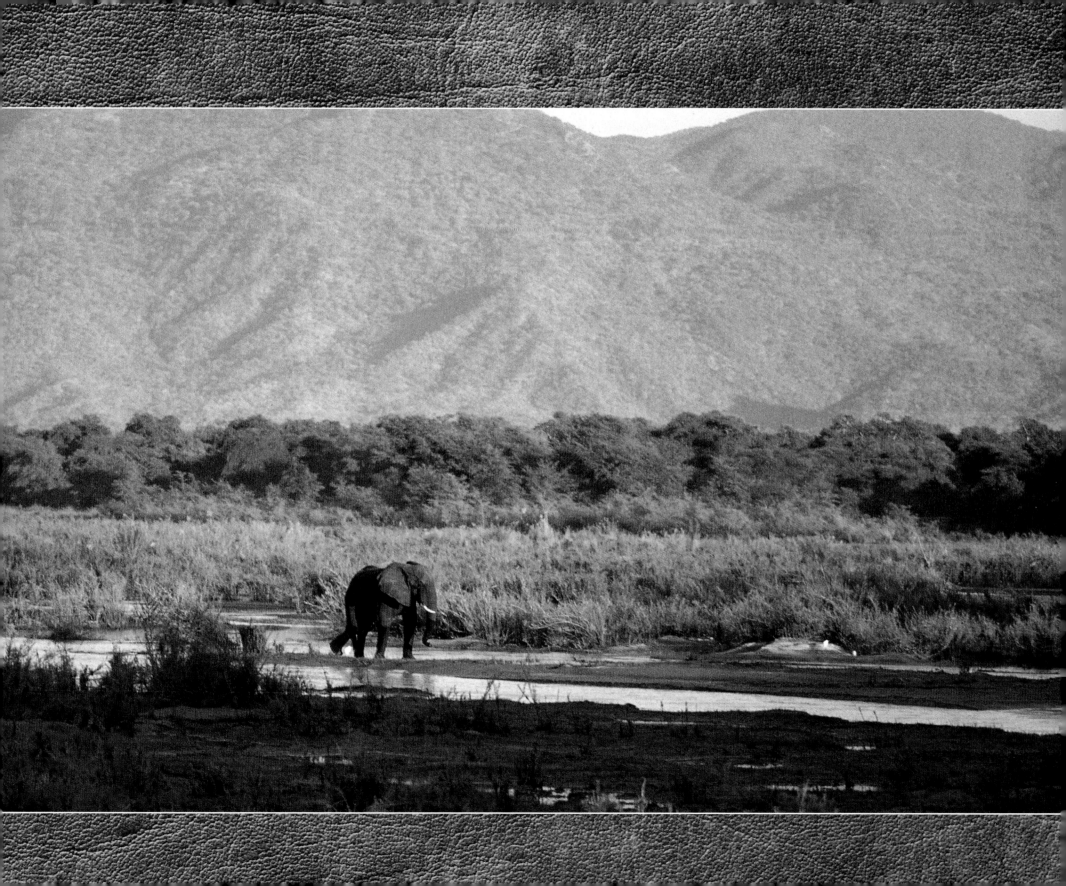

warthog. Head ranger Garth is waiting as we step out into the shimmering 40°C heat – and it's only 11 o'clock.

The Lower Zambezi Valley is immediately identifiable by the escarpment rising sharply away to the north sweeping round to the river far to the west; south - the broad, swift flowing Zambezi. The vegetation is varied and as we drive away from Jeki and cross a small stream, changes from open savanna to miombo woodland interspersed with stands of palm trees and the occasional baobab. Flood plain looms ahead of us, drying out from the rainy season but parts still muddy and treacherous. We slip and slide through into the shade of a jackalberry and sausage tree forest, almost bumping into an elephant browsing on the big trees as the camp appears before us.

Designed by the Tongabezi team of Ben and Will, Sausage Tree Camp is as innovative and original as Tongabezi itself. Huge marquee-style tents are the basis; each with its own enclosed shower and loo. The camp is open and unfenced, spread along the riverbank, shaded by massive trees. During the rainy season Jeki is just a morass and the camp is inaccessible, closing down for four months. Even now the cotton soil makes driving difficult with even the Land Rovers frequently getting stuck in the glutinous mud and having to be winched out.

The camp's shallow draught flat-bottomed boats are ideal for exploring this mighty river. Garth edges slowly away from the jetty, manoeuvring between sandbanks through narrow channels and tall reeds, giving a wide berth to a resident hippo pod before opening up as we hit deeper water.

Hippo display (Right)

Along the bank hippos glare at us before rushing for the water, mothers shepherding their calves in front of them.

Heads pop up keeping an eye on us as we pass. A pod tracks us from their perch on a sandbank before taking to the depths. Garth slows and turns into a quiet channel, clogged with water hyacinth. A waterbuck splashes away from us disturbing a cloud of egrets. A lone hippo bursts through the weeds eying us aggressively displaying huge tusks. This is his territory and Garth reverses taking another channel. A saddlebilled stork hunts in the shallows taking-off at our approach. Ahead the water hyacinth is too thick for us to plough through but not too thick for another lone hippo and behind him an elephant belly deep in the weed-choked water. Garth reverses again and we head back to the main channel.

A lone bull elephant appears in the river in front of us heading for the Zambian bank. He's either come from the Zimbabwe side or from one of the many islands. He splashes through the shallows ignoring us before disappearing in the tall papyrus. Back in camp we sit around the fire watching the sun slip behind the mountains enjoying our sundowners.

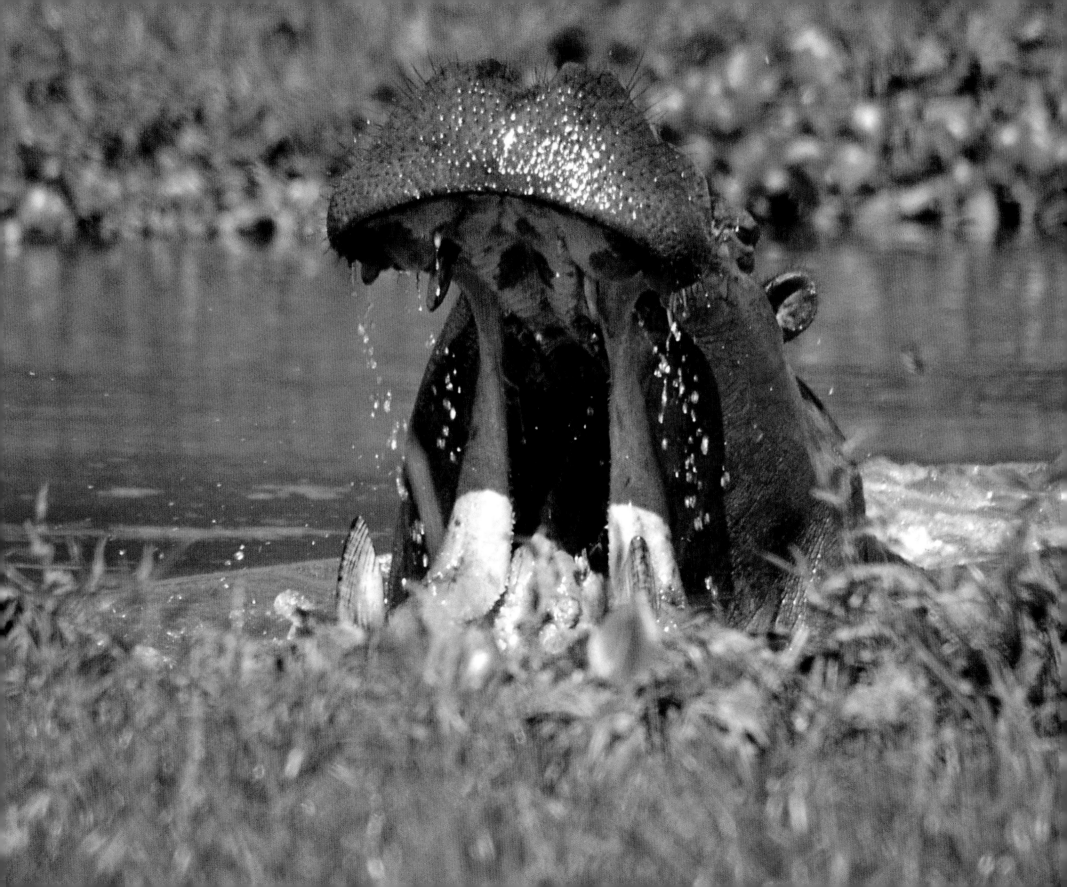

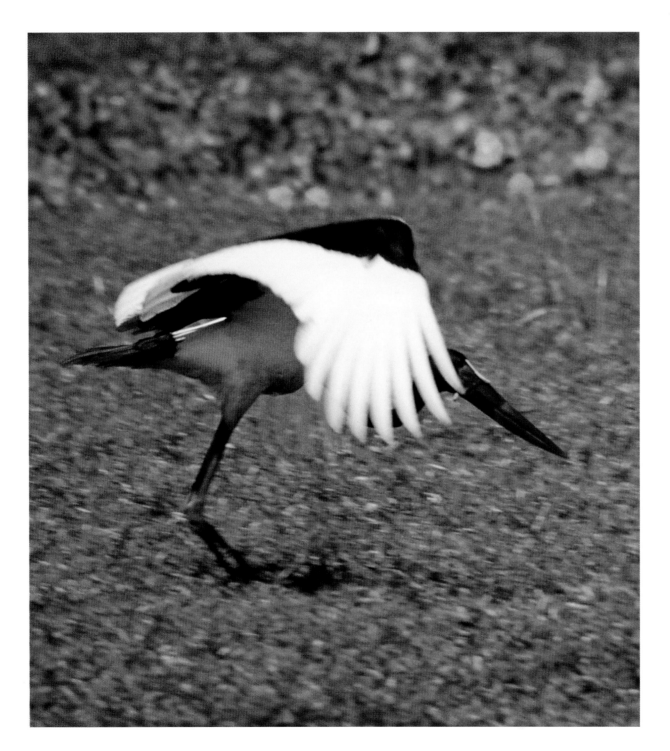

Whitefronted bee-eater (Above)

Saddlebilled stork take-off (Left)

Waterbuck splashing away (Right)

I've always thought that tree-climbing lions were a figment of someone's imagination although the exploits of the lions of the Lake Manyara area of Tanzania have been well documented as tree-climbers. Garth is insistent that the lions in the valley do climb trees. I must say that I'm sceptical – I can't imagine a 250-kilogram lion hauling itself into a tree – and for what reason? There seems to be no logical explanation. Lions are gregarious and generally hunt as a pack. Unlike leopards that are solitary, they don't need to stash their kills in trees away from other predators and scavengers. In short, lions can protect their kills; after all they have no natural enemies – except man. Garth is determined to prove his point and we're on a lion hunt. We're in the pride's territory but there's no sign of them apart from old tracks.

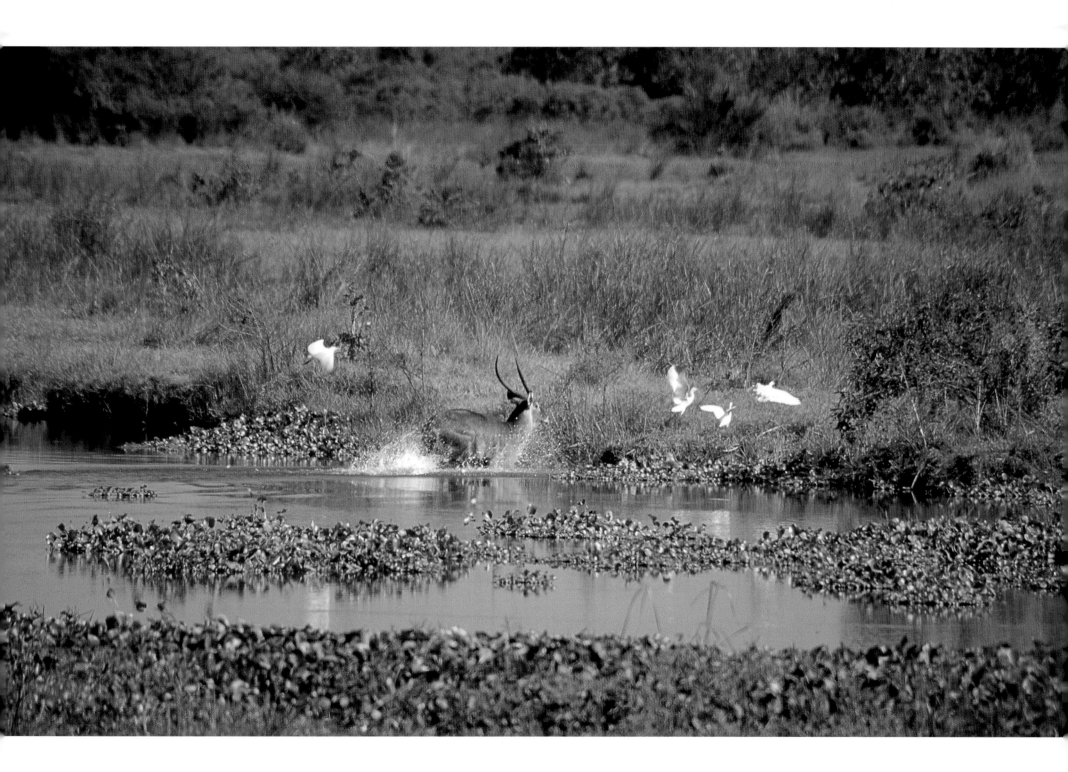

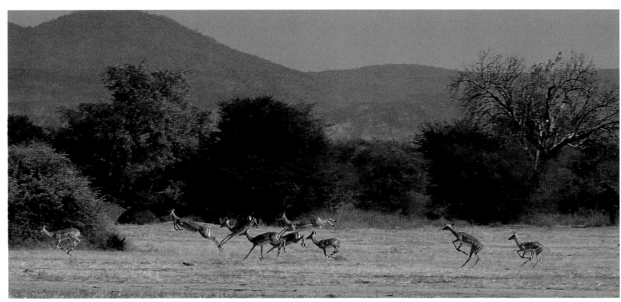

Impala leaping

The Lower Zambezi Valley is surely one of the most beautiful and diverse wilderness areas. Leaving camp, our Land Rover emerges from the shade of the riverine forest, lurches over the ruts and bumps left by the receding waters of the flood plain then slides sideways through a muddy stretch. The savanna opens up in front of us broken by tall palms, massive baobabs and phallic looking termite mounds.

An impala herd stands and stares before bounding off covering the ground with huge leaps – the most graceful and beautiful of creatures.

A baboon clambers into the fork of a tree, sitting between two trunks watching us as we approach, then climbs one trunk before leaping into space and shinning up the other. The bush is alive and a lappetfaced vulture glares from its perch atop a termite mound. Rounding a bend, we're confronted by a young elephant. He immediately grabs a small palm and starts tearing it apart, pulling pieces off, waving and tossing them around. He doesn't know whether to eat it or merely display his power to us. He finally moves off shaking a large palm branch at us as he crashes through the bush. "What was all that about?" I ask Garth. "Probably just showing off - typical adolescent," he replies.

Coming out onto the plains, a small herd of zebras – Equus burchelli – trot away from us keeping their distance. How does the zebra's camouflage work? The stark black and white stripes certainly don't blend into the vegetation. Garth explains that when the herd moves together the stripes break up the outline making it hard for predators to single out individuals to hunt. This group is one stallion and his harem!

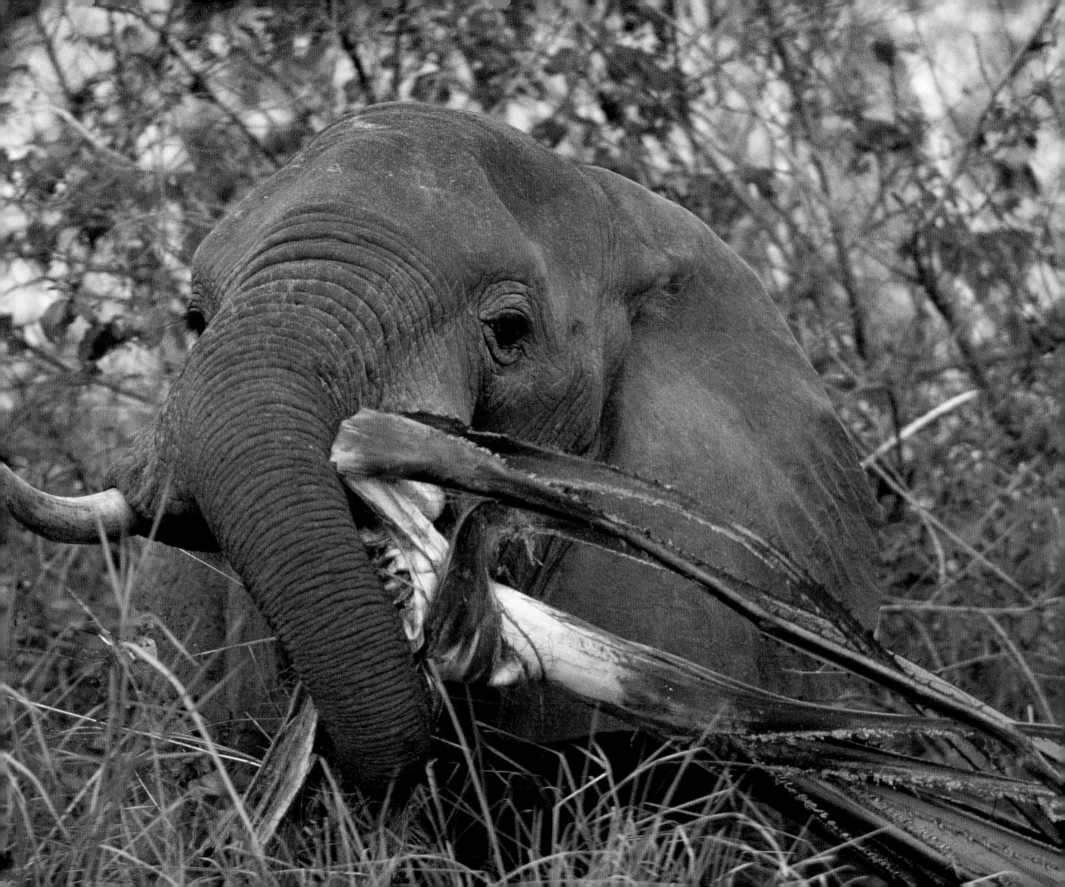

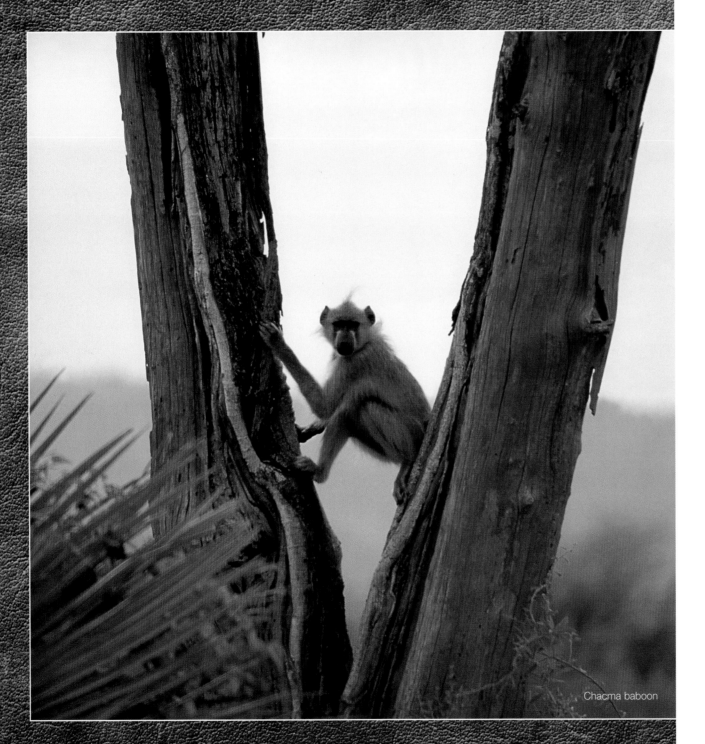

Chacma baboon

Back in camp we have a visitor – an elephant has come to feed on the sausage trees. He's completely indifferent to our presence, just enjoying the browse before leaving via the river. As he leaves, a small flock of bee-eaters fly into camp for a dust bath on the path to rid themselves of their resident parasites. On the riverbank yellow billed storks search for prey in the late afternoon sun.

Garth is determined to show me a lion in a tree and we're back on the trail. He's just picked up fresh tracks and interprets the spoor as a small family group, a lioness with two sub-adult cubs. We round some bushes and catch a glint of gold in a massive sausage tree. A head appears, it's the lioness spread out on a limb at least five metres up.

She lifts her head as we approach, stretches and climbs to a higher branch. She looks completely at ease, as comfortable as a leopard.

But no sign of the two cubs, until we move to the other side of the tree and find them dozing on some marshy ground, ears twitching, tails flailing, they're being plagued by flies. One gets up and jumps across a small stream, landing in the mud. He slopes off to the sausage tree and hauls himself clumsily into the lower branches – not nearly as graceful as his mother. His brother moves to the stream to drink before following him into the tree. They both look very uncomfortable. I ask Garth why lions would climb trees. He says he thinks it's to get away from the tsetse flies, which never seem to get more than a few feet above the ground.

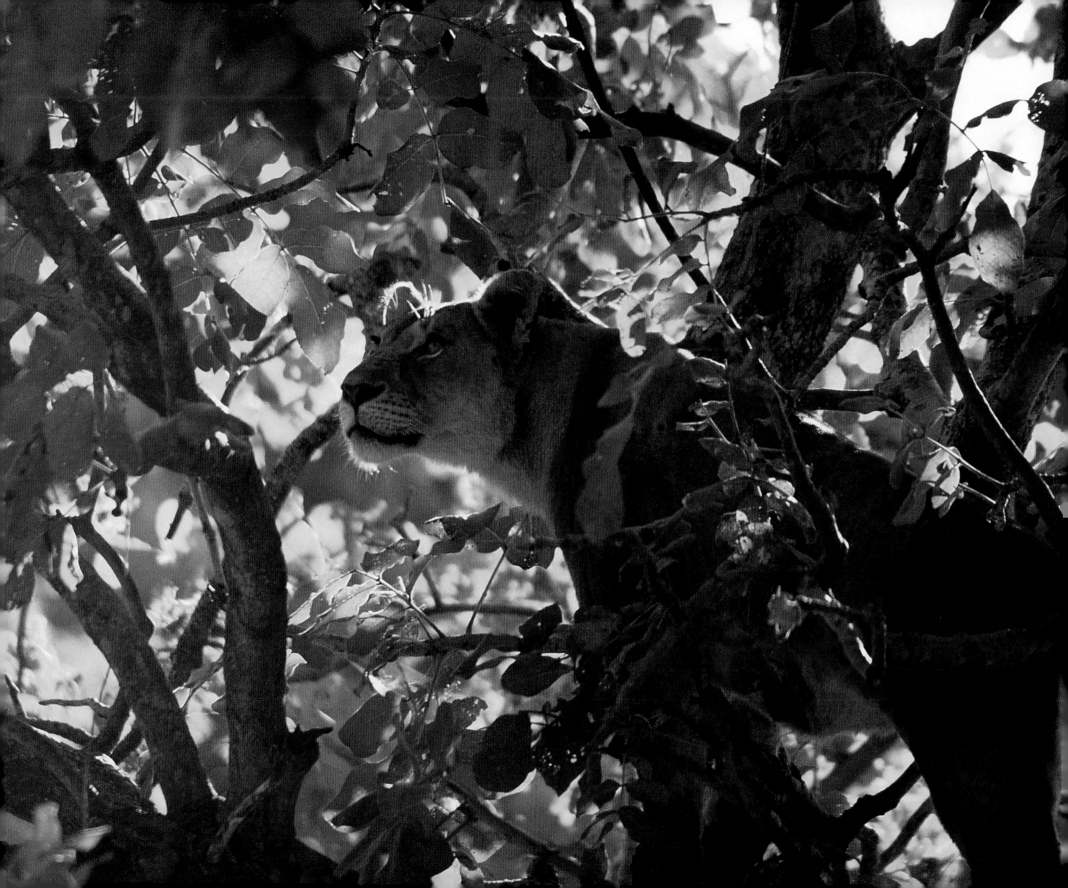

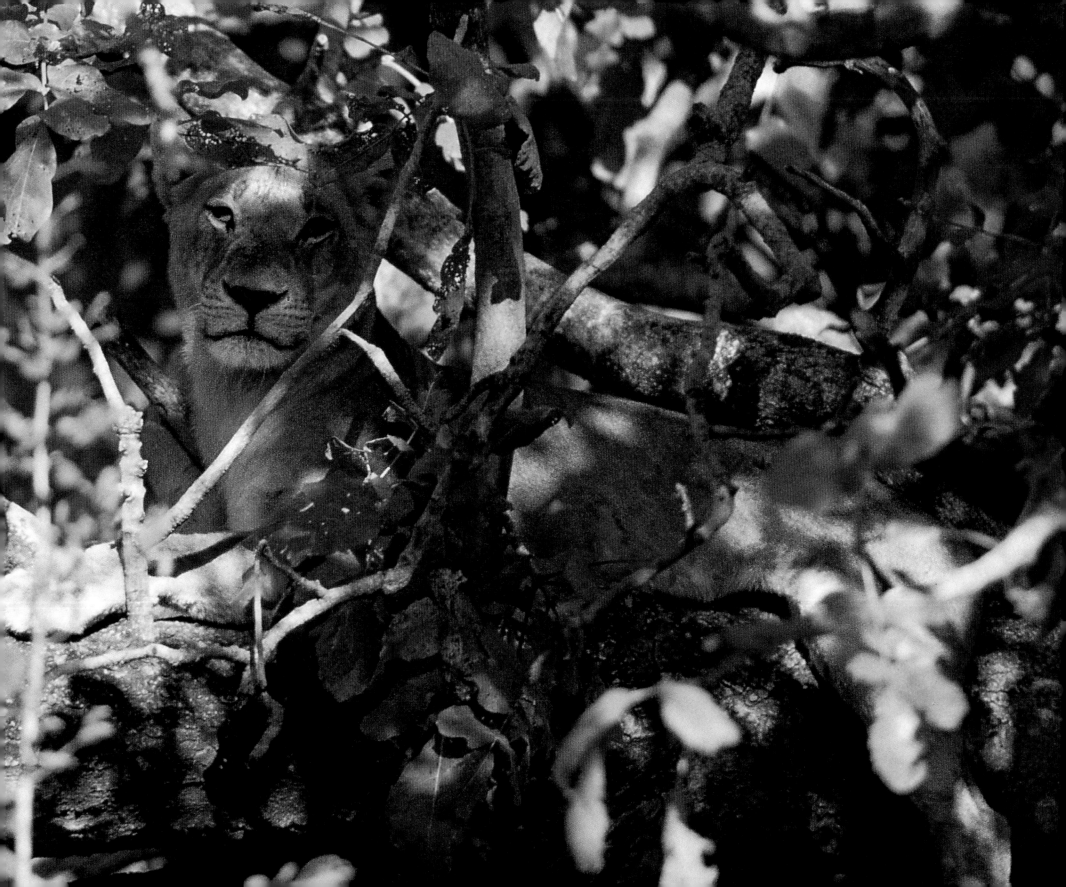

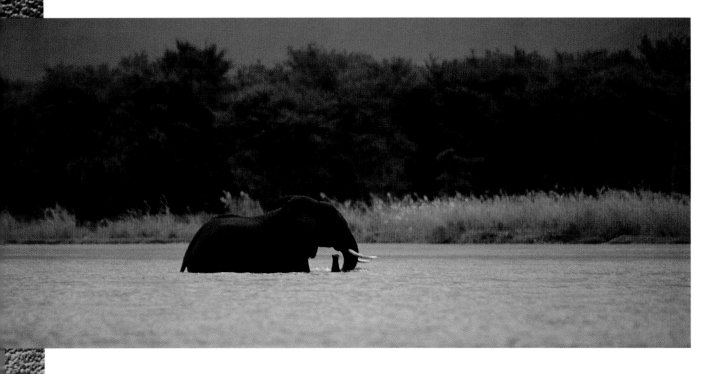

The cubs are really not happy, they keep changing position, obviously not able to get comfortable and before long, first one, and then the other climbs down descending rather more elegantly than their ascent. Mother watches, then goes back to sleep.

We encounter another muddy stretch and Garth looks for a way round. As we follow a drier path a herd of buffalos emerge from the tree line, immediately plunging into the swamp. Buffalos are immensely powerful but even they are having difficulty traversing this quagmire, sinking to their shoulders with every step, the calves especially struggling to get through the glutinous mud.

Round every bend the valley reveals a new vista, a more stunning visual treasure. In the golden evening light the mana pools are at their sparkling beautiful best. Garth explains that mana means 'still' in Shona and perfectly describes these tranquil tree-surrounded lakes – peaceful apart from the crocs and hippos lurking beneath the waters! It's time for our de rigueur sundowner stop and could there be a better spot? This is our last sundowner in the Lower Zambezi and a beer has never tasted better, so cold it almost burns my throat. Tomorrow we're off back to Joburg, before heading north to Uganda.

Garth and camp owner Jason have concocted a surprise. Instead of driving to Jeki airstrip we're going by boat. It's still early and we're enjoying coffee before embarking. Garth says we'll have a picnic breakfast on the way. Sounds good to me.

Instead of heading downstream Garth swings across the river and lands us on a sandbank. This is our picnic – breakfast on a sandbar in the middle of the Zambezi. This, though, is hardly a picnic – table and chairs set up with a full English breakfast in these fantastic surroundings with hippos honking in the background. Lunch on Livingstone Island recently was spectacular but this is surely the most unusual place I've ever eaten breakfast. We take time out to explore our new domain and marvel at the fantastic designs created in the sand by the river.

I'm loath to leave the valley – every day has been an adventure, every day has shown us a different aspect of this diverse and beautiful area. Garth is happy; he's shown me something I've never seen before, the tree-climbing lions of Chifungulu.

The journey down to Jeki is uneventful. Hippos of course and buffalos make an appearance on the bank. We land and board the Land Rover for the ten-minute ride to the airstrip. Chris is ready for us and we load up, Garth waves and we're off – watched by four inquisitive zebra at the end of the runway. It's back to my airport of memories, Livingstone, to clear immigration before heading south.

Mana pool glinting in evening light (Right)

Semliki

Uganda, East Africa, in recent years a barely trodden path for international travellers. The Idi Amin madness and violence spilling over from Rwanda, Burundi and the Congo kept them away from what was known as the Pearl of Africa.

Our journey from the Zambezi Valley has taken us by boat from Sausage Tree to Jeki then by Naturelink's Caravan back to Johannesburg where we picked up the Kenya Airways schedule to Entebbe on the shores of Lake Victoria. We're overnighting here and on the way to the hotel we pass a piece of history, the original airport and airliner destroyed in the infamous 1976 Israel hi-jack rescue drama. Early tomorrow we leave for Semliki in the Western Rift Valley on the Congo border.

We're expecting to be crammed into a 6-seater plane but find a spacious 17 seat high-wing Let waiting for us. Apparently when Eagle Air checked out the Semliki strip they found the grass was so long it would foul the propellers of a low-wing aircraft, and the Let is the only alternative.

Lake Victoria is vast, more like an inland sea and we fly low over the water before turning northwards. The cultivated fields die away and the terrain becomes wilder as we fly further from civilisation. The ground falls away as we drop over the edge of the escarpment and swoop down towards Semliki, buzzing the camp to let them know we've arrived.

The landing strip is hard to distinguish from the surrounding veld and appears to have a strange kink halfway along. A couple of antelope stand watching us, leaping away at the last minute as we touch down, sashay through the kink and plough to a halt in the tall grass. The door opens to a blast of heat and Semliki manager Clint greets us with ice-cold drinks.

The pilot says he'll return in a week, the plane wheels and they head back down the strip, negotiate the kink, climb away disappearing over the escarpment leaving us alone in the silence.

Clint's vehicle is a bit of a shock. It's a decrepit old Land Rover, practically falling apart, with dubious upholstery, paintwork of varying hues, its radiator bubbling and hissing, threatening to blow its top. In fact when Soundman Glenn climbed in the back seat it

The crew lugging equipment out of the forest (Above)

just collapsed. Clint explains that it's kept strictly for emergencies. The lodge's regular vehicle is in Kampala for major repairs and Semliki owner Jonathan Wright is arriving tomorrow with another 4x4, but we'll have to use the Land Rover as our second vehicle. It does have an interesting history; originally it belonged to the Ugandan army, when it came to the end of its life they sold it to the Sisters of Mercy Convent in Kampala. The Sisters showed no mercy running it into the ground, apparently never maintaining it, then sold it as scrap. Jonathan picked it up for a song and brought it down to Semliki to use as a workhorse and there's clearly life in the old dog yet—I guess it says a lot for old Land Rovers! Sue dubs it Sister of Mercy.

It's a few minutes to the lodge. The views are stupendous, behind us the Rift escarpment, to the

west the foothills of the Ruwenzori's and northwest the Blue Mountains; the Congo border is a mere 32 kilometres away. Semliki is remote, an area of diverse terrain and vegetation, wide savanna grasslands, miombo woodland, equatorial forest and hugging the eastern escarpment to the north of us, Lake Albert. The forest is home to chimps and colobus monkeys and the lake the haunt of the rare and elusive Shoebill.

Jonathan arrived this morning and is leading us on a chimp hunt. We 4-wheel across the trackless terrain to the forest, unload our equipment and set-off in single file along the path. The humidity is unbearable and so are the tsetse flies. We're soon covered in bites. The going is very tough as we clamber across streams and

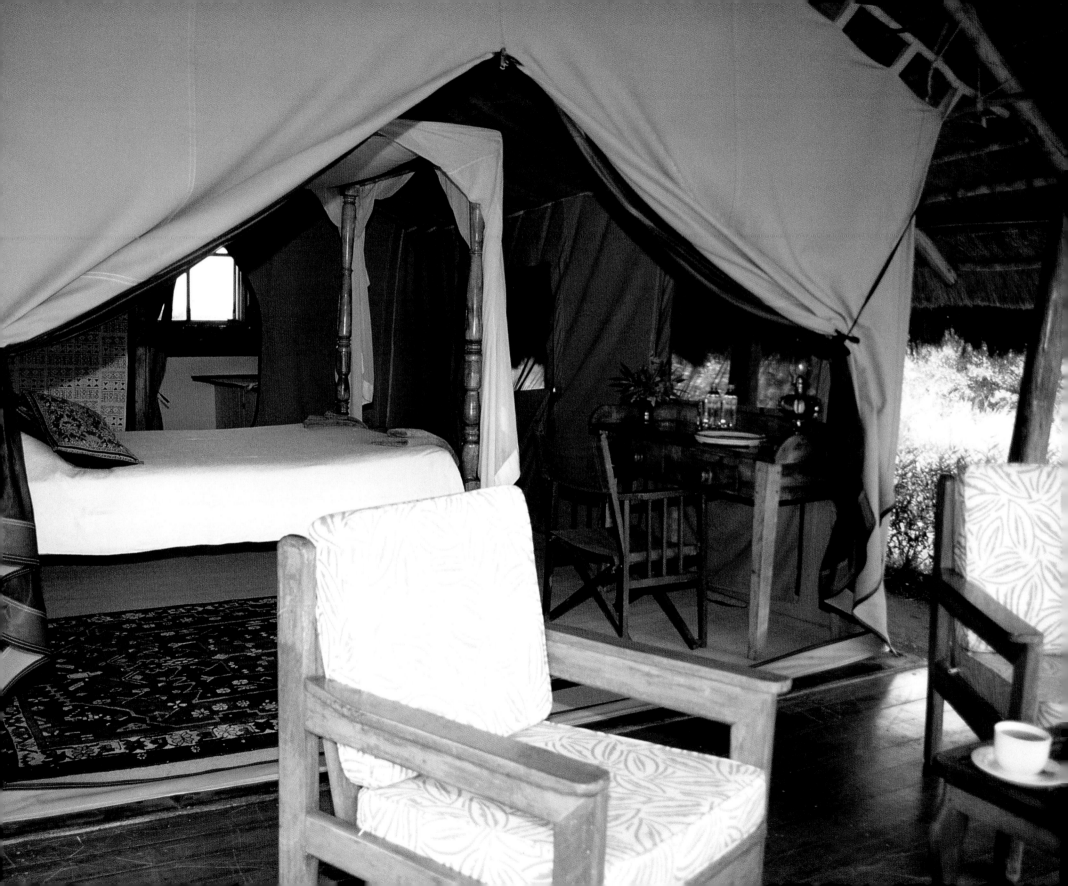

through mud. Our tracker picks up buffalo tracks – I don't fancy meeting an angry buff in the close confines of the forest and we tread warily. There's no trace of the chimps. Jonathan says that the army was patrolling here until recently and appears to have frightened them away. We glimpse a troop of black-and-white colobus monkeys before they swing away through the trees. Still no chimps though. Our tracker is about 5 metres ahead of us peering up through the branches looking for signs of the primates.

Suddenly he turns shouting, "wabs – killer wabs" and comes tearing past us. I don't know what he's saying but I'm not hanging around to find out, so I take off after him.

There's a loud buzzing sound above and I look up – wasps – I don't know if they're the killer variety but we keep our heads down and tear back down the path, leaping across a stream that had taken us 20 minutes to negotiate earlier. The noise abates and the wasps vanish.

We're 3 kilometres into the forest, it's taken us 3 hours and there's no sign of the chimps, although this is the area where they were last seen before the Army started its patrols. Everyone is exhausted and we decide to call it a day and start the long trek back to the vehicle. I certainly hadn't realised how tough the going would be in the heat and humidity and it's a relief to escape the claustrophobic confines of the forest.

The grass everywhere is very high, Jonathan says that the rains never ended and had come full circle to the

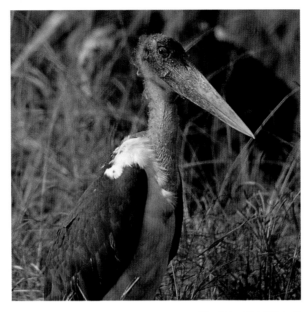
Marabou stork (Above)

beginning of the new wet season – shades of the Selous! I've noticed that there seems to be a haze over everything and ask him about it. He explains that normally at this time of the year the grass would have been burnt but this year it hasn't had a chance to dry out and instead of burning 'hot' just smoulders creating this smoky haze.

On our way to Lake Albert for the great Shoebill hunt, Jonathan spots a whole gaggle of Marabou storks and thinks they might be scavenging on a kill, so we investigate. We walk in, but there's no kill just a small pond that the storks are foot-stirring for frogs and small fish. Our approach disturbs them and they take-off en-masse in flapping flight. Some settle on the trees nearby, others back on the ground 10 or 15 metres away, bills clattering in protest at our presence.

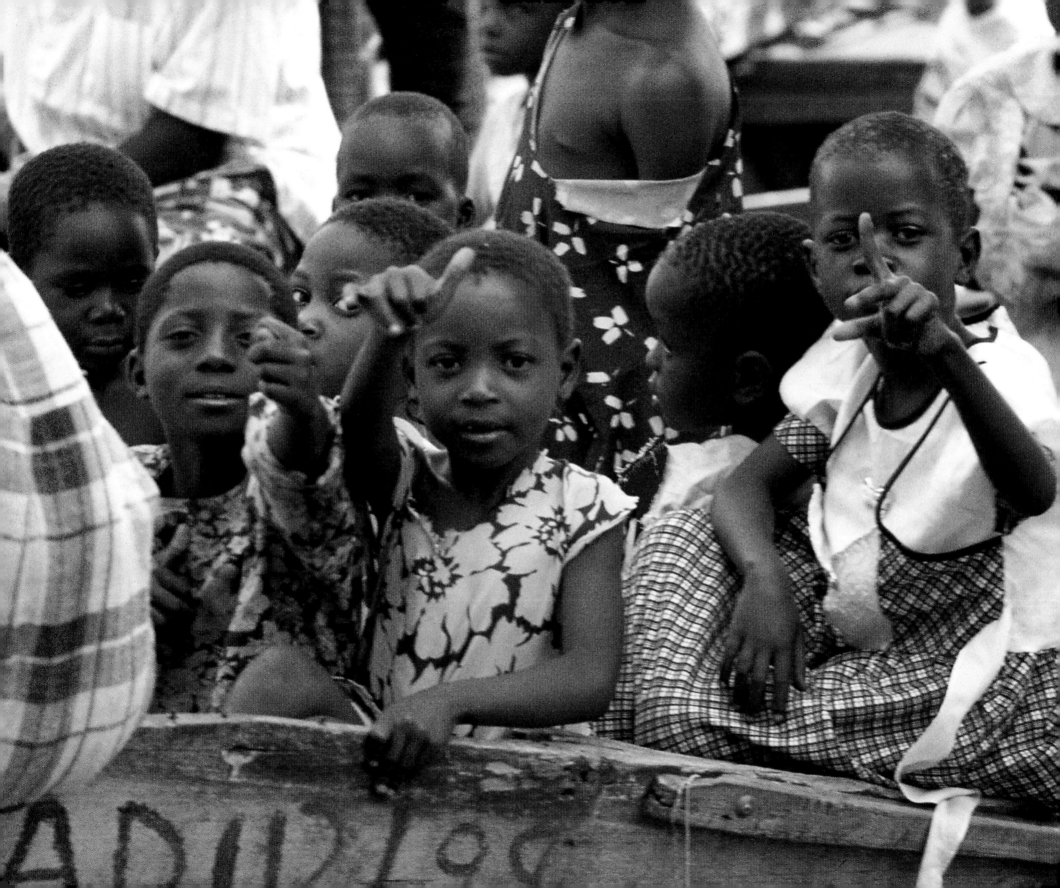

Toro is a small fishing village at the southern tip of Lake Albert and the place where we're launching our boat. Jonathan stops and local children surround us. Clearly we're something of a novelty. Maps can be deceptive, Lake Albert looks small especially compared to Victoria, but it's 200 kilometres long and about 40 wide. This is the lowest point in Uganda, the heat is stifling and it's refreshing to speed out onto the lake creating our own cooling breeze.

Jonathan is an experienced hunter of our quarry and heads for the suud – floating islands of vegetation – the habitat of the shoebill and its favoured food, lungfish. Cruising slowly around the suud searching for any shoebill signs we're keeping a sharp eye out for marauding hippos and crocs.

The sun is near its zenith, the intense heat reflecting off our aluminium boat is frying us, but there's no thought of giving up the hunt. Jonathan scans the suud with binoculars – nothing. He decides to move further out into the lake. The movement gives us temporary respite from the heat. More suud and a sandpiper pecks away on the floating leaves, ahead of us a grey shadow lifts off – a shoebill, but are we going to lose it? No, it lands almost immediately. Jonathan guns the motor to get us close, then cuts the engine using the oar to get even closer, pushing into the suud. It's almost within touching distance, just feet away. We're all quiet, holding our breath in case the bird flies. shoebills are notoriously wary of humans but this one ignores us, concentrating on its hunting.

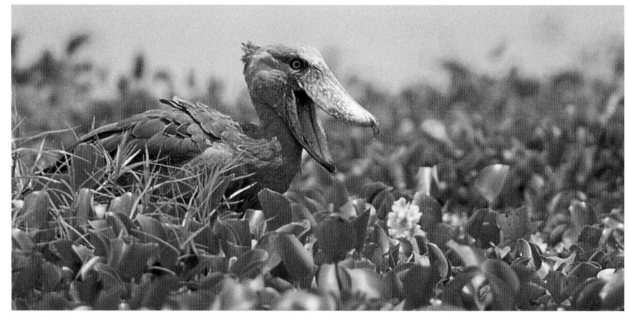

Shoebill hunting

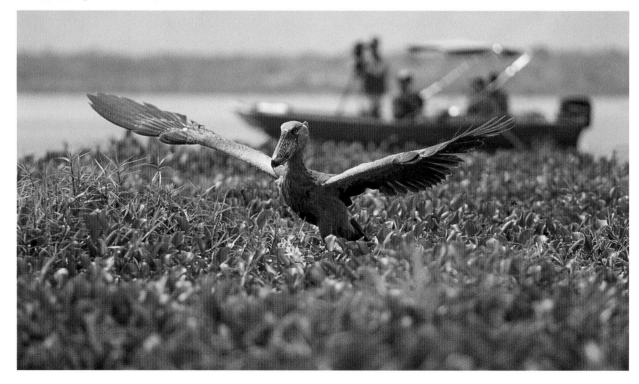

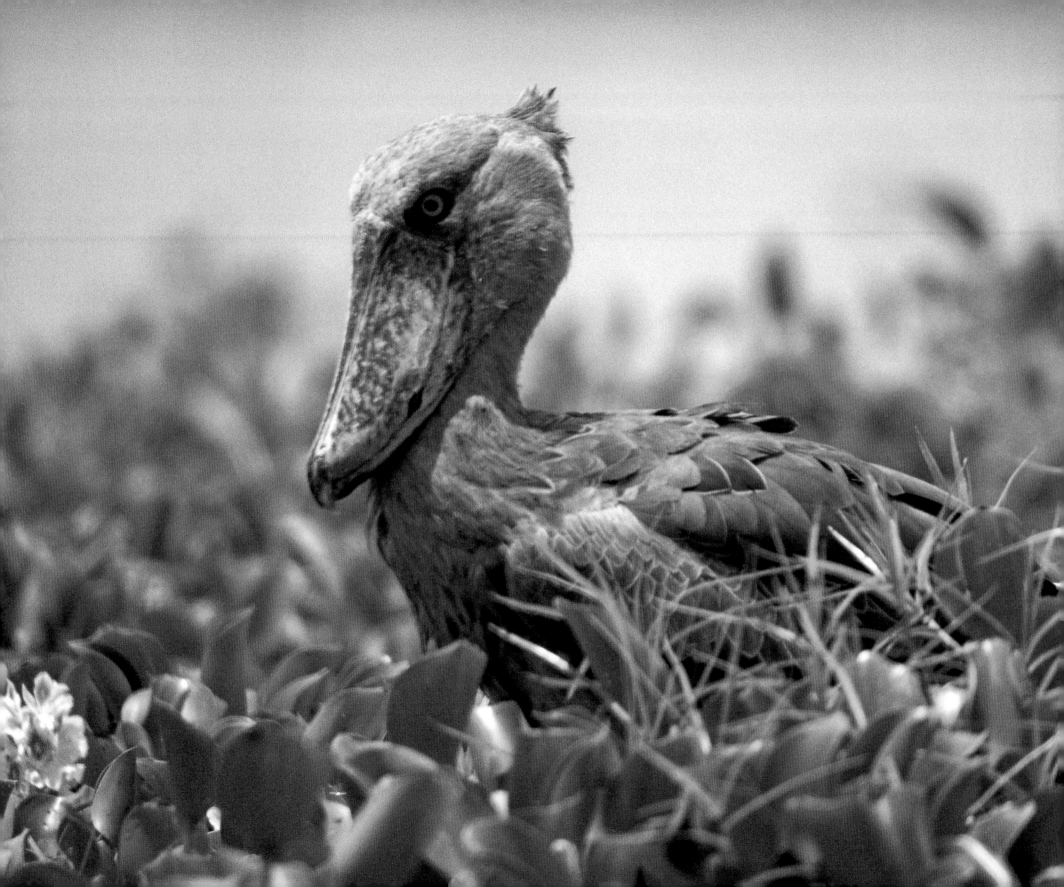

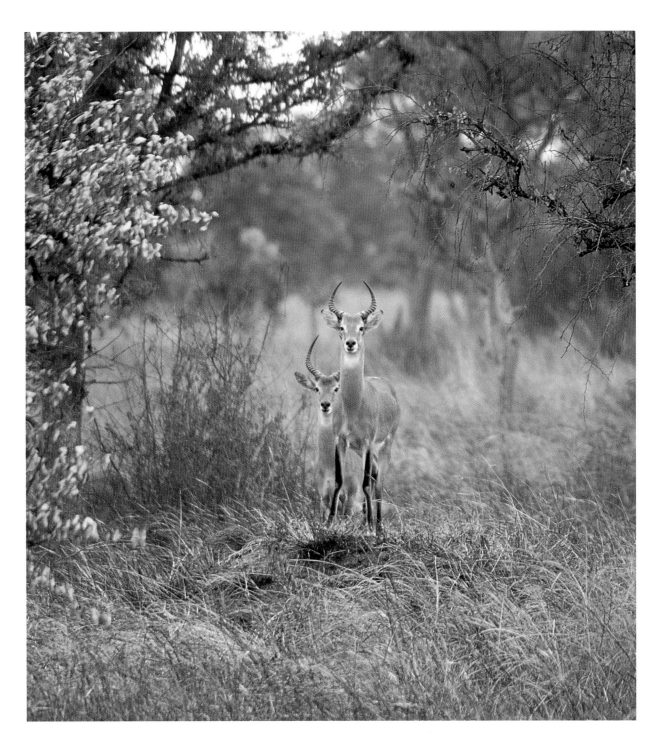

Fascinating to watch, it hunts by ambush, standing motionless for minutes on end before lunging clumsily at its prey, wings spread for balance. It looks like it's falling over, but the speed of the strike is awesome. This time it comes up empty-beaked and returns statue-like to the ambush position. Fifteen, twenty minutes pass, the bird is motionless, then it strikes again, same result, but like all hunters it has endless patience and will carry on 'til successful. The shoebill diet is quite varied – fish, water snakes, monitor lizards, turtles, rats, even baby crocodiles – but the crocs get their revenge as Shoebill chicks form part of their diet.

It really is the most amazing creature, primitive and violent looking with its madly glaring eye and great hooked beak, shaped like a shoe. The shoebill was only identified by science as late as 1851. Its Latin name, Balaeniceps rex, means King Whalehead but the Arabs called it Abu Markub meaning father of the shoe. This much sought after and rare bird is solitary and shy; its habitat is threatened and it's hunted for food. We're lucky to have found this specimen after only two days.

I've heard lions at night and we've found spoor of elephant and buffalo but so far the only mammal we've seen is the endemic Uganda kob. The very high grass makes it difficult to get around and to actually see anything.

In Semliki kob tend to congregate on leks or breeding grounds and there's one of these arenas quite close to camp.

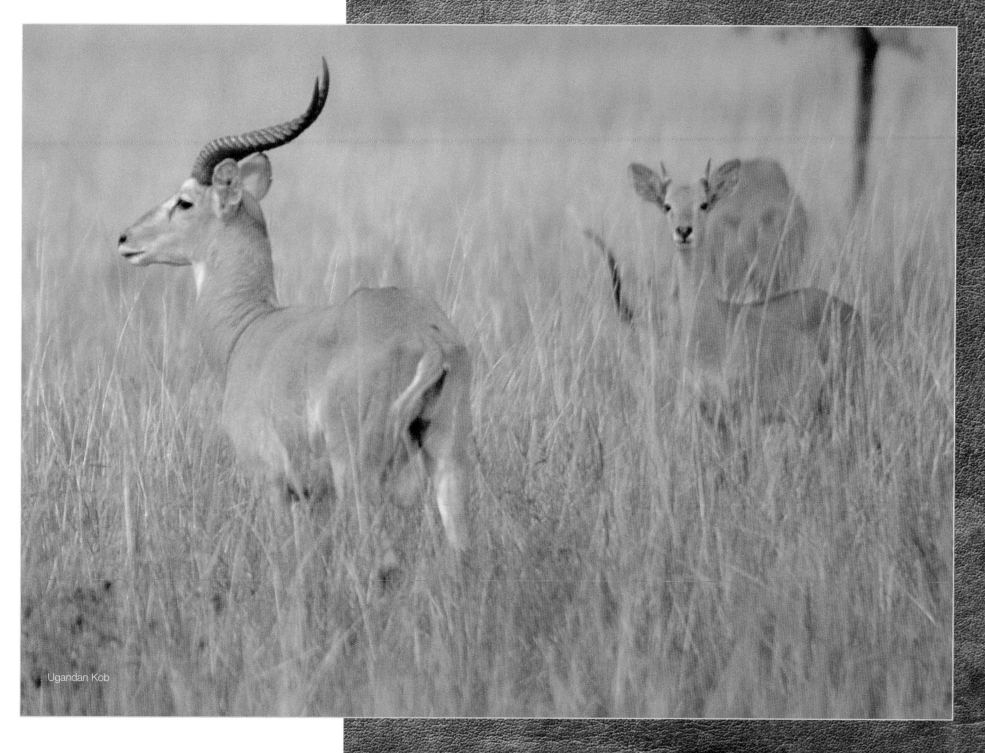

Ugandan Kob

These are the only areas of short grass around, which gives us a clear view of the kob. Up until now we've only glimpsed them leaping away through the tall grass. Here on the lek there's lots of toing and froing and attempts at mating – one ram especially is trying his luck with every female that passes by.

We're following very fresh elephant tracks; our best chance so far of finding one of the major species. The tracks lead down to the river – not a good sign. The vegetation here is impenetrable, the ground a morass. Short of hacking through the vegetation with machetes, there's no way we'll get through – frustration!!

Driving rather disconsolately back to camp, Jonathan smacks Clint on the shoulder bringing us to a halt, he jumps down, studying some spoor - " leopard – looks like a big male", he says and we immediately perk-up. Thoughts of returning to camp fade as we follow the tracks along the road, but it's getting dark and we don't have a spotlight so we decide to give up the hunt - for tonight. Tomorrow is another day!

First light, and we're back on the trail. The tracks turn off the road into the long grass - Jonathan and I clamber on to the roof for a better view. The spoor has disappeared but we cast around, the cat is probably laid up for the day, maybe under a bush, more likely in a tree. Binocs out, we quarter the area for any sign. Nothing. The grass is so thick it's going to be hard to find him unless he gives himself away with some movement. It's frustrating – we know he's around here somewhere. We stop again and stand on the roof looking down into the grass. Still nothing. The sea of grass stretches away from us. Clint has joined us with

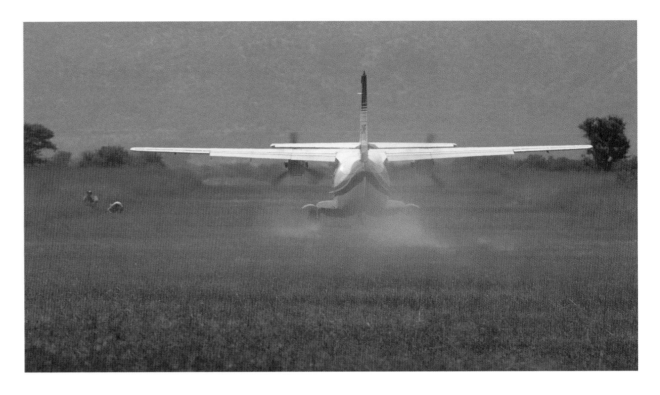

Sister of Mercy boiling merrily away as usual. Maybe with two vehicles we'll have more luck. An hour passes, then another – he's vanished. We go back to the road to see if he's come back this way – nothing, just a big troop of olive baboons sitting in the road and they scamper away as soon as we get near. We take a last turn through the grass still nothing, no sign of the cat at all. Jonathan thinks that if we go out tonight we might have more luck but without a spotlight I think we've no chance. It's amazing the pressure the presence of a film crew puts on people, even though we make it quite clear that we don't have any special expectations. I guess it's a matter of pride to try to find the big ones. I would have thought Jonathan would be happy with the Shoebill – for birders that's the ultimate sighting, better than any lion or leopard.

Our plane's picking us up at 8.00am. Just gives us time for a Semliki breakfast and then we're off to the airstrip. We have a Kenya Airways connection from Entebbe to Nairobi at 11.00, so we don't have much time to spare.

Jonathan and Clint have been great, Semliki is an undiscovered gem and I'd like to come back when they've had some respite from the rain and the grass is shorter. On the other hand, seeing the shoebill was really something. It was worth coming here just for that! Next time the chimps!

Taking off in the Let we discover that not only does the airstrip have a kink, it also has a hump – like a ski-jump in the kink. Makes for an interesting lift-off!

Masai Mara

Governors' Camps

From Entebbe it's a smooth hour to Nairobi, Kenya Airways landing precisely on time at Jomo Kenyatta International. We've got a couple of hours before our flight down to the Mara and we're lunching with Justin Grammaticas and Jane Dennyson from Governors' Camp, the base for our Masai Mara safari. It's been three years since my last visit to this pulsating, on the edge city. I like Nairobi;

it's got a great vibe, striking the right balance between traditional Africa and modernism. It's not too big and I always feel it's still a frontier town.

It's just 45 minutes in the Queensway Caravan from Nairobi's Wilson Airport to the Mara. Our pilot, Avid, is a Texan who came here for a year five years ago and is still here, he just stayed and stayed! On the

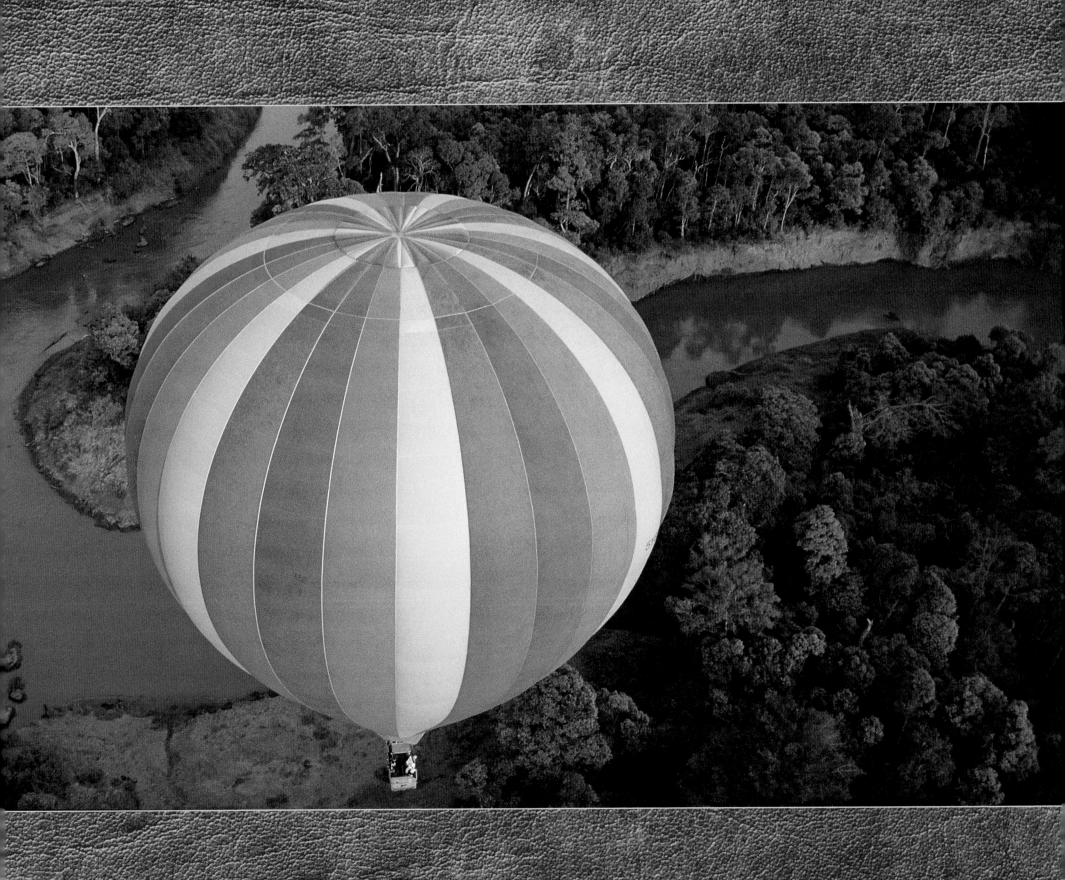

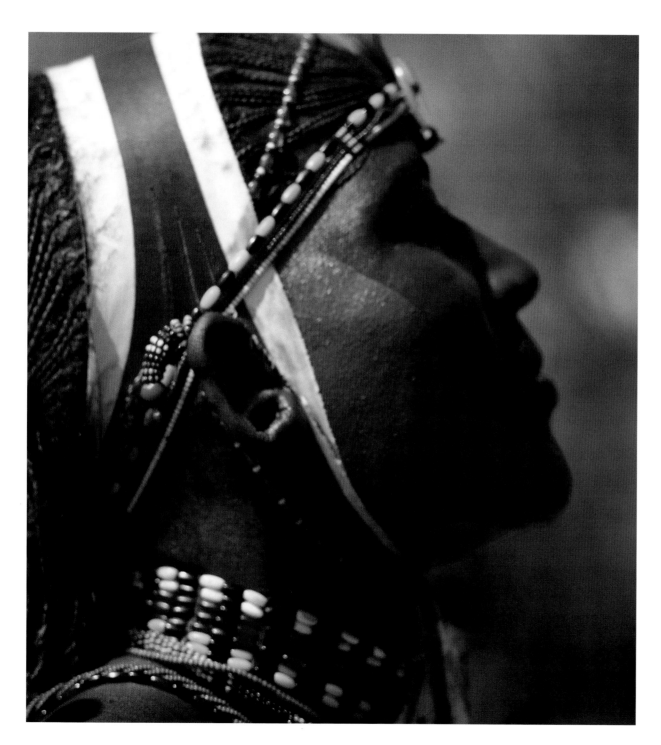

way we divert to another camp to drop off a couple of passengers. It's not a regular stop and Avid is a little concerned about the strip, it's very short, looks rough and the caravan has a full load. We touch down, Avid immediately hits the brakes and reverse thrust but the plane continues over the end of the strip and we bump down a narrow track skidding to a halt just a few feet short of some huts and their startled inhabitants! Avid doesn't turn a hair - bush pilots are a breed apart!

By contrast the Governors' strip is as well kept as a commercial runway. Our gear is loaded onto a vehicle and it's a short drive to Governors' Main Camp. In colonial times the site was reserved exclusively for the British Governors of Kenya, hence the name. The camp is spread out among the trees along the banks of the Mara, it's big, but the tents are well hidden, you can't see more than five or six at a time. Tents! Don't imagine that you have to crowd bent over into a small uncomfortable space. These are East African Safari Tents – huge with en-suite bathrooms and showers. They are as spacious, comfortable and well equipped as any hotel room and personally I prefer sleeping under canvas.

Matt and Stephen are our guides and we sit down with them over a beer to discuss our plans. We're here at Main Camp for the first week and then move to Il Moran a few kilometres along the river. Matt and Stephen will be with us for the duration. Matt gives us a warning – watch out for hippos in the camps, especially after dark.

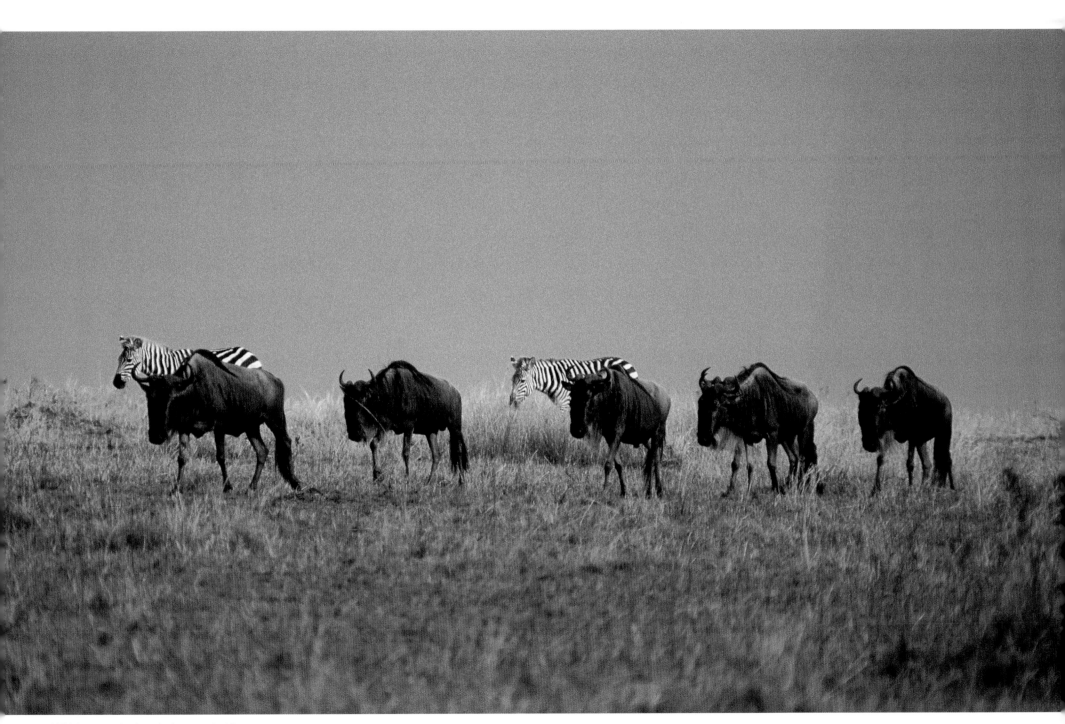

Wildebeest and zebra plod across the Mara

The African wilderness has many guises, the thick bush of the Sabi Sand, forests and long grass savanna of Semliki, floodplains of the Selous, the dry sandveld of the Kalahari and broad grass plains of the Masai Mara.

The Mara is indescribable – a vast open space dotted with wild fig and acacia trees, bisected by the Mara river, its western flank dominated by the Oolooloo escarpment.

Inhabited by the red-cloaked Masai and their cattle, this is the stage for one of the animal kingdom's greatest spectacles, the annual migration of hundreds of thousands of gazelles antelopes and zebra and the major predators following them, and it's happening here, now!

We're up before first light and head to the mess tent for coffee. Dark shapes move in front of us stopping us in our tracks – hippos blocking the way. We back off and wait until they move away toward the river.

Stephen greets me with, "Good morning, it's a beautiful day." It's still dark and I say it looks like it will be a nice day. He replies, "I mean it's a beautiful day because we've never met this day before." A wonderful piece of Masai philosophy!

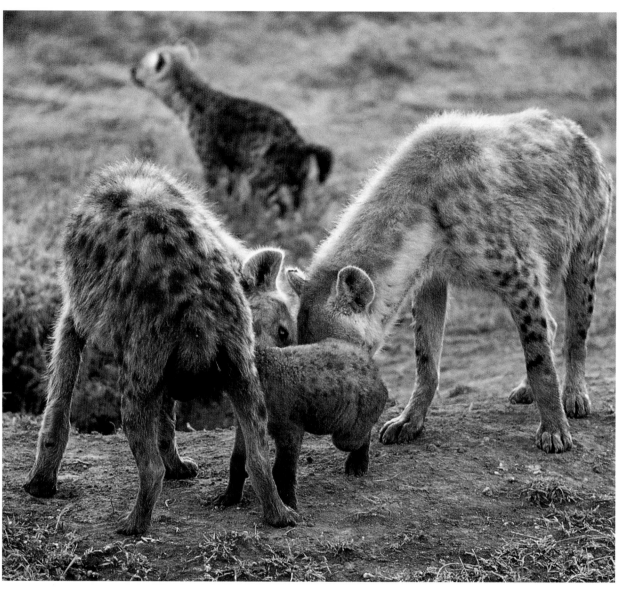

Action at the hyena den

Safaris are different in the Mara, you don't usually need a tracker – it's so open that it's easy to see animals. Well, it's certainly easy to see the masses of wildebeest and zebra trekking across the plains; the gazelles, antelope and giraffe scattered across the savanna. The predators are a different story, they may not have the dense thickets of other areas but still find cover; follow the prey species and you'll certainly find the carnivores, as long as you have a guide like Stephen with his years of experience and extensive local knowledge. Yesterday he found a hyena den and we're on our way. We get there just as the sun breaks

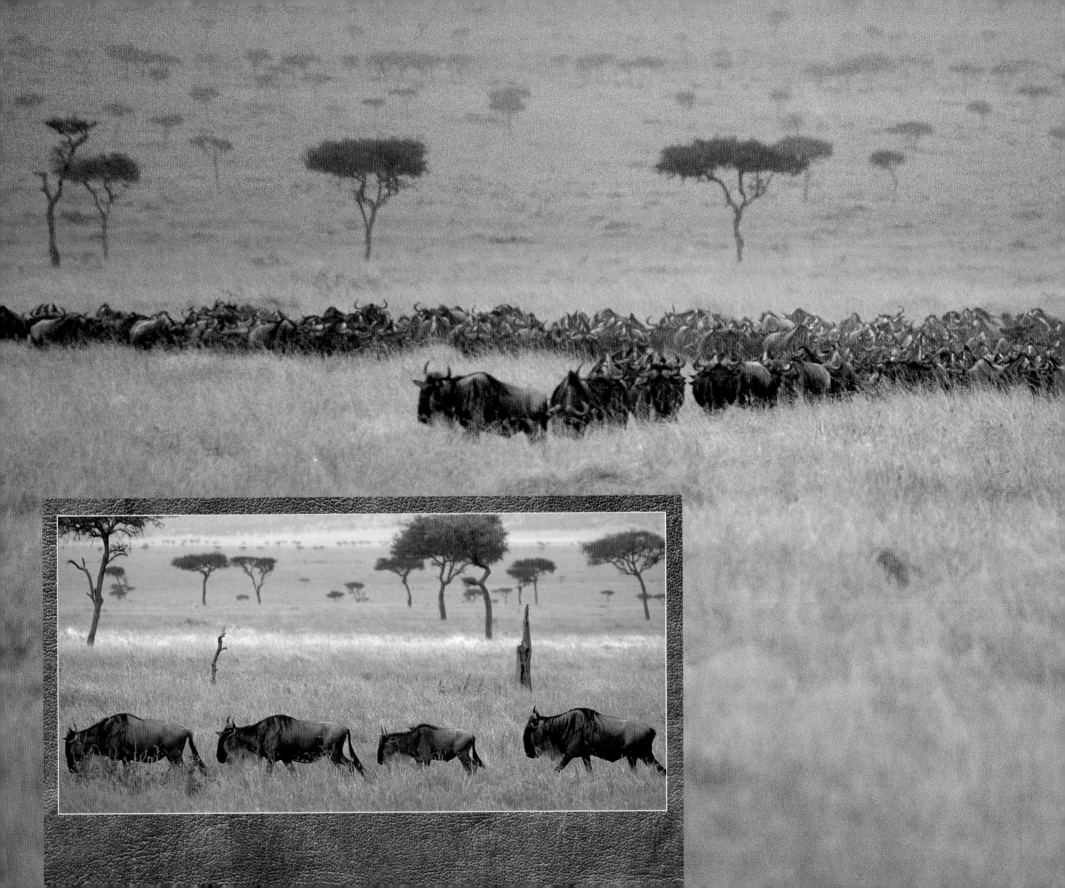

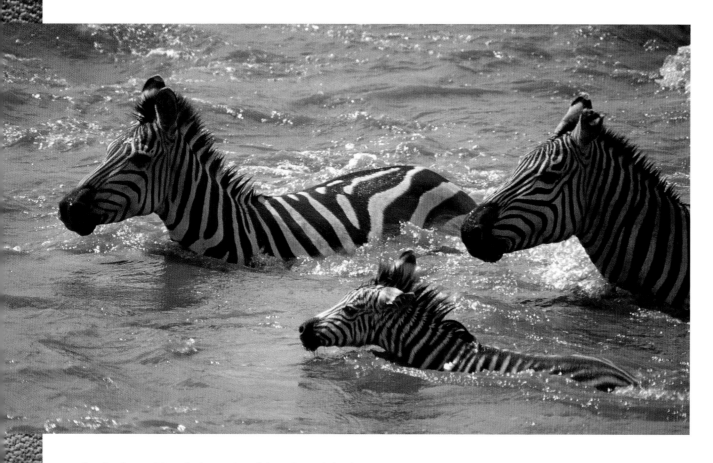

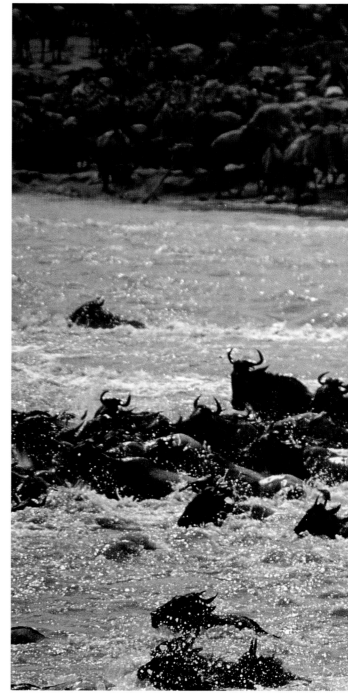

the horizon. There's lots of activity, the adults just returned from their night's hunting, the pups emerging from the lair to greet them. The competitive even combative nature of hyena society is evident as the various families in the clan nip and bite each other chasing around -and not just in play, this is serious stuff, training for the future.

It's an incredible sight, literally thousands upon thousands of wildebeest and zebra plodding across the vast spotted plain in search of the sweet grasses brought by the seasonal rain. They've trekked all the way from the Serengeti and when the rains return to

Tanzania they'll trek all the way back. But for now they face the daunting task of crossing the river, its banks lined with crocs lying in ambush for the young, weak and unwary. The huge predators will take some, others will be washed away by the swift current.

We're on the opposite bank from the heaving aggregation of animals, waiting in anticipation, no-one knows when they're going to cross – maybe today or tomorrow, maybe next week. They're constantly on the move, wary of the danger lurking in the river. A wildebeest puts a hoof in the water then draws back retreating up the bank. Another moves to take its

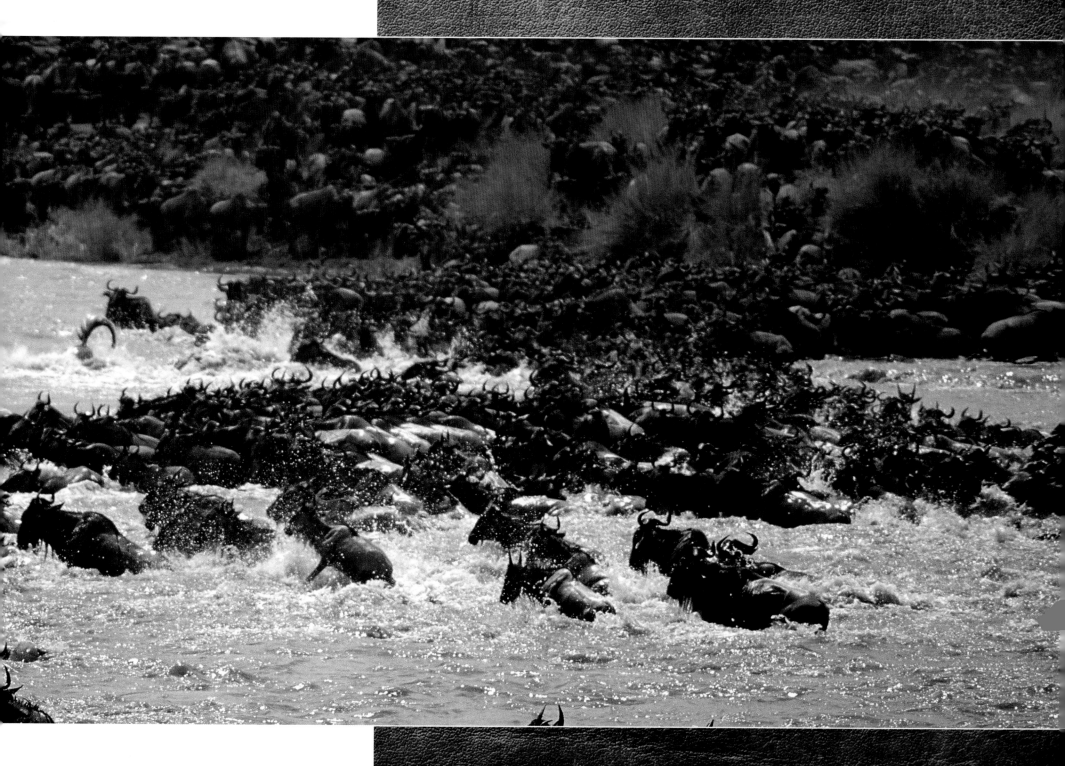

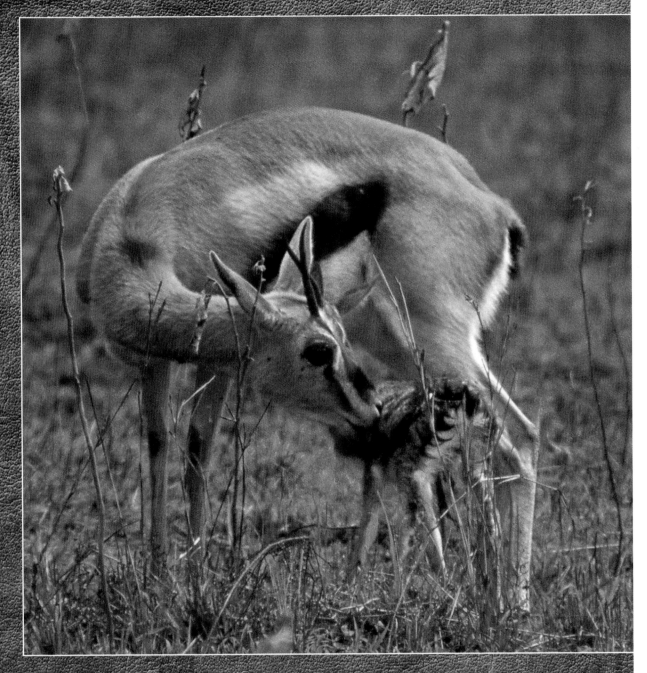

Thompson's gazelle and fawn (Above)
Hooded vulture (Right)

place almost crowded into the water by the masses behind. It, too, retreats and for no apparent reason the huge herds move back from the river, milling around aimlessly. Zebra move to the waters edge, they too back away from the foaming torrent. The animals move back and one wildebeest heads along the riverbank, others follow and eventually like sheep they're all moving in the same direction. Stephen says they won't cross today, so we decide to call it a day, dinner calls and it's a long way back to camp.

We're back on the river as the sun comes up. The multitudes are still here, jostling and pushing for position. Again an animal tests the water before pulling back; again another and another pushes forward before retreating. A small group of zebra including a mother and foal hustle through the crowd plunging in without warning, swimming strongly for the far bank, the foal being shepherded by its mother. The zebra are immediately followed by a small group of wildebeest then the floodgates open and hundreds plunge into the water. A croc's tail thrashes as it grabs a victim. The survivors

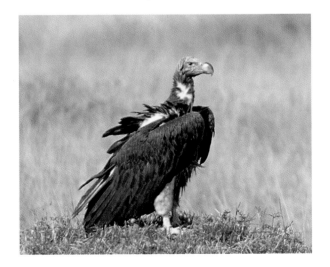

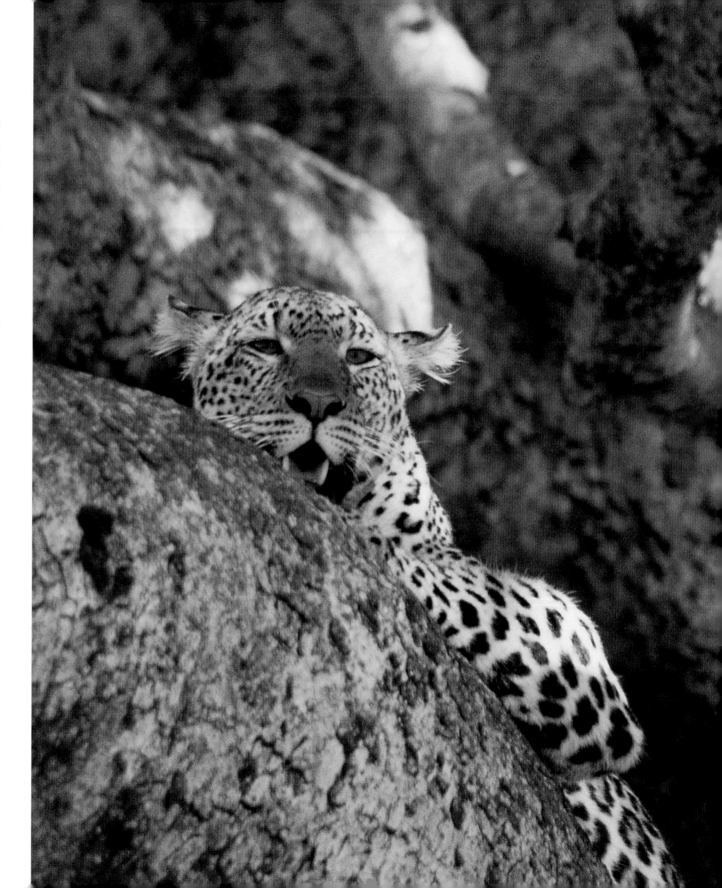

The survivors make it across climbing wild-eyed up the steep bank before streaming away up the hill behind us. One female rushes around frantically before plunging back into the maelstrom looking for her lost foal. She makes it back against the oncoming tide. The flood of animals slows and stops. Then the whole process begins again, the milling and jostling, the testing of the water before zebra again lead the way across.

The day passes, the sight is mesmerising and it's almost dark before we leave. The drive to camp is silent, each of us occupied with our own thoughts, marveling at the wonder of nature and the amazing spectacle we've witnessed.

Crossing an area of longer grass, Stephen spots a lone Thomson's gazelle.

He scours the area through his binoculars and finally finds what he suspected was there – a new-born fawn lying almost perfectly camouflaged in the grass, about fifty metres away from its mother.

She eventually moves closer and the fawn attempts to stand, but its legs are very wobbly and it collapses. Mother licks it, cleaning the afterbirth then moves away and the fawn struggles to its feet again, trying to

Hooded vulture - a major threat (Left)

Leopard gazing down at us (Right)

follow her before again falling down. Yet another attempt, this time taking a few unsteady steps. Mum stands still and the fawn starts to suckle. This behaviour will last for a couple of weeks. The fawn is almost odourless at this age making it difficult for predators to find. During this time its parent will stay close but far enough away to distract and draw-off anything that might threaten. A hooded vulture glides in and clumsily lands close by – a major threat. It waddles around before taking off, leaving the tommies in peace.

A radio message – cameraman Andre's guide has found a leopard. She's in a stunted tree just a metre above the ground, feeding on a Grant's gazelle. Already there's a hyena hanging around. A casque hornbill screeches a warning. The leopard doesn't look too secure in the low tree and moves, pulling the carcass down and dragging it across in front of us. It's heavy work, the gazelle weighing as much or more than she does, but leopards are immensely strong and we follow as she hauls it through the grass to a bigger tree. She stashes the carcass safely in a fork then climbs higher stretching herself along a branch gazing down at us. She's gorged herself and will sleep before she eats again.

The skyline is broken by a herd of giraffe striding purposefully across the plain. The group breaks up to feed on the acacia trees – a quintessential Mara scene. One stoops to drink from a small puddle, spray flying from its mouth as it lifts its head.

The mating pair (Right)

Masai giraffe scratching (Far right)

A line of wildebeest and zebra plod over the hill, the zebra interrupting their endless march to scratch themselves against a fallen tree.

For once in the Mara we are tracking. Matt and Stephen have been following lion spoor for the last half hour.

They keep losing it as it veers off into the bush then pick it up again when it appears back on the trail. While they concentrate on the tracks, my binoculars pick-up a big male lying in the shade of a bush. A lioness appears brushing herself against him before collapsing on her side. It's a mating pair; no wonder their tracks were all over the place. She rolls over and

offers herself. She rolls back, crouching down and he mounts her, biting at her neck. There's a constant growling during the fleeting coupling and as he dismounts she turns and snarls at him. He collapses next to her, temporarily exhausted. She eventually gets up and wanders off, he follows sniffing at her but she's not ready and spurns him. But twenty minutes later she again initiates proceedings and the whole noisy process is repeated. There are two young males following at a distance, they won't interfere but if the mating male flags and gives up, they will attempt to take over. Oestrus lasts for about five days with each sexual act lasting just twenty seconds or so, but repeated every twenty-thirty minutes. During this period they will not hunt or eat, the only interruption to the ritual will be when they go for water.

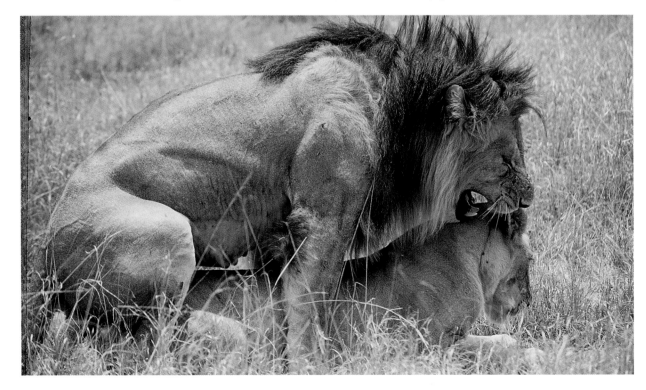

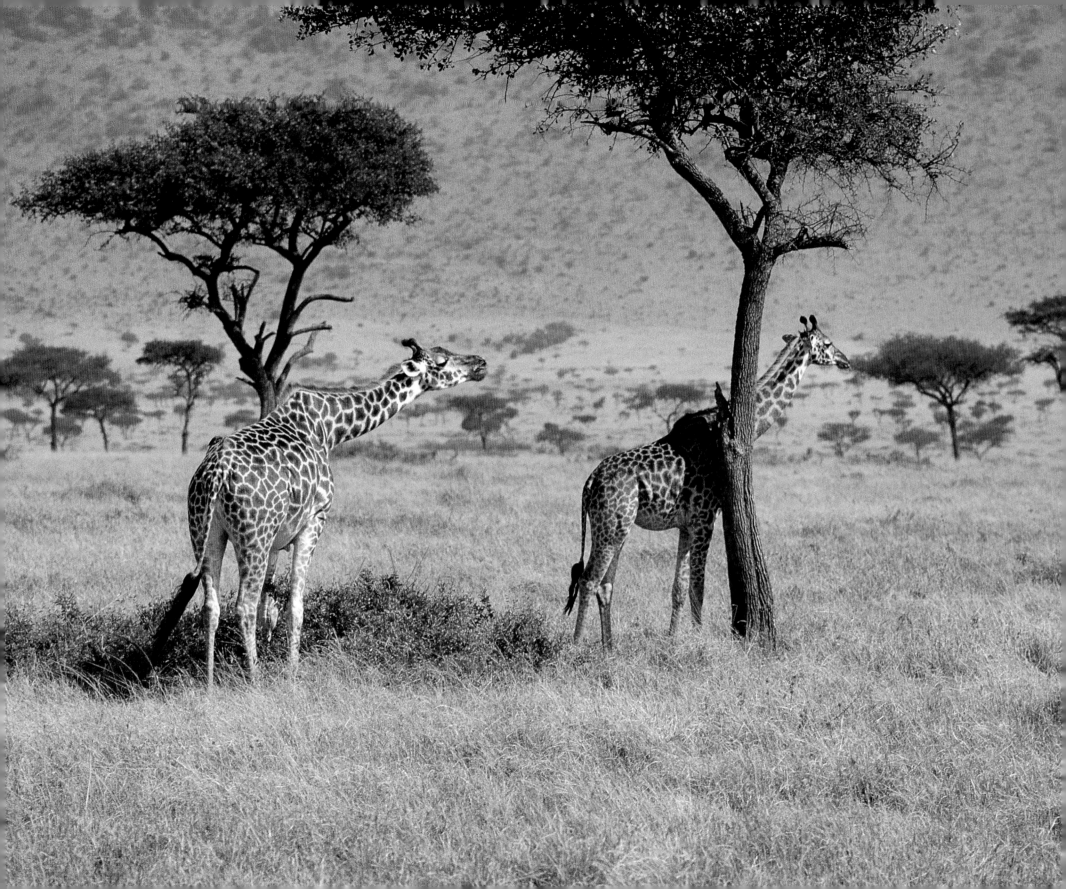

African Odyssey

A pair of tommy bucks spar, clashing horns. It's nothing too serious and they eventually settle down grazing peacefully. Around us topis stand on termite mounds advertising their territorial status to surrounding females.

Driving back to camp we're stopped by a small breeding herd of elephants crossing in front of us. A young calf follows closely behind its mother but stops in the middle of the road and rolls in the dust. His trunk flops around as he rolls back and forth not concerned with us, although mother is keeping a wary eye on him – and us. He's comical as he gets to his feet flopping his trunk loosely at us and stumbles across the road, struggling to climb the bank. Mum tosses her head at us and the group moves off.

For a different view of the Mara we're taking to the skies in a hot air balloon. It's another early start and still dark as we cross the river to the launch site. Balloon pilot Greg is preparing our craft and there's a whoosh! as he ignites the gas. The canopy inflates; we climb into the basket and lift gently off the ground, rising rapidly. The sky lightens to the east and the Mara unfolds below us as the darkness recedes. We drift over the forest along the river. The sun bursts over the horizon illuminating the world around us. Below a giraffe lopes away into the trees, buffalo and waterbuck stand and stare bovinely. Greg blasts gas into the canopy as he takes us higher above the level of the escarpment. In the distance elephants march en masse heading for water, hippos submerge but are still clearly visible from above.

Chasing our shadow across the plain, the view is forever, in the distance the Serengeti. Greg releases gas starting our descent, floating down slowly.

He's looking for a smooth landing place - an area without termite mounds, but the ground is full of them. Bracing ourselves we bump over the ground, tipping over as we come to rest against a hummock. The recovery vehicle's a short walk away, and the crew are already preparing breakfast using the balloon's gas burners to cook it! Stephen and Matt arrive just in time to join us for a magnificent repast - and with news of cheetah close by!

Stephen's sharp eyes pick up a movement across the plain. All I can see is a wild olive tree but as we get

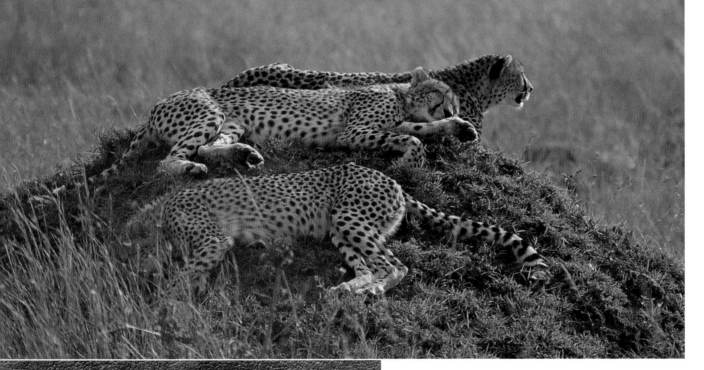

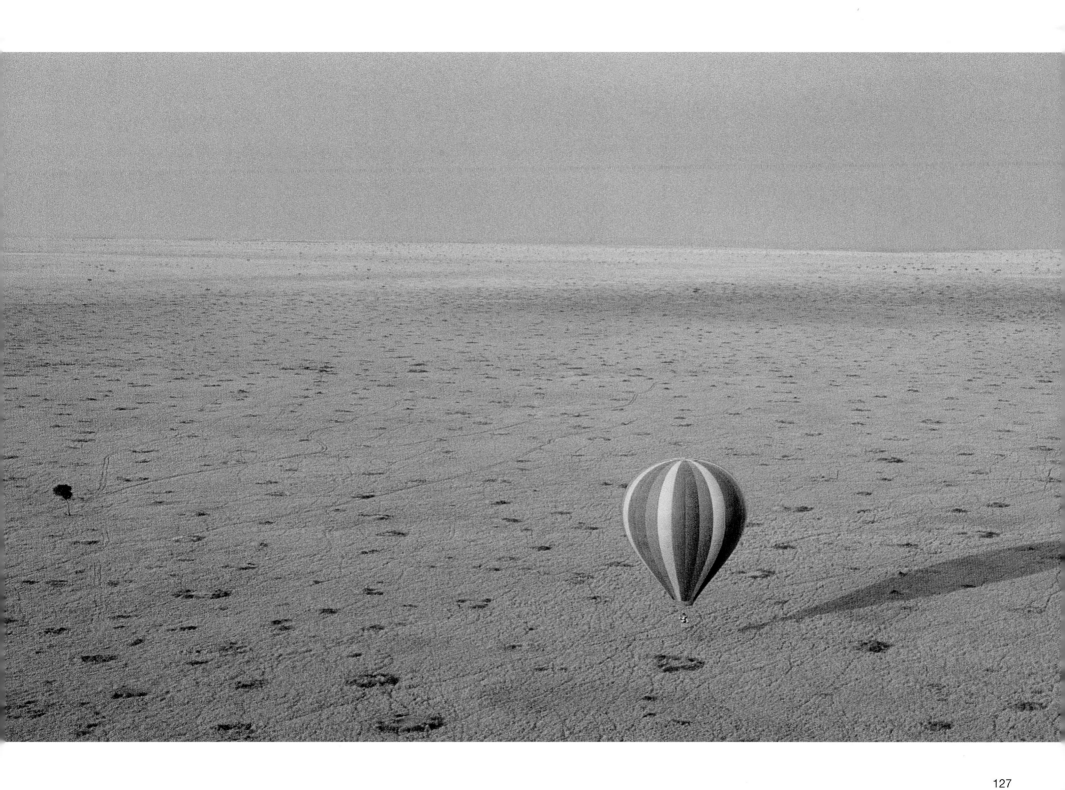

closer I see what he was looking at, a cheetah moving through the grass. No, not just one, three. They end up on a termite mound. I'm not sure if they're hunting or just playing around. They're constantly on the move, looking around and we decide to stay with them. They move off to the west and it looks like they're definitely on the hunt. There's no shortage of prey, Tommies, Grants and impala surround us, but they're on edge, very aware of the threat coming their way. One cheetah takes off, the other two seem to be working in tandem, moving from knoll to knoll, looking around, surveying their surroundings and no doubt considering their options. But as they move, their prey moves away and it's apparent that they're only half-hearted in the hunt.

We're distracted by a pair of black rhino lolling on the plain – a rare sighting in the Mara. Like everywhere else in Africa poachers have taken a heavy toll of these prehistoric looking beasts.

It's time for lunch and Matt suggest a shady spot on the banks of a small stream.

It's loaded with hippos and as Matt and I walk towards them they turn and splash away through the water creating a small tidal wave. A saddlbilled stork fishes in the shallows before hopping onto the bank, the brilliant colours of its bill sparkling in the sunlight. A pair of

Il Moran's mess tent (Top right)

Zebra with itch (Far right)

Egyptian geese carry-on a courtship, the male taking time off to chase away a rival. In a nearby tree a gymnogene hooks insects out of the bark.

Il Moran is a much smaller camp than Governors'. Conversely the tents are even bigger and the furnishings stunning. My wild olive wood bed is a work of art! Dinner is served outside on the riverbank and we're treated to a Masai dance. The high leaps are spectacular and the accompanying sound – the whoops and rhythmic humming riveting. I wish I was shooting with sound!

As we leave camp an African fish eagle warms itself in the early morning sun. Baboons scamper away through the trees, stopping to groom each other and a

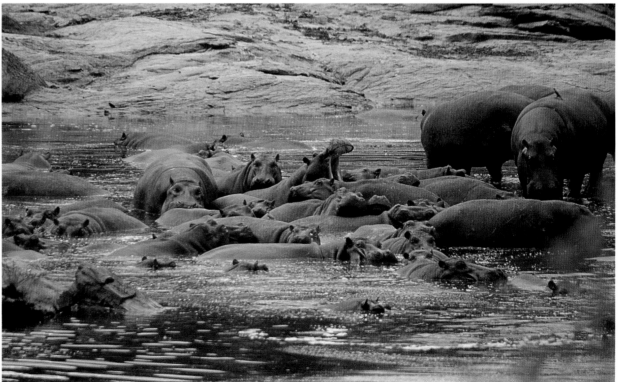

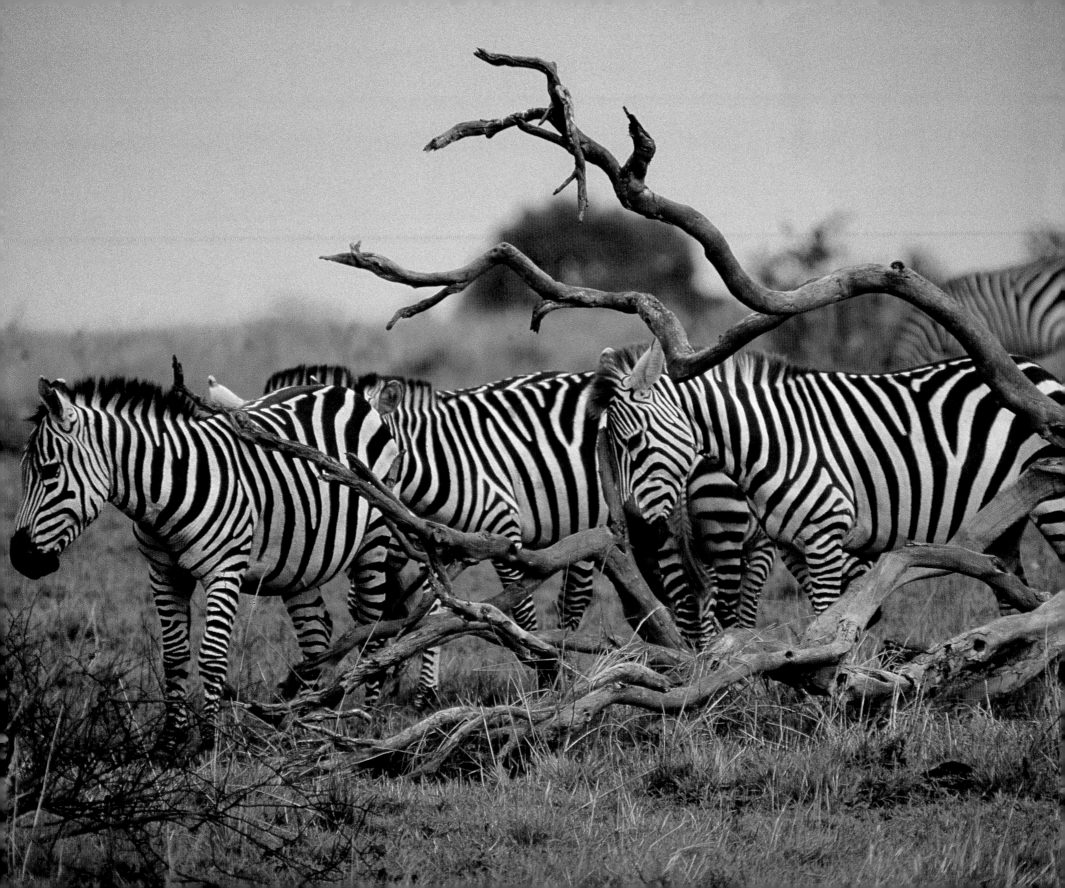

brilliantly coloured woodland kingfisher trills its call from a dead tree.

Out on the plain Stephen picks up the spoor of the mating lions about ten kilometres away from our last sighting. The male especially is showing signs of strain, looking decidedly haggard, but he's still following his mate closely. As we come up to them, he mounts her and the process continues. The intervals between copulation are getting longer; clearly her oestrus is coming to an end.

The best way to get close to animals is on foot and the Mara is great walking country. We leave the vehicles and Matt leads us across the plain. Zebra stare from a waterhole and a column of wildebeest heading straight for us angles imperceptibly away to avoid a confrontation.

Eland are the largest of the antelope species weighing close to 600 kilograms. They are notoriously shy but allow us to get quite close before lumbering off. Matt tells me they are great jumpers, able to clear three metres from standing position – incredible considering their bulk. It would make a great photograph. How can I get one to jump?

Ahead of us a trio of ground hornbills march through the grass hunting, and catching, frogs. A crowned eagle stares at us from a dead branch and everywhere there are vultures waiting for the next kill.

Our little stroll has taken us several kilometres – a long way when you're lugging heavy equipment and there's a sigh of relief when our vehicles come into view. But the walk has been very rewarding. Everything takes on a different aspect when you're on foot – for one thing, the animals appear a lot bigger.

The blood-red setting sun outlines a herd of wildebeest galloping aimlessly back and forth. One runs, they all follow, one stops, they all stop, continuing this aberrant behaviour until they're swallowed up by darkness.

Just outside camp a waterbuck lifts her head in the early morning sunlight and we've gone barely a couple of kilometres when Stephen slams on the anchors bringing us to an abrupt halt. Ahead a lioness has chased a waterbuck into a riverbed, made the kill and is dragging it back up the bank to some cover. We can't get through the riverbed and have to go quite a long way round. By the time we get to the kill she's lying under a tree and the kill has been taken over by two young hyenas with vultures waiting in the wings. It's a puzzle; surely the lioness wouldn't have given up the kill to a couple of inexperienced mpisi. It would be different if she were being mobbed by the whole clan, a common occurrence. Stephen thinks the kill was an opportunistic event and she isn't really hungry. Uncharacteristically she certainly gave up the kill very easily. The two hyenas scrap over the remains, the dominant one chasing the other away. But there's enough for both – and some left over for vultures. An unusual encounter, or rather an unusual outcome and a high point for our last major sighting before we have to leave.

The Mara has been fabulous, but all good things come to an end and it's time to continue our journey. In the meantime, Avid is waiting to transport us back to Nairobi for a night on the town before our very early departure for Joburg - that means a 4am call to be at the airport by 6!

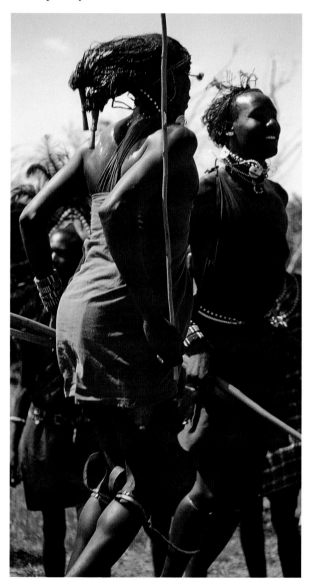

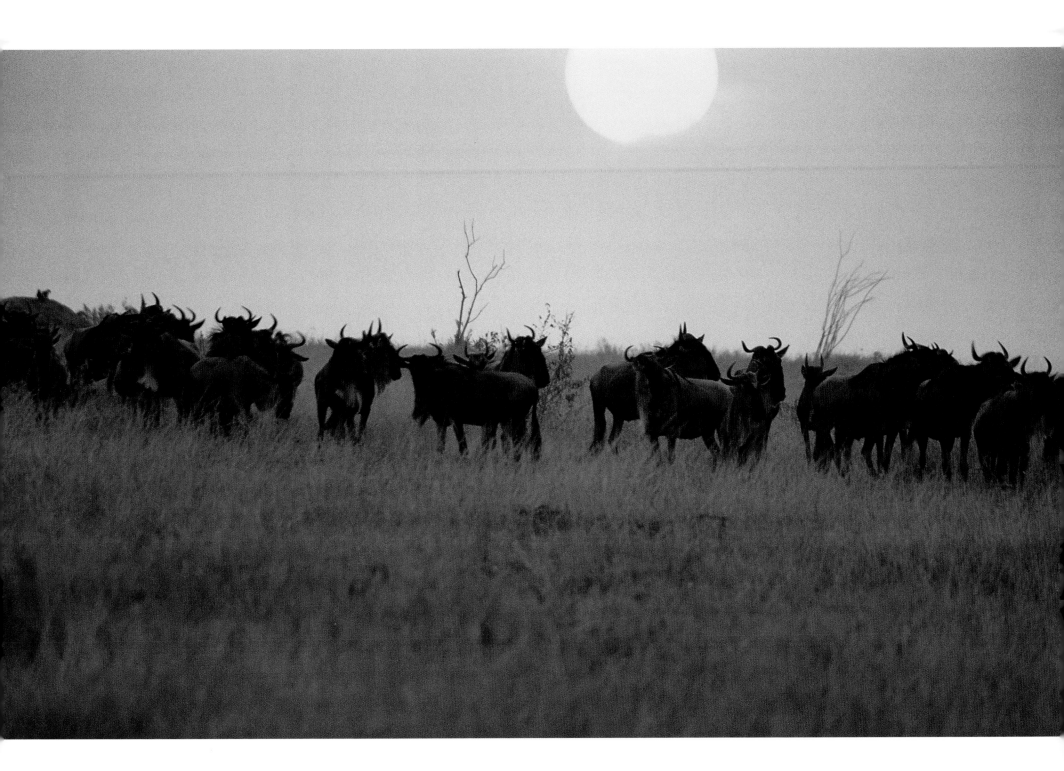

Caprivi Strip

Impalila Island & Susuwe

Islands **In Africa** somehow sounds bizarre. Island to me conjures up images of Seychelles or Mauritius, Hawaii or Tahiti – sandy beaches and swaying palms somewhere in the middle of a vast ocean. But of course there are many islands in Africa. The Rift Valley lakes and major African rivers have literally thousands.

The 'Cradle of Rivers' is where Zambia, Botswana, Namibia and Zimbabwe meet, the confluence of the Chobe and Zambezi rivers. Impalila Island lies between these two great waterways in the Caprivi Strip, that thin finger of Namibia between Botswana, Angola and Zambia.

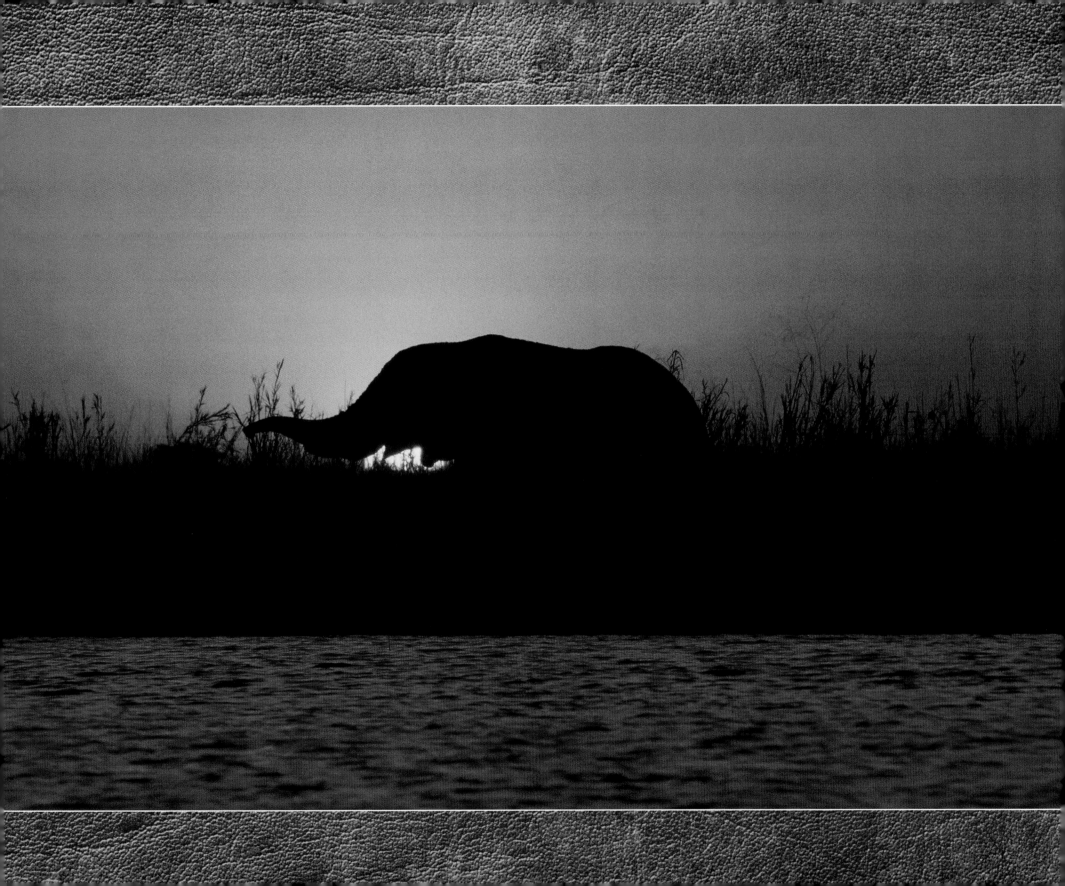

A fascinating place, just one hundred kilometres upstream from Victoria Falls and another stop on explorer Livingstone's epic journey. The swift flowing Zambezi is a world of flood plain, woodland and great baobabs, home to the legendary fighting tiger fish and astounding bird life. Yet boat down the Kasai channel and it's a different world. The more placid Chobe River forms the northern boundary of Chobe National Park. The Park is dry and dusty, denuded by the huge elephant herds which congregate in the river, attracted by the only permanent water in this sector of the reserve.

The Naturelink Caravan drones on its steady path, across eastern Botswana, just three thousand feet above the ground. Below us the Makgadikgadi and Nxai Pans blindingly white, a spume of dust lifting in the wind.

Apart from the Pans, it's featureless, only a fence line stretching away into the heat haze – you can see for miles.

The Chobe River and the border town of Kasane come up, we turn and put down on Impalila Island. First stop is the Impalila police post for the usual formalities; fill out a form, stamp the passport and we're away.

River guide and renowned fisherman, Simon, is waiting with a boat to transfer us to Impalila Lodge on the island's southern tip. It's an exhilarating ride, speeding through the channels, cormorants and egrets taking-off ahead of us in a flurry of silvered water.

Simon slows down as we enter the main Zambezi channel. The currents are dangerous; there are rapids

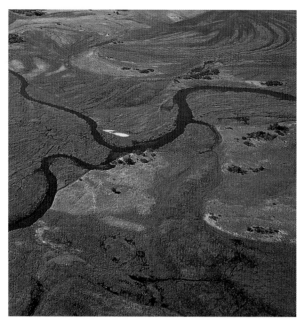

Kwando flood plain (Above)
Red lechwe (Right)

to be negotiated. He steers into a small tributary and the lodge appears, dominated by a massive baobab tree right on the water's edge.

The whole area between the Zambezi and Chobe is one huge wetland, reminiscent of the Selous, a paradise and haven for the thousands of water birds nesting in the reeds and the crocs lurking below. Birds are everywhere – kingfishers, bee-eaters, darters, cormorants, herons, spoonbills, storks, jacanas – the river is alive. A shy purple gallinule skulks in the reeds, feeding on tubers and flowers, rooting out insects and hunting for nestlings and birds eggs.

Elephants too are starting to gather, drifting down to the river. Some are already in the water and we're

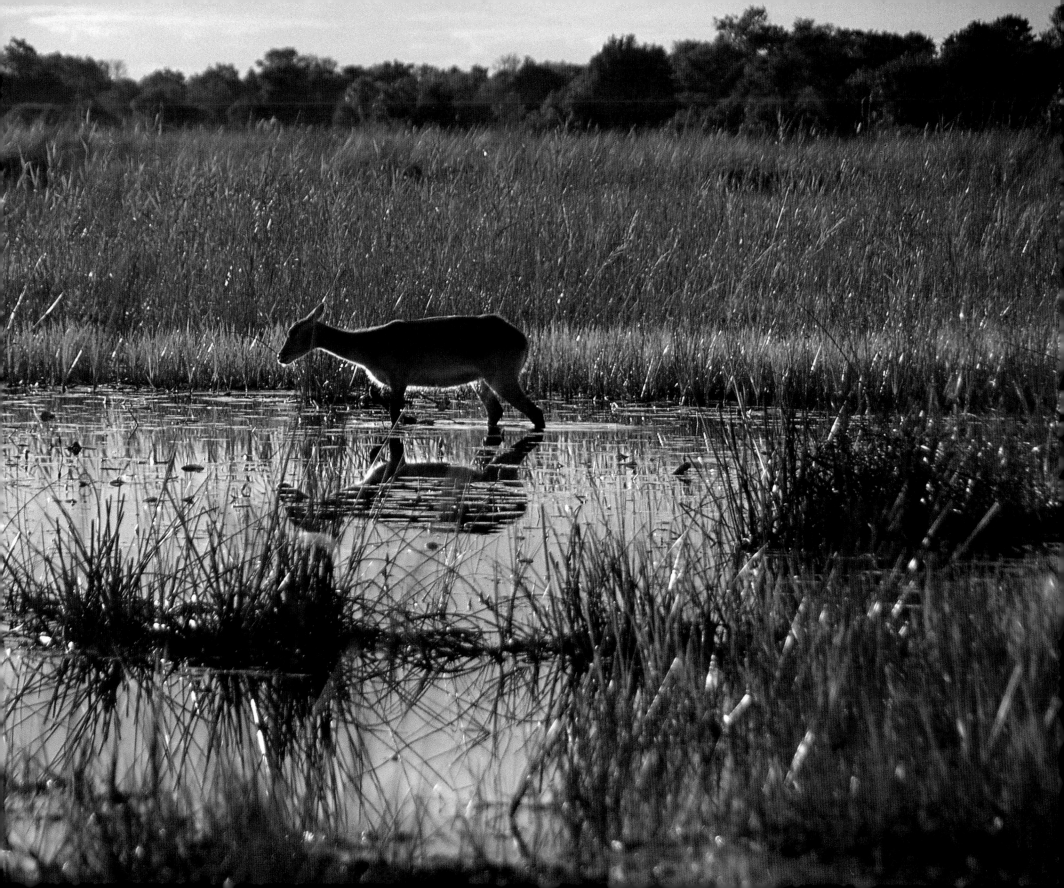

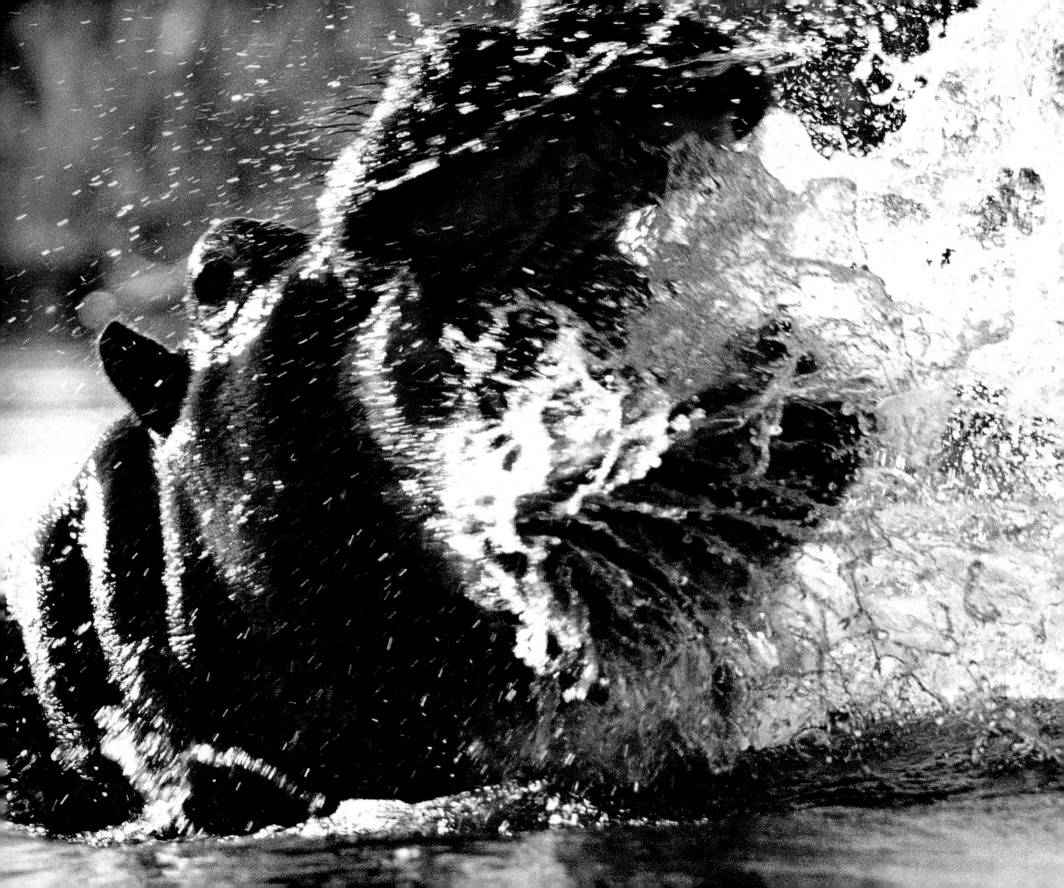

able to get in amongst them almost joining in their antics. Simon cuts the outboard and we watch them all around us.

The elephants add to the current, their movement through the water creating waves and our boat rocks as they move close.

Other animals are coming down to drink – a lone Chobe bushbuck, a single puku and a small herd of curved-horned sables hovering up on the bank, nervous and undecided, not sure if it's safe. A distant lion roar breaks the silence, the sable are right to be nervous. Most of the elephants are retreating back across the flood plain up into the trees of the Reserve. But some have crossed the river and will camp on the island for the night. They make a striking silhouette against the setting sun.

Fishing is not my thing but Simon has such a reputation and Impalila is so renowned for its tiger fish that I feel a fishing trip with him is mandatory. Jokingly, I ask him if he can guarantee a tiger catch – he answers "Within ten minutes." This I definitely want to see. Casting has always fascinated me and watching Simon is almost hypnotic, he's turned it into an art form, the line glistening in the sun as it whips back and forth. He's casting into a small area of rapids, obviously the haunt of tigers. He reels in and snap! He's got a bite. Pound for pound, tigers are amongst the toughest game fish, especially if you're only using a light fly rod, and Simon plays it, battling for several minutes before landing it. He grasps it behind its head to show me the vicious teeth – out of all

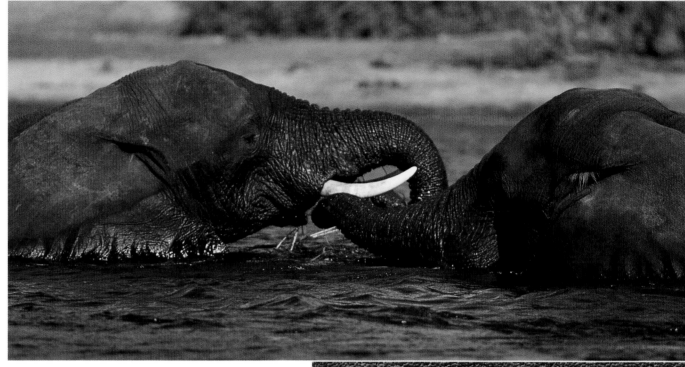

An angry hippo explodes out of the channel (Left)

Lilacbreasted roller (Below)

proportion to the size of the fish. He cuts out the hook and releases it into the river. At Impalila all fishing is catch and release. Simon hands me the rod, gives me a couple of pointers, and I try casting – it's my first attempt and I narrowly miss hooking my ear so I hand the rod back to him before I do some major damage. As I said fishing is not for me but I can see that it would be easy to become hooked!

Before moving on to Impalila's sister lodge, Susuwe, I've planned a quick expedition into the Chobe and made arrangements to spend a night camping.

137

Fearsome teeth of the tiger fish (Above)

preparing breakfast. I wander down to the river to see if I can spot some early morning birds. There's a soft growl to my left, I turn and suddenly I'm face to face with a young lion – he's appeared from nowhere. We both stop dead and look at each other. He reacts first and charges. There's a huge roar behind me – it's Steven to the rescue, he's shouting and waving his arms.

The lion skids to a halt in a great cloud of dust, gives us a long look then turns and lopes away through the mopane trees.

I breathe a sigh of relief, my knees are shaking, Steven too is shaking and he castigates me for going off on my own – I certainly should have known better. First rule of the bush, never wander off on your own, stay with your guide. Eating breakfast, I kept thinking that I could easily have been breakfast!

Simon's just dropped me off at Kasane, my guide Steven meets me for the brief drive into the Reserve. It's much as I expected; the elephant population has decimated the whole area. The trees are bare, stripped of all foliage. The huge herds I saw from the river have broken up into smaller groups trying to get whatever shade they can from the stunted trees. The calves are lying on the ground shaded by their elders. It all looks rather sad. No wonder they move to the river every day!

The clouds are looking threatening and we decide to set up camp early, the last thing we need is to start pitching tents in a rain squall. Just as well, the wind is rising and everything is blowing like crazy. We've just eaten and the first raindrops have hit, you know, those big fat drops that precede a deluge. In a matter of minutes my tent is flooded and I retreat to the Land Cruiser, which affords a modicum of shelter, but everything is soaked. It's well after midnight and the rain is just easing off. As quickly as the storm broke, it's passing and already the clouds are lifting and stars are appearing.

I'm up with the sun but already Steven and the camp staff are clearing up the debris from the storm and

Susuwe Island Lodge in the Babwata Reserve is remote, a hundred and twenty kilometers from Katima Mulilo the nearest town and an hour's flight from Impalila. The Zambezi bends north; the flood plain recedes, blending seamlessly into the dry savanna and Kalahari sandveld of the Caprivi. The Caravan hums along, the Kwando flood plain appearing as we start our descent. As we turn to land, I glimpse a vast lagoon sparkling in the sun. We touch down throwing up a choking cloud of dust. We'd radioed ahead from Impalila and a Land Cruiser is waiting. A 4-wheel drive is essential; the Babwata terrain is treacherous, one-minute deep sand, the next thick gooey mud, camouflaged by thick reeds and papyrus.

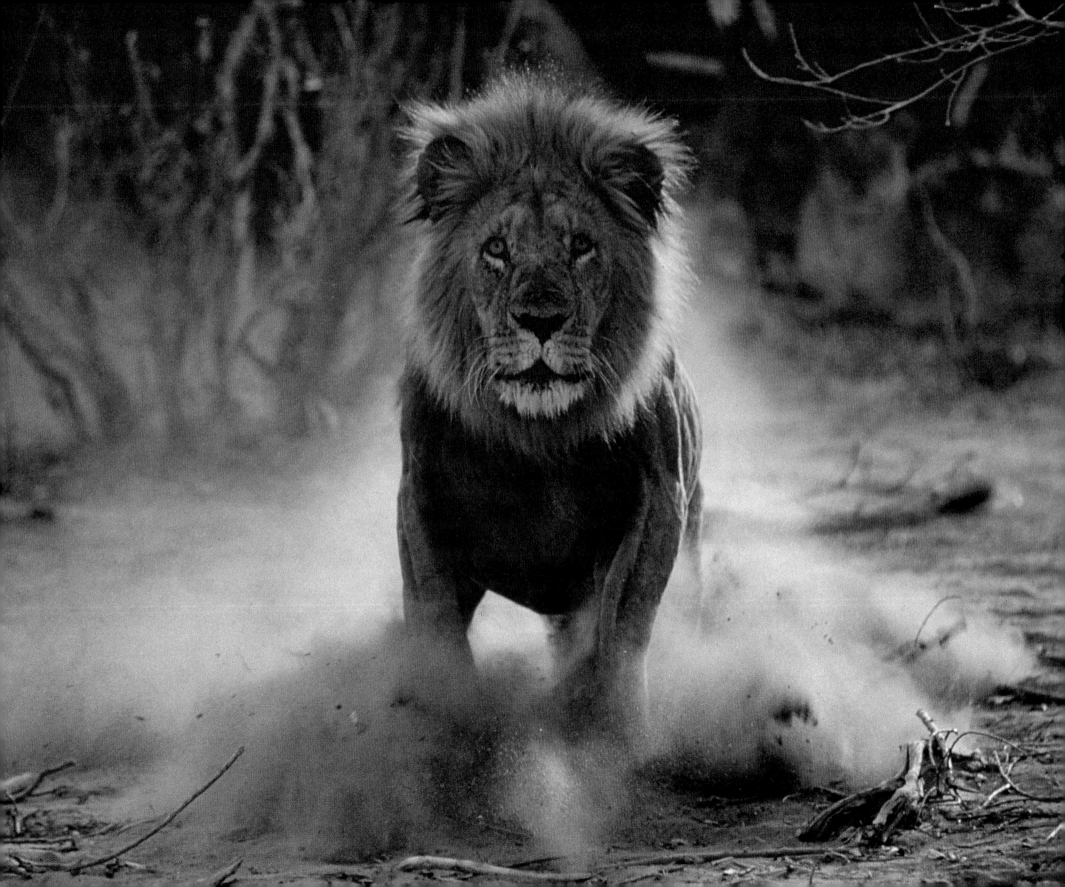

Impalila Island Lodge (Above)

Sunset on the Chobe (Right)

great to see it on display in this way. In front of the lodge is a huge bed of papyrus alive with nesting spottedbacked weavers.

Dusty, one of the lodge owners, has a microlight parked behind the lodge and offers to take me up in the morning. It's still dark as we push the flimsy craft out of its shed, climb aboard, zoom down the short strip and soar into the half-light of pre-dawn. Dusty's timed our take-off to be airborne as the sun comes up. It's hard to even see the lodge hidden away as it is, never mind photograph it. All around us the flood plain stretches away from the savanna, glittering watercourses breaking its surface.

Back on the ground, exhilarated by the flight, I've just time for coffee before Donovan takes us out on the river. After spending time on the wild Zambezi, the Kwando is like a pond. At this time of day there's no wind, not a ripple, disturbing the water. A few hippos surface, their eyes following us. This channel ends in a large pool, dividing into smaller creeks. We've disturbed a pod of seven or eight hippos and they explode away from us surging through the shallows creating a huge wave as they make for deeper water where they submerge, turning to face us as we come to a halt.

Water lilies open slowly as the sun strikes the water, lighting up the narrow channels. A darter splashes into a hurried take-off as long-legged African jacanas step delicately across lily leaves. The rare lesser jacana follows its bigger relative searching the papyrus and lily leaves for insects. A blackcrowned night heron hunts for frogs, reptiles

Fifteen minutes into the reserve an elephant mother and calf dash across the track in a flurry of dust. A rearguard teenager threatens us with a toss of his head as they vanish into the bush. The drive from the airstrip has taken us as long as the flight. The lodge is hidden away in the trees, hardly visible. A pontoon chugs across the Kwando to transport us. Camp manager, Donovan, is on the bank to greet us and show us around. Susuwe is quite spectacular in a kind of understated way; lots of unusual artistic touches in the décor, design and construction. I ask Donovan about this and he tells me that internationally famous artist/designer/photographer Karl De Haan was involved in the building of the lodge. I'm a long time admirer of Karl's work and it's

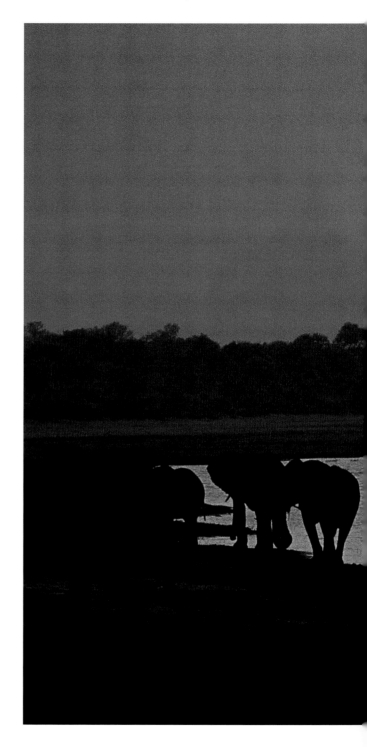

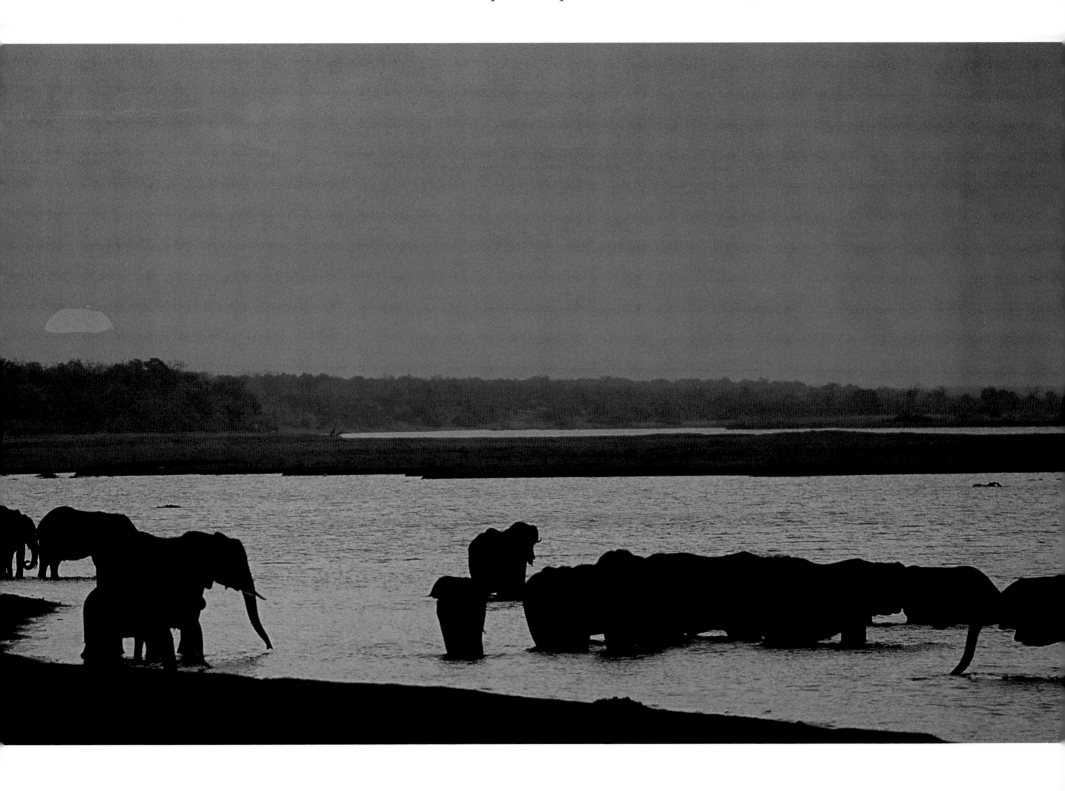

or crustaceans from its perch over the water. Donovan grounds the boat and we step ashore. Time for coffee and rusks, and croissant and muffins, and…it's a feast, everything freshly made at Susuwe by chef Peter. All the time we're on the bank the hippos are keeping a beady eye on us. Replete we clamber back on board and head for a rendezvous with the Land Cruiser.

Close to Horseshoe lagoon there are elephant tracks everywhere. This is obviously a meeting place for the pachyderms but when we arrive there are none to be seen, just a large scarred bull hippo basking on the bank.

Late afternoon we've driven far, way past Horseshoe and we're on our way back just coming up to the lagoon. We've been seeing elephants or traces of them all day. A pair burst out of the bush to our right bringing us to a halt. I can hear more off to the left but can't see them; the bush is too thick. We round a bend and Horseshoe comes into view. There are elephants everywhere – in the water, on the bank, in the tree line and more coming down to the water. We get closer and suddenly there are elephants all around us, literally hundreds. Donovan explains that very occasionally the different herds come together in huge congregations almost like a family reunion. Looking around I estimate there must be at least four or five hundred animals. There are elephants in the water playing, pushing each other, spraying water, one playing with a small branch,

Spottedbacked weavers and nests (Left)

Susuwe (Right)

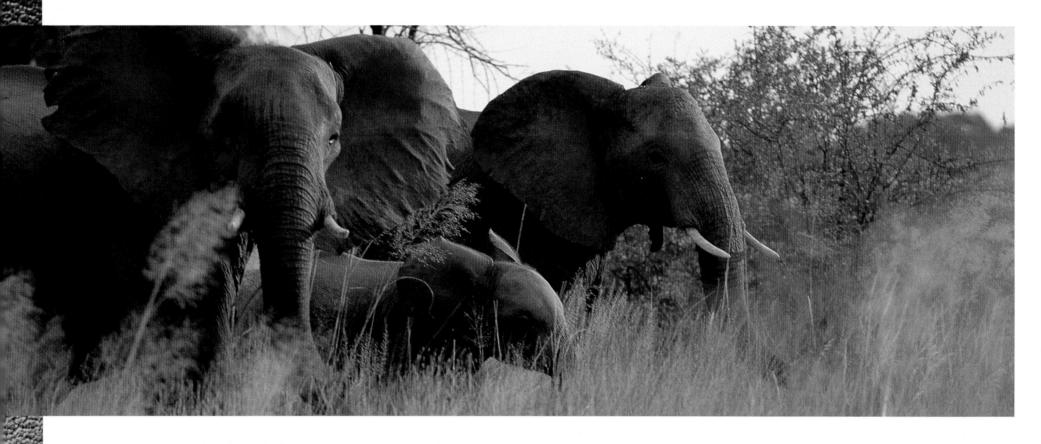

elephants on the bank, calves of all ages sparring, the younger ones struggling to control their trunks; families together, two or three generations being controlled and led by the matriarch. Young and old bulls sniff the air checking us out while all the time new groups arrive as others leave. Gradually they all start to leave the water heading for the trees. It seems the reunion is over. Within thirty minutes the lagoon is deserted and we move on.

Without warning a small breeding herd appears out of the golden light in front of us. I don't know how such large animals can be so quiet when they're moving at such a pace through the long grass, the noise is little more that a rustle. They seem to be suspicious of us, probably because of the young calves with them.

They're definitely not happy with our presence, maybe because we're blocking their path, something we wouldn't have done if we'd spotted them earlier.

This is amazing, they've all stopped at once, trunks in the air, motionless and silent for about thirty seconds, then as if a signal's been given they move as one and just melt away into the dust and long grass. Within seconds it's as if they were never here.

A word about Susuwe Lodge. Apart from its stunning décor and design, the food and the chef deserve a mention. Peter produces absolutely amazing haute cuisine in this place in the middle of nowhere. He grows his own herbs and vegetables – not easy, he has a constant battle with invading elephants and antelope looking for succulent morsels. He catches fresh fish and the closest shop is a two-hour drive, so he constantly has to improvise. I mean if he runs out of an ingredient he can't just pop to the nearest supermarket. Peter is always honing his skills, travelling to Italy every year to work in a top class restaurant bringing back new recipes and ideas. On top of all this he loves the bush and likes nothing more than taking guests out on safari!

Squacco heron in flight (Above)

Lilly trotting African jacanas (Right)

Our point of egress from Namibia is Katima Mulilo just thirty minutes flying time from Susuwe. We've just taken off and Chris is trying to raise Katima on the radio but is not getting any response. He keeps trying but Katima is now in sight and still no response. We land and Chris walks to the control tower to report in but there's no one there. The airport buildings are deserted – literally deserted. The passenger 'lounge' is totally devoid of anything – no posters, no newspapers, no magazines, just a few wooden benches and a kiosk with nothing to sell. The only adornment on the wall is a big sign saying 'nothing to be taken out of this building – offenders will be prosecuted'. I think we've been beaten to it! This is rather like the Marie Celeste!

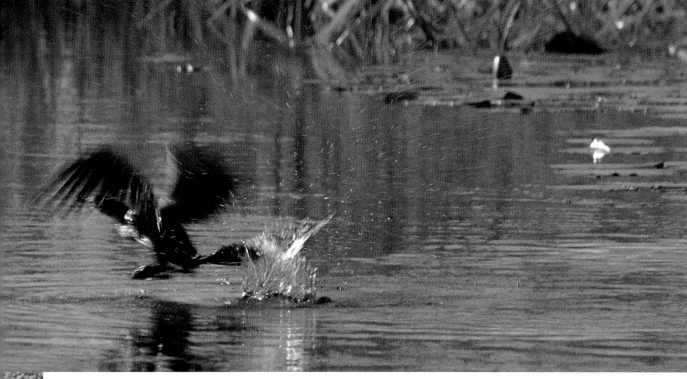

Cormorant take-off

Eventually a lone security guard emerges from a back room but no immigration or customs officers. The guard tells us that everyone has gone to a funeral in town, which is about twenty kilometres from the airport. Chris finally persuades the guard to phone into town and after about half-an-hour the customs guy arrives. Chris fills out the forms and we're ready to go, but still no immigration officer. The customs officer says he'll stamp our passports but the stamps are locked away in a filing cabinet and, of course, the key is with the immigration man. Chris says "How about forcing the drawer?" Mr Customs agrees but what to force it with? He eventually finds a spade and tries to open the drawer - no luck - not really surprising, the spade

is a tad cumbersome. With the officer's permission, Chris produces his knife, has a go and springs it open. The officer takes out the stamp and slams the drawer shut. We're ready with our passports. Surprise, no pad to ink the stamp – it's in the drawer that has of course automatically locked itself! Chris gets to work again, opens it once more and grabs the pad. Our passports are duly stamped and we head for the Caravan. We've been here nearly two hours. We're about to climb aboard when the security guard appears with a form to be completed. Couldn't he have done this while we were waiting? Two hours – we should have been at Katima for twenty minutes tops! Travelling in wildest Africa does have its quirks.

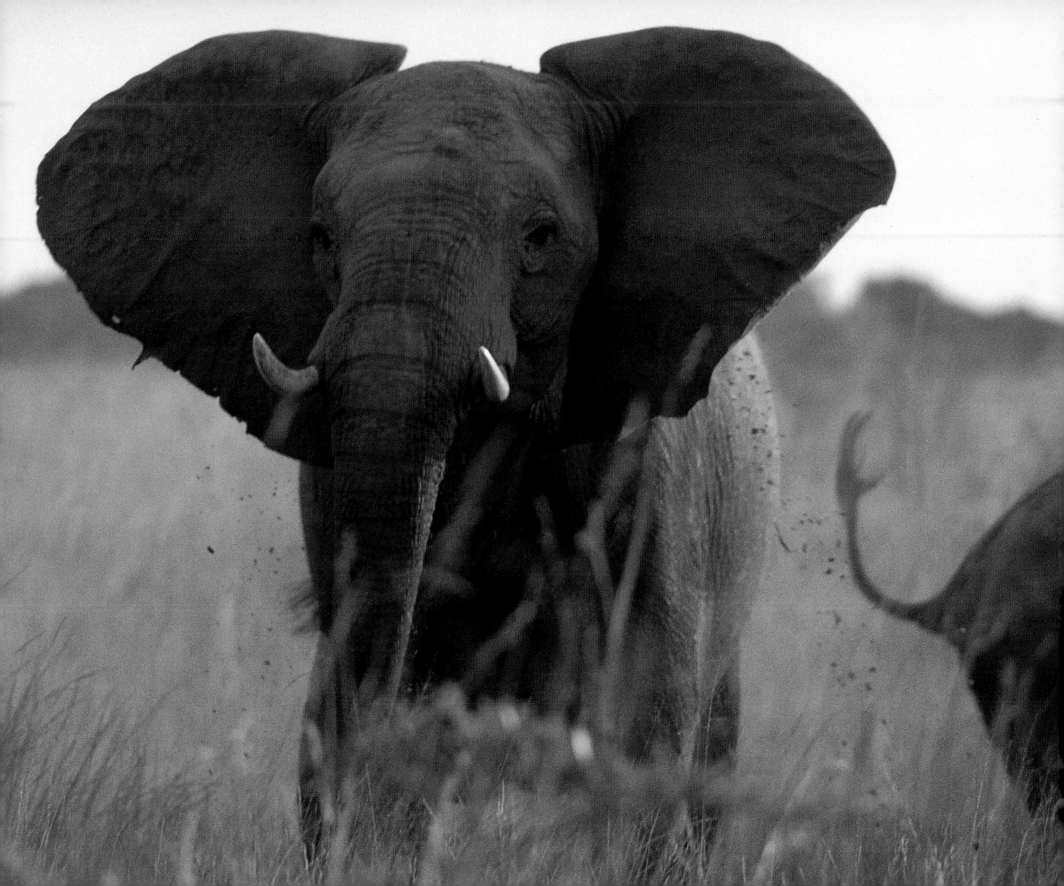

Madikwe

Jaci's Safari Lodge

Nine thousand animals relocated over a period of two years. That was Operation Phoenix. The time - 1993, the scene - the newly proclaimed Madikwe Reserve on the Botswana border some three hundred and fifty kilometres north west of Johannesburg. An area of mixed vegetation dominated by the dramatic Inselbergs – boulder-strewn mountains rising two hundred metres above the surrounding plains.

Madikwe is now home to all the major wildlife species that inhabited the area in the past – lion, elephant, giraffe, zebra, rhino, cheetah, wild dog, many antelope species and leopards, which were not relocated but were always here. Ten years later, the animal population has increased to more than fifteen thousand and most species have prospered and multiplied. I was last in Madikwe six years ago and the animals were either

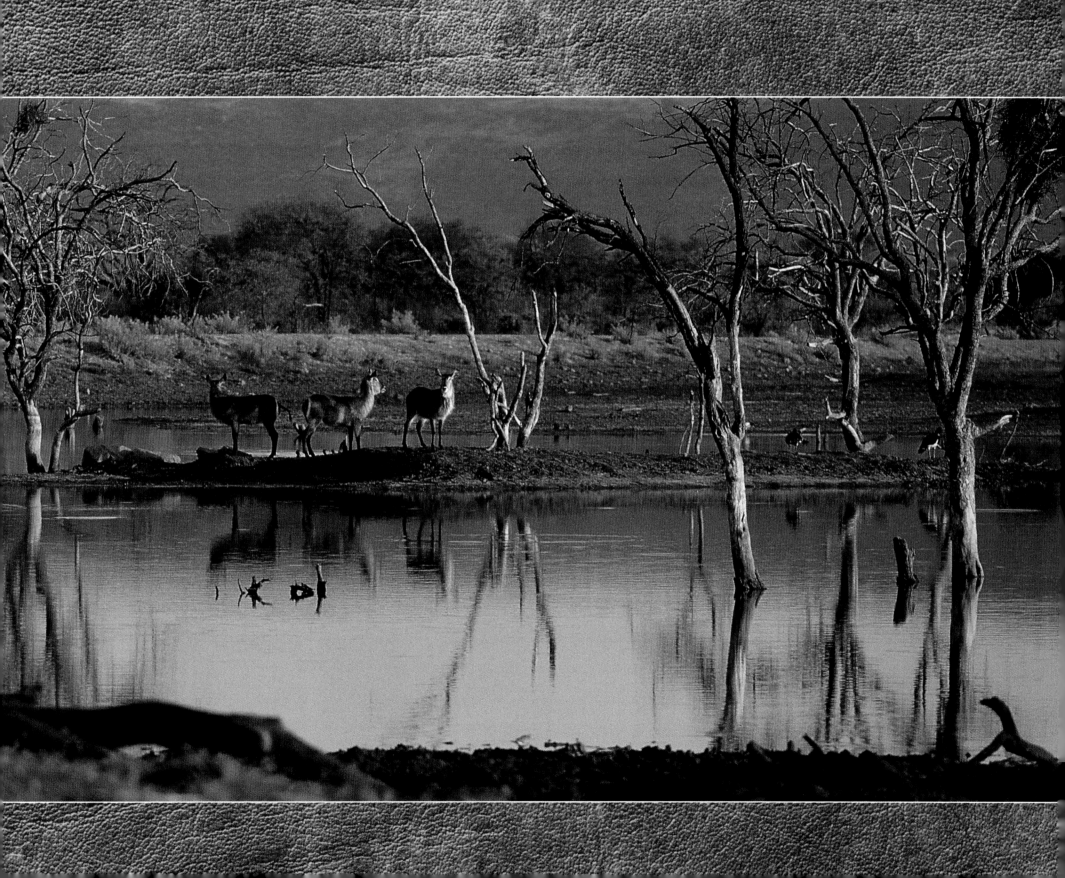

very aggressive or very skittish. I'm interested to see how things have changed. Our destination is Jaci's Safari Lodge in the southeastern corner of the reserve.

Our arrival is heralded by a violent early morning storm. It's been chasing us all the way from Wonderboom but we've managed to sneak onto Jaci's airstrip just ahead of it. As we land the heavens open but within minutes the deluge moves on, leaving the air clear and fresh. Owner Jaci van Heteren is here with two vehicles and introduces us to our guide John D. It's a beautiful morning and it seems a pity to waste time going to the lodge. Jaci arranges for our bags to go there while we head out for a recce of the reserve.

John D suggests our best bet would be to check out the waterholes, so we take the shortest route to Tshukudu dam. Our progress is interrupted by the appearance of a cross looking rhino determined to have right of way, naturally we stop to let him pass. He's in an aggressive mood for no apparent reason. We arrive at the dam at the same time as a small herd of wildebeest. We first encountered them on the road but they obviously took a short cut and appear out of the bush as we drive on to the dam wall. For wildebeest they're being remarkably active, cavorting in the mud and generally indulging in hongonyi interaction. This waterhole is popular – on the far side a pair of giraffe bulls joust, heads swinging before stooping to drink whilst others look on. There is very little surface water in the reserve, waterholes are a magnet for the animals so we'll be checking them out every day.

Jaci's Safari Lodge is on the edge of the reserve

We landed just before the storm (Above)
Charging rhino (Right)
Impala with faun (Far right)

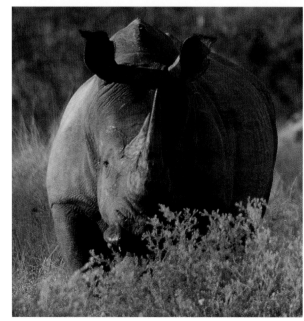

overlooking the Marico River. The lodge is quite small, interestingly built with a mixture of stone, thatch and canvas. Very colonial safari camp style but with all mod cons – fireplaces, huge beds, vast stone baths and outside showers with great views into the bush. We've just time for a swift lunch – then John D whisks us out again.

Driving through thick bush, John D spots a lone impala ewe with a newborn foal. As we stop, the foal moves closer, hugging mother's side, a real long-legged beauty. Hopefully she'll survive her vulnerable early years when she's easy meat for the many predators.

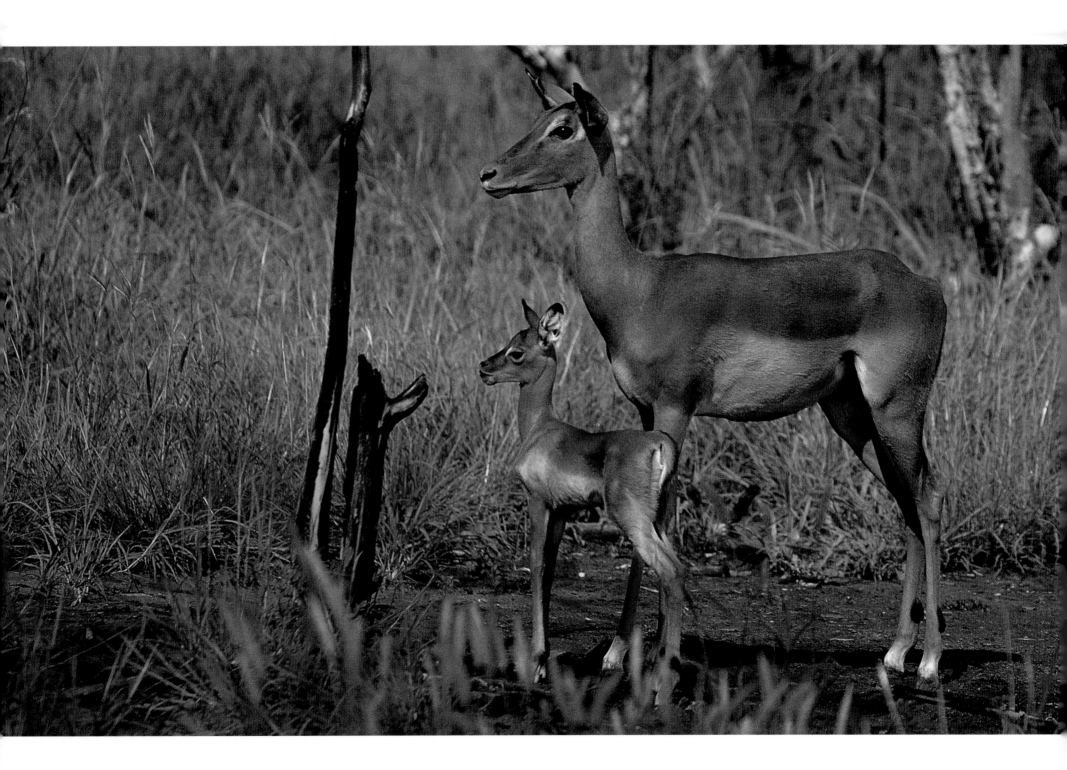

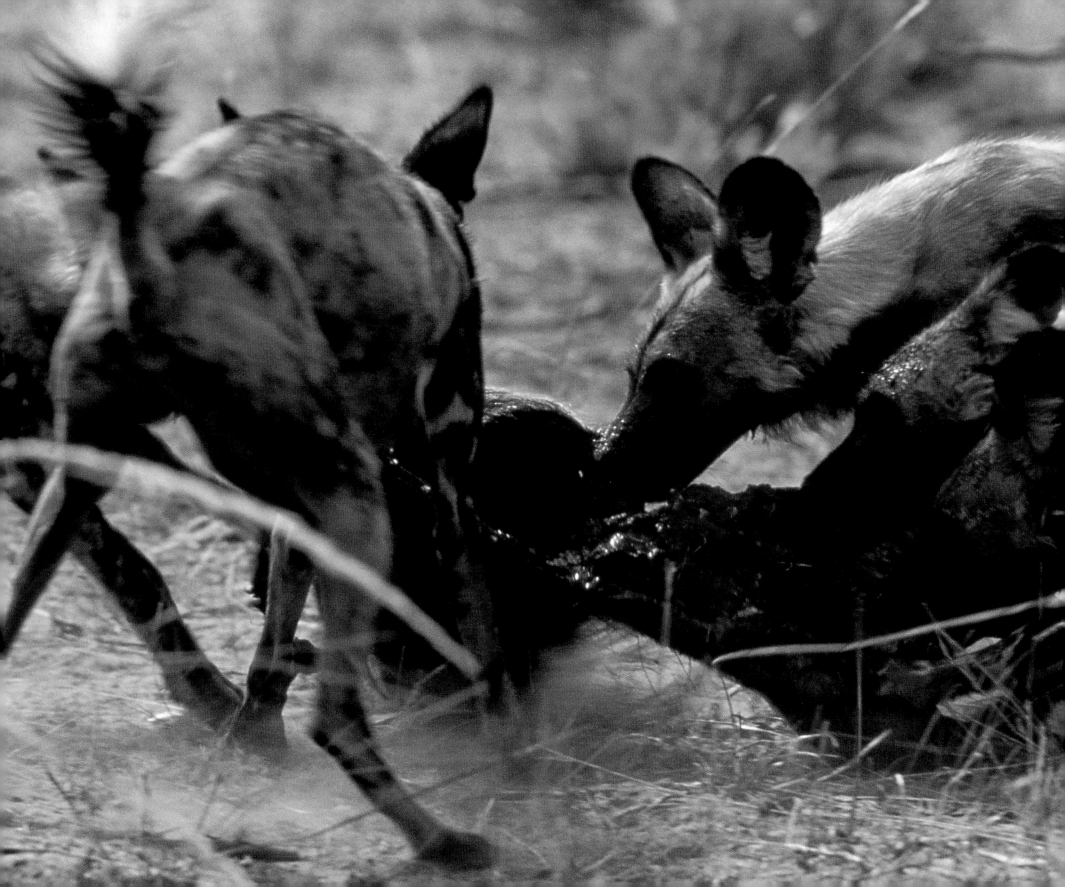

Wild dogs with kill

As we thought, the waterholes are where the action is, this time our arrival coincides with that of a small breeding herd of elephants with one very young calf. The adults drink from the muddy bank, the youngster struggles to get close to the water and slides down the bank. Then it battles to control its trunk to be able to drink – it's still very young and its trunk will be unmanageable for a while. Who can ever tire of watching these great beasts?

Usually when I see warthogs they're running away, aerial-like tails erect so it's quite a change to find two young boars having a dusty sparring match in a dried-up watercourse completely oblivious of us. I'm not sure if it's a serious fight, but they're really going head to head and those tusks can do a lot of damage.

We're off the Land Rover enjoying coffee when two wild dogs appear out of the bush, trotting past as if we weren't there, clearly on a mission. By the time we've clambered back on the Landy they've vanished, but John D picks up their tracks, it looks like they're headed for Tshukudu dam.

As we arrive, there's a terrible squealing; the rest of the pack are here, busy tearing a warthog apart, reducing it to flesh and bone in minutes. It's not a pretty sight.

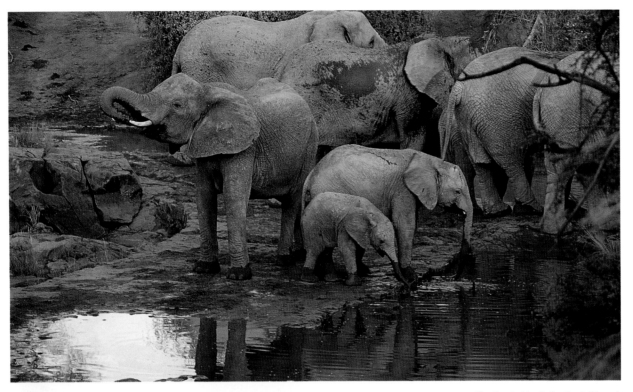

herd of eland drifting nervously away and a pair of rhinos chomping, their wide mouths clipping the grass down to the roots.

The grassy plain gives way to scrub thornveld and a sitting juvenile giraffe unfolds itself, standing-up and joining the rest of the herd – it's unusual to see these lanky animals sitting. They stride away but not too far and start feeding, one bending down in front of us, legs splayed, peering at us over a low acacia bush. One thing's quite clear, since my last visit the wildlife has settled down and become habituated to the new environment – it's now their home and we're just viewed as harmless intruders.

Another waterhole and an African spoonbill fishes in the shallows, a kudu herd approaches and starts drinking, two impala rams join them. An elephant appears from the tree line ambling towards the water; the kudu scatter – elephants can get very possessive about water.

A second elephant appears then more until there's a group of about ten or twelve heading for the water.

The Kudu hold their ground until a young ele chases them away. The elephants mill around, some drinking, others greeting family members. In the middle of this melee a bull in musth has designs on a cow in oestrus – he's laying his trunk along her neck then resting his head on her rump, a sure sign that mating is imminent. He mounts her, the rest of the herd backing towards the copulating pair, some urinating or defecating. Elephant mating is a communal business with lots of

Elephants block the ford (Above)

Spoonbill fishing (Left)

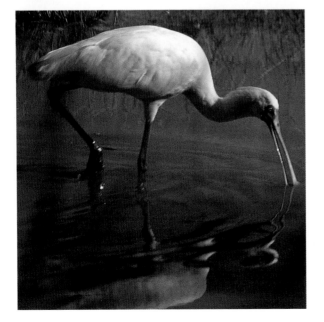

When we left the dam last night the dogs had all gone and I'm surprised to see three of them back this morning. They drink and trot off again, stopping on the road to check out some waterbuck deep in the bush. The dam is quiet, there are no other visitors this morning and we take time out to enjoy a cup of coffee before moving on.

The plain is reminiscent of the wide-open spaces of Serengeti or the Mara, not as big of course, but big enough. There's lots of general game around, grazing peacefully in the early morning. Zebras, impalas, a

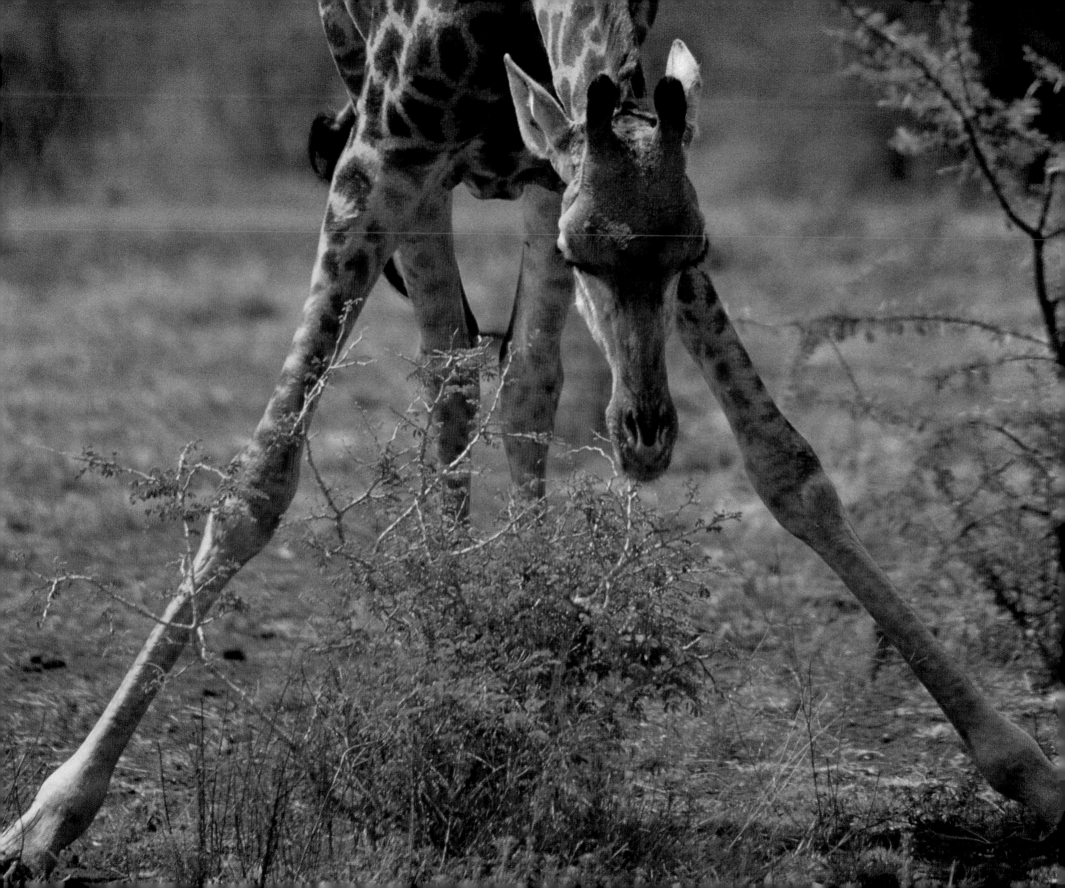

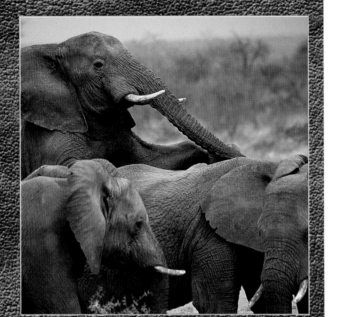

vocalising from the herd, quite unlike the solitary mating of lions we saw in the Mara. The elephants eventually move on and head for the trees leaving just one young bull in charge of the waterhole. The spoonbill carries on fishing, ignoring everything.

We head for camp making a small diversion to check out Tshukudu. The sun is dropping behind the Inselbergs, its golden light brilliantly illuminating three waterbuck cows seeking refuge on an island in the middle of the dam.

I heard lions in the night, they sounded quite close; John D plans to cross the river and scout the other side to see if he can find them. Our plan is thwarted; when we get to the ford it's occupied by a breeding herd of

elephants that seem disinclined to move, in fact a couple of females advance in our direction determined to chase us off. John D reverses so that we're not blocking their path but it doesn't help, they still come forward. Maybe it's a good idea to take another route, John D turns and we head off in a different direction. It's a serendipitous decision. Almost immediately John D picks up lion spoor – a male and female. "Very fresh," he says. The trail is clear and even I can follow it. The tracks turn off the road, fortunately the grass is sparse and the ground sandy, the paw marks easily visible. John D points out the size of the male tracks – they're big. The spoor leads to another path and standing there - looking at us as if to say, "Where've you been?" - a lion and lioness. John D was right about the male, he is powerful and the female a good mate, lithe and healthy. Another male appears from the bush, this one has only one eye, then another female and under a nearby bush a young lioness, still bloody from feeding on the previous night's kill. This is the nucleus of the Madikwe pride. They move into the shade and settle down – very relaxed and well fed.

It's a good time to leave, once lions settle down it's unlikely they'll move until they start the nightly hunt at dusk. Not far away a kudu bachelor herd browses on thorn trees, unaware of the nearby danger. A lone gemsbok lies in the thin shade of an acacia, then

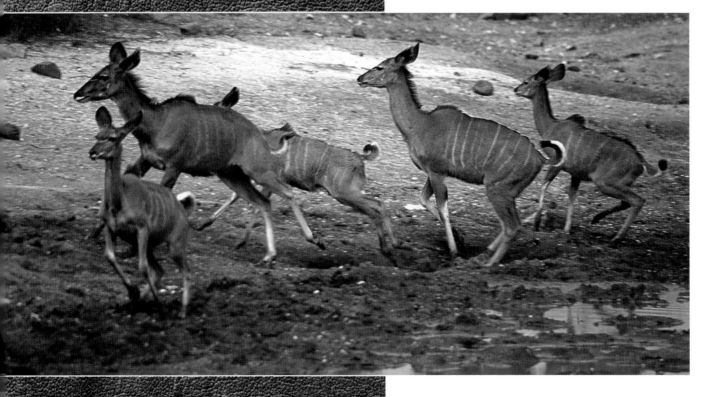

mating elephants (Above)

Kudu chased from water (Left)

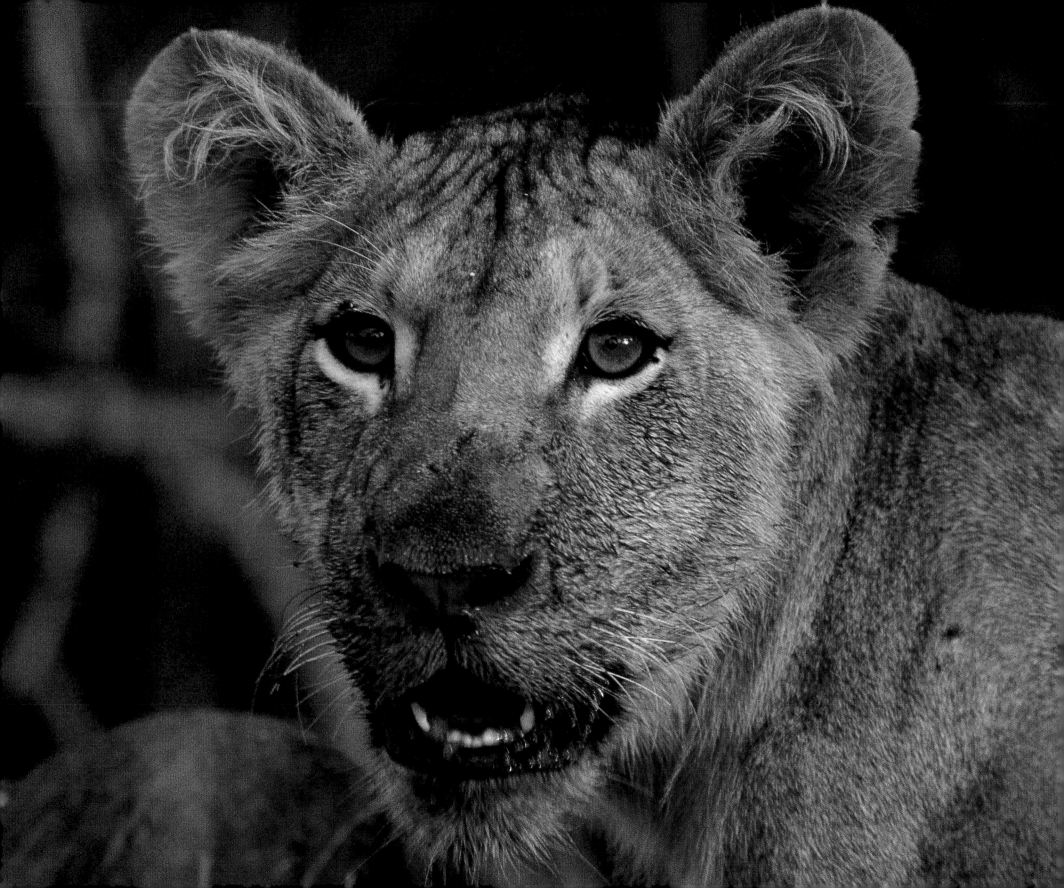

Warthog boars jousting (Above)

Ostrich pair heading into the sunset (Right)

stands – scimitar horns gleaming in the sun. Further on, John D stops as three ostriches appear out of the bush, a male, his red legs indicating his breeding season and two females vying for his attention. It's a strange performance, almost a dance as they move back and forth in an ancient ritual, until another female appears immediately grabbing the limelight and his full attention, drawing him away from the others before they trot-off into the sunset.

John D suggests an isolated waterhole for sundowners. Our approach stampedes some zebra into leaving and the waterhole is deserted until a lone giraffe appears striding down to the water for its own sundowner drink, standing tall against the setting sun.

Tomorrow we have to leave as early as possible. We're heading for the Okavango Delta and although Madikwe is right on the Botswana border we have to fly via Joburg to clear immigration. It would be so easy if we could just nip across the border and fly the six hundred kilometres to Maun. As it is, our journey is Madikwe-Joburg-Maun, nearly doubling our flying time and ironically our route from Joburg to the Delta will take us right over Madikwe!

Botswana

Okavango Delta
the de Voorsen Camps

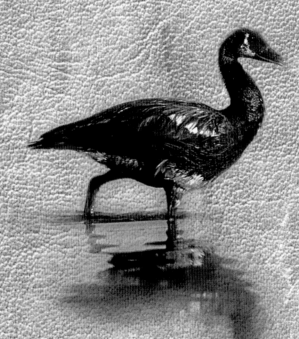

Botswana and the Okavango Delta had already provided us with our worst experience. It really is impossible to embark on a Safari without visiting the Delta, a true wilderness and a wonderful wildlife experience. A year ago we had made arrangements to film here. Wherever we go we rely on our hosts to organize any permits that may be needed, they're on the ground, usually know what is required and

have the necessary contacts. But for some reason they didn't get the necessary filming permit and on our second day the Wildlife authorities stepped in and stopped us filming. Not only that, they charged us – the police driving 140 kilometres from Maun to arrest us. The upshot was our tapes and equipment were confiscated, our departure was delayed and we had to appear in court. Fortunately. the police were very

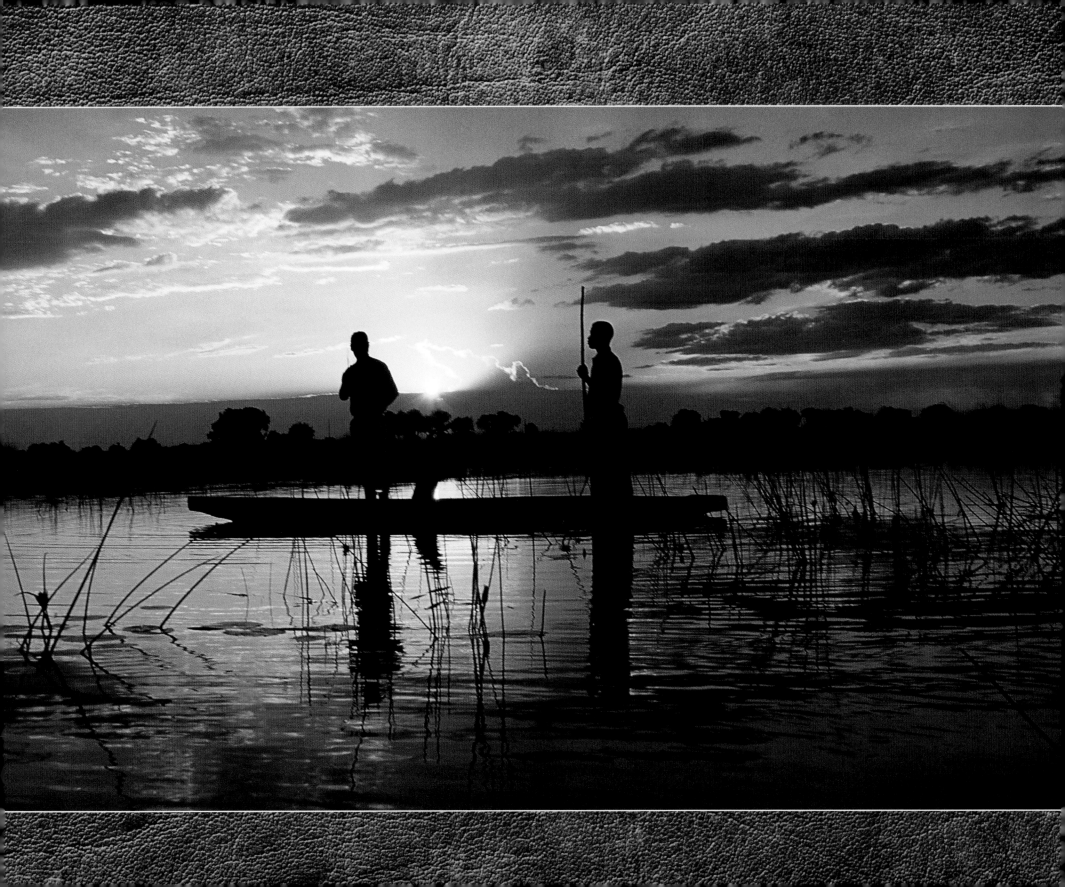

reasonable and didn't actually lock us up but it was touch and go. We spent a Sunday afternoon at Maun police station before being released on 'house arrest' with a warning to appear in court the next day. The camp owner flew in and employed a local lawyer to defend us. Well, he could have stepped straight out of LA Law, his performance in court was a tour de force and would have been the highlight of any TV series!

Sitting in the Maun court with sundry murderers and other serious offenders in leg irons was…. interesting!

We envisaged ourselves behind bars in a Botswana jail but fortunately the magistrate saw reason, our case was dismissed and we got our equipment and tapes back. Not a pleasant experience, though it's made for good dinner conversation and in retrospect seems to have its funny side.

"This time it's going to be different," I said. I'd had discussions with Ker & Downey, a very experienced Botswana operator and was satisfied that Nicky Keyes had everything organised. There are other plusses in dealing with K&D, the Delta is a huge area encompassing varied vegetation and very different areas; they have four camps in the Okavango and our safari taking us to all of them.

Walking at Footsteps (Below)

A labyrinth of channels and creeks (Right)

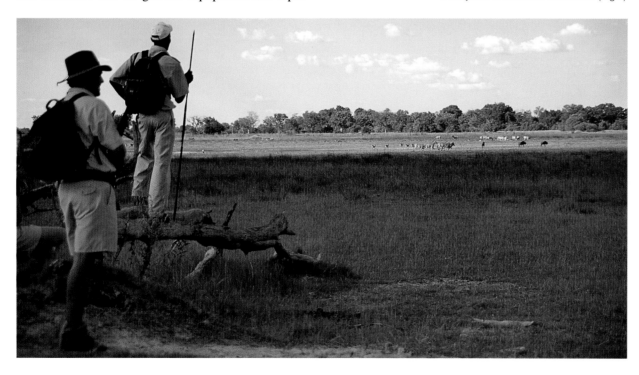

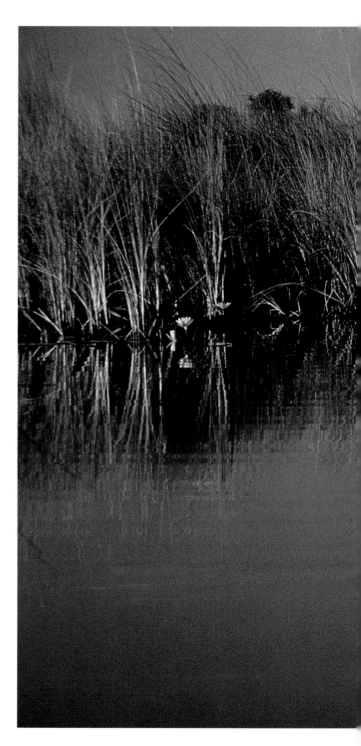

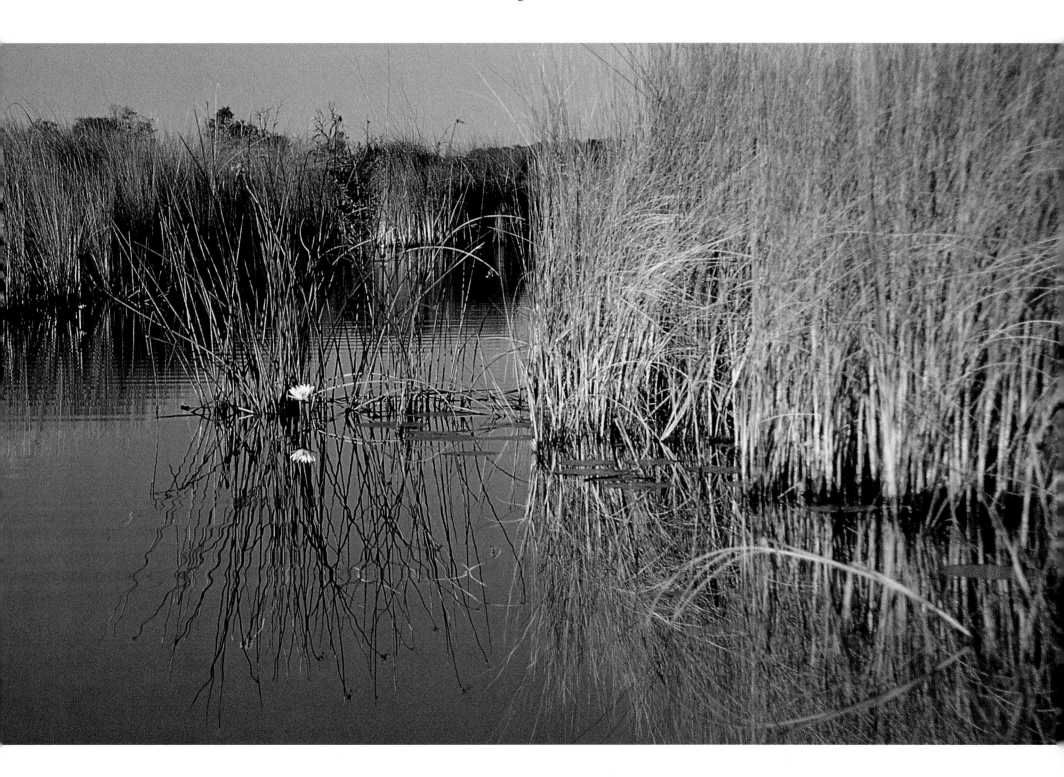

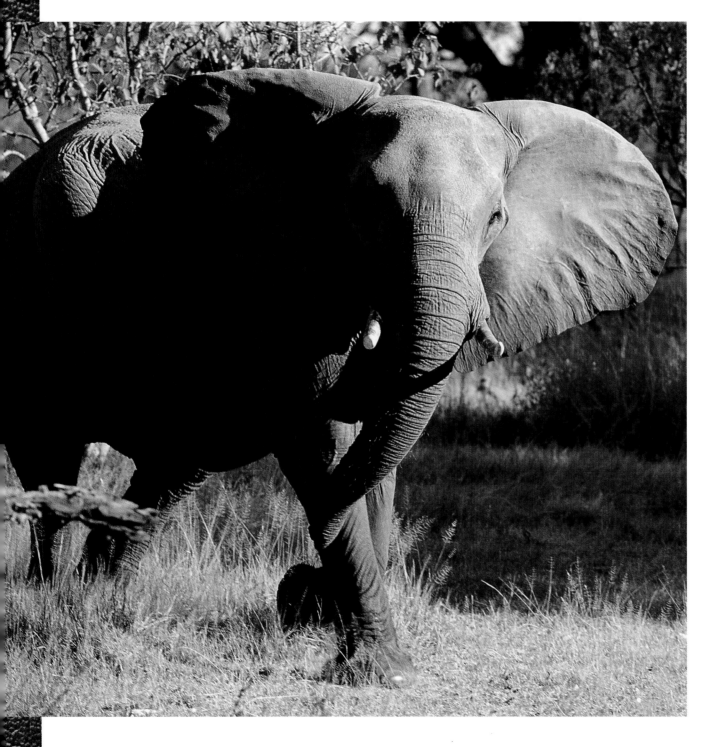

Air Botswana have just flown us from Joburg to Maun, the hub for the Okavango Delta and a jumping frontier-type town; its dusty streets patrolled by 4-wheel drives, big overland trucks and macho bush rangers in big hats and boots.

We cram our baggage and ourselves into a Northern Air Cessna and we're winging our way north to Kanana camp, a mere thousand feet above the ground. We haven't yet hit the wetland and everything is very arid. A giraffe moves languidly from the shade of a tree as we disturb its browsing. The Delta appears. From the air it reminds me of a gigantic golf course, one fit for the gods. Swathes of green interspersed with trees, sand, and lots of water. This is the world's largest inland delta – fifteen thousand square kilometres of wetland created by the Okavango river, rising in the highlands of Angola, flowing sixteen hundred kilometres until it reaches Botswana, where it spreads out dividing into myriad channels, creating an immense labyrinth of creeks, lagoons, islands, riverine forest and flood plains before being swallowed up by the dry sands of the Kalahari. Encompassing the Moremi Game Reserve, with Chobe National Park to the northeast, the Delta's waters are a magnet for thousands of wild animals and birds.

This is the dry season and the Kanana strip throws up a cloud of dust as we touch down. Stepping out of the plane I feel as if I've walked into a wall of heat. A Land Rover pulls out of the shade to meet us and we

A startled elephant charges across in front of us (Left)

Impala rams face off (Right)

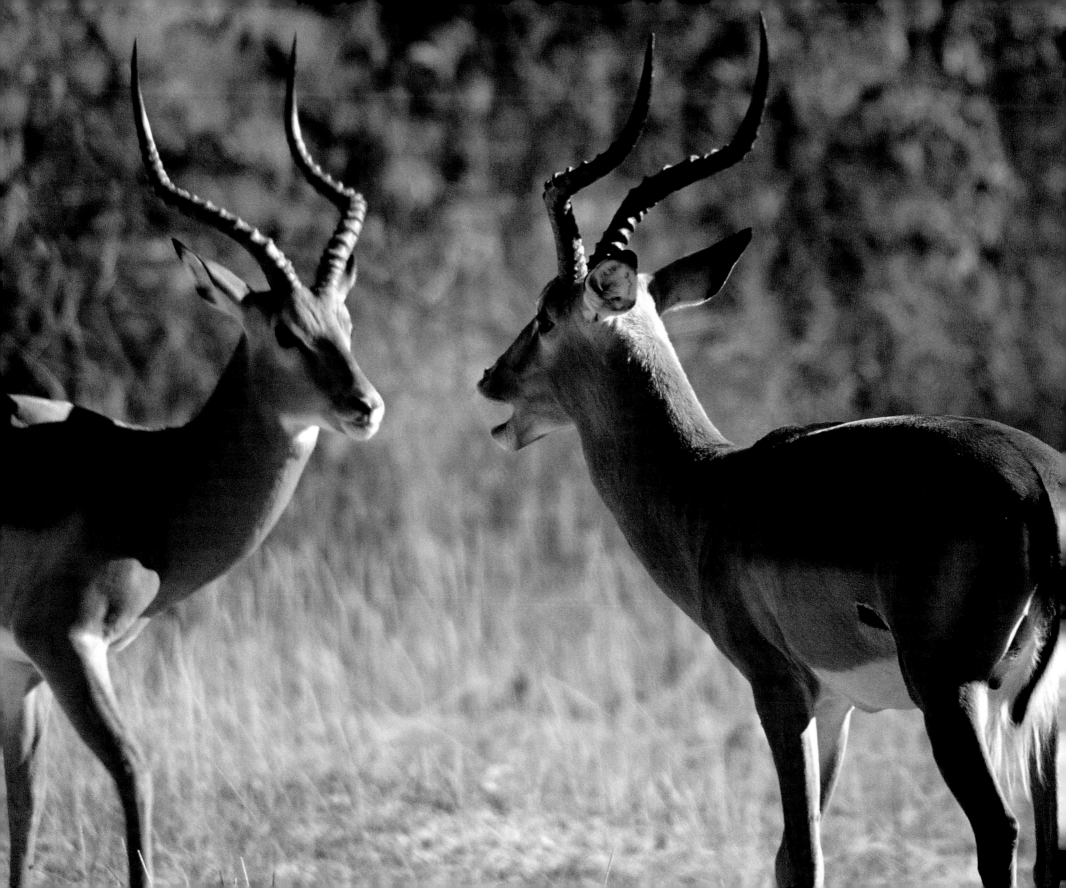

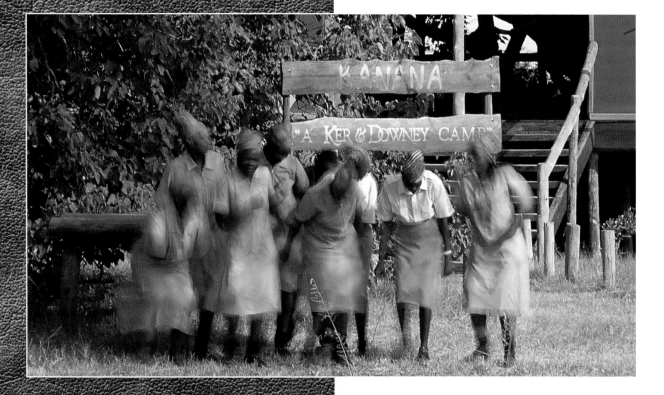

head for camp. As we arrive the Kanana ladies greet us with a Tswana dance and welcoming song.

Kanana Camp is just eight safari tents hidden away in the trees overlooking the Xudum River. The mess tent built in a 'U' around a huge old strangler fig tree is furnished with loads of character giving a wonderfully romantic feel of old Africa.

Our guide, TT, is driving as the Land Rover weaves its way through the riverine in the late afternoon sun. The animals are starting to wake from their mid-day torpor. An impala herd stands watching as we pass –

Candlelight dinner at Kanana (Left)

Kanana Camp (Right)

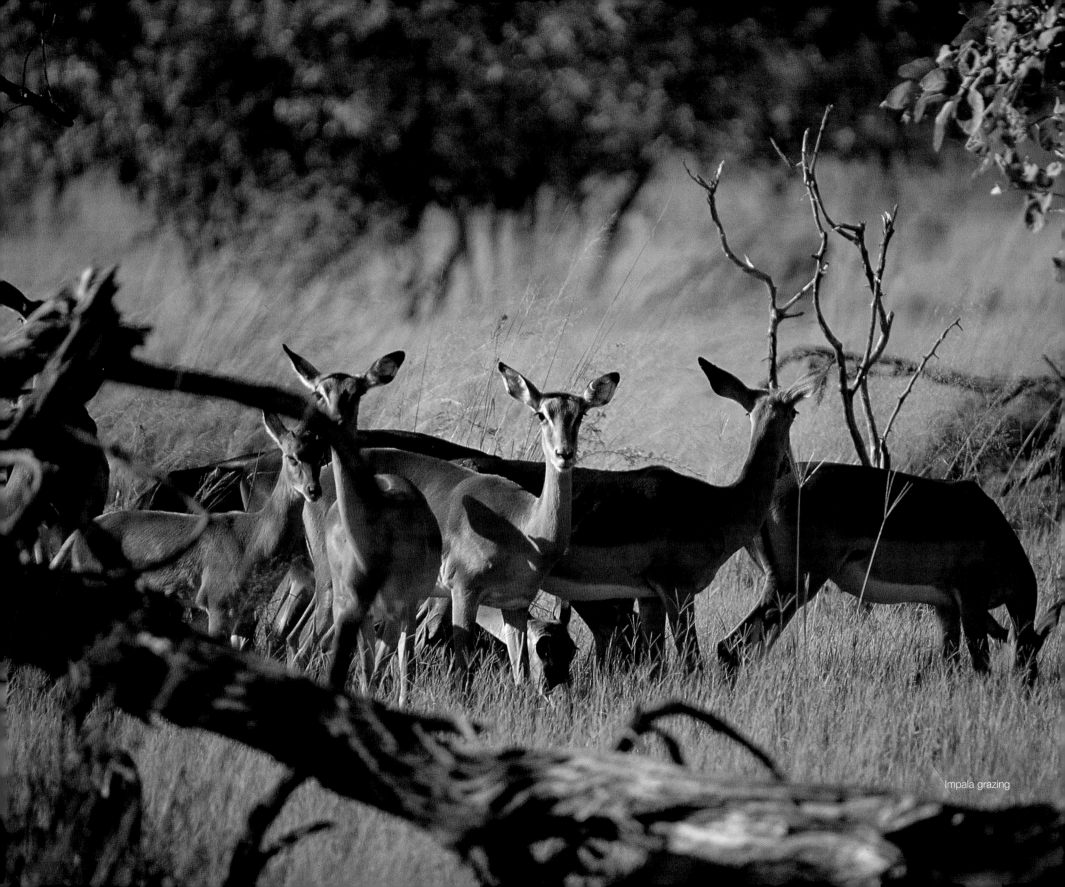

Impala grazing

nervous and ready to move at the slightest hint of danger. Ahead of us is one of the largest baobab trees I've seen – three massive trunks joined at the base. This is our destination for sundowners, a spectacular spot; the tree must be a thousand years old.

Kanana doesn't have electricity and we eat by candle-light on the deck overlooking a blazing fire. In the distance a lion roars, answered by one much nearer. A hyena whoops its lonesome call then silence as the African night closes in.

I wake to a lion roar close by. It's 4.30 and still dark. I grab my torch and camera and go out on the deck.

My torch picks up eyes – a big male padding softly through the grass not three metres away.

He stops and looks at me, I grab a quick shot, he blinks in the flash then turns away, vanishing into the long grass. Moments later I hear the lapping sounds of him drinking at the edge of the lagoon. We meet in the mess tent for early morning tea – everyone is excited, they all heard the lions but it's the first sighting at Kanana for two weeks.

Mokoros – dugout canoes – are the traditional means of transport in the Okavango. Historically carved out of a single tree, conservation has decreed that they are now made of fiberglass. They are the only craft able to navigate the shallow waters and narrow creeks of the Delta. Being on the water at this time of day is fabulous,

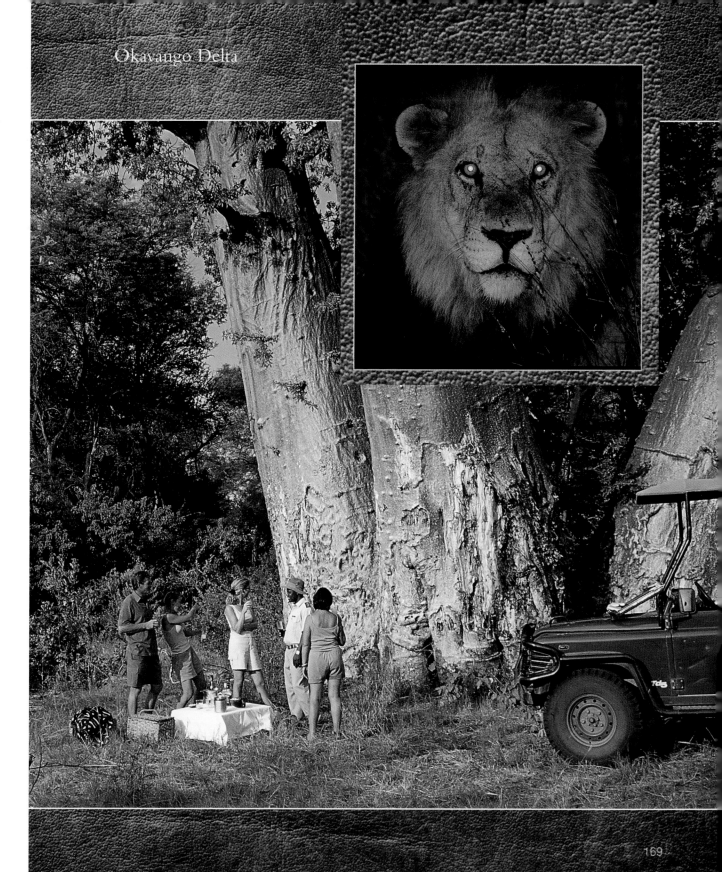

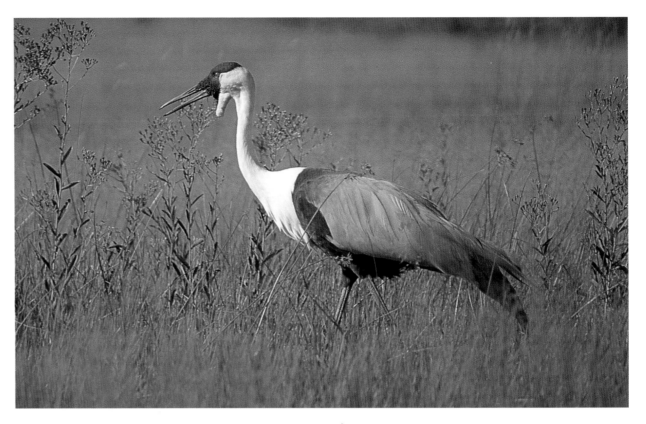

Painted reed frog (Top left)

Woodland kingfisher (Above)

Wattled crane (Top right)

Rufousbellied heron (Right)

so peaceful; the only sound water dripping off the pole as the poler lifts it out of the water. Birds are starting to stir and a spurwinged goose turns to watch as we pole by, his image mirrored in the still water of the lagoon. Hippos honk a warning and we change direction. Openbilled storks search for mussels, oysters and frogs and African spoonbills fish near a young crocodile basking on the bank. A brilliantly coloured malachite kingfisher poses on a papyrus reed. One of the most distinctive night sounds in the Delta is the call of reed frogs. Our guide points one out to me. At first I can't see it, it's so tiny – about 2 centimetres and the same colour as the reed it's clinging to. A woodland kingfisher eyes us from his perch, his red beak brilliant against the

blue sky. A lone giraffe lopes across the horizon and then an elephant appears, both too far away, but a reminder that wild animals surround us. We slip silently through the narrow channels back to camp encountering a saddlebilled stork on the way. I'm famished, I've been up for five hours and breakfast is very welcome.

Okuti Camp on the spectacularly beautiful Xaxanaka lagoon in the Moremi Game Reserve is a mere twenty minute flight from Kanana but here there's far more water.

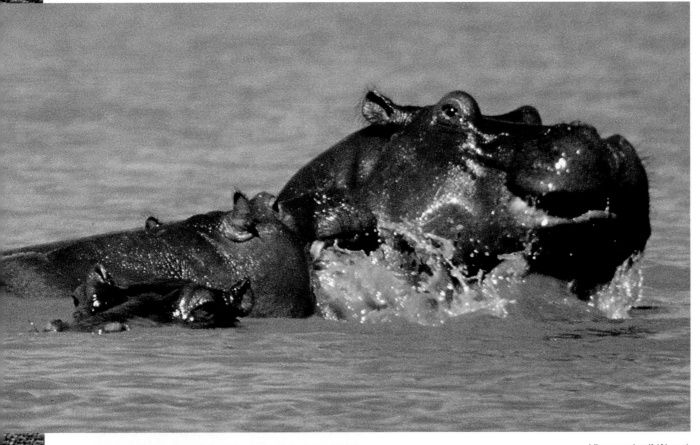

morning will be driving time. Big comfortable flat-bottomed boats ideal for the Delta, complete with cooler box for severe cases of thirst. I'd seen Xaxanaka lagoon from the air but nothing can compare with the sight as we leave the Okuti channel and enter the lagoon itself. It truly beggars description. Water birds are everywhere – darters, cormorants, egrets, herons – and the water lilies - it's like a fairyland.

African jacanas trot across the leaves turning up the edges looking for insects.

But it's the lagoon itself that captures the imagination. The sun is dropping to the tree-line on the far edge of the lagoon and the light is changing by the minute, the colours shifting from the harsh strong shadows of afternoon to softer oranges then reds as the sun gets closer to the horizon. The shallow water is still, reflecting and dissipating the rays. Silence reigns with just the chattering of birds beginning to roost for the night.

Hippo and calf (Above)

The two metre water monitor (Left)

African jacana (Opposite)

Early morning - elephants have been in camp feeding on the marula trees during the night, they love the fruit, it's one of their favourite foods. As we drive out of camp, a startled youngster charges across the road in front of us. The sun is beginning to slant through the trees and we stop to watch a pair of impala rams arguing over territory, the dominant one eventually chasing the other off.

Nicky is travelling with us and introduces us to camp manager Julius, a huge jovial guy who's been with K&D for twenty years. We settle our bags into the old-style thatched chalets then join Nicky and Julius at the open-air bar for a drink and planning session. While we're talking a water monitor emerges from the reeds and stalks across the grass; it's at least two metres long, by far the biggest I've ever seen. Water or land – boat or Land Cruiser? First water we decide, tomorrow

The trail takes us from one small lagoon to another. A hippo cavorts with her calf and water birds fish in the shallows. The terrain changes dramatically and suddenly we're in thick sand. Our truck lurches

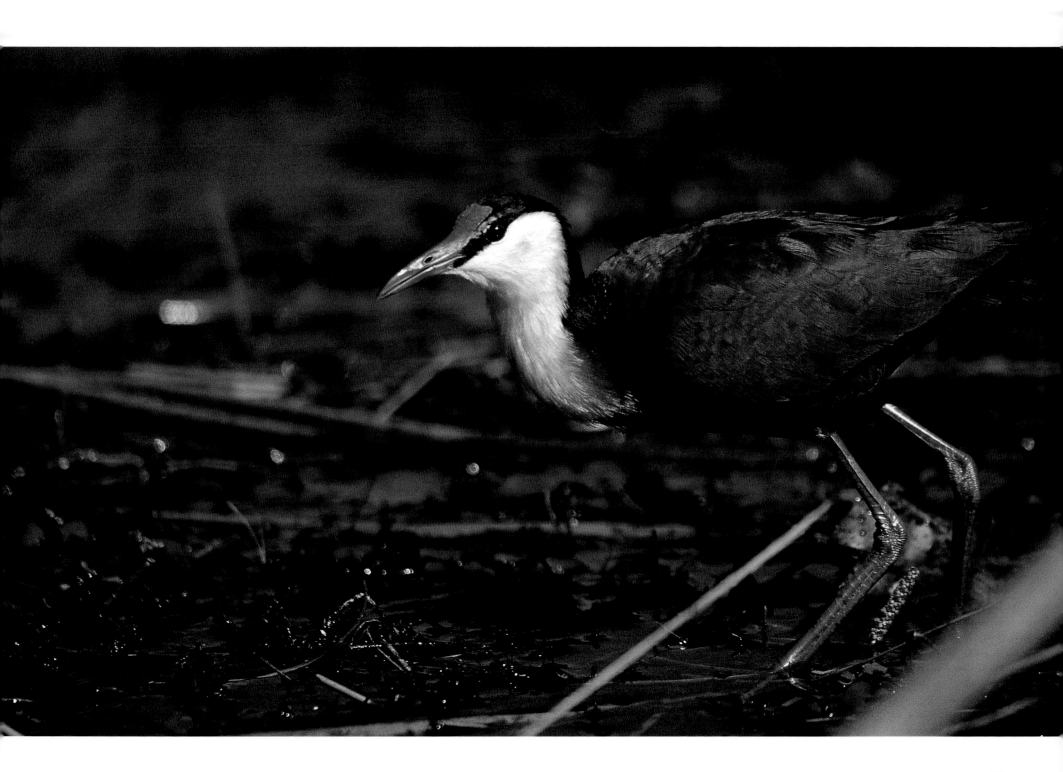

sideways, the wheels spin and we dig ourselves a deep hole. Our guide Alan radios the second 'Cruiser and Adam arrives.

We push, pull, dig, lay branches under the wheels, but no joy, we're stuck fast.

The more we try to get out the deeper we dig ourselves into the sand. We can't raise Okuti on the radio; we're out of range, we can only hope another vehicle will pass by. An hour passes and we hear an engine, a Land Cruiser appears. Fortunately they have a towrope and with a little effort from one vehicle pushing and the other pulling we extract our 'Cruiser from the sand and continue our meandering journey. A trio of ground hornbills hunt their way through the grass.

Driving through the aptly named Impala Forest we disturb a lone giraffe and she strides away scattering a small group of impala. A tree squirrel screeches a warning cry. Alan stops and looks around. Monkeys take up the alarm. Alan hushes us, there must be something around, a predator of some kind. He's searching through his binoculars and spots a twitch in the undergrowth. A young male leopard has just descended from his perch in a tree. He creeps away through the bush and Alan follows, but the cat is too quick and disappears, melting into the undergrowth. I think we've lost him but Alan picks him up again sneaking away from us. We track him as he tries to lose us; frustrated, he takes refuge in a mopane tree, stretching out along a branch some three metres up.

A monkey takes up the alarm (Left)

Alan pulls closer giving us a better view. This is one beautiful cat. He stares down at us now quite relaxed, secure in his position. But as soon as our second truck arrives he gets twitchy, sits up and peers down at us. He decides he's had enough and is just a blur as he scrambles down the trunk glaring at us before slinking off through the undergrowth. In seconds he's gone – this time for good.

We emerge from the forest to a remarkable sight, Goaxhlo also known as Dead Tree Island, named for the forest of fallen dead mopane trees drowned by rising water when the island was submerged. There are very few animals around, the grasses probably lack nutrition and it's only at the edge of the island where we find some lechwe feeding. Alan points, there's a lioness stalking them, hugging the ground using a fallen tree as cover. We stop to watch as she leopard-crawls forward on her belly, she only has eyes for the lechwe and creeps closer but the ram picks up her scent, snorts an alarm and they trot off, stopping a safe distance away – the females grazing, the ram alert, on guard. The lioness realises the futility of the chase and gives up, stopping to drink before stalking away towards some impalas. Maybe she'll have more luck with them.

Back in the riverine a small elephant herd hurries through the trees, a young male stopping to wave his ears and trunk, warning us off. Kudus stop browsing and stare as we pass. We bump through a shallow donga, push through the thick bush and emerge into a sandy clearing disturbing a pack of madutch - wild dogs or Cape hunting dogs - enjoying the late afternoon sun. They're pretty relaxed too, I'd guess

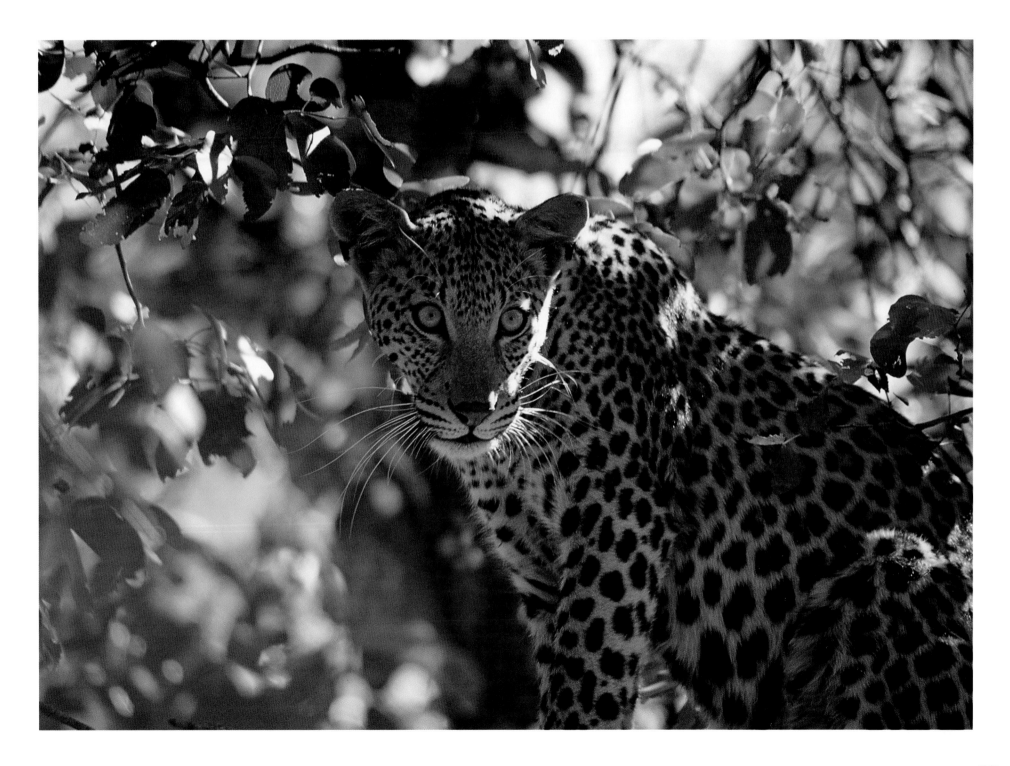

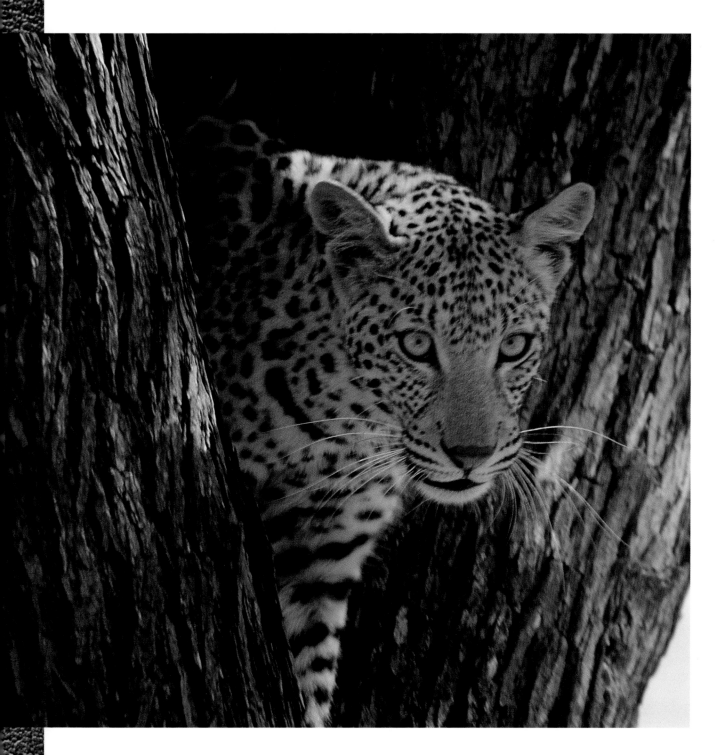

they've eaten recently - something big, kudu perhaps or wildebeest, something to have satisfied the pack, otherwise they'd be milling around getting ready to hunt again. I think the Latin name Lycaon pictus – painted wolves – perfectly describes these beautiful, and endangered animals.

It's amazing how everyone gravitates to a fire, no matter what the temperature.

Although the sun has gone down on Okuti it's still hot, but the fascination of the fire draws everyone to its glow to enjoy the camaraderie and icy drinks.

Tomorrow we're due to fly to Footsteps, but I ask Julius if it's possible to go by boat. He says the water is low but the channels to Footsteps are clear and we should have no problems.

It's a good decision, giving us a different aspect of the delta. The vegetation changes constantly, round every bend a more beautiful vista, an elephant comes down to bathe, water birds fly ahead of us. Some of the channels are very shallow and we ground on a sandbank but Alan manages to push us off, more seriously our propeller snags a sunken log and a blade shears off. Alan tilts the motor to check for damage, he says it'll be OK as long as we travel slowly. We stop for lunch on Gadikwe Island disembarking only after Alan has checked for crocs.

Footsteps' manager Peter, known around Maun as Ranger Rick, is waiting to transport us to the camp.

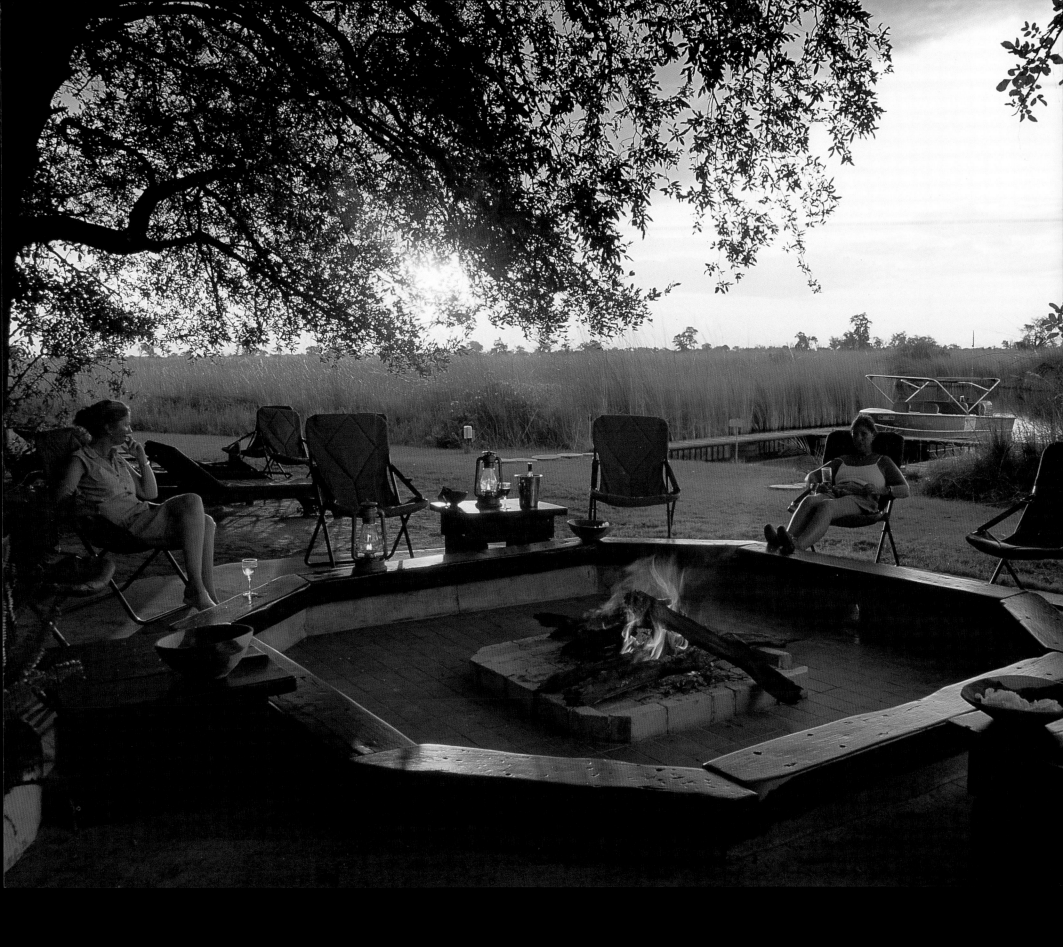

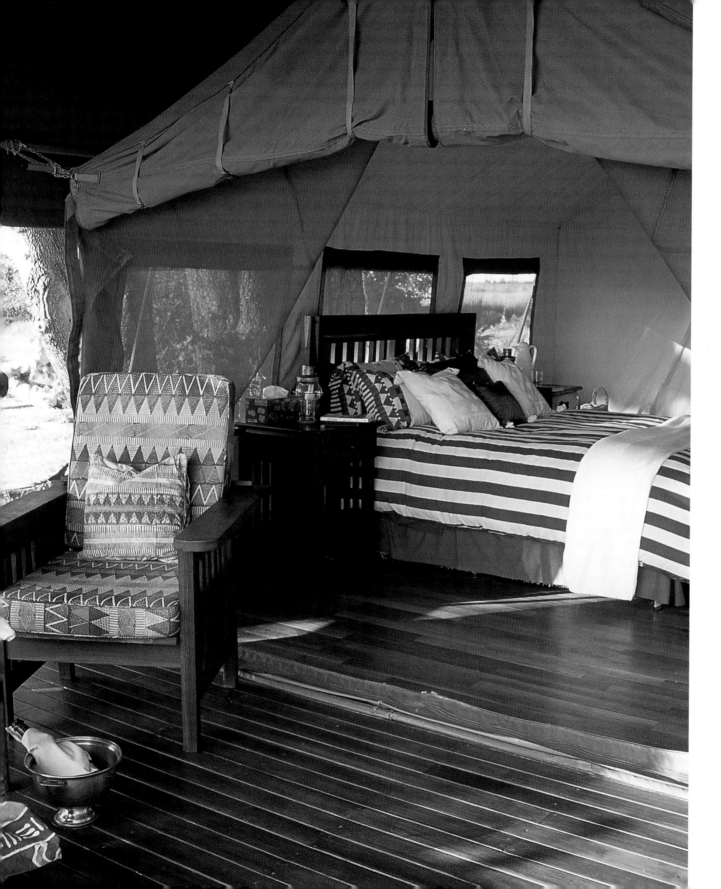

It takes only a short time to discover that he has a wicked sense of humour and loves taking the mickey. Sue ripostes, naming him Ranger Dick. It's clear on the drive to camp that our couple of days with Peter are going to be a real laugh.

Footsteps is a moveable fly-camp but a rather luxurious one.

It's a very different experience from both Kanana and Okuti. The tents are smaller than traditional safari tents, but big enough to stand in and extremely comfortable. The camp is on the banks of a small lagoon and transport here is either mokoro or on foot. Peter is a specialist walking guide as well as being an expert fisherman. Footsteps is actually just on the edge of the Delta and backs onto a huge savanna area teeming with plains game and the predators that prey on them.

Exploring the camp I discover a unique feature, a hip bath set in the middle of the bush - got to try that! Further exploration brings me to the kitchen. It's very primitive, open fires, a deep pit lined with hot coals and a tin trunk used as an oven! The only concession to modernity is a gas fridge and freezer – ice after all is an absolute necessity. Well it is in my book!

"Knock, knock – tea, tea." My shower has been filled with buckets of steaming water and I shower under the stars then head for the mess tent. There's a chill coming off the water, the ashes from last night's fire have been re-kindled into a small blaze and we huddle round enjoying tea and rusks. The sun breaks

Whitefaced ducks (Above)

through the trees behind us as boatmen prepare the mokoros. We're going to reconnoitre the creeks and islands around Footsteps. We pull out of camp in a small convoy, the channels are narrow, literally the width of a hippo and our guides struggle to negotiate the twists and turns through the dense papyrus. The channel opens up, a red lechwe bounds away in a high kicking flurry of sun-speckled water. A hippo pod bellows a warning and we reverse rapidly. Our boatman points and mouths "Sitatunga," a rare sighting. I struggle unsteadily to my feet in the unstable craft but too late, it's gone. The silence around us is almost deafening as we twist and turn through the narrow channels.

Fishing here is all catch and release and Peter demonstrates, casting into a favoured pool. A couple of casts and he gets a bite. He reels in a wriggling bream. He immediately clips off the hook, returns it to the water where it swishes its tail and shoots off seemingly none the worse for its experience. Such a quick catch stirs my interest in becoming an angler – well, almost.

Walking with 'Ranger Dick' is quite an experience. We set off at first light. At this time there's no real activity but as the sun comes up the francolins screech their morning call then the bird chorus starts. Peter stops and produces coffee from his backpack – very

179

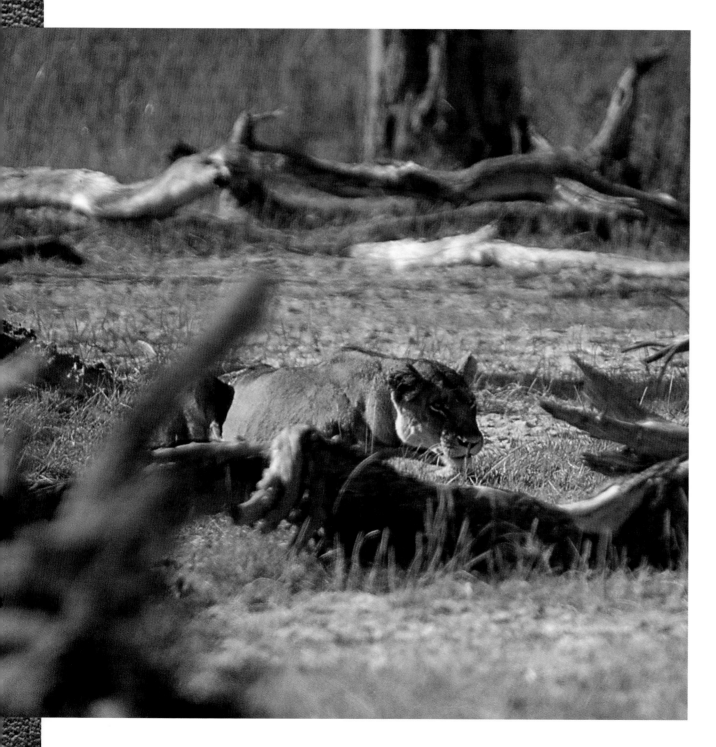

welcome, it's surprisingly fresh at this time of day. But it's quickly warming up as the sun climbs in the sky. Peter clambers up a termite mound to look around. He points off to the east, some zebras moving towards a waterhole.

Apart from the zebra there are wildebeest, impala, tsessebe and lechwe making their way to drink and unusually an African fish eagle on the ground. We change direction to avoid the herds and suddenly Peter stops, pulls out his binoculars and looks towards a grassy knoll. Without a word he hands me his glasses and I pick up a lioness sitting under a bush on a termite mound watching the action at the waterhole. Peter backtracks taking a wide detour, approaching her upwind, using the cover of bushes, trees and the large hummocks dotting the area. He stops and we crouch down.

The lioness is intent on her potential prey and either hasn't seen or is just ignoring us.

We're about twenty metres away – close enough! She moves slowly down the mound, disappearing in the long grass. She's at least a couple of hundred metres away from the nearest animal, it's going to be a long stalk and she's on her own, which will make the kill more difficult for her. I've completely lost track of her in the long grass. Peter points her out to me, she's motionless, almost invisible, just her twitching ears giving her away. We decide to leave her in peace and back away.

Zebras with attendant egrets trot off as we approach and just further away near the tree line are some

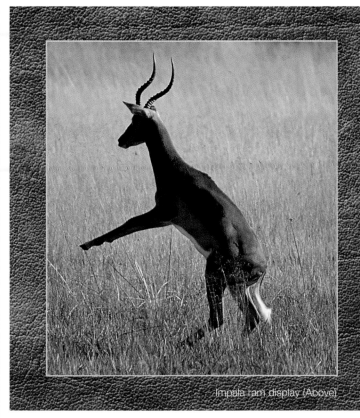

Impala ram display (Above)

impala, a mature male and his harem. A couple of females wander off, but he rounds them up. The small herd is suddenly alert all facing in the same direction, grooming and grazing forgotten. I don't know what's disturbed them, I can't see anything. The ram moves towards the treeline then does something I've never seen before, he stands on his hind legs taking a couple of steps then repeats it kicking his front legs. There must be something in the trees that upset them but whatever it is has obviously moved away because they relax and continue the grooming and grazing, the ram keeping an eye on his group, still very wary.

It's late when we get back to camp elated by some unusual sightings, the impala ram's behaviour quite bizarre.

Our journey to Shinde takes us through two river crossings, one very deep, the water flooding in over the floorboards. Fortunately the 'Cruiser has a snorkel and Peter easily negotiates the water. The camp is an oasis of giant ebony and sycamore trees set on the scenic Shinde lagoon backed by wide savanna and melapo – flooded plains - with resident herds of red lechwe and tsessebe and regular elephant visitors that come into camp whenever they feel like it.

As in all Ker & Downey camps tea arrives at our tent at 5.30 with the customary "knock, knock – tea, tea."

I'm enjoying a high-pressure hot shower, watching the stars fade as the sky lightens.

James is our Shinde guide, a savvy long-time resident who knows the Delta like the back of his hand. He found lions with cubs yesterday and we head for where he last saw them, an open area on the edge of a swamp. He says they won't travel far with such youngsters. As we approach, a lioness is standing up to her shoulders in the water; it looks like she's chased a lechwe deeper into the melapo – unsuccessful in her hunt. The cubs are standing on the edge watching. She turns

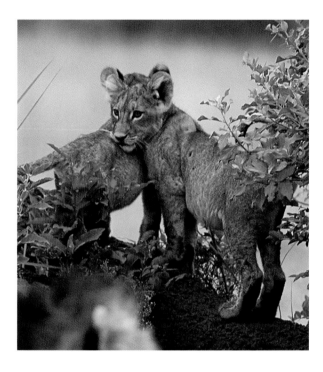

and leaves the water, her cubs following. We tag along as she stashes the cubs safely under a bush and heads off onto an island. Another female joins her they're clearly on a serious hunt. They're looking purposefully at something behind some bushes, out of our sight. They pad forward slowly intent on their prey then explode into a charge. There's a loud splashing, an anguished squeal, then silence. This time they've been successful and re-appear in the open, one searching for the cubs, the other dragging a dead lechwe. She drops it panting heavily then picks it up again and drags it to the cubs' hiding place. We can barely see them but can hear them gnawing on the carcass. They

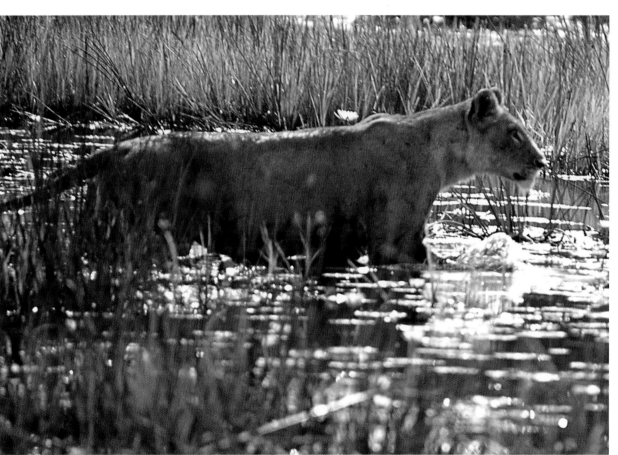

Marabou stork & Vultures (Right)

182

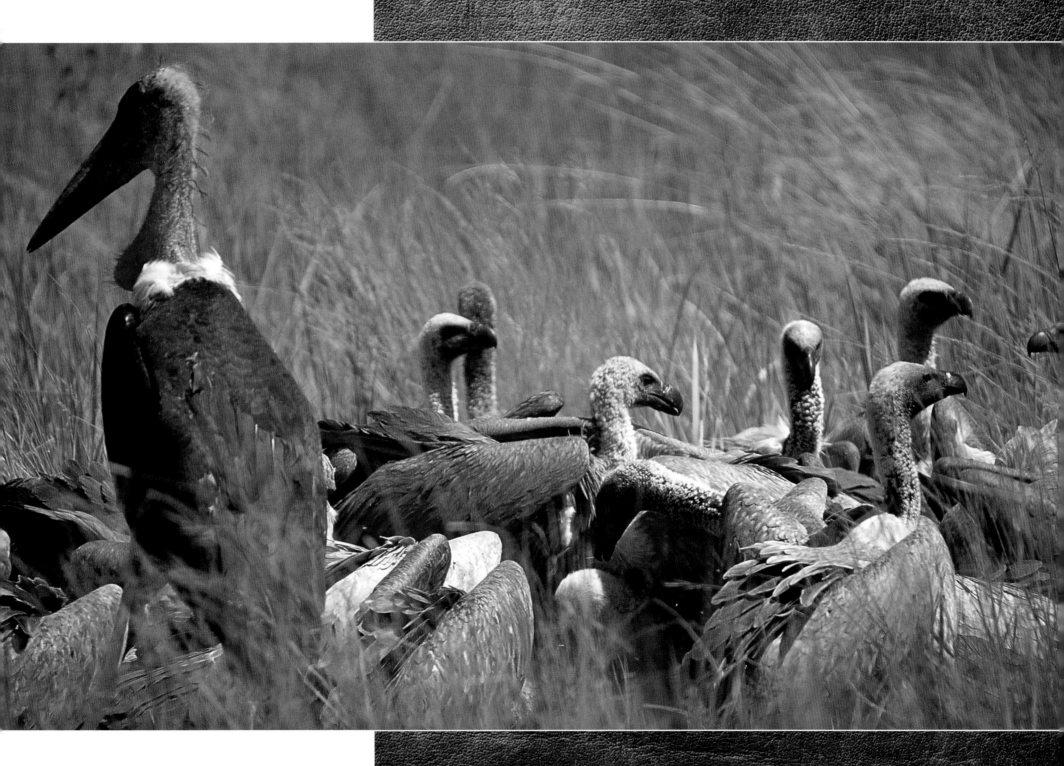

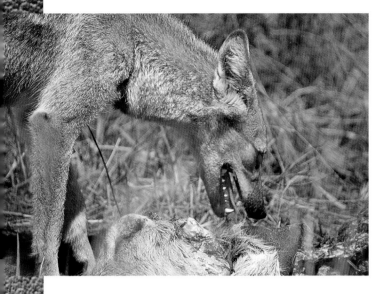

Side striped jackal

As night closes in, painted reed frogs start their rippling calls and other night sounds join the chorus, it's time to head back to camp.

Our first stop this morning is the swamp where we saw the lion kill. A handsome red lechwe buck moves into the water as we approach then stands watching us. A pair of spurwinged geese hunt in the shallow water and whitefaced ducks squabble in the background. James says the lions must be around somewhere. We find them stretched-out enjoying the warmth of the early morning sun. The cubs are quite active, the young male noticeably more dominant and very inquisitive. He's just seen some lechwes and is starting to stalk them. A bit out of his league I think, but good practice for when he grows up.

We have a plane to catch in Maun so we start to make our way back to camp. Cruising through the long grass we come across a pair of wattled cranes – an endangered species and a rare sighting – another highlight of our Okavango expedition.

I duck as Clifford comes in low almost giving me a close haircut. It's only minutes to load up and take off. I persuade Clifford to do a couple of low passes over Shinde and my last sight is of elephants feeding on the plain.

move deeper into the encompassing grass completely out of our sight.

James has spotted vultures circling and drives through the long grass towards them. There are dozens on the ground tearing at a lechwe carcass and pecking at each other. A marabou stork stands in the middle as more wheel in; off to our left a side-striped jackal gnaws at the skull. Of the killer there's no sign but James thinks it was cheetah or leopard. "Lions," he says "wouldn't have left as much behind." As we leave the scene a lappet-faced vulture glares malevolently from a tall termite mound.

It's been a full day and we head for the water to enjoy sundowners and the peace of Shinde lagoon.

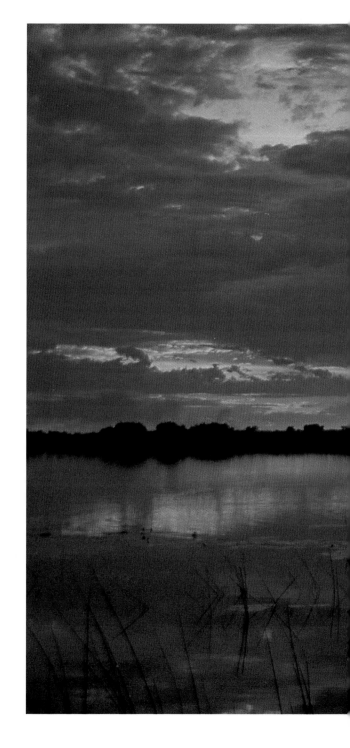

184

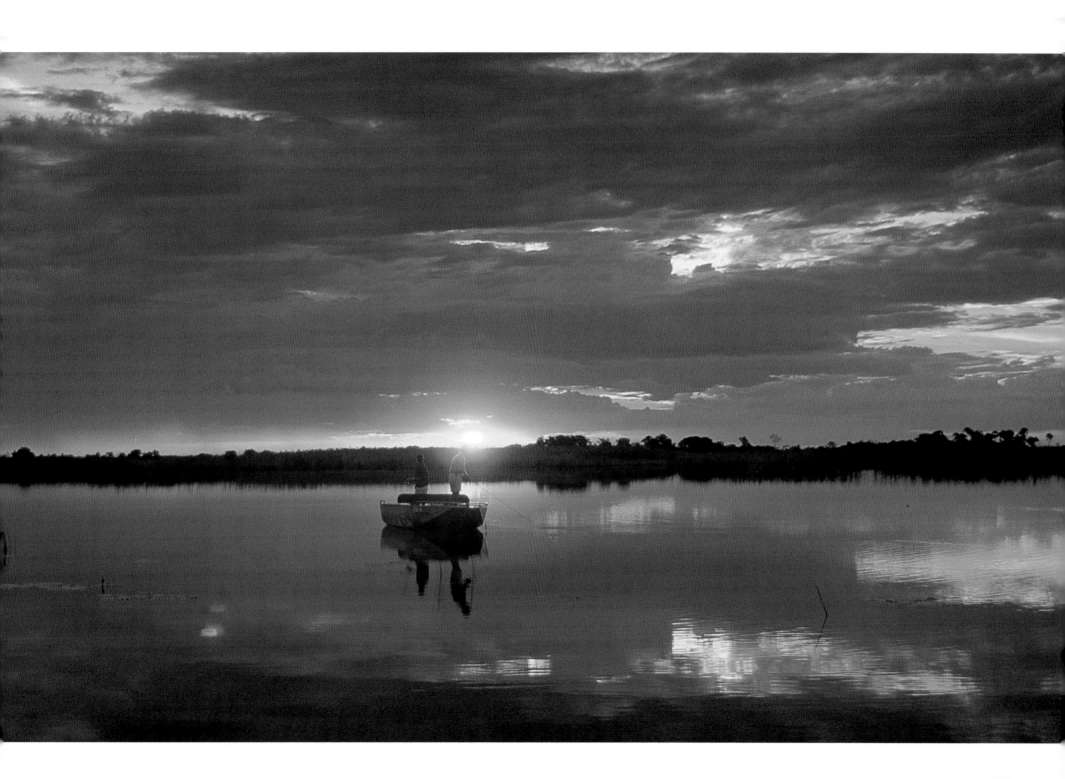

Sabi Sand

Mala Mala

My journey has taken me from South Africa through Botswana, Namibia, Zambia, Tanzania, Uganda and Kenya exploring just a handful of the many places I plan to visit. Our TV series is finished but my safari is not; to complete this, the first stage of my odyssey, I'm returning to the birthplace of the African Photographic Safari – South Africa's game-rich Sabi Sand Reserve. I'm taking time out to

photograph wildlife without the encumbrance of filming and there are a couple of safari pioneers I want to talk to.

By its very nature the safari world throws up characters. On our travels we met Kenya's pioneering Aris Grammaticas whose story I still have to capture, the passionate Sabi Sabi team of Michel Girardin and

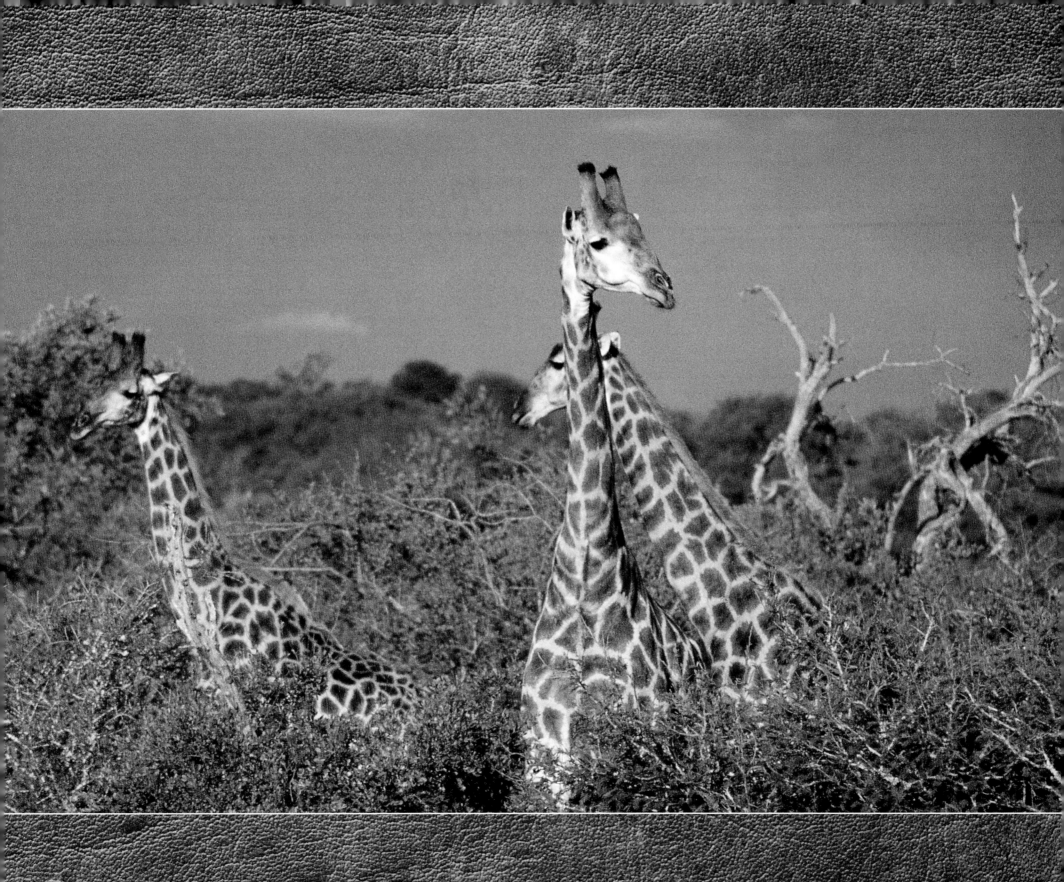

Patrick Shorten and the young free spirit Ben Parker of Tongabezi who would undoubtedly have been an African explorer, or perhaps privateer, in the 19th century and even today is a safari ground breaker and pioneer in a 21st century kind of way.

Mala Mala, the name is synonymous with the very best in African safaris, conservation and luxury game camps. It was in 1927 that legendary hunter, conservationist, raconteur and African character 'WAC` Campbell acquired Mala Mala, leading hunting safaris and entertaining his friends. In the 50's he handed over to his son Urban. After his father's death in 1962, in a ground-breaking move, Urban replaced the gun with the camera, marketing Mala Mala as a bushveld paradise. In 1963 he decided to sell and 'WAC's' old

friend and fellow farmer, Loring Rattray, who already owned adjoining Exeter, snapped it up. It was Loring's son Mike, the present owner, who saw the burgeoning public interest in the neighbouring Kruger National Park and made the decision to go full-bore and launch photographic safaris in a big way.

In the intervening years he's acquired more land and today Mala Mala encompasses 18,500 hectares – 46,000 acres – bordering the unfenced western boundary of the Kruger.

It was in fact Mike who championed the removal of all the boundary fences between the Kruger and the

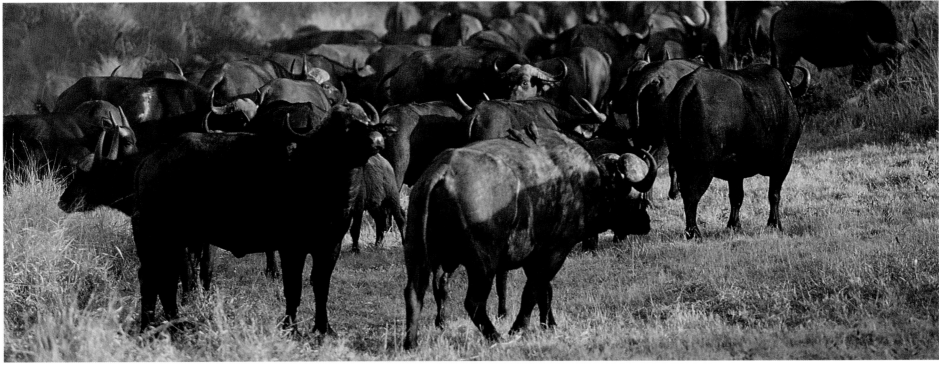

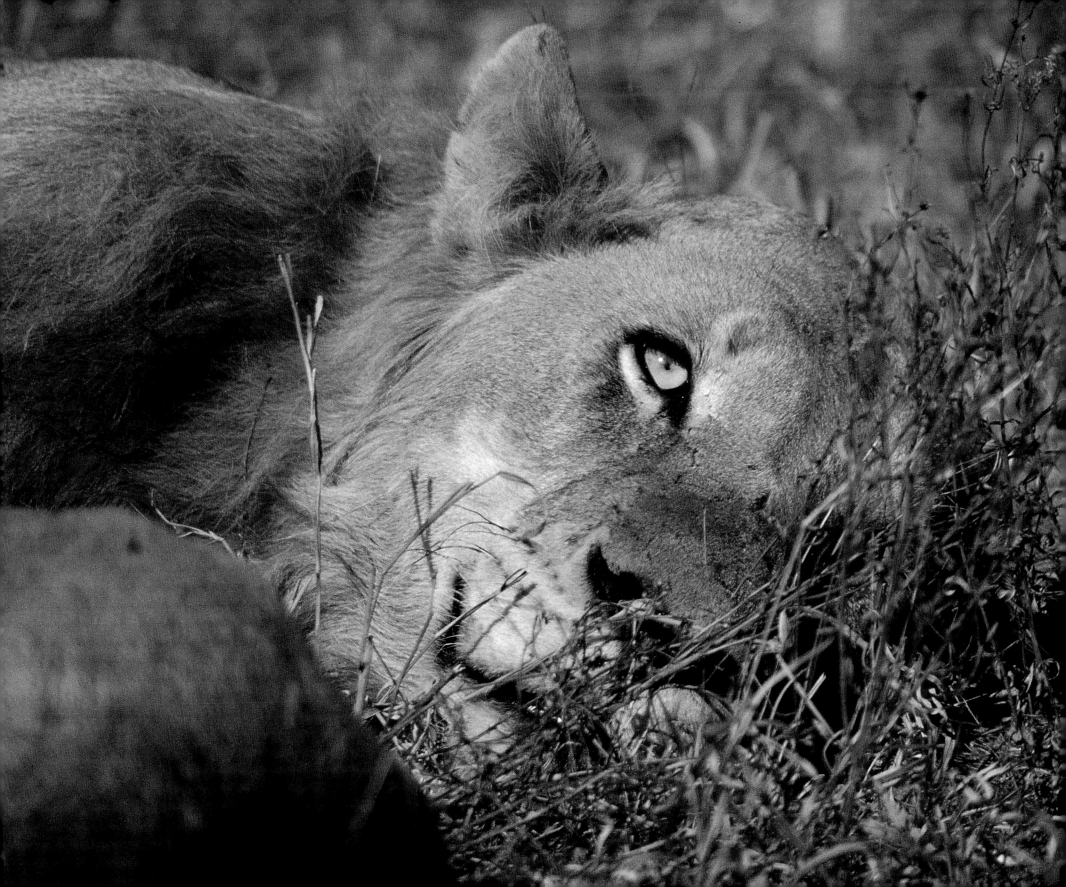

Leopard mother and cub

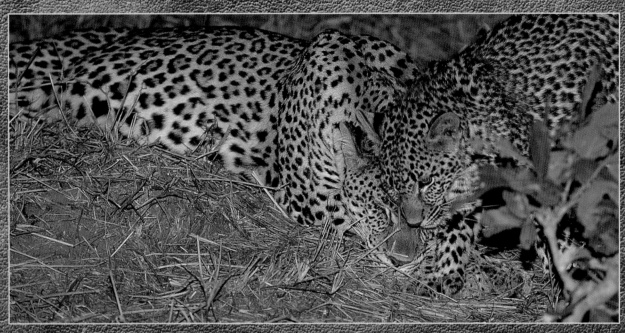

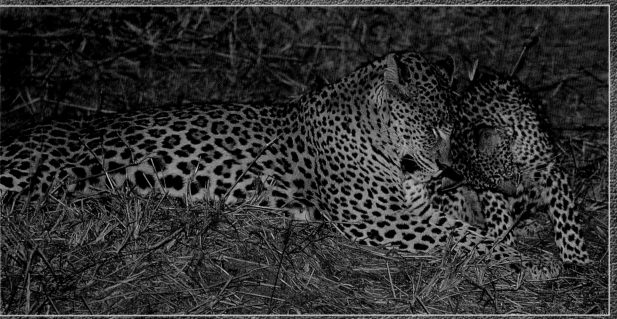

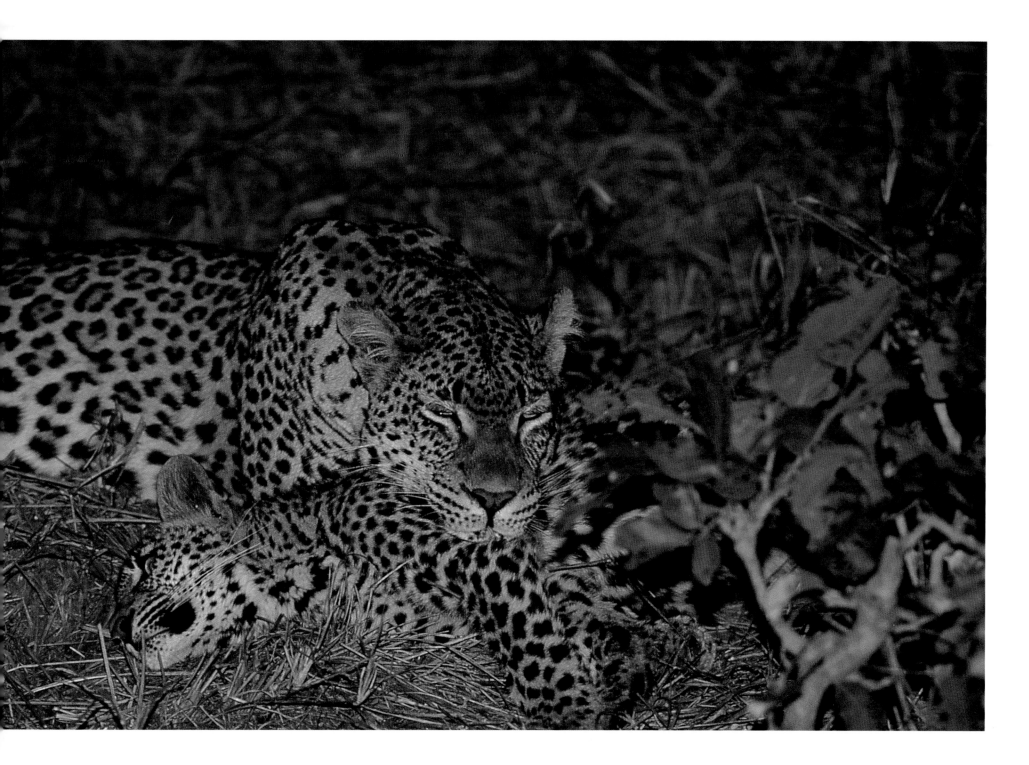

private reserves, thus incorporating the Sabi Sand – and further north the Manyaleti and Timbavati – into the Greater Kruger area of more than 22 million hectares of unfenced wilderness.

Sitting with Mike, farmer, international polo player and horse breeder, at Mala Mala Main Camp overlooking the Sand River – a magnet for wildlife, especially in the dry winter season – it's apparent that he runs a very hands-on operation. We're constantly interrupted with 'Mr Rattray this', or 'Mr Rattray that'. Nobody calls him anything but Mr Rattray, an indication of the great respect everybody has for him. It's fascinating that forty years down the line, Mike still has his finger on the pulse of every aspect of Mala Mala from the latest game sightings, to which ranger has dinged a Land Rover.

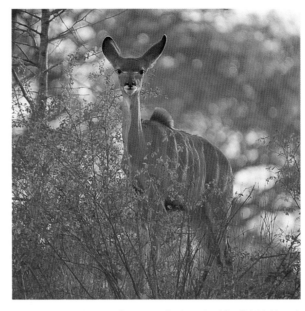

A nervous kudu poised for flight (Above)

Leopard - King of his realm (Right)

I ask Mike about his safari beginnings, how and why he pioneered the Photographic Safari. "Well," he says "I'd inherited Mala Mala at the time hunting was going out of favour. I looked next door at the Kruger and saw that the reserve was attracting more and more visitors, fascinated by the possibility of seeing wildlife in the raw. I decided that that was where our future lay, rebuilt our camp and opened to visitors." "Must have been great – no competition," I say. "Not at all," he replies. "Our competition was the Kruger. In fact when we started marketing Mala Mala our slogan was 'In the Kruger you see people, at Mala Mala you see animals'." As Mike points out this was the first time guests were able to go into the bush off-road, tracking animals, guided and informed by expert rangers and enjoy comfortable, later to become luxurious, accommodation.

Getting Mike to talk about himself is difficult – he keeps changing the subject – so I ask him about any memorable experiences or encounters. "We had a local dignitary staying, a politician with six bodyguards. I was escorting them to dinner when we came face to face with an elephant. He was browsing peacefully but instead of just backing off, the bodyguards rushed forward pulling out their pistols. Of course I stopped them, those little popguns would only enrage the animal, they certainly wouldn't have stopped him!" "So what did you do?" I ask. "Just backed away and took another path!" he says, "If you leave animals

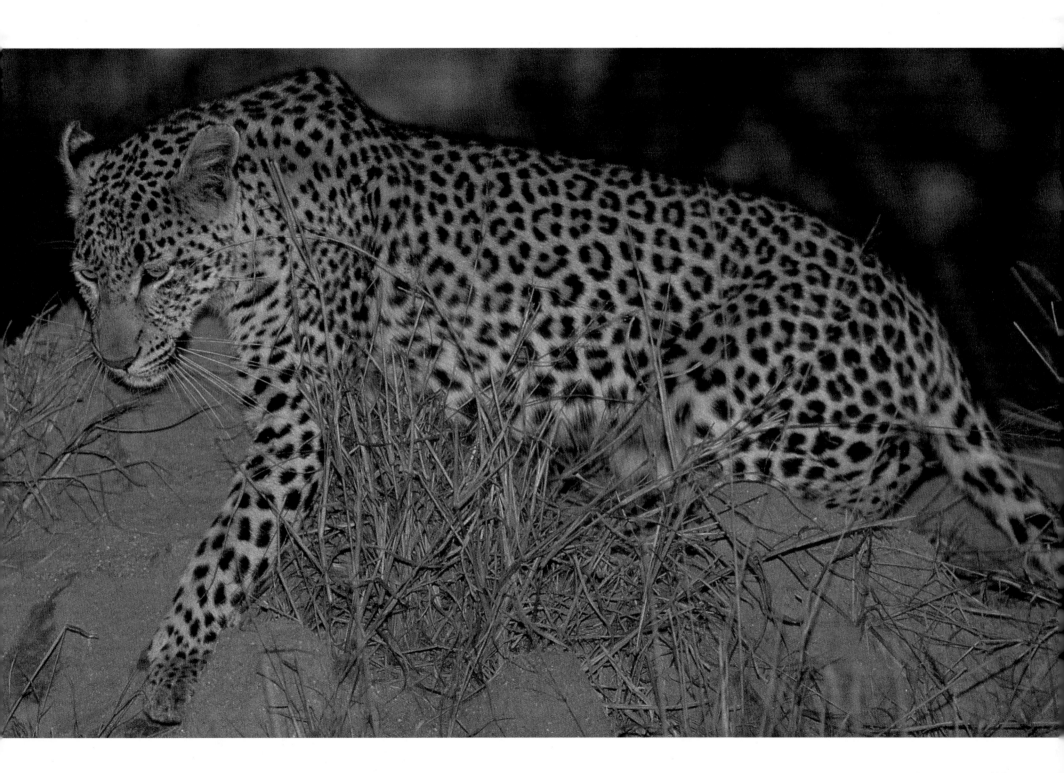

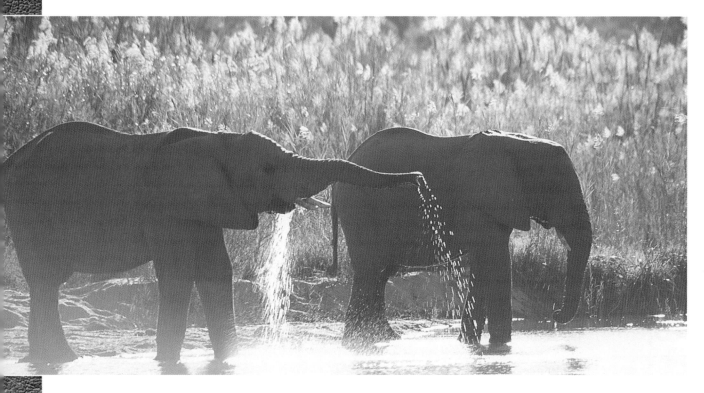

steenbok, unusually standing still, gazing nervously at us as we pass.

It's 7.00am and before we leave Mala Mala I want to get pictures of Main Camp from the far bank of the Sand River. Across the causeway we're manoeuvering the vehicle looking for the right angle when the tracker's hand shoots up bringing us to a halt. I can't see anything but there's a sound like muted thunder and a buffalo bursts past, then another and another, stampeding either side of us heading for water. Three, maybe four hundred animals creating their own dust cloud. We just sit tight, pictures of the camp forgotten. After an hour they start to move off and we head back to camp for a delayed breakfast. But we can take our time, there's no hurry, our next stop and the last stage of my journey is less than an hour away.

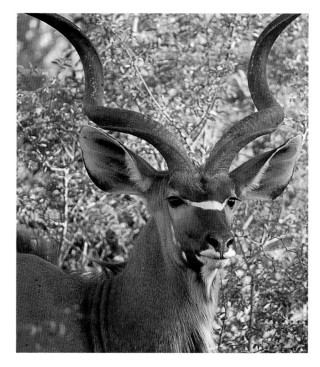

alone, they'll generally just ignore you unless they feel threatened. We've never had a bad incident in forty years." "What makes Mala Mala so special – why has it won so many international awards?" "Keep it simple," Mike replies. "Good home cooking, good service, a good cellar but above all a great game experience. That, after all, is why people come here."

In the Mala Mala lounge before dinner I can see why Mike is so very successful. It's the personal touch He goes round the room talking to every guest, making sure they have drinks and asking about their day, the perfect host. Over dinner, which displays the good cooking, good service and good cellar part of the equation, Mike offers to be our guide for the next few days and show us a real Mala Mala wildlife experience.

He did not disappoint. His intimate knowledge and familiarity with the reserve and its inhabitants are invaluable in tracking and finding animals. It's a rewarding few days dominated by leopard sightings. Tracking a male on the hunt in the early evening and another during the day. Following a female and cub to her kill stashed in a tree, then finding them again the next evening.

Watching two young bull elephants drinking and being surrounded by a large buffalo herd. A vehicle-habituated forktailed drongo, following our Land Rover, feeding on the insects we disturb as if we're a large mammal – their usual hosts. We encountered lions, too stuffed to move, rhino and general game – kudu, impala, wildebeest, giraffe, zebra and a solitary

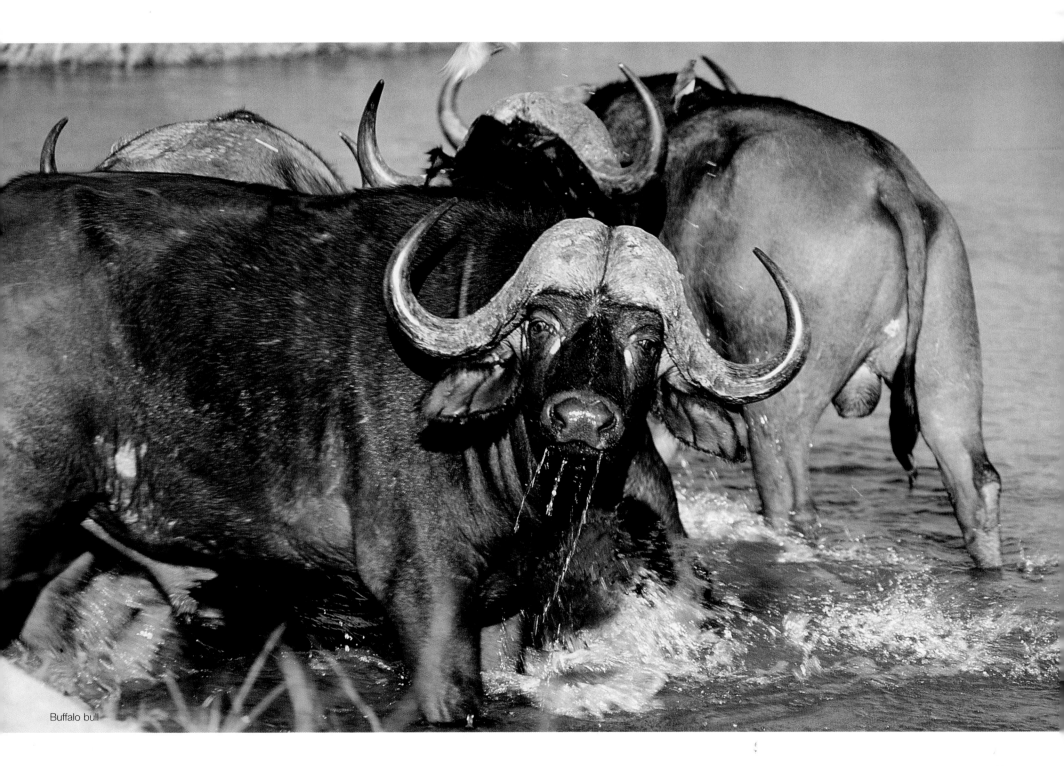

Buffalo bull

Sabi Sand

Notten's

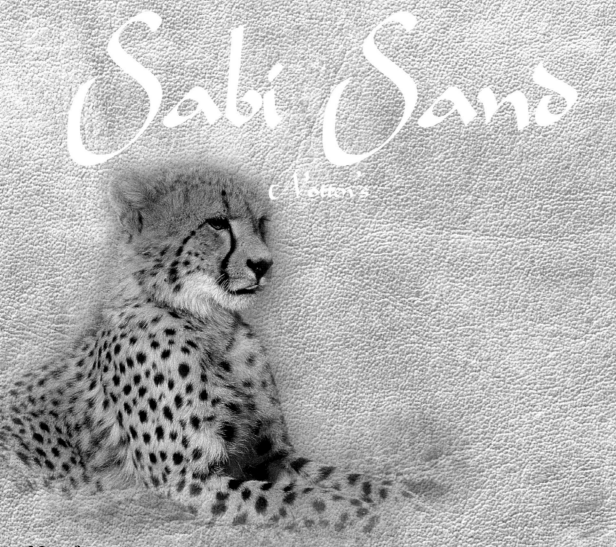

Redbilled oxpecker on buffalo

Not far from Mala Mala is Notten's, a small camp home to another great character, or I should say, two great characters, Gilly and Bambi Notten. We're sitting on the camp deck, Bambi recounting their story with interjections from the bubbly Gilly. Bambi's father bought Notten's in 1964 – the same year that Mike Rattray launched Mala Mala on the world. Bambi was a bush baby, his family owned a nature reserve in what is now Lonehill on the outskirts of Johannesburg, but in his own words, "The Sabi Sand opened up a new world, giving me entrée into the world of big game."

Bambi and Gilly were school friends from a young age. In 1968 Bambi invited the 16-year-old Gilly and her then boyfriend Mart to Notten's for a

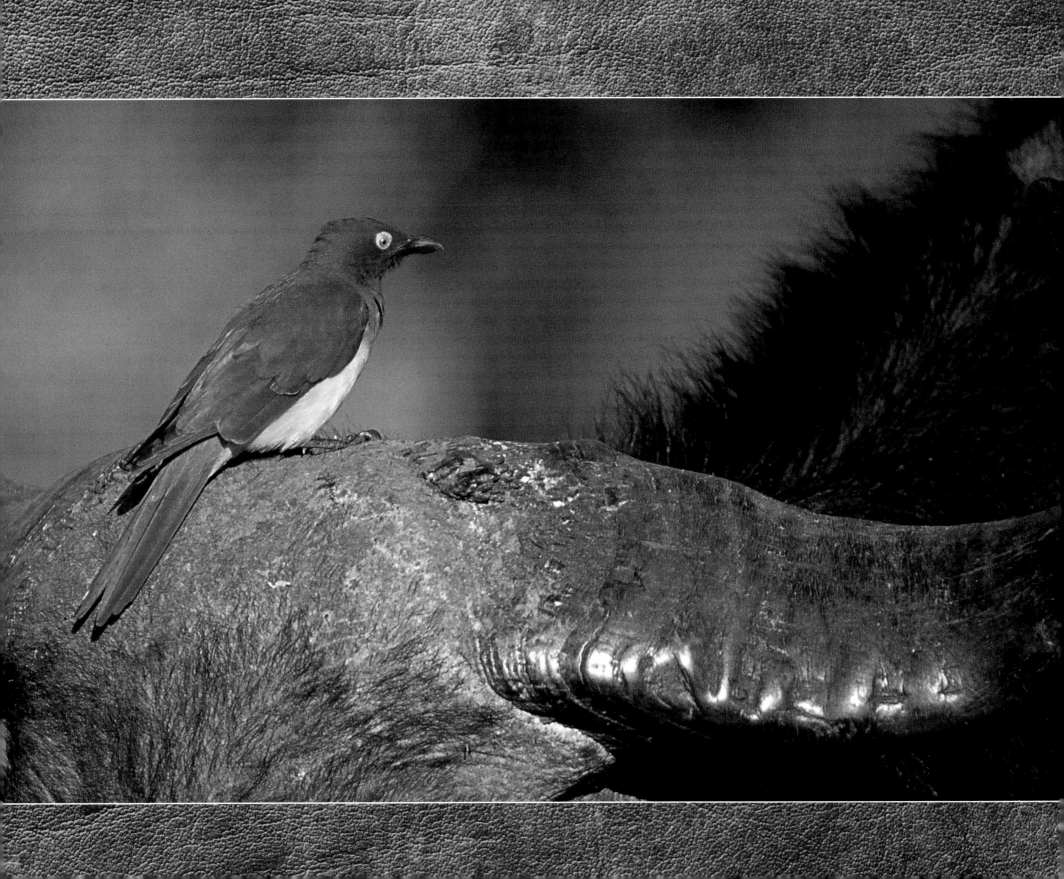

weekend – chaperoned of course by Gilly's brother. Gilly says, "I was terrified – all those wild animals and insects!" They were on their way to Newington Gate for provisions when the Land Rover blew a tyre. No spare, so Bambi and Mart set-off back to camp for help. But Gilly refused to stay on her own in the vehicle and made them stop a train, then still running on the now defunct Selati line, to take her to Newington Gate. It must have been quite a sight, two young men furiously waving down a steam train in the middle of the bush! Gilly says, "During that weekend I dogged Bambi's footsteps, he was so big and protective that he made me feel safe." The beginnings of romance, two years later they married.

During these years the camp was basic, just a week-end haunt for the family. Gilly and Bambi became fanatical about the bush but as Bambi points out, "She was still terrified and refused to walk to the outside loo during the night. I had to drive her – all of twenty metres!"

They had always dreamed of living in the bush but it remained just that, a dream, until the 80's.

Bambi – "I was a building contractor and business was on the floor. Mala Mala was operating and Sabi Sabi had just started. It seemed to me that if we did the camp up a bit we could commercialise the operation. I knew we wouldn't starve – I could always shoot an impala for the pot!" Within three months they had moved, rebuilt the camp and were ready for business.

Tranquility at Notten's (Above)
Doe-eyed Kudu cow searching for that 'special' leaf (Right)

But it almost didn't happen, they both went down with serious malaria. Bambi says, "We were lying in bed, it was 45°C, and I thought we were dying." No sympathy from Gilly's father; his comment, "I knew they hadn't been drinking enough gin and tonic!"

They opened at Easter 1986 and their first paying guests were friends. For the inaugural safari Bambi wasn't there and Gilly – all 5ft 2in - took their guests out – probably the first woman in the Sabi Sand, maybe anywhere, to act as a guide. The following day more friends arrived, loved it and immediately booked for a further ten days. As Bambi says, "Maybe it was something to do with the fact that our entire stock of port ran out on the first night!"

Sons Grant and David took to the new life like ducks to water. Normal schooling continued of course but home was now the wonderland of the Sabi Sand and as Grant says, "We were learning without realising it, just absorbing information from Spector and Joseph." As knowledgeable as any qualified guide or ranger, Grant started taking guests on safari from the age of sixteen – he needed a cushion to reach the Land Rover pedals! As he says, "It was the very best kind of education, mixing with international guests from different countries with different cultures, sharing our knowledge of the bush was just a fantastic experience."

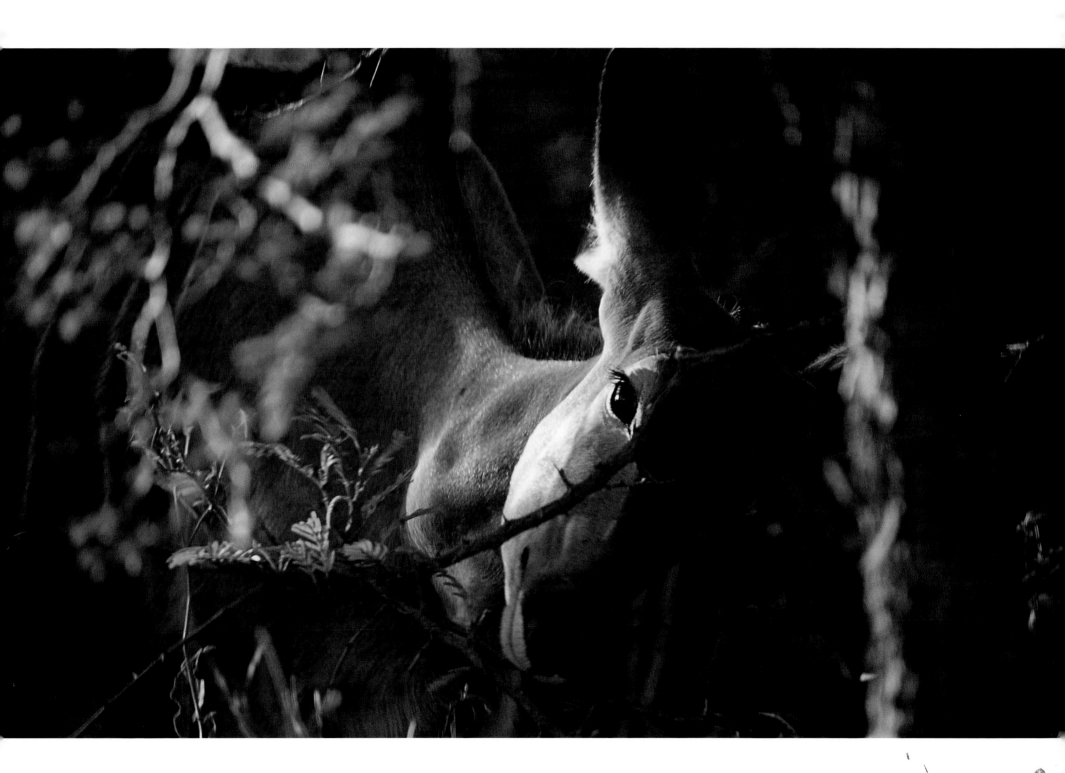

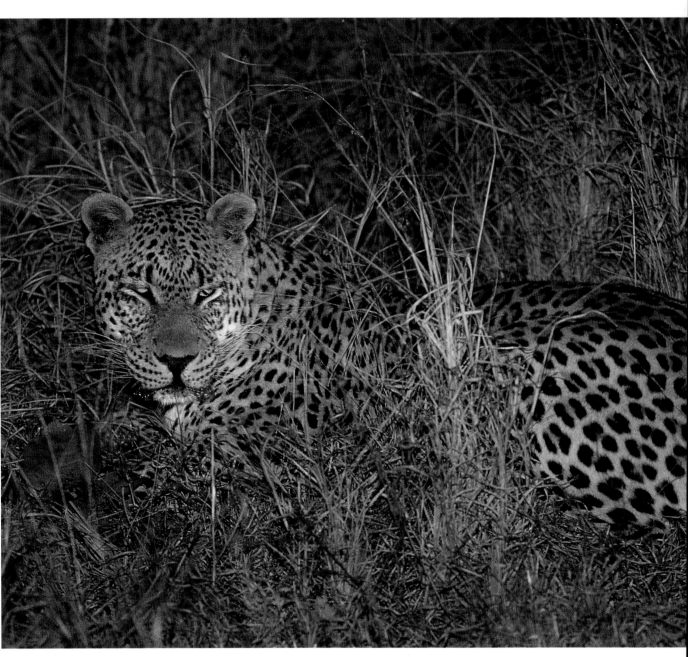

Sporting the scars of a fresh encounter with a leopard a rhino stalks myopically off through the bush (Left)

The loser stares balefully into the spotlight (Above)

A Bambi anecdote: "I was escorting guests to their room after a Notten's boma dinner. My torch picked up eyes – a leopard ambling along next to the path. I came to an abrupt halt, stepped off the path and cocked my rifle but it just carried on past us, only a couple of metres away!" I asked if he'd ever fired his rifle in anger. "Never," he answered. "It's there just in case." And another: "We were having dinner in the boma and I felt something heavy move over my foot, I looked down and nearly had a heart attack! It was a three metre black mamba. I froze as it wrapped itself around my legs. After what seemed a life time it slithered away. It took a very large dark brown whisky, in fact several, to stop the trembling."

And one from Gilly: "I heard a great commotion in the kitchen one night and rushed in to see what was going on – three hyenas had chased a kudu into the kitchen and were tearing it to pieces. There was blood all over the place, right up the walls, everywhere." "What did you do?" I ask. "Slammed the door and called Bambi," she replies. "Bambi, how did you get the hyenas out of the kitchen?" "Get them out? No chance, all I could do was open the door, wait until they had finished feeding and left, then drag the remains out. That took a day and the kitchen was unusable for two - the mess was unbelievable."

"Anymore unusual animal encounters?" I ask. "The giraffe," says Gilly. "Lions killed an old giraffe close to camp and we noticed a stream of giraffes visiting and touching the remains, paying homage to the old bull. He was obviously revered by the giraffe community and they were paying their respects and it went on for

eighteen months." Unusual indeed. There are many documented examples of elephants honouring their dead in this way, but I've never heard of any other animals doing so. Fascinating!

Bambi chips in with another anecdote, "We'd been swimming and left towels out on our deck. A lion came up onto the deck, grabbed a towel and retreated with it to our front lawn where the rest of the pride was lying. We never got the towel back!"

Grant likes nothing better than escaping from camp and taking a Land Rover out into the bush. He's passionate about wildlife and proved a highly skilled guide. An elephant is our first encounter.

We watch as he pushes over a tree. Is he going for the succulent roots or just showing off? It's the roots.

Then kudu, handsome and glowing in the morning light. A lovely leggy zebra foal staying close to mother, more kudu, then a nervous impala herd. A saddlebilled stork fishing in a small pool - eyes glinting in the sun. Buffalo grazing their way across the grass, oxpeckers hunting for ticks.

More impala, then tracker Gideon picks up cheetah spoor. Looks like mother and two cubs. The tracks disappear into the long grass and we lose them. We search - nothing. A steenbok stops and stares before bounding away. Kudu browsing, one female twisting her head to get at a juicy leaf. A dagga boy – lone old

Pale chanting goshawk (Above)
Elephantine strength and dexterity (Right)

buffalo - kicked out of the herd, bad-tempered and dangerous but too busy feeding to bother with us. A Pale chanting goshawk preens on a dead tree and two rhinos eye us short-sightedly.

Grant is determined to find the cheetah and we resume the search. Gideon picks up fresh tracks, they're easy to follow in the sandy road. We come over a low rise and there, lying warming themselves in the early morning sun, a beautiful female and two cubs – a pigeon pair – brother and sister. They're very relaxed just sitting watching us. We move around

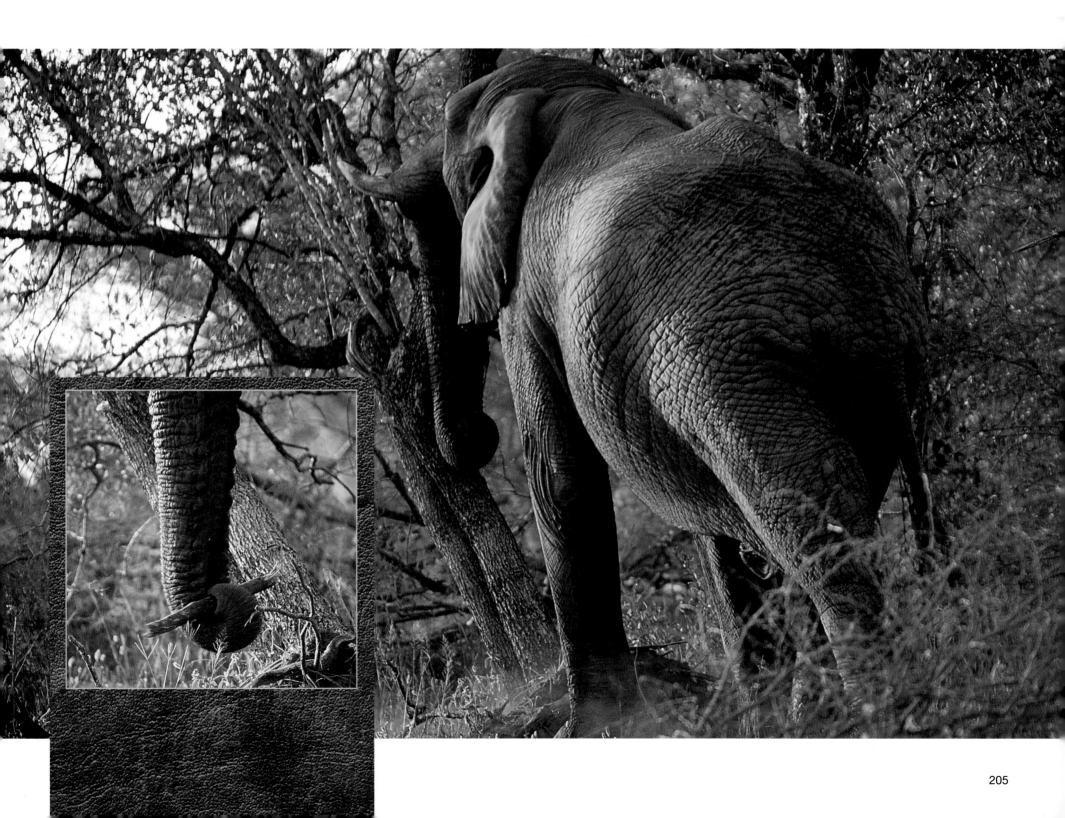

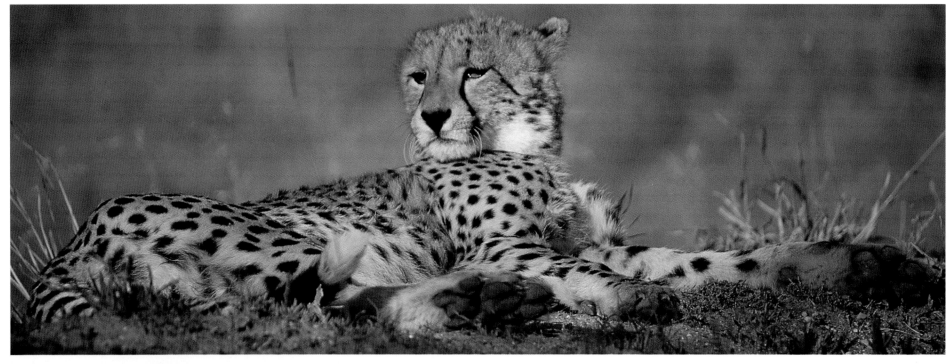

Cheetah cub, relaxed, but still alert (Above)

Scanning the horizon (Left)

Too thorny (Right)

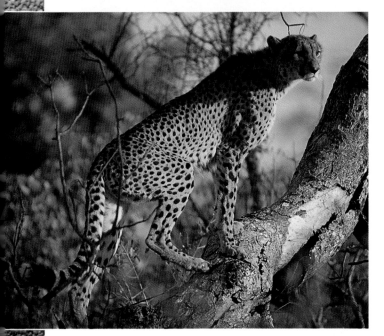

them, their eyes follow us. Eventually mother stands and stretches then moves into the grass, the cubs follow, frolicking like kittens. The young male clambers into a thorn tree then scrambles straight down again – too thorny! We stay with them as they stop and lie down again in the grass. Then mother moves off, the cubs follow, there seems to be intent, maybe they're on the hunt. She climbs a tree and looks around – some impala, not far off. She jumps down and the young male replaces her in the tree, looking in the same direction – the impala. He climbs down and they stalk slowly and cautiously in the direction of the impala. But there's an alarm snort and the impala run. Breakfast has gone. The skankaan stop and re-group, they have to start again from scratch. Maybe we spoilt the hunt for them so we leave them in peace.

Gideon's spotlight picks up a leopard – there's a crashing through the bush and a rhino appears heading straight for the cat. No contest – the cat hurries away into thick bush. Why would the rhino bother to chase-off a leopard? It's not a threat – another mystery of the bush! The carnivores are really having a tough time!

The radio crackles; it's the camp manager. He's tracking a leopard just outside camp. We're on our way. Gideon picks up the ingwe spoor, his spotlight catches a glint of eye. He's lying as still and quiet as a

mouse, shadowing an impala herd. We watch as he crawls forward from bush to bush. Gideon turns off the spot – we don't want to spoil the hunt. The leopard stalks closer, but the impala are nervous. They pick up the cat's scent. There's an alarm snort and they're off scattering in different directions. Within seconds they're gone. The ingwe gives up and melts away into the darkness to find new prey.

The thrill of the chase has gone and the night chill is starting to bite. We head back to camp for warming drinks and dinner round a roaring fire in the boma.

The company, as always after a successful safari, is convivial. Bambi and Gilly entertain their guests with a multitude of bush stories. Methinks the port might run out again tonight!

Tomorrow I must leave; my safari has come to an end. It's time to get back to the real world and start planning my next photographic exploration, my next voyage of discovery – Serengeti, the Timbavati, Uganda's Bwindi, the Luangwa Valley, the south eastern Mara, Chobe, Meru, Laikipia, Selinda, Tarangire, Chief's Island in the Delta - just a few of Africa's magical places that beckon.

a Bambi-eyed Steenbok (Above)

and (Left) a Saddlebilled Stork eyes glinting in the sun

African Odyssey

Boma Ulanga & Mikokoni
Tanzania

Tourcare

Mala Mala
South Africa

Tel: +27 (0)11 442 2267
Fax: +27 (0)11 442 2318
malamalares@malamala.com
www.malamala.com

Simbambili
South Africa

Tel: +27 (0)11 883 7918
Fax: +27 (0)11 883 8201
res@inzalosafaris.com
www.inzalosafaris.co.za

Deception Valley Lodge
Botswana

Tel: +27 (0)11 706 7207
info@islandsinafrica.com
www.islandsinafrica.com

Notten's Bush Camp
South Africa

Tel: +27 (0)13 735 5105
Fax: +27 (0)13 735 5970
nottens@iafrica.com
www.nottens.com

Susuwe Island Lodge & Impalila Island Lodge
Namibia

Tel: +27 (0)11 706 7207
info@islandsinafrica.com
www.islandsinafrica.com

Governors' Camp and Il Moran Camp
Kenya

Tel: +254 20 2734000/5
Fax: +254 20 2734023
info@governorscamp.com
www.governorscamp.com

Selati Sabi Sabi
South Africa

Tel: +27 (0)11 483 3939
Fax: +27 (0)11 483 3799
res@sabisabi.com
www.sabisabi.com

Tongabezi
Zambia

Tel: +260 3324450
reservations@tongabezi.com
www.tongabezi.com

Jaci's Safari Lodge
South Africa

Tel: +27 837002071
Fax: +27 (0)14 778 9900
jaci@madikwe.com
www.madikwe.com

Sausage Tree Camp
Zambia

Tel: +260 (0)1 272 456
info@sausagetreecamp.com
www.sausagetreecamp.com

Sponsors:

Naturelink Charters
South Africa

Tel: +27 (0)12 543 3448 Fax: +27 (0)12 543 9110
parts@naturelink.co.za
www.naturelink.co.za

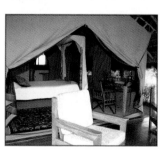

Ker & Downey: Kanana, Okuti, Footsteps, Shinde
Botswana

+267 6860 375
safari@kerdowney.bw
www.kerdowney.com

Semliki Safari Lodge
Uganda

Tel: +256 (0)41 251182
Fax: +256 (0)41 344653
tusc@africaonline.co.ug
www.safariuganda.com

Kenya Airways
South Africa

Tel: +27 (0)11 881 9795 Fax: +27 (0)11 881 9786
Linda.Graber@Kenya-Airways.com
www.kenya-airways.com

Acknowledgements

African Odyssey the book grew out of our TV series. The crew worked tirelessly and was dedicated to make the series a success. Co–producers Raymond Hennessey and Sue Walker and the rest of the team, Andre van den Heever, Glenn Howden, Karl Maeder, Charles Bengis, Mike Brink and Sven Cheattle. Thanks guys.

Lilla Hurst, Anthony Kimble and Ann Roder at TVF International who saw the potential of the TV series and turned it into sales and Michelle Berridge at Discovery who has provided continued advice and assistance.

We encountered many wonderful guides, rangers and trackers in our Odyssey. They are the essence of any African Safari and added immensely to our experience. They are mentioned in the text.

Others, too, smoothed our way - the lodge owners, managers and marketing people all helped to make our journey easier. Their hospitality and assistance cannot be exaggerated: Lesley Simpson, Sharon Joss, Herby Rosenberg, Patrick Shorten, Hilton Loon, Mike and Tanya Cowden, Jan and Jaci van Heteren, Liesl Nel, Susan and Mike Rothbletz, Dusty Rogers, Ben and Vanessa Parker, Alan Harkness, Jason Mott, Jonathan Wright, Aris and Justin Grammaticas, Jane Dennyson, Nicky Keyes, Peter Brandon, Mike Rattray, David Evans, Gilly and Bambi Notten, Grant Notten, Mohamed Yassin.

My amazing loyal and loving daughters Susan and Ingrid who said "yes you can", gave me endless enthusiastic encouragement, support and input never having any doubt that African Odyssey would be produced and would be stunning. And my son Calvin, the epitome of cool, who expresses his interest and excitement in a more laid-back way as befits his generation.

Sue's Mom, Joan, who provided us with a home from home in the wilds of Warwickshire as well as inspiration, encouragement and enthusiasm for African Odyssey. Her presence and wisdom are sorely missed but I know she's smiling approval.

Sue's brother Pete and his wife Lionel, friends as well as relatives, who have travelled and partied with us in Africa and Europe, lived through the trauma of both TV and book production and always given us unfailing support and hospitality.

Our long time and dear friends Les and Chrissie Cocks who always entertained us royally on our business trips to London.

My two great protagonists Michel Girardin and "Roger" (Ron) Walter who encouraged my metamorphosis from would-be music mogul to wildlife photographer, TV producer and writer. They opened doors and constantly promoted African Odyssey and me to anyone who would listen. Their assistance and friendship has been immeasurable

Without good friends this book would never have happened – no one can work in a vacuum, so special thanks to those who lived patiently through the idea, the outline, then the roughs, and finally gave me opinions on the proofs:

Joyce and Ken, Dawn and Alec, Derek and Sheila, Sam and Pat, Mick and Elaine, Bonnie, Tony and Claire, Andy and Jean, Patric and Charles, Anne and Brian, Raymond and Elaine, the Robots aka Ronnie and Louise, Clare and Michel, Kevin and Eve, Tony and Mary-Anne, Jenny and Bruno, John and Sheila, Anna P, Francis, Anna B, Darryl and Lyn, Russell and Roz, Maggi, Manfred and Renate, Mike and Sang, Rose and Tony, Alizanne and Mike, Irene, Barbara and Ben, Peter and Tinker

Christopher Coleman of Fountain Press is a Publisher with vision and a true professional. His dry humour and enthusiasm for African Odyssey made working with him a pleasure.

Special thanks to our designer Rob House for his innovative and stunning treatment of my African Odyssey. It complements perfectly my vision for the book and the result speaks for itself.

My son-in-law Kevin and his team at Inuntius in Los Angeles were responsible for the brilliant and imaginative design of the African Odyssey website.

Pilot extraordinaire Chris Briers and his team at Naturelink flew us round Africa with the utmost reliability. Chris's experience was invaluable in helping us plan our Odyssey and overcome some of the bureaucratic hurdles as well as occasionally acting as stand-in game guide.

Kenya Airways have always given us a high level of service and efficiency, they are deservedly the Pride of Africa – our international airline of choice.

Queensway flew us in the Mara and Botswana Air made it easy to get to Maun, the hub for the Okavango Delta.

EQUIPMENT

I use only Nikon cameras – not just brilliant optics, accurate metering, fast auto-focus and reliable shutter speeds but also ease of handling and an unrivalled ability to absorb hard knocks, essential in the often extreme African conditions. The advent of digital photography has changed the parameters and Nikon have set the standard with their superb new cameras and specially designed lenses.

Special thanks to Brian Schwartz and Jan Pretorius of Foto Distributors in Johannesburg. They and the rest of the Nikon team have had the onerous and demanding task of looking after my equipment as well as constantly keeping me up to date with the latest advances in a fast developing and highly technical field. Service par excellence!

Binoculars are a vital and essential piece of equipment for any photographer in Africa. Apart from their outstanding, brilliant optics enabling me to find and track many animals, my Minox glasses have proven to be resilient to the many hard knocks and tough African conditions of dust, heat and humidity.

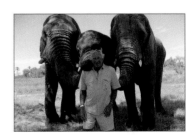